VERROCCHIO

COMPLETE EDITION BY

G · PASSAVANT

PHAIDON

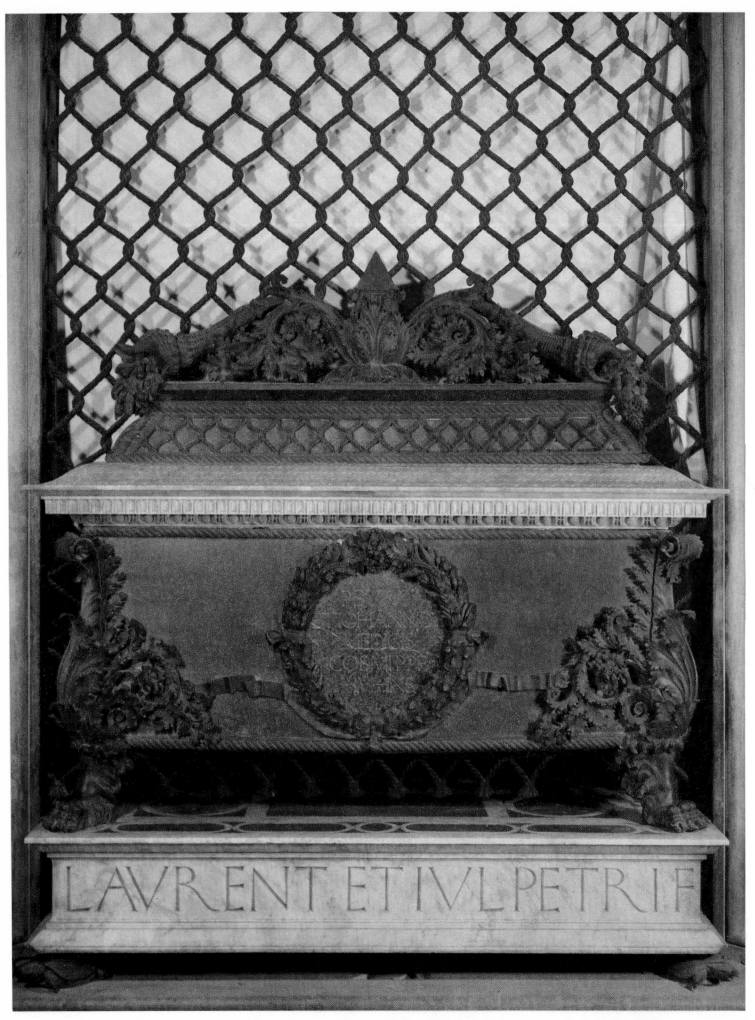

Tomb for Giovanni and Piero de' Medici: sarcophagus, plinth and net. Porphyry, serpentine, marble and bronze.
Florence, San Lorenzo, Old Sacristy. Cf. Plate 5

VERROCCHIO

Sculptures · Paintings and Drawings

COMPLETE EDITION
BY G·PASSAVANT

PHAIDON

© 1969 BY PHAIDON PRESS LTD · 5 CROMWELL PLACE · LONDON SW7

PHAIDON PUBLISHERS INC · NEW YORK
DISTRIBUTORS IN THE UNITED STATES: FREDERICK A. PRAEGER INC
III FOURTH AVENUE · NEW YORK · N.Y. 10003
LIBRARY OF CONGRESS CATALOG CARD NUMBER: 69–12790

TRANSLATED FROM THE GERMAN
BY KATHERINE WATSON

SBN 7148 1370 2

MADE IN GREAT BRITAIN
PLATES PRINTED BY HENRY STONE & SON LTD · BANBURY · OXON
TEXT PRINTED BY R. & R. CLARK LTD · EDINBURGH

CONTENTS

PREFACE

THE main purpose of the following essay is to provide a straightforward introduction to Verrocchio's works and to encourage the reader to approach them direct. With this in view it has not been possible to include a detailed study of such controversial but, for the art historian, important problems as Verrocchio's artistic antecedents and early training or a full discussion of certain works recorded in literary sources but now lost. The study of autograph paintings and drawings makes use of the compositional analyses and of the conclusions published in 1959 in my book *Andrea del Verrocchio als Maler*. In dealing with Verrocchio's sculpture it has proved necessary to continue the process, begun by Planiscig in his monograph of 1941, of eliminating doubtful works of inferior quality. It will be found that by reducing the extent of his *œuvre* (in no way compensated by new attributions) an essential prerequisite has been created for a deeper understanding of his stature and originality as an artist. Of works which, in my opinion, have been wrongly ascribed to Verrocchio, only those which Planiscig still regarded as authentic have been discussed in detail in the essay and included in the catalogue.

The bibliographies following each catalogue entry are designed to facilitate the location of the more important comments and conclusions, although owing to the extent of the literature there are inevitable deficiencies and omissions. Studies published in and after 1966 have only been included in some instances. Certain controversial recent attributions which, in my opinion, would add nothing significant to our knowledge and appreciation of the artist have not been discussed. This applies for example to the thesis, advanced mainly by E. P. Richardson, that Verrocchio had a share in the design of the *Adoration with Two Angels*, acquired as a Leonardo by the Detroit Institute of Arts. Equally, it applies to Dario A. Covi's proposed attribution of the tomb-slab of Fra Giuliano Verrocchio in S. Croce in Florence and to the terracotta figure of St John the Baptist now in the Hessisches Landesmuseum in Darmstadt.

I should like to thank all those who have helped me in my work and during the writing of this book: first of all the museum directors, private collectors and art dealers who drew my attention to works by the artist and his circle and enabled me to examine them in the original; also the directors of art historical institutes, other scholars and colleagues whose suggestions, advice and criticism were of great value to me. I am very grateful to Mr Ludwig Goldscheider, to whom I owe the impulse to write this book, Mrs Katherine Watson, who made a careful English translation from the German manuscript, and Dr I. Grafe and his colleagues at the Phaidon Press, who saw the book through the press. Lastly I wish to express special thanks to Mrs Elizabeth Beatson, for her untiring and selfless assistance: she has helped to correct a number of mistakes and errors and has contributed to the present wording, especially in English, of both essay and catalogue.

Munich, October 1968 GÜNTER PASSAVANT

VERROCCHIO AND THE CRITICS

OPINION on Verrocchio's work has been conflicting and uncertain in all writing on art since Vasari's *Lives*. This is partly because of general changes in attitude towards the quattrocento, but it is symptomatic too of the exceptionally wide scope of Verrocchio's activity and of the special place that his art occupies on the threshold of the High Renaissance. While it was impossible for any critic to remain entirely indifferent to the impact of his masterpieces, whatever fault he might find in detail, no direct approach to Verrocchio's work as a whole was possible as long as the attempt was being made to evaluate his *œuvre* according to set aesthetic principles and to fit it neatly into a general pattern of artistic development and stylistic sequence.

Yet some aspects of his work have been held in unchanged regard throughout the centuries. Firstly there has always been praise for the great technical ability which distinguished him as a sculptor, especially in bronze. And secondly, Verrocchio's personality and strength of character, his high artistic zeal and intense endeavour to master each artistic problem as it arose, have always remained impressive. On the other hand he has been blamed principally for the 'mere realism' which according to Burckhardt seemed the characteristic aesthetic axiom of his art. For Vasari this 'maniera alquanto dura e crudetta', which he criticizes in Verrocchio's works, resulted from the artist's efforts to make up for inadequate talent by hard study. He describes him as self-taught, calls him 'orefice, prospettivo, scultore, intagliatore, pittore e musico' and, without express emphasis, allows as well a spiritual affinity with his pupil Leonardo in his multiplicity of interests and knowledge. Vasari is not niggardly of recognition when he describes single works; he stresses the technical perfection of the bronze sculptures and admires, entirely in the spirit of the cinquecento, the richness of invention and taste in the conception of these pieces. He praises the 'very beautiful and well arranged' drapery of the Christ and St Thomas group and admires the conception and the execution of the grille of bronze netting over the Medici tomb in the Old Sacristy of S. Lorenzo. Not for two and a half centuries after the second edition of Vasari's *Lives* was there any new critical appraisal of Verrocchio's art. Then in 1813 Conte Leopoldo Cicognara published his *Storia della scultura dal suo risorgimento in Italia fino al secolo di Canova*, 'per servire di continuazione all'opere di Winckelmann e di d'Agincourt'. Cicognara calls Verrocchio 'valentissimo artista' and acknowledges '. . . fra gli uomini che onorano la statuaria egli ha uno dei più distinti luoghi'. He calls special attention to the importance of the artist in the development of monumental sculpture; but his criteria are derived from Winckelmann's view of art, and he therefore condemns the 'excesses' in Verrocchio's works, his stark naturalism no less than the bombast which goes beyond the bounds of 'nobiltà'; and the later writers of the nineteenth century all followed him in these

criticisms. Cicognara complains for instance of the rendering of drapery in the Christ and St Thomas group, once so praised by Vasari, because it 'produce alcune linee ingrate, e dà troppo nel minuto e nel secco'.

Between 1827 and 1831, in the last years of Goethe's life, the Freiherr von Rumohr wrote the three volumes of his *Italienische Forschungen*, republished in 1920. There we read in the section on Verrocchio: 'It is true that this artist, whose talent Vasari rated far too low because of his preference for facility of manner, only mastered his material in a few works; but in these successful pieces he showed himself possessed of a very remarkable spirit and this it was which caused him to strive continually after an even more austere and profound motivation for his representations; it is this which often gives his work a pedantic aspect.' Rumohr approaches closer to Vasari's opinion when he remarks elsewhere that Verrocchio's works 'all seem to bear the impress of an anxious and oppressive preoccupation with physical presence'. Like Cicognara he finds the garments of the Christ and St Thomas group tastelessly arranged, but he gives high praise to the Putto with a Dolphin, which he calls one of the most successful of the master's works. The following neat quotation from Ludwig Schorn in his German edition of Vasari of 1839 is of course not a very profound statement, but it is telling: 'Characteristic of Verrocchio's art is a fundamental, indeed an unusually deep and vivid view of nature, but it is entirely lacking in any poetic impetus.' A decade and a half later Burckhardt wrote in his *Cicerone*: '. . . The reality of life without higher understanding sometimes becomes too much for him' and in another place: 'His David is nothing more than the image of an ordinary boy, and is even inferior both in composition and form to the bronze David by Donatello which stands as its companion piece.' To see the force of this judgment we need to know what Burckhardt thought of Donatello's realism: 'Donatello exercised an enormous and at times a dangerous influence on the whole of Italian sculpture.' But there is nothing that reveals better the idea and the ideal of beauty in the art literature of the midnineteenth century than Burckhardt's remarks on the Christ and St Thomas group: 'In places the ideal which Ghiberti had rescued from the German period and refined according to the standards of his century, forces its way through. As long as we do not allow ourselves to be disturbed by Verrocchio's quite unusually fussy and crumpled treatment of the folds of the drapery we can distinguish motifs of most delicate feeling. This is true of parts of the bronze group of Christ with St Thomas on Or San Michele; the attitude of the Christ figure is strongly compelling, the two heads are splendidly free and beautiful.' Burckhardt criticizes the bronze decoration on the Medici tomb as bombastic and heavy and condemns the 'rather unfortunate' use of bronze netting which Vasari had so much prized. Charles C. Perkins in his *Tuscan Sculptors: Their Lives, Works, and Times* of 1864 tried at last to give a positive appreciation of the bronze David, and found enthusiastic words to describe the Putto with a Dolphin. In the same year appeared the first English edition of the *History of Painting in Italy* by J. A. Crowe and G. B. Cavalcaselle. For the first time since Vasari the painting of Verrocchio was also discussed and its importance emphasized from the standpoint of a practising artist. Furthermore the whole *œuvre* of the artist was given a new critical

appraisal. This marked the beginning of a much higher estimation of Verrocchio's art, facilitated by the general growth in understanding of the problems and accomplishment of the quattrocento, which resulted largely from the new rehabilitation of mediaeval art which had just taken place. It is most instructive to compare Crowe and Cavalcaselle's description of the two bronze David figures by Donatello and Verrocchio with Burckhardt's criticism of them.

In Heinrich Wölfflin's *Classic Art*, dedicated to the memory of Jakob Burckhardt, the new, more sympathetic attitude to the quattrocento is manifest, although the aim of the study necessarily presents the classical precisely in its opposition to the stylistic principles of quattrocento art. This contrast obviously applies most strongly to the works of Pollaiuolo and Verrocchio immediately preceding the classical phase in time, and entails a number of misrepresentations in their evaluation. At the same time Wölfflin ignores in them all those tendencies which were not operative in the classical movement, but which were working towards the anti-classical trends of the Late Renaissance or the Baroque.

In the last third of the nineteenth century meanwhile, the art of the quattrocento had become one of the most important fields of acquisition for museums and private collectors, and there was fierce competition among the directors of the great European galleries to track down and purchase examples of Verrocchio's work, particularly his paintings. At this time the stock of the artist stood exceptionally high: Adolf Bayersdorfer, one of the most respected connoisseurs of Italian art, wrote to a friend from Florence in 1876 that Verrocchio did not paint 'like Raphael, who lavishes his divine gift without asking whence the blessing comes, but like the earnest explorer, seeking the way to the inner Heaven; a man who refines his feeling and recasts it again and again, until he has worked himself into the divine essence of the thing. Not until the spark flies up in confirmation does he set about creating his work; and when he cannot find this inner call, when he cannot find the highest way out, he prefers to do nothing. Next to his pupil Leonardo his is the greatest artistic *character* that has ever existed. The lofty and strict principles of his studio brought back worth and value to Florentine art at a time when these qualities were on the point of extinction, and showed it the path to a new kingdom.' Six years later Wilhelm Bode published his treatise *Bildwerke des Andrea del Verrocchio*, which included a discussion of the paintings. Together with the passionate replies of Giovanni Morelli it started a vigorous and long-lived controversy in the world of art criticism. A small brochure on Verrocchio by Hans Semper in 1877 was followed in the early years of this century by the monographs of Hans Mackowsky, Maud Cruttwell and Marcel Reymond. Maud Cruttwell's book provided a more scholarly basis for what was known about Verrocchio by assembling and evaluating the source material, while Reymond's book was probably the more profound attempt to assess the significance and content of his art.

The extensive monographs on Leonardo which appeared around 1910 by Woldemar von Seidlitz, Jens Thiis and Osvald Sirèn brought the spheres of research on Verrocchio and Leonardo so close that subsequently every treatment of the early development of the younger genius was

liable to involve an evaluation of the artistic work of the teacher. According to Adolfo Venturi almost every large work of Verrocchio's bears the imprint of Leonardo's collaboration or his strong influence. There have been warnings not to project Leonardesque forms backwards into the activity of his teacher, by Luitpold Dussler in his article written in 1940 for Thieme and Becker's *Künstlerlexikon*, and by Leo Planiscig in his monograph on Verrocchio of 1941; yet even today this old-fashioned notion of 'the genius' tends to militate against a clear understanding of the interaction of influence between the two artists; we are not helped by the fact that we do not possess a single authenticated sculpture by Leonardo. In the early thirties, and then especially in his publications of 1941 and 1944, W. R. Valentiner tried to demonstrate new methods of identifying examples of the early sculptural work of Leonardo; in 1950 he brought his theses together more explicitly in his *Studies of Italian Renaissance Sculpture*. John Pope-Hennessy's well balanced presentation of the development of Italian Renaissance sculpture in 1958 deliberately ignores this whole issue, however. Instead he gives critical comparisons of Verrocchio's most important sculptures with those of other quattrocento artists who were dealing with similar problems, and thereby makes a valuable contribution to our understanding of Verrocchio's place in the historical development.

Research in recent decades has rightly reduced the inflated estimate of the number of Verrocchio's own works which was to be observed since the time of Bode, both in art criticism and on the art market. The number of anonymous 'Verrocchiesque' works has thus become much greater, and there is now a pressing need for detailed assessment of the fruitful influence of Verrocchio's art and teaching on the development of the artists working at the end of the fifteenth century – not only those sculptors and painters who are traditionally known to have been his pupils but also artists like Benedetto da Maiano, Andrea Sansovino or Andrea della Robbia, Luca Signorelli or Cosimo Rosselli. In this monograph, however, it will not be possible to deal with other works than those by Verrocchio himself, or those carried out from his designs, together with a few pieces by his pupils which were produced at the same time and in close association with his own work.

II

BIOGRAPHY AND ARTISTIC CAREER

VERY little is known of the material facts of Verrocchio's personal life; documents and sources are few and not very informative. Andrea was born in 1435 and grew up in modest circumstances. His father Michele di Francesco Cioni was originally a brick-maker, but in later life he earned his living as a customs collector. Andrea was the eldest of five children. His brother Tommaso was eight years younger than he. Lorenza was born in 1440 but apparently

died in childhood. Then came Apollonia and Margherita, who received a large part of the family's assets as their dowries after the death of their father. At that time, in the second half of the fifties, the artist was still living with his stepmother Nannina, the second wife of Michele, in his father's house in the parish of San Ambrogio in Florence. In his Catasto return of 1457 he complains of financial difficulties and describes himself as a goldsmith. If we are to believe the Catasto returns his means did not improve appreciably throughout his life, although his studio at times was very busy. The artist remained unmarried. He had to support the family of his sister Margherita for many years, and her children even lived in his house from time to time; later he also had to provide for the maintenance and even the dowry of his brother's daughters, Marietta and Agnoletta. In his Catasto return for 1480 he declares that he has let off the house he inherited from his father and moved into a small house near the Cathedral which he has rented from the Bischeri family. This was the same 'casetta' between the Palazzo Bischeri and the Opera del Duomo where Donatello rented a studio and dwelling, at least after his stay in Padua.

There is hardly any definite information about the beginnings of Verrocchio's artistic career. A seventeenth-century source mentions that Andrea received his first training from a goldsmith called Giuliano da Verrocchi and adopted his name; but nothing further is known about this goldsmith. It is certainly unusual that Andrea did not follow his training in one of the well-known studios, either in Ghiberti's or in that of Michelozzo, for instance, who was working on the silver altar for the Baptistery in Florence just then, at the turn of the half-century. Possibly he would have found recognition and work in the profession more rapidly had he done so. In his tax return for 1457, Verrocchio complained that there was no work in his craft, yet this was the very year in which Antonio del Pollaiuolo, together with some other goldsmiths, received the important commission for the silver cross in the Baptistery. Verrocchio's assertion that he had been forced to take on work outside the craft in which he was qualified in order to maintain himself may mean that he was already working as a sculptor in marble. At any rate he must have acquired the necessary knowledge and practical experience at the latest by the second half of the fourteen-fifties, because soon afterwards he was competing against Desiderio da Settignano and two other artists for a commission to erect a 'cappella' in the Duomo at Orvieto. This chapel was to provide a new and worthy frame for a wonder-working image of the Madonna that was venerated there. He was paid in 1461 for the drawings he submitted, but the Sienese Giovanni di Meaccio was entrusted with the execution of the chapel. It is no longer preserved. It was probably a marble 'tempietto' similar to those erected in the Prato Duomo for the Sacro Cingolo or in SS. Annunziata in Florence for its wonder-working painting of the Annunciation. While Vasari says that Verrocchio's many-sided training was self-acquired, he also mentions several collective works in which Verrocchio is supposed to have participated. It is true that he only once speaks of a large work in marble on which Verrocchio collaborated 'ancora giovane': Andrea is said to have completed the roundel of the Madonna for Bernardo Rossellino's monument to Lionardo Bruni in S. Croce. Whether Verrocchio studied the technique of marble sculpture with Desiderio da

B

Settignano for a time, or by working in the studio of Rossellino, is a question repeatedly discussed and never yet settled, and in this respect Vasari's evidence is significant. Furthermore it is difficult to imagine that Verrocchio would come forward as a rival of Desiderio in 1461 if he really owed his training as 'marmorario' to this artist. Desiderio was, in any case, only seven years his senior.

No more is heard of Verrocchio's work for another five years. Suddenly in the second half of the sixties we learn of numerous commissions, some very important. The bronze group of Christ and St Thomas was commissioned for the central niche on the outside of the east wall of Or San Michele, at the end of 1466 at the latest. As a sculptor in stone he executed the plain tomb slab of multi-coloured marbles for Cosimo de' Medici, whose body was buried under the crossing before the High Altar of San Lorenzo in October 1467. In 1468 he received a commission for the great bronze ball to crown the dome of the Cathedral in Florence, and another at about the same time for a bronze candlestick, almost the height of a man, for the audience hall of the Palazzo Vecchio. The 'palla' was at first to be cast in bronze. Verrocchio himself took part in the deliberations which decided in favour of this technique. But in the end the 'palla' was made by soldering hammered sheets of bronze together, and then gilded. In May 1471 the work was finished and mounted. On 7th January 1600 it fell down, having several times in the intervening years been struck by lightning. The Grandduke Ferdinand I had it replaced in 1602 with a new and larger ball.

By the end of the sixties Verrocchio was already active as a painter. He painted the pennant which Lorenzo de' Medici ordered for himself in 1468 for the joust in honour of Lucretia de' Donati. There is no trace of the design of this pennant; documentary evidence exists for a portrait of Lucretia by Verrocchio, but even this work has disappeared. In 1469 Andrea tried but failed to obtain the commission to paint a series of Virtues in the Università de' Mercatanti on the walls of the Sala di Consiglio above the seats. He received payment for a drawing of Faith; but the execution of the nine pictures was given to Antonio and Piero Pollaiuolo and to Botticelli, who painted the figure of Fortitude. By this time at the latest therefore Verrocchio must have achieved some reputation as a painter, or he would not be competing for such an appointment. It would appear from his early paintings – only attributable to him, however, on stylistic grounds – that he learnt the technique and practice of panel painting in the studio of Fra Filippo Lippi at the same time as Botticelli, ten years his junior. Lippi was mainly occupied during the sixties with his frescoes in the Duomo at Prato. About 1467 the Prato studio seems to have been wound up, after Lippi had taken on some important new work outside Tuscany, at Spoleto. Verrocchio's work in this sphere must then presumably have started before the middle of the decade.

The commissions for the Christ and St Thomas and for the ball on the Duomo show that the artist was already an experienced bronze-caster by 1467/8. He must by then have been running his own foundry, for at the end of 1467 he was charged with an account for a delivery of metal which he placed at the disposal of Luca della Robbia and Michelozzo for completion of the bronze doors of the sacristy in the Duomo. During the consultations about the casting of the ball on

the Duomo Antonio Pollaiuolo and Luca della Robbia were called in as experienced bronze-door makers; they were evidently also at first Verrocchio's rivals for the commission, but for the Christ and St Thomas group there does not seem to have been any competition. In 1466 Verrocchio the bronze sculptor steps into the place of Donatello, who had just died, and who a decade earlier would certainly have been commissioned with the two monumental bronze figures. This explains why an early sixteenth-century source, the publication *De Sculptura* by Pomponius Gauricus, refers to Verrocchio as 'aemulus' of Donatello, meaning the successor and artistic heir, and not, as has often been supposed, implying a true teacher-pupil relationship.

Verrocchio's main works were done after 1467/8, in the last two decades of his life. This can be established although – indeed because – the documents and sources report relatively little about his earlier activity. He owed his advancement as an artist primarily to the encouragement of Piero de' Medici and his son Lorenzo; this advancement only became possible after the place had been vacated which Donatello as protégé of the Medici had occupied until his death. Henceforth Verrocchio obtained all his most important commissions from the Medici or through their agency. In 1471 the Florentine Opera del Duomo decided to replace Brunelleschi's wooden choir stalls with new stone architecture. The stalls were to be decorated with marble and bronze on the outside, and it was decided to entrust Verrocchio with the designs and execution, as 'homo intendente'. The scheme must have fallen through; the present choir stalls in the Duomo were not made until the middle of the sixteenth century when Baccio Bandinelli and his associates did them, entirely in marble. Between 1470 and 1472 Verrocchio worked on the tomb of Piero de' Medici and his brother Giovanni. Piero's sons Lorenzo and Giuliano will therefore have commissioned it soon after the death of their father at the end of 1469. The inscription on the tomb gives 1472 as the year of completion. In the same year Verrocchio joined the Florentine Guild of St Luke. He is entered in the list of members as 'dipintore e intagliatore', while Pollaiuolo is given as 'orafo e dipintore'. This shows that by that time Andrea's original profession of goldsmith was entirely overshadowed by his work as painter and sculptor. From the early seventies there are records of a few smaller commissions and works for special occasions; as court artist to the Medici he arranged the state reception for the Duke of Milan, Galeazzo Sforza, who entered Florence in March 1471 with his wife and a large following and was entertained by Lorenzo de' Medici in his palace with much pomp and splendour. In 1473 Verrocchio was called to Prato to act as assessor for payment of the marble pulpit by Antonio Rossellino and Mino da Fiesole; he was now evidently considered an expert in marble sculpture. In 1474 he was concerned with the casting of a figured bronze bell, known to us only from a single documentary source, for the monastery of Monte Scalari. At the end of the same year Andrea painted the pennant which Giuliano de' Medici carried in the tournament in honour of Simonetta Vespucci, held in 1475 in the Piazza Santa Croce; a surviving drawing by Verrocchio probably shows the figured scene on one side of the pennant.

During the early seventies and round about the middle of the decade the artist must have

received two important commissions for paintings: the first of these, the large Baptism of Christ, can be dated on stylistic grounds to about 1474/5. In Vasari's time it was to be seen in the monastery of San Salvi outside the city walls. The second was for an altarpiece of the Madonna with Saints which was ordered under the will of Bishop Donato de' Medici, who died at the end of 1474, for a chapel dedicated to the Madonna to be added in his memory to the Duomo of Pistoia. The painting stood unfinished in Verrocchio's studio for many years and was only completed in the late eighties by Lorenzo di Credi. It is still preserved in Pistoia. Verrocchio did some important sculpture during this period as well as these two large altarpieces. Among other things he was working on the bronze David, which Lorenzo and Giuliano de' Medici sold in 1476 to the Signoria of Florence. At the same time he was busy with designs for the cenotaph of Cardinal Niccolò Forteguerri; Andrea's clay model was submitted along with the models of his competitors to the council of Pistoia in 1476. The final decision in favour of Verrocchio was not taken until 1477, and once again it was the opinion and partisanship of his patron Lorenzo de' Medici which decided the issue. The monument was unfinished at Verrocchio's death. In 1477 Andrea competed against Antonio Pollaiuolo and other goldsmiths for the commission for the reliefs on the side panels of the fourteenth-century silver antependium for the Baptistery altar which still remained to be done. He was given the commission for a relief of the Decollation of the Baptist and delivered it in 1480. In 1478 he was probably working on the bronze Putto with a Dolphin, which later decorated the courtyard of the Palazzo Vecchio, but which originally surmounted a fountain in the Medici villa in Careggi, as is known from the records. Vasari mentions another work by Andrea from the late seventies, done in Rome; this is a tomb for Francesca Tornabuoni, who died in 1477. It was to be seen in S. Maria sopra Minerva. Apparently only one marble relief with two figured scenes, now in the Bargello, has survived.

At the end of July 1479 the Signoria of Venice decided on the erection of a bronze equestrian monument to Bartolomeo Colleoni. Verrocchio sent in to the prescribed competition a full-size model of the horse in wood, covered with black leather. It was finished in 1481, but was not put on public view in Venice until two years later. When at last he had finished the Christ and St Thomas, ordered more than fifteen years before, and seen it set up in its niche on Or San Michele in 1483, Verrocchio appears to have left Florence. He started a second workshop in Venice in order to work on the large clay model of horse and rider for the Colleoni monument, and to prepare the casting. He died in 1488 in Venice after making his will on 25th June. In it he describes himself as 'habitator venetii in contrata santi marciliani' and appoints Lorenzo di Credi as his artistic executor, entrusting him with the responsibilities of his studio. From the year of his death there survives one more document, from which it is known that the artist had been honoured by the commission to make a marble fountain to be donated by the Hungarian king Matthias Corvinus to the city of Florence. Vasari recounts that Verrocchio died from a chill caught during the casting of the Colleoni monument. In fact it seems that at his death only the final clay models had been completed. The Signoria entrusted Alessandro Leopardi with the casting and erection

of the statue two years later. Against the wish recorded in Verrocchio's will that he should be buried in the cemetery of the church of the Madonna dell'Orto in Venice, Lorenzo di Credi had his remains brought to Florence and laid in the Cioni family vault in San Ambrogio.

Credi then carried on his teacher's studio. His name appears in the – unsuccessful – negotiations over the completion of the Forteguerri cenotaph. Credi is also named in 1495 as still being the tenant of the *casetta* behind the Duomo in which Donatello had worked before Verrocchio.

III

THE EARLY DECORATIVE WORKS

THE tombstone for Cosimo de' Medici in San Lorenzo, the bronze candlestick for the Sala dell'Udienza of the Palazzo Vecchio and the funerary monument for Piero and Giovanni de' Medici in the Old Sacristy of San Lorenzo are Verrocchio's earliest authenticated works. In them we meet him as a decorative artist who could deal with the problems of architectural and ornamental form with equal authority, and who was already possessed of a technical ability which was the wonder of his contemporaries (Plates 1–13). At first sight these works, though they can hardly be considered *juvenilia*, may seem to present few of the special qualities on which his fame as a monumental sculptor depends. It may well be that the absence of any figurative decoration on the tombstone for Cosimo (Plate 1, fig. 1) was at the express wish of the deceased, and in the Old Sacristy the artist was, as will be shown later, very probably influenced by the context and emplacement of the monument. A closer examination of the Medici sarcophagus makes it clear however that Verrocchio was here quite consciously drawing on his experience and skills as a goldsmith; he was not attempting anything resembling the marble monuments with complex figures set up during the past decades by Desiderio da Settignano or the brothers Rossellino in Santa Croce or San Miniato.

When Vasari refers to Verrocchio's early training as a goldsmith, and mentions elsewhere that in his early youth he studied geometry, it should remind us that the goldsmiths' workshops in Florence at that time by no means confined themselves to producing religious and secular metalwork and jewellery, but were concerned with theoretical and technical problems of every kind: studies in perspective and geometry, mosaic, inlay and work in *pietre dure*, niello and enamel techniques, engraving and every possible treatment of precious and base metals, and not least with bronze casting. It is surely this all-round training and activity, rather than the prominent status of the goldsmiths among other branches of craft, which explains why so many important Florentine artists of the quattrocento like Brunelleschi, Ghiberti, Luca della Robbia and even Botticelli and Ghirlandaio all spent a training period as goldsmiths.

For the tombstone of Cosimo de' Medici Verrocchio designed a large-scale geometrical pattern (Plate 1) which owes its effect primarily to the variety of colour in the mediums used: marble, porphyry, serpentine, *pietra serena* (grey sandstone) and brass. The square surface of the tombstone is divided into a system of circles and ovals outlined by white bands of marble all of the same width. First a circle of maximum diameter is inscribed within the square; the four outer corners of *pietra serena* each hold a metal shield with six small circles of porphyry, the 'palle' of the Medici arms. Inside the large circle are two ovals of equal length but unequal width, laid one across the other to form an irregular quatrefoil which touches the surrounding circle at each apex. In the centre the crossed ovals form a rectangle with sides in the relation of 4 : 3, filled on the inside with a slab of porphyry. Lunettes are thus formed by the remaining sections of the ovals outside the rectangle. Those of the narrower oval each contain a white marble tablet inscribed with incised letters, and those of the broader oval a mandorla of dark green serpentine. Each mandorla has a white marble edging which touches the sides of the rectangle inwards, and outwards cuts into the curve of the oval. Lastly small circles of serpentine with white marble borders are inlaid in the spandrel shapes left between the quatrefoil and the large circle. The austerity and simplicity of the geometric pattern, devoid of all ornament, set Cosimo's tombstone aside from the great tradition of incrustation, for which the Florentine prototypes were the pavements and wall panellings in the Baptistery and San Miniato. The floor of Santa Croce boasts the most numerous examples of these inlaid stone tomb plaques, from many different periods; they show two-dimensional architectural motifs or plant ornament, usually carried out in dark stone laid into white marble, or they have a combination of geometric patterns with small-scale ornamental forms of this kind. The chapel of the Cardinal of Portugal in San Miniato has a particularly rich example in the central section of its pavement (fig. 2). When compared with this minute inlay work of white marble, porphyry, serpentine and oriental granite, the 'lapidary' simplicity and austerity of the pattern on Cosimo's tombstone looks more like the ground plan of a building or the design for a single panel of a bronze lattice. The novel technique of its execution is typical of Verrocchio: the white bands of marble are not made up so much of separate curved or straight pieces as in the floor plaque in San Miniato already mentioned; the whole white pattern consists rather of three rectangular sections and within these sections all the white articulation is worked from a single marble slab. The width of each of the three sections is different and is deliberately chosen so that when the slabs are fixed together the joints do not correspond to the straight edges of the marble bands. Furthermore the dark fillings of various colours are themselves – and quite independently of the joints of the white pattern – also executed in continuous stone slabs. This curious inlay technique with its system of white bands, dividing up the coloured fields and running unbroken within each of the sections, is more reminiscent of the technique of enamel work than of stone inlay.

The bronze candelabrum which Verrocchio made for the audience hall of the Palazzo Vecchio in Florence (Plates 2–4) is dated a year later than the tombstone of Cosimo. It has a triangular base

standing on lions' feet, and round the narrow edges of the base runs the inscription MAGGIO E GIVGNO MCCCCLXVIII. Acanthus leaves grow from the lions' feet, covering the corners of the base and curving upwards into volutes and downwards into volutes below the base. The base is equilateral with slightly concave sides, and directly out of it rises a section in the form of a chalice. This must be the reason for an early description 'a similitudine di certo vaso', and it is therefore presumably formed on the model of an antique vessel known in Florence at the time. Above the chalice rises the candelabrum shaft proper, in tall very slender sections disguised as lance-shaped leaves. The rich mouldings between the sections and the headpiece are decorated with egg-and-dart pattern, spiral or straight fluting, and with leaf ornament. The wealth of decorative motifs and mouldings and the beautifully balanced proportions within each separate zone almost give the impression that the various sections of the candlestick are each to be used separately in a different context and for quite different purposes. Yet the general concept is so significant and 'of a piece' that there is no hiatus anywhere, and the motifs and combinations drawn from the antique repertoire are fused together into a new unity. The form of the piece has more in common with antique bronze candlesticks or with mediaeval lamp-stands than with the candelabra of later times; it arises from a combination of smooth-turned curves, free naturalistic motifs and architectural elements of decoration, from a rhythmic interplay of rising and down-curving, tightly bound and open, unfolding elements. Everything is concise and firm in effect, full of concentrated energy; the contours are delicate but nowhere are they weakly rounded or bulging slackly. A form of candelabrum so typically quattrocento might, like Verrocchio's bronze David, seem too cold and thin, too spindly and sharp-edged for the taste of the High Renaissance; yet this piece provided the goldsmith of later centuries with a type of lamp which proved a constant source of inspiration, both as a complete composition and as a source of decorative forms. The design and the technical perfection of this candlestick together show what artistic maturity Verrocchio had achieved by the end of the sixties both as a decorative artist and as a goldsmith skilled in bronze casting. There are few comparable pieces from the fifteenth century; perhaps the closest is the seven-branched bronze candlestick made by Maso di Bartolomeo in 1442 for Pistoia Cathedral. Its lower zone consists likewise of an antique vase form rising about a triangular base (fig. 3). As one of the finest examples of its kind Verrocchio's candelabrum takes its place beside the much more ambitious Medici tomb in San Lorenzo which he designed at about the same time.

The Medici monument in the Old Sacristy of San Lorenzo (Plates 5–13) holds a special place in the development of the Florentine tomb. It is a double-sided wall tomb, and thus constitutes a type midway between the tomb placed in a niche and the freestanding tomb. This tomb for two members of a powerful and distinguished Florentine family shows no portrait of the deceased. There is no figure decoration of any kind and no Christian symbol. The use of different kinds of marble and stone to create a polychrome effect is traditional; the combination of multi-coloured stone with cast bronze ornamentation is new. As is unfortunately the case with nearly all Verrocchio's work there is no record of the terms or circumstances of the commission. This

lack of information is the more regrettable since the concept of the monument is so unusual. We cannot tell how far the special form and placing of the monument was laid down by the patrons nor how far they influenced the choice of tomb type, or even whether it was they who stipulated the highly formal presentation. Since we do not know the reasons for its being thus designed it is difficult to distinguish and evaluate Verrocchio's artistic contribution. The form of the Medici tomb belongs on the one hand to the niche type as it was developed by Antonio Rossellino so sumptuously and convincingly in the tomb of the Cardinal of Portugal in San Miniato, but it also takes something from the two-sided Gothic tombs. The wall chosen for the erection of the Medici monument was that which separates the Old Sacristy from the second family chapel of the Medici, dedicated to SS. Cosmas and Damian, which lay at the end of the south transept of San Lorenzo. Thus it was possible to make the tomb face two ways: i.e. with one side on the Sacristy and the other on the neighbouring chapel. This is reminiscent of the forms of the fourteenth-century tombs built in Santa Croce in closely similar circumstances. There, in the Bardi chapel at the north end of the transept (fig. 4) and in the Baroncelli chapel, in which the south transept ends, we find the sarcophagus of the founder placed in a wall-embrasure with a pointed arch and architectural frame, making it visible and approachable both from the transept and from the chapel. The sarcophagus in each case is decorated on both sides and the opening above it is filled in, either partially or completely, with a bronze grille in the usual quatrefoil pattern of the time.

The tomb of the Medici (Plates 5–13) in the Old Sacristy was destined to hold the remains of Piero de' Medici and his brother Giovanni. Its function as a double tomb already militates against the choice of a type like the Humanist tombs in Santa Croce on which lay a recumbent figure of the deceased. The absence of the Christian allegorical figures usual on niche tombs can likewise be explained by the double viewpoint which does not readily lend itself to a setting of lunette reliefs with the Madonna surrounded by angels, or of relief plaques with figures of the Virtues. The absence even of full relief figures of any kind, such as occur on the tombs by Desiderio or the brothers Rossellino, is however remarkable here: no putti, childlike or youthful angels kneeling in mourning over the sarcophagus or spreading great garlands, holding shields or winding the shroud. The complete absence of figures on the Medici tomb must in the last resort be accepted as the outcome of Verrocchio's artistic intention, even supposing that it was agreed in consultation with the patron. At this stage of his development the artist is seeking to give full play to the entire range of his resources and capabilities as goldsmith, bronze-caster and decorative artist, and to emphasize these qualities as against the celebrated achievements of the sculptors in marble. He builds a sarcophagus from smooth slabs of porphyry and uses cast bronze for every ornament which, for example in Desiderio's tomb for Marzuppini (fig. 5), is usually carved from the stone itself. The sharp, rugged and strongly shadowed bronze decoration enhances the charm of the colour and surface effect of the noble smoothly polished stone. The sarcophagus stands free on four bronze lion's feet; the acanthus leafwork growing out of them and climbing over the

corners of the chest combines with the cast bronze ropes on the upper and lower edges of the porphyry panels, and with several hidden bronze anchors and brackets to hold the whole structure of the sarcophagus together. The bronze work is similar in aesthetic and functional effect, though on a larger scale, to the gold or silver mounts with which goldsmiths surrounded valuable antique or oriental vessels of semi-precious stone or other rare materials. Comparison with a small casket reliquary in the Museo dell'Opera del Duomo in Florence (fig. 6) shows how near *orfèvrerie* lay to the Medici sarcophagus in its combination of different mediums in different colours. The side walls and lid panels of this reliquary are of *pietre dure* held together with a framework of chased silver; the feet are in the form of birds' claws, and the leaf ornament round the corners of the casket rises above them. Comparison of the two pieces is informative, even quite apart from the problem of whether the reliquary is really based on the form of the Medici's sarcophagus, as has been supposed, or whether it should be dated to the first half of the quattrocento and therefore antedate Verrocchio's work by many years. The type of the casket reliquary is much older and has parallels in the tomb chests of the fourteenth century.

The Medici sarcophagus, standing within the rounded archway cut through the wall, is raised on a rectangular platform borne by bronze tortoises. The narrow edge of the platform has an inscription on all four sides giving the names of the donors, Lorenzo and Giuliano de' Medici, and the date of completion of the monument, 1472. The top surface of the plinth, seen between the lions' feet, is decorated with a pattern in white marble inlaid with circles and rings of porphyry and serpentine. The embrasure is filled in, above and round the sides of the sarcophagus and even under it, with a large-mesh net of twisted rope, cast (presumably in sections) in this massive form. The net pattern is repeated on the lid of the sarcophagus between two lines of rope running horizontally. Both sides of the body of the sarcophagus have a similar border of horizontal rope along the upper and lower edges, and in the centre a circular inscription tablet of serpentine framed in a bronze wreath. Narrow ribbons run out from the lower part of the wreath to right and left to join the acanthus ornament on the corners of the chest. Through the lush foliage growing out of the lions' feet, curling and spreading across the front, long firm metallic lancet-shaped leaves push upwards and turn outwards upon themselves in volutes below the lid. They seem to be the bearing element among these richly luxuriant plant forms. Their supple movement and curve is followed for half the height of the corner by a spray of thick acanthus leaves which swells strongly outwards and thus veils the heavy angularity of the porphyry chest. In this way the outer profile is made to approach the rounded bath shape devised with reference to antique models by Desiderio for the Marzuppini monument (fig. 5). Marzuppini's sarcophagus was without doubt an important influence on Verrocchio's design. He adopted several elements of articulation and decorative motifs from it; the lion's feet with acanthus growing from them, for instance, and the roof-tile or scale pattern on the cornice-like zone of the sarcophagus lid. This strongly projecting roof-shaped border zone with the band of enriched moulding beneath it is made of white marble. It is intentionally distinct from the porphyry and bronze parts of the

sarcophagus, and meant to be seen in relation to the white panels of the supporting plinth below. The outer edges of both correspond exactly. The sarcophagus is crowned with a mighty arrangement of bronze: four baroque shell cornucopiae, pouring their fruits over the corners of the lid, grow out of a central acanthus cluster which surrounds the Medici diamond raised on a fluted pillar. This arrangement anticipates a decorative tradition for the crowning of baldaquins over altars and thrones, catafalques, princely oratories and state carriages, that was to last for centuries. In the bronze decoration of the Medici sarcophagus Verrocchio's imitation and adaptation of the dynamics of growth in nature and the development of natural forms blazed the trail for Leonardo and his studies of movement in the plant and animal world.

The architectural frame of the Medici monument does not correspond to the form known from the Humanist tombs in Santa Croce. They lie under arches supported on pilasters. Verrocchio frames the arch on both sides by covering the inward-sloping faces of the embrasures with a broad band of richly decorated white marble, between simple mouldings of grey-green Florentine *macigno*. This provides the necessary link with the decorative elements in the Sacristy, particularly the corresponding framing of the reliefs by Donatello over the doors. The marble surround is ornamented with symmetrically arranged festoons rising from richly decorated vases of antique design; sheaves of palm leaves alternate with clusters of laurel branches, punctuated with the Medici ring and fluttering ribbons. At the crest of the arch there is a bronze rosette, again set with the pyramidal diamond.

The Medici monument in the Old Sacristy was much admired by Verrocchio's contemporaries for the splendour and multiplicity of its materials and above all for its technical perfection, but it found no successor worthy of note among Florentine tombs. This may in part be due to its secular character and to the absence of any figure decoration or Christian symbolism, but the main reason is undoubtedly its unusual context in a lofty archway through a wall, standing between two chapels both belonging to the same family. This gave Verrocchio opportunities and suggested ideas which are not often feasible. The conception of the tomb is entirely based on its double viewpoint, and on the possibility of seeing through the archway, hung with its bronze net. Strangely enough Verrocchio's form of sarcophagus has often been copied for wooden chests or for small bronze jewel-caskets or reliquaries of gold or silver. Since the idea of the Medici tomb stands very near to that of a free-standing monument it is not surprising that there are traces of its inspiration among Michelangelo's sketches for the tomb of Julius II or in Leonardo's drawings for the Trivulzio monument.

IV

THE BRONZE FIGURES AND THE SILVER WORK
OF THE FLORENTINE PERIOD

THE first figure sculpture by Verrocchio, the bronze David in the Museo Nazionale in Florence (Plates 16–23), also belongs among the works commissioned by the Medici as we learn from the inventory drawn up by Tommaso Verrocchio. There is however no indication as to where it was originally designed to stand. There is further a document showing that Lorenzo and Giuliano, the sons of Piero de' Medici, sold the bronze David to the Signoria of Florence on 10th May 1476. From the fact that the two brothers effected the sale together it might at first be deduced that the piece formed part of the estate of their father, who died in 1469. Since the figure cannot be dated so early, i.e. in the sixties, on stylistic grounds, it must be concluded that Piero de' Medici had indeed commissioned the work before his death and made some advance payments on it, but that completion, i.e. the casting of the figure, did not take place until much later – indeed during the months directly preceding the sale by Piero's heirs. The style of the figure argues for a date of about 1475. Vasari speaks of an early stay in Rome by Verrocchio during which time the artist worked on several silver apostles for Sixtus IV. He places the David in the period directly after Andrea's return to Florence. It has not yet been possible to confirm or refute these suggestions. The David is not conceived to stand in a niche. The back view is particularly fine. The sense of movement is conveyed from the most varied angles; yet – unlike the Putto with a Dolphin, for instance – not all the aspects of the figure are equally effective or successful. There has long been disagreement on which is intended to be the principal viewpoint. For decades Mackowsky's position was accepted; his opinion, based on a photograph of a plaster cast, was that the figure was to be looked at so that the head of the boy was directly facing us. This makes the right arm dissolve into the silhouette of the torso and the whole posture look very stiff and tense, rather like Donatello's St George. That this is certainly not the right viewpoint is proved by the fact that the eyes are not looking at us, but, as can be seen from the delineation of the pupils, are looking to one side, directed at some unspecified object. Among earlier published photographs of the bronze David the most nearly correct viewpoint is that illustrated by Max Dvořák in his *Geschichte der italienischen Kunst*.

Verrocchio's figure was conceived with the earlier bronze David by Donatello (fig. 7) very much in mind. It also had been commissioned by the Medici and now decorated the courtyard of the palace in the Via Larga which had been built for Cosimo il Vecchio. Verrocchio took over the general movement of the Donatello, particularly the disposition of the legs. Although his young warrior is not naked but clothed in a short cuirass, this thin leather tunic lies on the

15

torso like a second skin, and the modelling of the body is indicated almost more strongly than in Donatello's nude. Since Verrocchio is quite patently challenging Donatello's figure we may consider every modification of the earlier work in the light of a correction. Most important is the concept of the theme. The David appears in two different versions in Donatello's *œuvre*. The early marble statue made for the Duomo in Florence (fig. 8) presents the youthful prophet as a majestic Old Testament character, bare-headed, laurel crowned, cloaked in a long flowing mantle, in regal pose. Donatello's bronze David, not made for the Church, introduced a direct translation of the David theme into the language of antiquity: the youthful naked hero, of Apollonian stature, indomitable and calm – a mythical figure in which the youth, beauty and grace of such a body become a theme in themselves. Cellini's Perseus comes nearer to this bronze than Donatello's earlier marble David. We read in Vasari that the young Desiderio da Settignano made a marble pedestal decorated with harpies for Donatello's bronze David, and this motif corresponds perfectly to Donatello's complete re-interpretation of the David theme in the light of antiquity. Now Verrocchio presents neither David the youthful prophet nor a David–Perseus, but the fearless young shepherd boy who has defeated and beheaded Goliath in the battle against the Philistines. When Verrocchio's Florentine contemporaries pictured the Bible story in their minds they must have imagined just such a David as lies behind this bronze figure. The statue depicts a particular moment in the story. David no longer holds his sling, but a short sword in his right hand. With it he has just severed the head of the giant, which lies at his feet with a gaping wound in its brow. To Donatello the criterium of objective accuracy is irrelevant. He gives his marble David both sling and the head of Goliath, the usual attributes. His naked, charmingly costumed bronze David holds both sword and stone, while the head of Goliath lying at his feet in its mighty, splendidly decorated helmet would clearly have been proof against any sling stone.

Verrocchio's David differs essentially from Donatello's bronze in the spiritual penetration and interpretation of the theme. Donatello's incarnation of the youthful liberator of his people is undramatic and somewhat uncompelling in effect. The face, shadowed by the ornate helmet, is expressive neither of fate and mission nor of outstanding traits of character nor of the emotions appropriate to the situation. A happy, lyrically soft mood emanates from the relaxed peaceful posture of the well-formed body. In Verrocchio's David we see first and foremost the face framed in a wild wreath of curls, with its precocious, somewhat over-mature features and the slight hint of a supercilious triumphant smile. The effect of this young man's head is in unison with the import of the movement in the limbs: the keenly curved eyebrows and the narrow sharply modelled nose, the awareness of fate in a look confidently directed into the distance are echoed by the left arm held energetically against the side and the lowered but strongly tensed right arm with its drawn sword. In Donatello's figure the soft curve of the left arm, turned so that it is supported by the back of the hand resting on the hip, and the flowing movement of the right arm with the sword resting on the head of Goliath, correspond to the relaxed, passive and peaceful pose of the body. Verrocchio's David is given a spontaneous and aggressive expression from

the stronger twist forward of the left elbow, now quite pointed and angular, and the sword blade raised ready and threatening, thrusting out from the otherwise smoothly falling contour of his side. Verrocchio has taken over the motif of the hand on the hip from Donatello only to give it a completely new and stirring significance – a gesture of pride and self-confidence. The placing of the hand too acquires a new meaning: the tense effect of the fingers betrays suppressed excitement. The ability of art to make feelings visible not only in the face and pose but in the expression of the hand, which became so important in all later figure representations, is here newly seen and developed – and this perhaps arose directly from considering his figure in relation to Donatello's interpretation. We should not overlook the heightening of expression provided by the severed head of Goliath: instead of the gorgeous helmet decorated with its striking metal wings in Donatello's bronze we have the gaping wound and the agonized expression of this gigantic and terrifying head.

Verrocchio's David stood for many years with Donatello's bronze in the same room of the Museo Nazionale. This has certainly favoured the fulness and multiplicity of comparative appraisals and descriptions. Marcel Reymond rather too emphatically extols Verrocchio *à propos* of his bronze as 'un des maîtres les plus raffinés de l'art moderne' (one of the most exquisite masters of modern art) and places him on a par with the Greek sculptor of the Boy with a Thorn, whereas Heinrich Wölfflin made one of the most telling interpretations of the figure, in spite of his highly critical, indeed almost depreciatory attitude to the fifteenth century. Verrocchio's bronze David is for Wölfflin one of the key pieces for an understanding of the trends dominating the art of the final third of the quattrocento; '. . . a lightly-built youth . . ., quite thin, so that the structure of the body is plainly visible, with the sharp elbow of his bent arm deliberately playing a part in the principal silhouette. There is tension in all the limbs, the leg stretched backward, the straightened knee, the tensed arm with the sword – what a contrast to the peaceful disposition of Donatello's figure. The whole motif is an expression of movement. And since it is now also necessary that there should be a sign of movement from the head, a smile flickers over the features of the youthful victor. The taste of embellishment is met in the details of the armour, which delicately follows and breaks across the fine lines of the body. If we look through to the nude beneath, the summary treatment of it in Donatello seems almost empty beside the wealth of form in Verrocchio.'

The bronze Putto with a Dolphin (Plates 24–27), which Verrocchio worked for a fountain for the Medici villa in Careggi probably at the end of the seventies, is a free-standing figure in a new sense. It is a figure developed on all sides equally, so that it is impossible to pin down a single intentional principal viewpoint. Unlike Donatello's Judith, Pollaiuolo's small bronze of Hercules and Antaeus or Verrocchio's David, it is even impossible to establish three or four especially effective aspects on which the design of the movement is based. The spiral movement of the Putto is continuous for the spectator who walks round the figure or before whom the figure is turned. A German visitor to Florence at the end of the sixteenth century, who interested himself

particularly in waterworks and fountain installations, describes the fountain which had just been set up with the figure in the courtyard of the Palazzo Vecchio: 'a marble jet fountain on which the Cupid is driven round by the water'. Taking into account the writer's factual reporting, this can only mean that the figure was actually installed so that it could revolve under pressure of the water. There is unconscious resistance in these days to the idea that the first post-antique free-standing figure designed to be seen from all angles should have owed its conception to the mastery of such a trivial technical device; yet the special quality which we distinguish in the works we have inherited and call art was not to be separated in the quattrocento from the spirit of invention and technical expertise, from engineering science and experiments in chemistry and physics, even if the scope of interests and studies did not often extend as widely as it did with Leonardo. The artists were employed in providing décors for galas and tournaments, theatre machinery, fire-work and waterwork displays. We know of Verrocchio himself that he not only prepared special helmets and painted standards for the tournaments of the Medici but made such things as the bronze figure which struck the hours on the Mercato Nuovo in Florence – similar to the one that still works on the Piazza di S. Marco in Venice. In fact the fountain figure is so perfectly balanced in the way it projects on every side that its fulcrum lies exactly down the central axis and it is perfectly adapted to serve as a rotating fountain figure. Marcel Reymond writing on the Putto with a Dolphin declares that Verrocchio evidently enjoyed creating new problems for himself when designing his works, so that he obtained still greater fame and satisfaction by overcoming them. Here the essential word has been spoken about an artist many of whose most important and influential works – the Medici sarcophagus, the Christ and St Thomas and indeed the Putto with a Dolphin – involved peculiarly difficult problems of realization dictated by circumstance, by the peculiar conditions of the commission or the way in which he himself chose to handle it. The theme of the Putto with a Dolphin is foreshadowed in antique art, as can be seen from a bronze in the Naples Museum (fig. 10). It can hardly now be established which of these bronze cupids, surviving in various forms, decided the patron in his choice of a theme or influenced the design of the figure. Winged cupids holding water-spitting dolphins were known in Antiquity as fountain figures. Like the cupids or *amorini*, dolphins had always belonged among the attributes of the sea-borne Venus; they appear in the *Fasti* of Ovid with special meaning as the happy discoverers of secret love. The movement of Verrocchio's Putto has sometimes been interpreted as flying, sometimes as swift running, or as both at once. Yet it does not look as though the boy's leg, raised far out behind, would be brought forward in the next moment and placed on the ground. The figure is balanced on one leg as though it were dancing on a tight rope or spinning on ice. The impression of movement round the central axis given by the whole structure of this *figura serpentinata* is enhanced by the sideways tossing of the child's head which looks back over a shoulder in roguish delight. The putto holds the dolphin so tight against his chest that he seems to be squeezing the water out of it. The water spouts up from the creature's mouth and trickles down again over the figure. This explains the strange treatment of

the child's hair and the shirt on his back. The hair is wet and forms peculiar strands of clinging curls; the shirt is wet too and adheres to the body in large patches with crumpled folds between. The Putto with a Dolphin was designed with its function and effect as a fountain figure in mind. Here is the logical result and the most convincing vindication of a view of art which sees the basis of every work in a representation of reality which is true to nature and factually correct. Verrocchio with his experience of working bronze took into account from the first the watery element in which the Putto was to have his being and in so doing he discovered what new and charming effects were to be drawn from the surface of his material.

The Putto with a Dolphin is the only work of Verrocchio's which has received unreserved praise from the critics, from his own time to the present day. The reason for this is primarily that here the artist found himself confronted by a subject which gave him the opportunity to develop to the full his inner need to formulate visible reality and at the same time find an expression of movement that derived from the theme and dominated the whole figure. He has often been criticized for his choice of models, which admittedly lends a somewhat trivial flavour to some of his religious representations, such as the Baptism of Christ. But that absence of idealization is here a positive advantage; it enhances the characterization of careless joy and childish high-spirits. The theme demanded the choice of a different, more ordinary type of child than the Christ-child of the Madonnas.

Verrocchio was assigned the execution of the saint for the central niche on the exterior east wall of Or San Michele at the latest in January 1467. The niche had been set up in the early twenties for a statue of St Louis, patron saint of the Parte Guelfa. After the niche had been ceded in March 1463 to the Mercanzia, the Florentine commercial tribunal, it seems that the first intention was to set up another single bronze statue in the place of the figure of St Louis by Donatello (fig. 14). The first document explicitly mentioning 'figures' is of March 1468. The Christ and St Thomas (Plates 28–39) remained unfinished until 1483. It can be seen from the stylistic differences between the two figures, particularly in the drapery, that the Christ is some years earlier than the St Thomas. From the sequence and frequency of entries in the register of payments and from the wording of an entry in 1479 it can be deduced that the casting of the first figure took place about 1477/78, and that of the St Thomas in the early eighties.

It is not clear when the Mercanzia, which as mercantile tribunal was set over the guilds, first chose a patron saint, nor whether the 'statua di bronzo' still mentioned in the records in January 1467 referred at first to a figure of St Thomas alone. The idea of setting up a scenic group in one of the niches instead of one or even several statues of the patron saints of the guilds is an entirely new departure in the plan for the figures on Or San Michele. The butchers' guild, for example, could equally justifiably have represented their patron St Peter in a scene with two figures, also including Christ. Scenes from the lives of the patron saints do not occur on Or San Michele except at most as reliefs along the base of a niche, as for the statue of St George. The new conception of the scene between Christ and St Thomas was possible because it was destined for a prominent

position in the central niche of the principal wall of the oratory; it may also have been thought desirable because the four patrons of the masons' guild had been represented by Nanni di Banco in a conventional group (fig. 12) in the central niche on the north side.

The artistic antecedents for the Christ and St Thomas do not lie there, however, but in Donatello's monumental Annunciation for the Cavalcanti altar (fig. 16), in the great relief scenes like Nanni's Presentation of the Girdle on the Porta della Mandorla (fig. 15) and even in the monumental Gothic groups of figures like the Baptism, which was still to be seen at that time over the south doorway of the Baptistery. It seems highly probable, and the alterations of wording in the various documents support the thesis, that the idea of a scenic group only arose after Verrocchio had begun to consider his task, during 1467.

Verrocchio left the niche architecture unchanged as he found it. The hollow is much flatter than that of the Quattro Santi Coronati on the north wall. Hence the figures could only be slightly over life size, which was much smaller than those in the side niches or Donatello's St Louis. Nanni di Banco places his figures in a deep and rather narrow semi-spherical niche; not so Verrocchio. Nor does he use the niche like a flat box, in the Attic tomb relief tradition adopted by Donatello for the Cavalcanti altar. He starts out with the premiss that the narrow width of the niche and the curve of its wall behind do not allow of a picture-like arrangement of the scene all in the same plane, like Donatello's group of the Annunciation or in the painting of the Incredulity of St Thomas by Rossello di Jacopo Franchi, now in the Accademia (fig. 13). He translates into three dimensions the usual two-figure composition scheme of paintings of the Annunciation, the Visitation or the Baptism and arranges the figures round an imaginary centre on the central axis of the niche, where the event which connects the two figures, the showing and feeling of the wound in the side of Christ, is focussed. The figure of Christ is placed rather to one side of the niche; the movements of the figures open out towards the centre of the niche, while the unbroken outer line of the whole encloses the group. The Christ stands slightly raised on a plinth. The forceful gesture of his right arm is the dominating element in the group. Thomas turns into the niche in a spiral movement on his own axis; his right foot is set at an angle, suggesting that he has just taken a step to approach the Christ, and it remains outside the niche. Christ looks down into the face of his disciple and bares the wound in his side with his left hand. Thomas is examining the wound, just touching the edge of the slit in the garment with the middle finger of his right hand. The hand gestures do no more than illustrate the actions portrayed, yet they imply more. Just as the group as a whole, realistic as it is, transcends the immediate incident and achieves a monumental allegorical universality, so the hands speak in the mime language of the classical world: Christ lays his hand over his breast to symbolize acknowledgment and affirmation, while the outstretched right hand of the disciple conveys argument and demonstration. Similar hand gestures can be seen in the disputing apostles and prophets of Donatello's bronze doors for the Old Sacristy of San Lorenzo, and in the figures on the choir stalls at Bamberg.

Although it can be agreed that the over-all design of the Or San Michele group was conceived

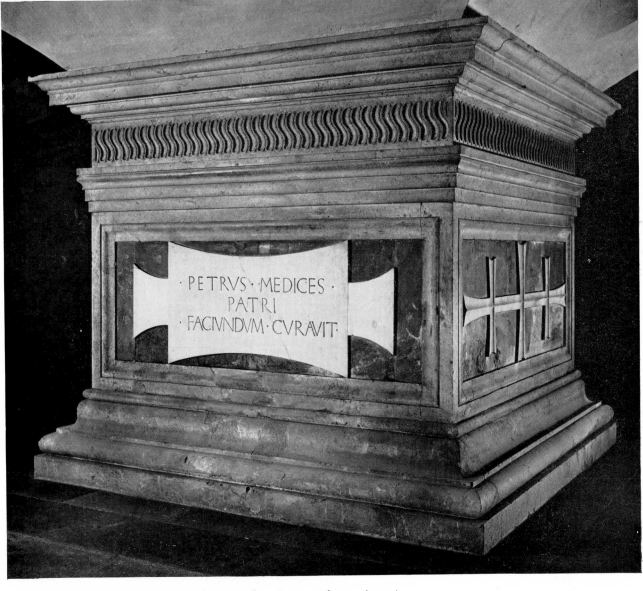

Fig. 1. Tomb of Cosimo de'Medici in the crypt of San Lorenzo, Florence (p. 171)

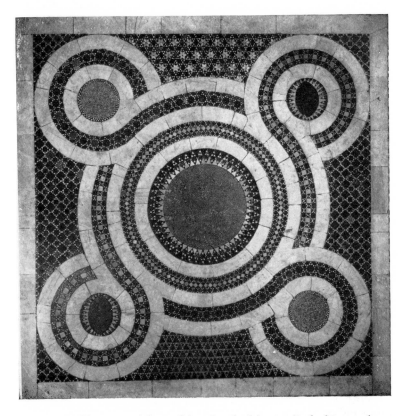

Fig. 2. Marble-incrusted floor of the Chapel of the Cardinal of Portugal.
Florence, San Miniato (p. 10)

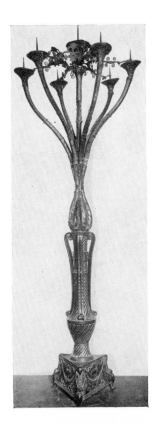

Fig. 3. Maso di Bartolomeo: Bronze
candelabrum. Pistoia, Duomo (p. 11)

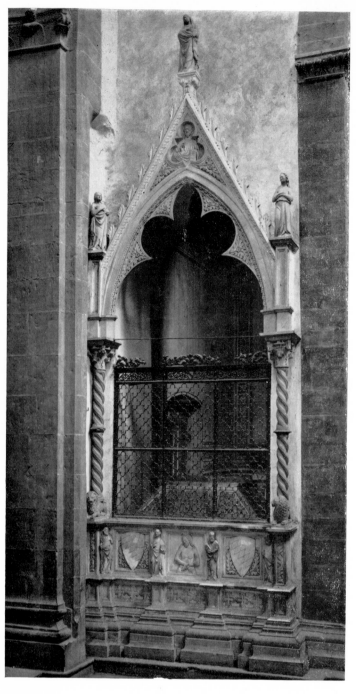

Fig. 4. Donor's tomb in the Bardi Chapel. Florence, S.Croce (p. 12)

Fig. 5. Desiderio da Settignano: Marzuppini Tomb. Florence, S.Croce (p. 12)

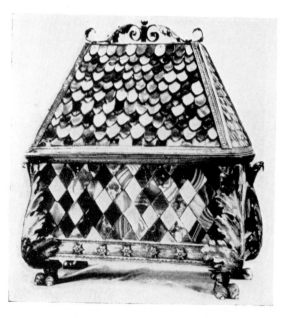

Fig. 6. Reliquary casket. Florence, Museo dell'Opera
del Duomo (p. 13)

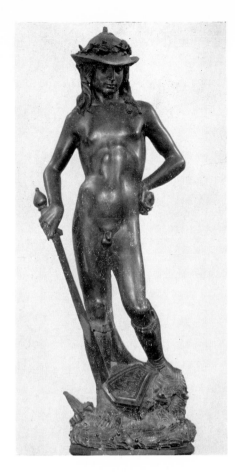

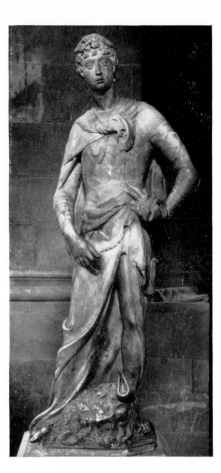

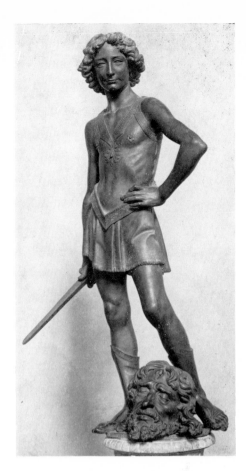

Fig. 7. Donatello: Bronze David. Florence,
Museo Nazionale del Bargello (p. 15)

Fig. 8. Donatello: Marble David. Florence,
Museo Nazionale del Bargello (p. 16)

Fig. 9. Verrocchio: David seen from old,
erroneous view-point (p. 15)

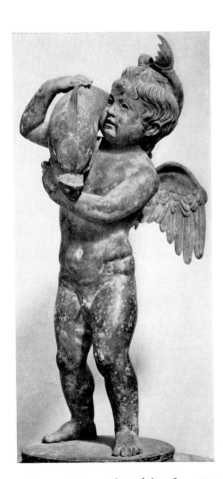

Fig. 10. Bronze Putto with Dolphin from Pompeii.
Naples, Museo Nazionale (p. 18)

Fig. 11. Porphyry basin in the second courtyard of the Palazzo Vecchio,
Florence (p. 175)

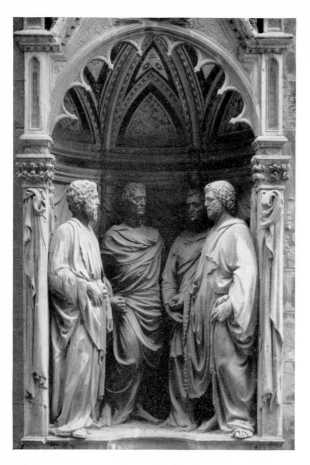

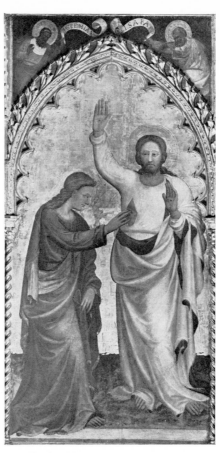

Fig. 12. Nanni de Banco: The Patron Saints of the Stonemason's Guild. Florence, Or San Michele (p. 20)

Fig. 13. Rossello di Jacopo Franchi : The Incredulity of St. Thomas. Florence, Galleria dell' Accademia (p. 20)

Fig. 14. Donatello: St. Louis, temporarily restored to its original position on Or San Michele, Florence (p. 19)

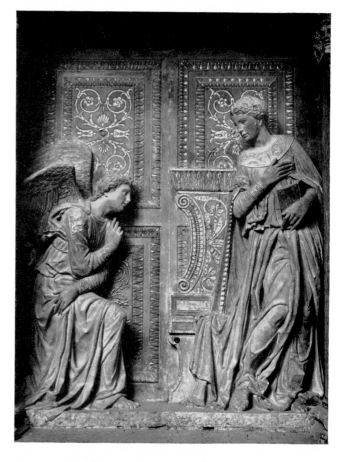

Fig. 15. Nanni di Banco: Madonna della Cintola. Relief on the Porta della Mandorla, Florence Duomo (pp. 20 and 26)

Fig. 16. Donatello: Annunciation. Relief of the Cavalcanti altar. Florence, S.Croce (p. 20)

Fig. 17. Heemskerck: Sketch of the Tomb of Francesca Tornabuoni in Rome.
Roman Sketch-book, Vol. 1, fol. 40v. Berlin Kupferstichkabinett (p. 24)

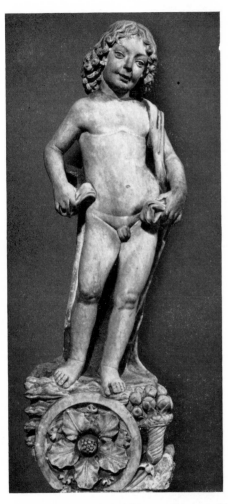 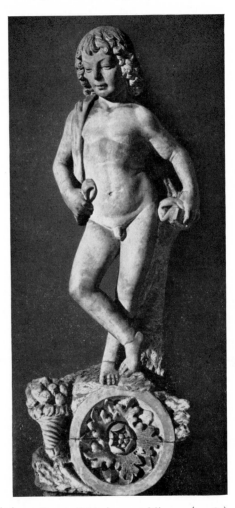

Figs. 18-19. Workshop of Verrocchio: Marble figures of two nude boys. Rome, S.Maria sopra Minerva (p. 181)

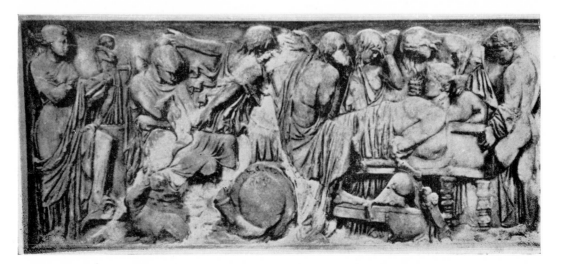

Fig. 20. Meleager sarcophagus. Florence, Palazzo Montalvo, Borgo degli Albizzi (p. 24)

Fig. 21. Drawing after Perugino's lost fresco over the altar of the Sistine Chapel, Rome (p. 26)

Fig. 22. Lorenzetto: Kneeling figure of Cardinal Forteguerri. Pistoia, Museo Civico (p. 25)

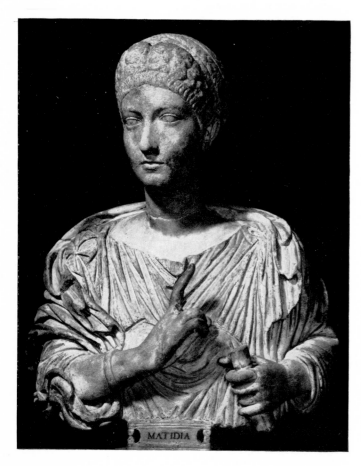

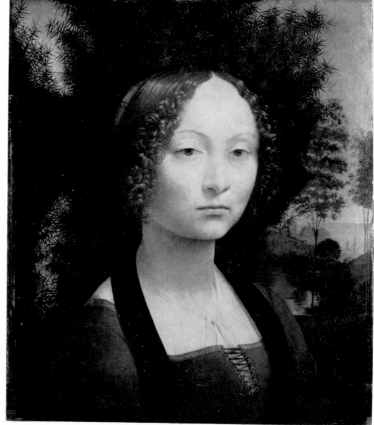

Fig. 23. Roman marble bust of "Matidia". Florence, Uffizi (p. 33)

Fig. 24. Leonardo da Vinci: Ginevra de' Benci. Washington, National Gallery of Art (p. 33)

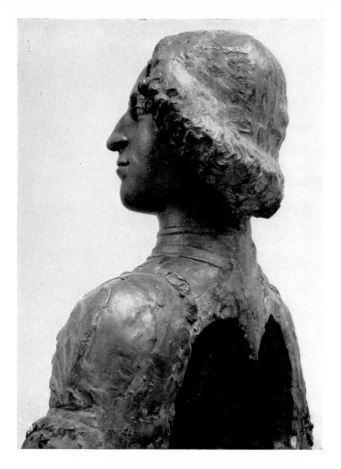

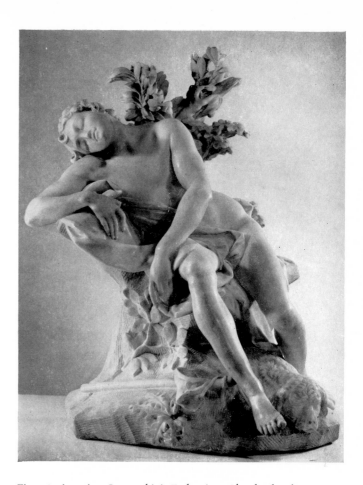

Fig. 25. Verrocchio: Giuliano de'Medici. Back view (p. 183)

Fig. 26. Agostino Cornacchini: Endymion. Cleveland, Ohio, Cleveland Museum of Art (p. 36)

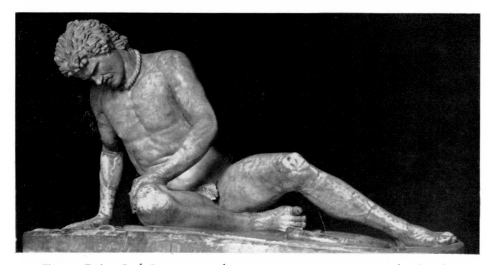

Fig. 27. Dying Gaul, Roman, second century B.C. Rome, Museo Capitolino (p. 36)

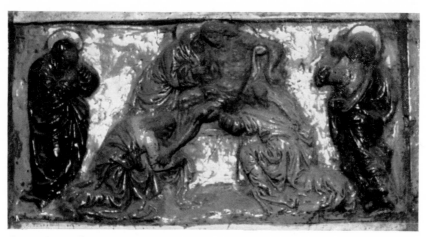

Fig. 28. Della Robbia Follower: Predella panel after Verrocchio's relief of the Lamentation (Plate 61). Camerino, Marche, Chiesa dei Cappuccini (p. 37)

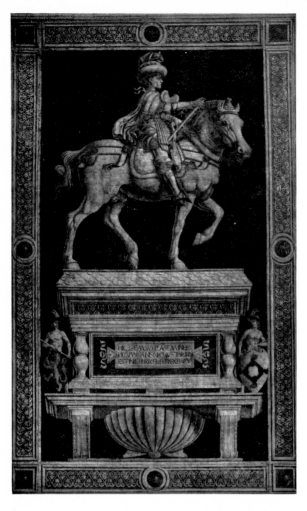

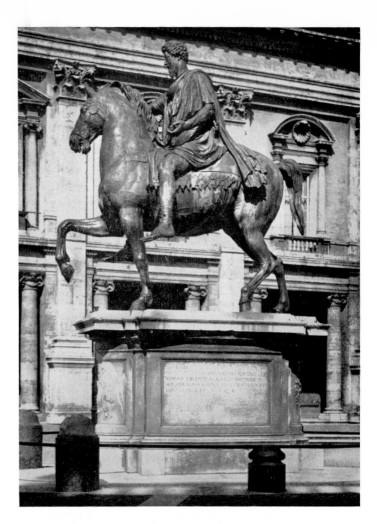

Fig. 29. Castagno: Fresco of Niccolò da Tolentino. Florence, Duomo (p. 63)

Fig 30. Equestrian statue of Marcus Aurelius. Rome, Campidoglio (p. 63)

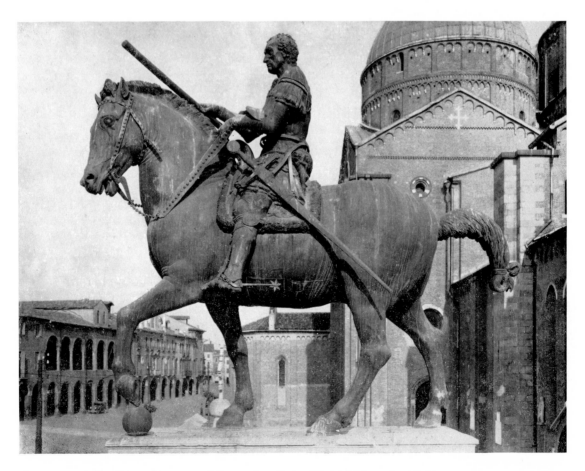

Fig. 31. Donatello: Equestrian statue of Gattamelata. Padua, Piazza del Santo (p. 63)

and broadly speaking settled in drawings and models by 1476/77, that is before the execution of the statue of Christ, there are differences in the working out of the two figures which characterize different stages in the development of Verrocchio's sculptural style. This is particularly apparent in the folds of drapery, though it also obtains for the treatment of the heads. The faces of Christ and St Thomas both have the same sharp ridges defining the eye cavities, and the same shape of eyes with the heavy long upper lids, which gives them both a similar expression. But the head of St Thomas is heavily square, and solid in appearance, and with its strongly prominent and angular chin and cheeks, its broad nose and – in contrast to the breadth of the area around the eyes – the rather narrow but sharp-cut mouth, it approximates in style to the Colleoni head; whereas the general shape of the head of Christ, more rounded and more smoothly domed, is reminiscent of the bronze David, in which the detailed modelling of the face follows pronouncedly the form of the features, and the expression of feeling overshadows even more the sculptural effect. The head of Christ is more noble and spiritual, and even in shape is leaner and less voluminous than the very massive head of Thomas. This latter head is reduced to the basic essentials, anticipating the exaggerated aggressive plasticity of Verrocchio's style in the second half of the eighties.

In the garments of Christ and of St Thomas the principal motifs of the folds are brought so much into relation one with the other that the group blends into a single unity within the architectural frame of the niche. The drapery is not used to express the movement of the figures alone; it has here a special function in the composition, to intensify the spatial relationship of the two figures which are locked together by one great outline. One almost has the impression of a single voluminously draped figure decorating the central niche on the east wall of Or San Michele – in the place of Donatello's powerful St Louis. It is chiefly from the study of Donatello's St Louis that Verrocchio seems to have developed the style of drapery for his Christ figure, which seeks to exploit to the full the special possibilities of bronze technique: the firm, stiff cloth of the mantle is pushed forward or dented as though it were not a textile but hard metal. For the St Thomas four years later he sets out from the first to treat the drapery more naturalistically as stuff: the cloth of the mantle is light and thick in effect, as though it were quilted with cotton wool; it is crumpled into many small hollows and rolls, and lies in so many creases that even the large sweeps enveloping the body are broken up everywhere and are never smooth. The garment under the mantle too, evidently of even softer material, makes narrow flat little creases which in places run together, creating the effect of ornamental motifs. The drapery style he developed about 1480 for the Thomas figure was adopted as a prototype by Verrocchio's pupils for many years to come, as can be seen in Credi's Madonnas of the fourteen-eighties or the figure reliefs of Francesco di Simone, and most of all in Perugino's frescoes in the Sistine Chapel.

In January 1478 the Consuls of the Florentine Merchants' Guild commissioned Verrocchio with the execution of a silver relief of the Decollation of St John the Baptist (Plates 53–56), which with three other reliefs was to decorate the still unfinished side panels of the silver antependium of the

altar in the Baptistery. A competition was held a year before the commission was given; Andrea submitted two models, and Antonio Pollaiuolo and three other goldsmiths were also involved. In 1480 Verrocchio's relief was completed and delivered. He and the other artists concerned in completing the antependium were required to accommodate their new scenes to the trecento relief scenes on the front, both in format and technique of execution and in the size of the figures. In these earlier reliefs the figures on average are almost two-thirds the height of the space to be filled, and the scenes are frieze-like in a flat spatial zone. Verrocchio chose as setting for the beheading of the Baptist an open palace courtyard which he made to appear very deep by foreshortening the perspective, thus creating an illusion of space which heightens the tension and drama of the situation represented. The figures do not, however, fill this whole space with their movements; the furthest zone of the courtyard, clearly defined in its extent by the architectural projection on the right, remains empty. This gives a peculiar vehemence to the action of the executioner, who is seen in violent foreshortening. In the left half of the scene kneels the Baptist. Behind him stand two soldiers who await the execution with great emotion. The younger is clutching at the arm of his companion in fear. On the left beside the Baptist appears a youth with strange dancing gait, holding the silver salver on which the severed head of John is to be carried to Herodias. A gentle smile lights the beautiful boylike face of this soldier; he is bending his head to one side and raising his left hand, either in a gesture of interception or appeasement. Strangely enough, for this youth, who resembles a figure from a Last Judgement scene, the artist has again used the same attitude as for the Archangel in his somewhat earlier Tobias painting (Plate 72). The relationship between the young soldier and the kneeling figure of the Baptist has also something of the relaxed and hallowed atmosphere of the picture. Verrocchio has here created a peaceful counter-point, a figure in contrast to the executioner, who appears to dominate the situation, that hideous offspring of human brutality and violence. The soldier in the middle distance shrinks back horrified from the executioner's angry movement into the space behind; it leaves a void, free of figures, which stretches into the corner of the court at the back, and through it the executioner plunges away from us, his arms held high. Within the traditional biblical scene this action is motivated from the procedure of the execution. Moreover in Verrocchio's interpretation of the theme, the figure fleeing from the scene like one of the guards at the Resurrection takes on a symbolical significance. His movement of flight becomes an expression of the impotence of evil and brutality against the pious humility and quiet dedication of St John, who seems to be drawing holy comfort and succour from the youth with the salver. The proximity of the youth on the one hand and on the other the panic-like tension of the executioner, whose body forms a harsh straight contour line towards the Baptist, symbolize the contest, long since decided, for the soul of the Baptist, who is here awaiting the end of his martyrdom. The two figures who fill the right-hand third of the scene with their quarrel take the old theme of the 'disputatio' to its ultimate dramatic pitch. This group with its combination of a frontal view with a figure seen from the back, reminiscent of certain panels of Donatello's bronze

doors in the Old Sacristy of San Lorenzo, emphasizes the full extent of tension in the event portrayed, sharpened at the moment of culmination, and at the same time actualizes the underlying significance of the event. It is instructive to see how in the Decollation Verrocchio adopts and recasts motifs which have long been used in the traditional scenes of the Passion or of martyrdom. The Middle Ages had numerous examples of the executioner as the personification of evil, seen from the back and moving away aggressively into the background; there are many sources of comparison to be cited, particularly in representations of the Carrying of the Cross, the Scourging of Christ or Christ before Pilate in northern paintings and drawings.

Verrocchio supplied some small figures of apostles as well as the relief for the silver altar of the Baptistery. These were set in niches on the upper gallery of the architectural frame, on the same side of the antependium as the relief of the Decollation. The statuettes, four of which survive, are solid silver and barely ten centimetres high. They are finely cast and worked in great detail (Plate 57). Although on such a small scale, the movements, hand gestures and facial expressions are as developed as in niche figures of monumental size. The apostle seen in completely frontal pose with the Christ-like head is a kind of variant of the Or San Michele Christ; the youthful beardless apostle on his right is closely related in stance and posture with one of the figures on the Campanile of the Duomo in Florence, the prophet Obadiah by Nanni di Bartolo. Because their garments are shorter, the two middle statuettes show the position of the feet, and the hands are more completely and expressively modelled; in quality these two figures are hardly inferior to the figures of the Decollation. They can perhaps give us an approximate idea of the (much larger) silver apostles which, according to Vasari, Verrocchio was commissioned to make by Sixtus IV.

V

THE LARGE MARBLE MONUMENTS

WHILE the bronzes of Verrocchio's Florentine period, which we have so far discussed, the David, the Putto with a Dolphin and the group of Christ and St Thomas, are nowadays universally accepted as Verrocchio's own work, there are two pieces of marble sculpture confirmed by contemporary documents or by other sources as by him which were nevertheless quite evidently done with the active collaboration of pupils and assistants. These are the monument for Francesca Tornabuoni referred to by Vasari in S. Maria sopra Minerva in Rome and probably executed at the end of the seventies, and the cenotaph for Cardinal Niccolò Forteguerri. Verrocchio had already worked out designs for the latter by about 1475, but it was only partly completed before he died in 1488.

Of the Tornabuoni monument, which was broken up around the beginning of the nineteenth

century, the only fragment surviving is a marble panel with two frieze-like multi-figured scenes, in the manner of the reliefs on antique sarcophagi (Plates 50–52). The panel is now preserved in the Museo Nazionale in Florence; presumably it originally formed the front of a pedestal-type base for the sarcophagus on which lay the figure of the deceased (probably life-size) on a bier. A drawing in the Roman sketch-book of Heemskerck (fig. 17) records the form of the sarcophagus and figure. Francesca Tornabuoni died in childbed, and the stillborn infant was buried with her; Verrocchio therefore places the child on the lap of its mother as she lies on the bier. Heemskerck was evidently struck by this unusual and impressive motif, and noted it in his sketch-book, without unfortunately giving any information about the rest of the monument or its structure. Vasari adds that there were also three Virtues placed close to the narrative scene, but they have not been preserved. The marble panel in the Bargello shows on the left the scene where the doctor and the nurse bring the news of the death of his wife and the child to Giovanni Torna-buoni; on the right is the death scene: Francesca lies propped up very high and leaning weakly forward on a couch which is, incidentally, much too short for a deathbed. The nurse holds the right hand of the dying woman; the elder women stand quietly grieving while some younger mourning women, their hair unloosed, express their grief in passionate gestures. In the near foreground a woman crouches on the floor, holding her head in her hands in a gesture of despair. In the right-hand corner sits a maid with the swaddled child in her lap. This composition seems to be inspired from classical sarcophagus reliefs, as can be seen from a comparison with the Meleager sarcophagus in Florence (fig. 20). The general arrangement of figures in the left-hand relief, however, follows a scheme used in paintings representing such scenes as the Betrothal of Mary or the Presentation of Christ in the Temple. Each scene is complete in itself and closely knit, so that an empty space without figures is sufficient to separate one from the other. There is no ornamental frame and no hint of an architectural motif.

The Tornabuoni marble relief is patently related to Roman sarcophagi in the frieze-like manner of filling the horizontal rectangular surface and in the style of the figures; but that is not enough to explain the striking deficiencies of proportion in the figures and in the handling of detail. The grimacing faces, the ugly treatment of hands and feet and the clumsy, stiff style of the drapery make it certain that they are not by Verrocchio's own hand. Even if we accept that this work is based on the master's designs they can hardly have done more than provide the basis for the composition.

On 21st December 1473 Cardinal Niccolò Forteguerri, Bishop of Teano, Papal Treasurer and Nuncio of Pius II for the crusade against the Turks, died at the age of fifty-four in his palace at Viterbo. His body was carried to Rome and buried in the church of S. Cecilia in Trastevere, whose titular cardinal he had been. Mino da Fiesole built his tomb there. Two weeks after the cardinal's death the council of his native town, Pistoia, decided to honour his memory with an expensive monument. After lengthy negotiations a competition was announced and finally in May 1476 five models by different artists were submitted. Verrocchio's model was first chosen for

execution, but since the artist required a higher price than the Council was at first willing to provide, negotiations began again; meantime Piero Pollaiuolo was commissioned to work out a further design. When his design was submitted it was preferred to Verrocchio's, particularly by the family of the deceased, and the advice of Lorenzo de' Medici was sought. Lorenzo, however, decided in favour of Verrocchio's design. The execution of the cenotaph was extremely protracted; at Verrocchio's death several figures and the architectural framework had not been finished, some of them apparently not even begun. It is possible that the artist lost interest and enthusiasm for the commission and was annoyed first by the indecision of his clients and then by their calling in a rival. In any case in the late seventies and early eighties he was immersed in the work for the silver antependium in the Baptistery and even more in the completion of the Christ and St Thomas. At that time too he was beginning the designs for the Colleoni monument.

It was not until 1514, more than forty years after Cardinal Forteguerri's death, that it was decided to have the cenotaph finished by the young Lorenzo Lotti (called Lorenzetto). Lorenzetto undertook to restore the finished parts which had been deposited in the Pistoia Opera del Duomo and which had received some damage, to supply the missing figures and to instal the monument in its place in the Duomo. He first executed the figure of the kneeling cardinal (fig. 22) (which is now preserved in the Museo Civico in Pistoia), and of Charity, the latter evidently to his own design. There is no unambiguous record of other work on the cenotaph or of its provisional installation during the sixteenth century. It was not definitively set up until two hundred years later, in the middle of the eighteenth century, when the parts made in Verrocchio's studio and those by Lotti were fitted into an ornate and much too cramping frame (Plate 41). Gaetano Masoni, who was entrusted with the completion and installation of the monument, added the sarcophagus with the bust of the Cardinal between two mourning putti holding torches. The decoration for the plinth under the sarcophagus was already to hand in a marble relief by one of Verrocchio's pupils, showing two putti with an inscription tablet. Masoni's additions, particularly the unarchitectonic baroque frame, make it still more difficult to appreciate the quattrocento parts, the uneven execution of which was already recognized and criticized by earlier students of Verrocchio's work.

The terracotta model submitted for the competition by Verrocchio in 1476 survives and is preserved in the Victoria and Albert Museum (Plate 40). It shows the artist's original idea; it alone provides the proper basis for an evaluation of the quattrocento parts of the monument and for deciding their place within the œuvre of the artist. The model shows a mandorla borne by four wingless angels enclosing a figure of Christ in Majesty with an open book, his right hand raised in benediction; under the mandorla kneels the figure of Niccolò Forteguerri surrounded by the three Cardinal Virtues. The arched upper part of the relief is filled to its fullest extent by the scene in the heavenly zone; the figures of the Virtues and the Cardinal are so disposed as to give the impression of being arranged as an equilateral triangle. Here in the lower third of the model it can be seen that alterations and additions have been made; they probably date from the sixteenth

century and they make it impossible to be certain about the intended form of the area around the base. On the figures of Faith and Hope and of the kneeling Cardinal the parts that project most, particularly the heads, have at some time been re-done. The model will originally have included an architectural frame, i.e. an arch placed against the wall. It is possible that Verrocchio's design included the motif of the opened curtain which was often used for tombs in the quattrocento, and which Masoni used for his baroque frame. The arrangement of the upper pair of angels holding the mandorla suggests this and there are traces on the back of the model that tend to support this suggestion.

The nearest iconographic parallel to the London *bozzetto* is significantly in a wall painting, in an example of trecento tomb art in S. Croce. Over Bettino Bardi's sarcophagus Maso di Banco has portrayed him kneeling before Christ as Judge, who appears in the Heavens in a mandorla. Verrocchio has also worked in certain ideas derived from Nanni di Banco's relief of the Presentation of the Girdle on the Porta della Mandorla of the Duomo in Florence for the composition of the upper zone of his design for the cenotaph. What is original is the way he combines all three sections, the lunette composition, an allegory of the Virtues and the figure of the Cardinal rendered as in life, and makes the whole into a single visionary scene. Verrocchio is here anticipating baroque compositions, whereas the development of the Renaissance tomb was to follow other paths. We cannot say now whether the new type that Verrocchio invented here might have had earlier successors if the cenotaph had been completed and set up in the fifteenth century. There are few other indications that Italian tomb sculpture was tending towards this pictorial unity. Neither the brothers Pollaiuolo in their tombs for Innocent VIII and Sixtus IV nor, later, Michelangelo in his projects for the tomb of Julius II, make any attempt to dissolve the figurative programme into a single scene. Verrocchio's conception is one more example of that interpenetration of the fields of sculpture and painting which is characteristic of his art. The arrangement of the figures in two zones set one above the other compares more relevantly with Perugino's fresco in the apse of the old Basilica of St Peter's, or in his fresco for the altar in the Sistine chapel – also known now only from later drawings (fig. 21) – than with any of the various fifteenth- and sixteenth-century solutions to the problems of funerary art. Yet a comparison with Perugino's compositions immediately shows up the scenic dynamism of the London *bozzetto*, the striking directness of conception in the figures and the inexhaustible wealth of invention in varying the attitudes and finding new ways of dealing with the draperies. The four mandorla angels in particular have a vehemence of action and expressiveness of gesture that puts them among the most impressive and felicitous of the artist's creations. They are not as noble and grand as Nanni's angels on the Porta della Mandorla, but their excitement and their movements are much more human and lively in effect. They perform their task with the enthusiasm and zest of youth. Holding up the mandorla is no longer presented as a symbolic gesture but as lifting and supporting a real weight. Verrocchio's design differs from Nanni's relief in adopting a single scale for the principal and secondary figures, in which the figures in the heavenly zone are deliberately

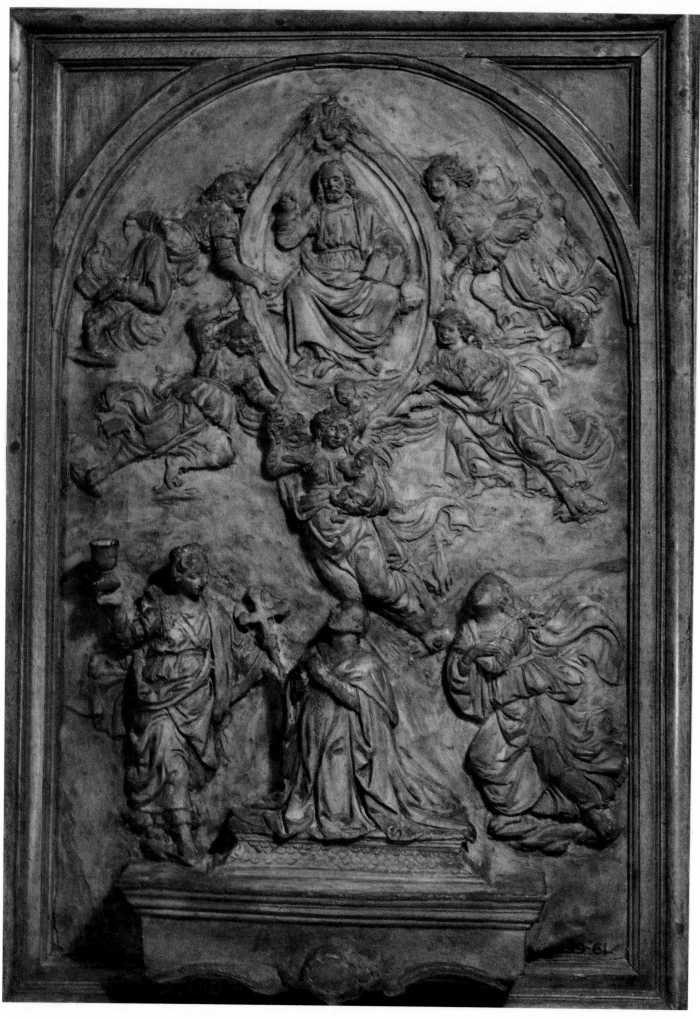

Bozzetto for the Cenotaph of Cardinal Niccolò Forteguerri. London, Victoria and Albert Museum
(Cat. No. 9)

rather smaller because they are depicted as being further away in space than the Virtues and the figure of the Cardinal. It seems incredible today that the London sketch could have once been attributed to Piero Pollaiuolo or Andrea Ferrucci, or even dismissed as a modern fake. Where do any of Piero's figures show such impetuous and spatially complicated movements which remain so natural in effect and at the same time possess such sculptural significance and clarity?

The effect of the quattrocento parts of the Forteguerri cenotaph is spoilt today by the baroque frame and the added figures of the lower zone; it is spoilt even more because, when Masoni came to combine the various older elements, he gave far too little consideration to the original general conception of the monument as we see it preserved in the model. The group of angels with the mandorla which is so widely spaced out in the model is today huddled close together. The mandorla has become far too small in relation to the Christ figure. The lower pair of angels is holding the edge of the mandorla too far down, almost at the very apex. In the model the apex is covered by the outstretched wings and the torso of Charity who, from her attitude and the way she is placed, acts as a link between the heraldic arrangement of the heavenly sphere above and the asymmetrical figure composition beneath. Lorenzetto's Charity with her smooth neat-winged silhouette is smaller in proportions than all the other figures and is too static and statuesque in concept to fit in harmoniously with the general movement of the composition. The empty stone surface which is most noticeable around the figure of Charity appears dead, hard and dark instead of light and airy like the background of the model. The Charity is better suited to the classicising ordering of the plinth zone than to the baroque mobility of the quattrocento elements which Masoni tries to curb with his heavy clamp-like frame instead of enhancing its effect. By packing all the figures close together Masoni loses the impression of an open space filled with action. No wonder the angels now need their wings in order to convey some sense of hovering or flying. While the movement and draperies are to a large extent taken over from the model the wings are noticeably not envisaged there. So Verrocchio must subsequently have altered the design in that particular from the conception preserved in the London *bozzetto*, probably to please the client.

However, it does not seem possible to consider the terracotta reliefs of the Thiers collection now preserved in the Louvre (Plates 58–59) as intermediary studies between the London model and the monument as executed. The model is much closer to the finished work than the Louvre angels are to the corresponding parts of the cenotaph. The left-hand angel in the Louvre cannot have been made as a model for the lower left-hand mandorla angel, for there is no room in either the *bozzetto* or in the completed relief for the widely spread very visible right wing. The position of the angel's head and the direction of his gaze would be meaningless in the same context in the Forteguerri group. There is no hint of a mandorla frame in the Louvre reliefs; instead parts of a ring of cloud are discernible. The Louvre angels, of which more will be said later, are separate reliefs, their composition clearly dictated by the square format in which they are set.

Even taking into account its unfavourable position and the bad lighting which still obtains

today in the Pistoia Duomo, the Forteguerri cenotaph itself is very disappointing in effect. The exemplary publication on the monument by C. Kennedy, E. Wilder and P. Bacci in 1932 led to a strong uptrend in evaluating the work among students of Verrocchio's art; since then it has become usual to study the work and analyse the style of its quattrocento parts from Kennedy's photographs published in great detail and carefully chosen, which are still indispensable today. These photographs transfigure the impression of the original by bringing the heads, hands and feet of the figures and even the details of their draperies into a soft rather diffused light. Thus the forms which are often very flat and jejune are enlivened and their harshness mitigated. Even the best parts, the head of Christ and the head of Faith (Plates 42–43), cannot, when seen in the original, brook comparison with authentic works of Verrocchio like the Madonna relief from S. Maria Nuova or the Bust of a Woman in the Bargello. The Christ in the Berlin Lamentation relief or in the Or San Michele group has, it is true, the same serene and sublime expression, the same noble features, clear cut and simply rendered, but the precision of the forms and intensity of expression which distinguish the bronze Christ have degenerated in the Forteguerri monument to a cool, rather unengaging kindliness. The quattrocento parts of the cenotaph were probably produced by a group of Verrocchio's pupils and assistants from his model and detailed studies. The uneven quality of execution, which is so marked in the treatment of the draperies, and the modelling of the hands and feet, betray the different degrees of talent and the varying skill and experience of the artists taking part, and no doubt the irregular supervision of the work by Verrocchio as well. How far the artist himself participated in the execution of the more important elements, how far he intended to go over details with his own hand before the final completion of the monument can hardly be determined now. It is notable, however, that in some figures, unlike the unessential details of wings and garments, such important features as face and hands have been left unfinished.

The two reliefs of angels in the Louvre (Plates 58–59) cannot have been studies for the Forteguerri monument. This does not mean however that the reliefs have no connection with the London terracotta or with the Pistoia angel figures which are based on it, though in a somewhat altered form. The left-hand Louvre angel has analogies with the lower left-hand mandorla angel of the model: the position of the legs and the drapery are similar. His arms, however, resemble those of the corresponding figure on the cenotaph itself. But the tilt of the head, seen more in profile, the peculiar projection of the upper part of the body with the strongly foreshortened shoulder and especially the position (reminiscent of the angel in the Uffizi Annunciation) of the wing, spread wide and held horizontally, all show that this figure was newly conceived for its square relief panel and was intended, together with its companion piece, to flank an image that was obviously on *the same level* as itself and not diagonally above or below it. One could perhaps imagine a ring of cloud with a half-figure of Christ or possibly a roundel of the Madonna between the two reliefs. The right-hand Louvre angel uses the same movement as the upper right-hand mandorla angel of the London *bozzetto*, but it is considerably altered as if the limbs were laid

out flat. The foreshortening of the shoulder is disguised by the massive pair of wings held parallel to the picture plane; the running step is so modified that the outstretched left leg of the angel is now shown beside and in a line with the right leg instead of obliquely in front of it, and the foot held out behind is, significantly, not turned to show half the sole, as on the figure in the model, but is seen as if from above. Thus although a complex movement has in the first instance been adopted from the London *bozzetto*, a movement which is very rich in changing aspects, the spatial effect is eliminated as far as possible from the foreshortenings resulting from it. Of course the alterations necessary to do this create a loss of clarity in the structure of the body; the top of the body is turned so that it is seen from the back and one cannot quite see how the pelvic area can be twisted so far round as to make this view of the running position possible. The hips and legs are, however, covered and surrounded with a swirl of draperies, with the folds all parallel to the picture plane, so that the spectator is aware primarily of the grace and movement of the angel and is filled with admiration, without questioning the structural correctness of the figure. The aim is not so much to give a clear plastic and spatial rendering of the figure as to create an effective surface pattern like the initial in an illumination, spreading its motifs and forms over the whole available surface. The fluttering looped ribbons and the overlapping wings have the effect of reducing the three-dimensional appearance of the angel still further. On the angel's back the ribbon hides the specially critical area where the wings are attached. Its two-dimensional projection is in fact wrong if the composition be judged by criteria of anatomical correctness or clear spatial realization of the figure. These remarks do not imply any qualitative inferiority in the relief; they are made to draw attention to various features of a style of figure representation which is logical in itself and highly individual. They apply only to the right-hand Louvre relief, not to its companion. There too the same unusual movement is presented from its main viewpoint; but the movement is observed as a free action unfolding in depth. Unlike the angel of the right-hand relief, it is easy to imagine what this figure would look like if one could walk round it. The consistent three-quarter view is maintained even in the arrangement of the outstretched wings. This creates a strong tension between spatial and surface values; and although here too the movement of the angel is clearly dominated in its surface projection by the square shape of the relief, the space around the figure seems to be more a matter of chance than it is in the case of the right-hand Louvre angel. The effect of the empty background enhances the illusion of depth created by the foreshortenings. The area in which the figure moves is seen as part of a space continuing in every plane beyond the relief. Again in such details as the rendering of facial features and hair there are significant differences between the two figures. The head of the left-hand angel is modelled on broader lines and with greater assurance. The locks of hair are ruffled and in disorder, in keeping with the impetuosity of movement in the body; they do not lie close to the head but fall free to form shadowy hollows. The face of the right-hand angel is more gently and timidly modelled and the expression too is softer and more poetic; he is pensive and withdrawn compared with his alert and spontaneous companion. The beautifully arranged and much finer hair is

modelled in very low relief; the charm of the way it lies is enhanced by the garland of flowers resting on it.

As the Louvre reliefs were made as companion pieces they must have been made within a short time of each other, and the differences in style we have noted can hardly be explained as stages in Verrocchio's own development. A comparison with the authenticated works indubitably shows the left-hand angel to be by Verrocchio himself, while the companion piece has points of style which we find again in compositions by Leonardo. If we put the right-hand Louvre relief beside the angel seen in profile in the Baptism (Plate 82) or the angel of the Paris Madonna of the Rocks the close relationship of all three angels is clear to see. The position and movement of each figure is entirely thought out and depicted from that single aspect which is most effective for the beholder. The expressive values of the movements and the aesthetic values of the forms in certain details (face, hair, throat and neck area, hands) interact harmoniously and enhance the effect of each to its fullest extent. Expression is conveyed not by face or hands alone but by the whole surface pattern of the figure. We cannot do better than quote three extracts from Leonardo's 'Rules of Painting' to explain the right-hand Louvre angel and the angel figures in the paintings: 'Remember, painter, when you depict a single figure, to avoid foreshortening it . . .' 'Never make the head turn in the same direction as the chest, nor let the arm go together with the leg . . .' 'Therefore, painter, compose the parts of your figures arbitrarily, then attend first to the movements representative of the mental attitudes of the creatures composing your narrative painting, rather than to the beauty and goodness of the parts of their bodies. . . .'

VI

SCULPTURES ATTRIBUTED TO VERROCCHIO ON STYLISTIC GROUNDS

THERE are several other works in terracotta and marble for which no documentary evidence exists that they come from Verrocchio's studio but which on grounds of style have long been accepted as forming part of his œuvre. The terracotta half-length relief of a Madonna with the Child standing on a cushion (Plates 14–15) is among the earliest known of Verrocchio's figure sculptures. It was once in S. Maria Nuova in Florence and was moved first to the Uffizi and finally in 1903 to the Bargello. It must have been executed about the same time as the bronze David, in the mid-seventies. The technique of painted unglazed terracotta was very popular towards the end of the fifteenth century in Florence, as is shown by the large number of reliefs of this kind still preserved in collections all over the world. The advantages of this technique lay mainly in

the small cost of the materials and in the short time it took to produce the works. The original colouring of the Bargello Madonna was intended to give the effect of a marble relief; unfortunately it has suffered so much from later overpainting that when this was removed much of the surface was spoilt; this accounts for the distressing spotted effect which is particularly noticeable in photographs.

This particular type of half-length Madonna with Standing Child is anticipated in the circle of Ghiberti and by Michelozzo, and most closely in the marble Madonna roundels on the Marzuppini tomb by Desiderio da Settignano and on the Bruni tomb by Bernardo Rossellino (fig. 5 and App. 7). Verrocchio represents the Child naked. The body is still that of a baby, unarticulated and very plump, with rolls of fat on the thighs and upper arms. It stands rather insecurely on a cushion placed on the ledge, which forms the base of the relief. The effect of childish high spirits, of untroubled liveliness and restlessness which Verrocchio has been able to extract even from the classical standing motif of this *contraposto* is reflected in the fresh childish face, its fun and gaiety caught with astonishing directness. The Madonna's hand, quietly and reassuringly poised as if to forestall the next impulsive and unexpected movement, adds to the sense of the Child's unpredictability. The untidy locks, the small mouth with full slightly parted lips, the fat chubby cheeks, short snub-nose and the long eye-openings curving broadly above the heavy under-lids certainly belong to a nobler type than the Putto with a Dolphin, but just how little idealization has done to refine and modify the reality of experience will be apparent if we compare it with the images of the Christ-child by Michelangelo and his contemporaries. The intermediate stage in this transformation can perhaps be found in Leonardo, in the two versions of the Virgin and Child with St Anne, while in the Virgin of the Rocks the adaptation of his child studies from nature which he used as a basis are not entirely convincing.

But the effectiveness of the child figure in Verrocchio's relief is not only a matter of directness and freshness in rendering forms and motifs studied from nature. The Christ-child, though placed far to one side on the right, is clearly emphasized as the main figure and centre of the scene. This is less because the figure is almost frontal and nowhere overlapped, or because of the striking stance and the gesture of benediction from the raised right arm supported by his mother, than because of the Madonna's concentration on him. She looks down on him from under lowered eyelids, while his interest is entirely directed outside the scene on those he is blessing. The Madonna's head seen in three-quarter profile with its high-domed brow and ingeniously draped veil is, like the boy, almost in full relief, while her torso, kept in much flatter relief, recedes towards the centre behind the Child. This oblique posture is veiled in the left-hand third of the image by the rich folds of the mantle, which in the close foreground run parallel to the picture plane. The three-quarter pose of the half-figure Madonna accentuates the frontality of the Child and his look fixed on us. The whole composition is subordinated to the child figure; it could be removed from the relief and set up alone to crown a tabernacle of the Sacrament. This Christ-child is one of the most gracious and vigorous child images in Italian art; and in spite of its small format it

has a monumentality and radiates a fascination possessed by few single religious figures of the quattrocento.

The bust of the Lady with a Bunch of Flowers in the Museo Nazionale in Florence (Plates 44, 47, 49) is probably the only marble sculpture executed entirely by Verrocchio's hand; it represents the classical stage in his sculpture and is to be dated around 1478. This attribution rests entirely on an analysis of style; documentary evidence is lacking. The bust was in the possession of the Medici Grand-Ducal house. It does not appear in Tommaso Verrocchio's list of works executed by his brother for the Medici, nor has it yet been identified with any of the busts mentioned in the inventory of the Medici collections. The identity of the sitter is not certain. Possibly she is the same woman as in Leonardo's portrait from the Liechtenstein collection, believed to be Ginevra dei Benci (fig. 24).

Verrocchio has adopted an antique type of portrait bust, used mainly for Roman officials though occasionally for women as well. These half-figure busts include arms and hands. Verrocchio was obviously led to choose this type by his acquaintance with the Roman bust of the so-called 'Matidia' (fig. 23) in the Medici collections. But we should not leave out of account the influence of portrait paintings on Verrocchio, since his work so frequently shows an interpenetration of the characteristics of painting and sculpture, and painted portraits of the period frequently include the hands. It is not surprising that Verrocchio was the first to adopt this antique bust type again. In most of his figures the hands play an important part in portraying expression. No less than the features and expression of the faces, he uses them to convey the temperament of the person portrayed, the main traits of character and the immediate reaction to the situation in which they are depicted. The primacy of psychological expression which characterizes nearly all of Verrocchio's figures is brought about by an intensification of the expressive value of hand gesture and mime. This implies a new interest in physiological and psychological problems, which Verrocchio evidently shared with the young Leonardo. The common studies which, as Leonardo's early drawings testify, played so important a part in Verrocchio's studio, explain many of the parallels in the works of teacher and pupil: the repetition of certain hand types and gestures, expressive motifs in the movement of fingers, the 'Mona Lisa smile' of the bronze David, the fierce Colleoni expression in Leonardo's caricatures and drawings of old men. Both Verrocchio and the young Leonardo show an equal pleasure in the charm of the curls on the Christ-child or St John, in putti or angels, and in the beauty of carefully arranged hair such as we see in their Madonnas. Vasari recounts that Leonardo used to copy women's heads from his teacher's drawings and imitate their imaginative hair arrangements.

Verrocchio's marble Portrait of a Lady is exhibited in the same room of the Bargello as the terracotta Madonna executed some three years earlier, and it is instructive to compare the two pieces. One is a portrait in the round, the other a relief based on a particular Madonna type and conceived from one viewpoint only, so that certain differences are to be expected; even so the novelty of sculptural thinking in the marble is striking. The woman's portrait head shows a far

greater concern with planes than with the general spherical shape; instead of the high rounded brow which characterizes the Madonna we have a shallow forehead surface whose breadth is emphasized further by the hair arrangement. The hair is drawn tightly to each side of the central parting and does not fall, as it does in the Liechtenstein portrait, obliquely across the brow to the temples. The curled ends at each side broaden the effect of the face, and they set off the soft modelling of the smooth, matt-glowing skin by their restless deep-cut relief and strong shadows. The artist has very consciously made use of the colour effect and attractive surface of the white Carrara marble for the rendering of the face and aristocratic hands. The choice of the dress too with the light, softly falling cloth and gossamer thin under-shift coming high up to the neck clearly exploits the special character of the colour and texture of the marble. Neither in his bronzes, nor in his terracottas or silver work does Verrocchio take such pains as here in marble to extract the effect of the soft delicate gathered stuff from the hard brittle medium. He avoids portraying the sitter in a smooth bodice or a dress of thick dull-coloured cloth, as Leonardo did in the Liechtenstein portrait, but consciously, in emulation of Desiderio's marbles and of the classical models, he chooses a task which is technically much more difficult, but much more attractive, success in which will give him more satisfaction and more artistic glory.

Both the conception and execution of the Bargello bust show considerable influence from the antique. The adoption of the 'Matidia' type of bust is indicative. An entry in Tommaso's list makes it clear that Verrocchio did some work as restorer in the Medici collection of antiquities; he restored and completed a red marble figure of Marsyas (now vanished) and many 'teste', i.e. busts, which were set up over the doors of the Giardino and the inner courtyard of the Palazzo Medici.

The bust of Giuliano de' Medici, now in the National Gallery in Washington (Plates 45, 46, 48; fig. 25), also has features derived from Roman portraiture. Among the numerous terracotta busts exhibited in museums and private collections under the name of Verrocchio this is the only piece which has the importance and quality of an autograph work. From the style of the bust it should be dated about 1479/80, later than the Lady with a Bunch of Flowers and about contemporary with the final model for the St Thomas of the Or San Michele group. The success of this portrait in conveying the sitter's exalted sense of power, the expression of an intrepid, conceited and somewhat domineering character, is in no small measure due to the energetic tilt of the up-tossed head. This classical motif which Verrocchio uses as a formula for conveying certain characteristics and situations occurs again to typify Colleoni, and even more forcefully in Michelangelo's bust of Brutus. The antique origin of the motif is as patent in Michelangelo's work as it was two generations earlier in Nanni di Banco's Isaiah or Michelozzo's Justice in Montepulciano. But in Verrocchio the antique motif is overlaid by the 'realism' of the image and by the impact of forms taken direct from nature. It is the same with the David, with the Child of the terracotta Madonna in the Bargello and in the Christ and St Thomas: they all give the impression that the classical stance

and movement have influenced the figure only indirectly through the model – posing 'all'antica' – and were not present at the germination of the artistic idea.

Verrocchio's terracotta preserves for posterity the most vivid portrait of Giuliano, probably the closest likeness as well. The artist made no concessions in rendering the heavy, ugly structure of the face and the unusual shape of head. Yet the physiognomy is so strongly simplified and condensed into its significant and essentially characteristic forms, and the expression of this dynamic and vital personality is rendered with such intensity that the portrait bust achieves an entirely new monumentality. It aims higher than at presenting a reliable likeness of the sitter, the sort of thing that could be done by wax life-masks, so often used as models for busts in the quattrocento; it creates a hero, and becomes a monument to perpetuate the memory of the brother of Lorenzo de' Medici, Giuliano, who was murdered in 1478 in the Pazzi conspiracy.

The high quality of this work becomes evident if it be compared with the terracotta bust of Lorenzo de' Medici in the collection of Mr Quincy Shaw to be seen in the Museum of Fine Arts in Boston (App. 3), also attributed by some scholars to Verrocchio. This portrait can hardly claim to be by the master's hand. It is the work of an imitator of Verrocchio, obviously based on the Giuliano portrait. In contrast to the strong rounded shoulders and chest of the Giuliano bust the torso of Lorenzo is stiff and wooden. The Washington bust broadens out towards the base, thereby strengthening the impact of the massive form, which appears to be almost on the point of bursting, while the Lorenzo is more vertical, and his arms hang close beside his body: the armour seems hardly to allow the arms to move. Verrocchio's decorative gift comes to the fore on Giuliano's breastplate. As on the Amsterdam candlestick, the decoration is derived from a perfect blending of naturalistic and formal elements. Every motif has its immovable and inevitable place. The distribution of the decorative elements is related to the three-dimensional form of the whole bust, not to the shapes of the various surfaces to be filled. The convexity of the chest is emphasized by the arcading pattern round the neck with the overlapping discs diminishing in size towards the top, and the ornamental edging to the arm attachment with its cusps pointing to the winged mask. The mask glares straight at its wearer's opponent, thus creating a direct and spontaneous reaction in the spectator, while he feels at the same time the contrast between the loud aggressive effect of this screaming face and the imperious aloof expression of the head. The whole decoration of the armour culminates in the centrally placed mask, and it is also modelled in higher relief than the rest. The wildly dishevelled locks are reminiscent of the snake hair of the Gorgon's head, which is the antique model on which this form of mask is based. Lorenzo's armour on the other hand seems strangely botched together and uncoordinated. The two harpies ram their heads against the border of the compartments allotted to them on the breastplate. The minute shield held in the claws of the fabulous beasts is resting on the very bottom edge of the bust. The breastplate is not treated here like the upper zone of a complete piece of armour, intentionally cut off by the form of the bust. The ornament appears rather to have been designed exclusively in order

to fill the exact area of chest portrayed, without any thought of implying a general idea of the armour and its different components and decoration. The Giuliano bust is quite different: it seems like the upper section of a whole figure; a comparison with the torso of Colleoni (Plate 65) will make this clear.

The terracotta statuette of a Sleeping Youth in the Staatliche Museen in Berlin (Plate 60) has been regarded since its acquisition as a work by Verrocchio himself; the attribution goes back to Bode, and the only scholar to question it has been Adolfo Venturi, who in 1926 tried to transfer it to Antonio Pollaiuolo. The general posture of the figure is strongly reminiscent of the Hellenistic figure of the Dying Gaul in the Capitoline Museum in Rome (fig. 27). It is certainly not simply a study of a nude, but is the illustration of a character from classical mythology. The suggestion that Endymion is intended is based primarily on its relationship with the Endymion of Agostino Cornacchini (fig. 26), who may even have taken his inspiration from Verrocchio's terracotta. The modelling of the thorax, pelvic region, and limbs shows the same wealth of form that we meet in the bronze David; neither is the body of the Berlin statuette that of a particularly noble youth. The anatomical displacements caused by this particular recumbent pose are all drawn with great precision: nothing is lost of the irregularly tensed muscles, the joints here and there protruding sharp and hard. The hands, which seem to consist entirely of bones and tendons, are rather large in relation to the length and thickness of the arms. Such a nude is eloquent testimony to the intense and profound anatomical studies carried on in Verrocchio's studio. Yet no one could possibly consider the Berlin terracotta simply as a sort of study-model. The dreamy relaxed expression of the charming face echoes the pose of the body, particularly the utterly relaxed and drooping hands. Every separate motif, studied so intensely from the life, is transfigured by a soft, withdrawn and silent mood pervading the whole figure, and we find ourselves instinctively wondering which figure of mythology is intended and in what scene the artist has represented him. We do not know whether this terracotta, which shows no trace of having been coloured, was made originally as a model for a bronze. It can be dated more or less to the same time as the Decollation relief, about 1480.

Among the unfortunate war losses from the Kaiser-Friedrich-Museum in Berlin was the small unpainted terracotta relief of a Lamentation for Christ (Plate 61). Its genuineness as an autograph work has scarcely ever been called in question. The rendering of the heads is close to that in the Decollation relief, while the treatment of the draperies already has elements of the style of the St Thomas on Or San Michele, so that a dating round 1480/81 seems acceptable. Unlike the terracotta model for the Forteguerri cenotaph it is not a quick sketch model for a larger composition but a carefully modelled relief with a smoothed surface, comparable to the terracotta Madonna from Santa Maria Nuova in the quality of its execution. Whether like this latter it was to be coloured, and is an independent work of art complete in itself, or whether it was intended as a full-size model for a bronze relief, it is hard to say. Nothing is known of who commissioned it or for what purpose. For a time it was thought to belong to the Forteguerri cenotaph, and the

Nicodemus figure kneeling in the foreground to be a portrait of the deceased cardinal. But this thesis, held mainly by Mackowsky, has proved untenable.

Nonetheless the conspicuous placing of the kneeling figure, its striking movement, and particularly the detailed treatment of the head and its deliberate setting in profile, all suggest that it is probably the portrait of a donor. The relief was badly damaged along the upper edge, particularly in the right-hand corner, and gave absolutely no indication in itself as to the kind of altar or tomb structure for which it was originally intended. A very simplified copy of the scene has been found as the glazed terracotta centre-piece of the predella of an altar made for the Capuchin church in Camerino (Marche) by a later imitator of Della Robbia (fig. 28). The female figure with long flowing hair in the far background does not appear in the copy, but the general form of the figure of St John on the far right, the upper part of which is missing in the Berlin relief, can be completed in imagination by reference to its counterpart in the copy.

The placing of the figures in this Lamentation scene is clear and distinct and at first sight seems fairly simple. The dead Christ is propped up and raised so high by the mourners that he seems to be sitting on the front edge of the chest-shaped sarcophagus which is scarcely more than indicated. The body together with the figure of Nicodemus and the Magdalene bending over the feet of Christ is so arranged as to create a triangle in which the greater part of the torso of Mary is included. The converging lines meet on the central axis of the relief and it is here almost at the apex that the Madonna's face touches the head of Christ as it inclines towards her. This last sorrowful and intimate meeting of Mother and Son is the culminating point not only of the composition but of the emotional content of the scene. The expression of the helplessly drooping head of Christ and the aged face of the woman as she bends forward, is echoed in the motif of the hands folded one across the other, still and completely without pathos. The woman standing on the far left, in the zone behind the kneeling Magdalene, also expresses her silent grief and despair with her hands alone: her left hand hides her eyes while her right hand clasps at the folds of her mantle. It envelops her whole body, leaving only her face uncovered. Precisely in this figure, almost free of any overlapping and to be seen in full, do we find the style of the folds which anticipates the draperies on the St Thomas. Compared with the Christ on Or San Michele the cloth-like effect is heightened, but it has not yet reached the detailed rendering of folds in rolls that seem almost padded, like the garments of St Thomas. The upper part of the figure of another woman can be seen standing between the woman with covered face and Mary; her head is missing, but the long loose hair and the kind of clothing under which can be seen the soft modelling of the breast suggest that it was a young woman.

The figure of St John to the far right, as far as can be judged from the fragmentary condition of this section of the relief and the repetition of the figure in the terracotta copy mentioned above, is in an attitude reminiscent of the St Thomas on Or San Michele. St John is shown as he has just taken a step to approach the central group. His left foot, still turned outwards, appears in the extreme foreground and passes slightly beyond the right edge of the frame. The body is turned

in a spiral movement towards the scene; his right leg is suggested behind the left foot of the kneeling Nicodemus. Although the composition of the Lamentation is highly complicated in the spatial disposition of the figures, this is so cleverly disguised by the surface design of the scene that it gives a general effect that is symmetrical and delicately balanced. Only when the scene is analysed into its spatial components do the small irregularities and displacements, which do so much to add to the animation of the scene, become apparent. Of all Verrocchio's representational scenes, not excluding the paintings, the Berlin relief is perhaps the only one to have freed itself entirely from quattrocento rules of form. The way in which he reconciles an affecting and impressive illustration of the theme with the requirements of a clear, immediately visible hieratical representation is typical of the classical phase in Verrocchio's artistic development. This little terracotta relief deserves a prominent place among the Renaissance representations of the Lamentation and Deposition of Christ.

VII

THREE WORKS IN TERRACOTTA FORMERLY ASCRIBED TO VERROCCHIO

THE coloured terracotta relief of the Resurrection of Christ is universally recognized as an autograph work of Verrocchio, though its chronological position within his *œuvre* is still much discussed. It came to the Bargello from the Medici villa in Careggi (figs. 45–46). The composition derives from the relief of the Resurrection by Luca della Robbia over the door of the Sacristy in the Duomo in Florence (fig. 47). The rendering of the scene is strikingly dramatic. This the artist achieves by stressing the various psychological states of the watchers; some of them are peacefully sleeping, some starting up in panic. There is an obvious connection with the studies of heads of men shouting and in violent excitement which Leonardo did when preparing the drawings for the Battle of Anghiari. On the other hand the Bargello relief has weaknesses in the proportions and construction of single figures and a certain clumsiness and fussiness in the treatment of his material which point to a relatively young artist who has not yet fully mastered the special technique. A mature and practised artist would not have approached the adaptation of his prototype in this violent and impetuous way; we feel the difficulty he has experienced in converting the idea into plastic terms. Nor does he quite manage to combine the different motifs, powerfully expressive though each single one may be, into a unified scenic effect. Observations of this kind suggest that the Resurrection is a very early work of Verrocchio's, and since the work came to light most scholars have taken this view; only rarely, particularly recently, has an early dating been questioned. The relief cannot be earlier than the Christ on Or San Michele, nor can

it be dated right at the beginning of Verrocchio's activity, before the bronze David. It reflects so strongly the mature, fully developed style of the master that its origin in Verrocchio's studio leaps to the eye. The head of the Christ in the Resurrection presupposes the Christ of Or San Michele (Plate 37) and of the clay model for the Forteguerri cenotaph (Plate 40), while in the draperies it has clear affinities with the figure of St John in the Baptism (Plate 78). The Bargello relief cannot be an early work of Verrocchio nor indeed an autograph work of the master at all. It must date from the second half of the seventies, a period in which Verrocchio's figure style was much more assured and significant. In spite of the numerous impressively dramatic effects the figures themselves are strangely doll-like and unmonumental. In contrast to the violently emotional heads the bodies are mostly too elegant and fragile, the shoulders are too narrow and the arms noticeably short. Let us compare the Risen Christ with the Christ on Or San Michele (Plate 31). The artist's sole concern has been to depict the scene as it were in mime, from the psychological standpoint; the figures have coarse mask-like faces which in no way give the impression of forming part of heads of the same plastic value. Everything is so placed and posed before the spectator as to evoke the maximum response to the drama. Even the crouching watcher at the right in the foreground looking up in anguish over his shoulder is only depicted with this particular viewpoint of his movement in mind; the folds and crumplings of his garment are arranged to emphasize the pictorial effect from the front. The ornamental folds of drapery do not stress the plastic volumes of the body, but lead all the spatial tensions evoked by the complicated pose back into the single surface plane. And this method of composition is precisely an anticipation of Leonardo's work of the eighties, exemplified for instance in the angel of the Madonna of the Rocks. In fact the Resurrection relief belongs to one of the very few works from the studio of Verrocchio where the early activity of Leonardo in sculpture can be traced. In 1930 W. R. Valentiner pointed out the traits characteristic of Leonardo and argued that the relief was a work of collaboration between master and pupil executed in 1478; he was emphatically contradicted in 1941 by Leo Planiscig. In my opinion the work cannot have been either executed or conceived by Verrocchio, and must have been produced in Verrocchio's studio in the late seventies. Possibly Leonardo designed the composition and a fellow worker in the studio helped him in the execution of less important parts like the angel figures.

A terracotta statuette of St Jerome sitting reading, now in the Victoria and Albert Museum, has for long been attributed to Verrocchio (fig. 49); in the Museum's new catalogue, however, the figure is correctly described as the work of an anonymous pupil of Verrocchio. Besides the uncertainty and disharmony in the rendering of the nude, the choice of the unnatural pose for the saint, seated with a double twist of torso and head, speaks strongly against the authorship of Verrocchio. Even allowing that the statuette is designed like a figure for a niche with only one viewpoint in mind, it remains incomprehensible why the wealth of movement so carefully planned to be effective from this one aspect is not carried through more clearly in the realization of the various parts of the body. Just those zones which are most interesting to the sculptor,

where there are displacements and tensions in the musculature and bone structure caused by the peculiar seated position and the bend of the trunk, are veiled by the arm bent over the chest and the decorative drapery motif arranged as if on a model. Apart from the fact that the crossed-leg motif taken from the Boy with a Thorn with its sharply bent leg is much more appropriate to a boy or a youth than to a bearded old man, the organic fusion of the legs with the heavy torso is missing. The figure falls into two parts which do not fit together either as regards the attitude of the body or the type of saint and what he is engaged in doing. The decoratively arranged folds in no way add to the full three-dimensional appearance of the figure; as in Verrocchio's terracotta Madonna in the Bargello, which is, however, a relief, they lead the spatial values back to the surface. This is characteristic of the pictorial single-view conception of the figure. The Herculean body of the old man, his peculiar seated position, his concentrated reading, the motif of the hand grasping the beard are all features consciously presented to make an effect from the single main viewpoint. The artist is concerned here with modelling a figure according to certain of Leonardo's basic rules of figure representation. We referred to these principles and the explanations of them in Leonardo's Treatise on Painting when we discussed the angel in the Louvre (p. 29 ff.). Similar seated figures with crossed legs and twisted trunk are, incidentally, to be found among Leonardo's early sketches for the Last Supper and his drawings for an Adoration of the Shepherds and for his Epiphany. The London St Jerome was probably modelled in the early eighties by a member of Verrocchio's studio in Florence, who was strongly influenced by some of Leonardo's work. It is the only piece of sculpture which might possibly be attributed to Lorenzo di Credi.

Another piece which should be removed from the list of Verrocchio's autographs is the terracotta figure of the running Putto poised on a Globe in the National Gallery of Art, Washington (figs. 56–57). One is immediately struck by the effect of the chubby-faced boy's head, closely akin in type to baroque puttos, and by his rather affected attitude. The movement is a motif inspired by the Boy with a Dolphin; but the terracotta has not the spiral turning on its own axis of a *figura serpentinata* like Verrocchio's bronze; it is a very free forward movement, slightly curved to the right, and followed through by the turn of the head. As in the Boy with a Dolphin the artist's aim is to pose the figure so that the limbs spread out in space in all directions. Verrocchio used the specific opportunities provided by bronze to emancipate plastic forms and created a free-standing figure which offers a rich and delightful silhouette from every conceivable view. The Washington Putto, however, has scarcely a single aspect not deformed by foreshortening. The general effect of the pose and movement is spoilt at every turn by unfortunate overlapping of the contours or details with ugly shapes. Part of the trouble is that the artist has chosen a podgy baby body with rolls of fat at the joints and folds on the arms and legs, very like the Christ-children in the paintings of Lorenzo di Credi and indeed, in less exaggerated form, like the child in Verrocchio's Madonna relief from S. Maria Nuova (Plate 15). There, however, it is at least in keeping with the uncertain, uncontrolled stance of the infant. The merry, lively Boy with a Dolphin (Plates 24–27) is of much firmer and neater build.

What is most problematical in the Washington terracotta Putto is the choice of the particular running motif for a free standing figure placed on such a narrow support. The movement spreads out wide and presses strongly forwards, very like the right-hand angel of the pair of reliefs in the Louvre (Plate 59) we have already discussed. But a motif like this is not easy to transpose into a free-standing figure to be seen from all sides. The whole weight of the body at this phase of the movement is resting on nothing but the top of a half-sphere, and that only with one foot. The central axis of the figure will have to be set so that it runs straight down to the point of contact. This does not seem to have been achieved in the Putto; particularly from the oblique aspects it gives the impression that the body is slipping to one side off the sphere. A figure dashing across its support in one direction cannot be made to balance such outspread limbs and forms as was possible in the Boy with a Dolphin, without destroying the naturalness of the movement. Giovanni da Bologna adopted a similar motif for his Mercury; but there the theme allows the running motion to be transformed into a skilful balancing on the point of one foot, a hovering appropriate to the subject. Despite all these objections to the choice of motif as unsuitable to the subject and to many details of execution there can be no doubt that the terracotta in Washington is the work of a pupil of Verrocchio, of a sculptor whose artistic rank and perceptive faculties must have given him no mean rôle in Florence at the turn of the century. The Putto is very close to figures by Benedetto da Maiano in the treatment of the hair and the structure of the face. The effect of the nose is very flat and short beside the generous mouth with the open uncontoured lips. The bridge of the nose forms a very low and spreading ridge between the wide-set eyes; particularly characteristic are the very protruding eyeballs and upper lids and the puffy area just above them. This produces the special dreamy, passive, rather stupid sentimentality which is the typical expression on most of Benedetto's figures. The face of the terracotta Putto seems strangely soft and lethargic, and has none of the vigour and gaiety which the lively movement of the body would warrant.

VIII

PROBLEMATICAL ATTRIBUTIONS FROM SOURCES

BEFORE we study the paintings and drawings of Verrocchio and the great sculptural work of his final post-Florentine period, the Colleoni Monument in Venice, we must discuss two further works of sculpture which are mentioned in the sources. They have always been attributed to Verrocchio but, in my opinion, they should be erased from the catalogue of his œuvre. These are the marble lavabo in a small room adjoining the Old Sacristy of San Lorenzo (figs. 59–60) and the so-called Alexander Relief, also in marble, which appeared on the Viennese art market in the early twenties of this century, was for many years in the collection of Mr and

Mrs Herbert N. Strauss in New York and is now to be seen in the National Gallery of Art in Washington (fig. 48). The lavabo is counted among the earliest works of the artist, before the bronze candlestick and before the Medici sarcophagus, because it bears the device and motto of Piero de' Medici who died in 1469. The Alexander relief has until now been almost universally dated 'about 1480', in the later years of Verrocchio's activity in Florence.

The lavabo is mentioned in Antonio Billi's notes, used by Vasari for his first edition of the *Lives*, as a work of collaboration between Donatello and Verrocchio, though it had been differently described earlier in Albertini's 'Memoriale' of 1510 as 'lavatorio del Rossello'. Vasari only makes use of Billi's statement in his Life of Donatello but, unlike Billi, without specifying Verrocchio's contribution more exactly. In his Life of Verrocchio the lavabo is not mentioned; evidently Vasari was doubtful of the reliability of the information. The lavabo in the main does not seem to have been made either for its present context or for its function as a hand-basin in a Sacristy. This argument is not only based on the curious decorative repertoire (harpies, dolphins, dragon and lion heads) and the fact that today the extravagantly rich decoration loses most of its effect from the narrow confines of its position. Much more striking are a number of single observations – dealt with in detail in the catalogue – which go to show that the lavabo in its present form consists on the one hand of homogeneous parts made for each other by the same artist and on the other of various subsequent additions made necessary or desirable by its present location. The original parts can hardly have been conceived for a lavabo. These are the lower basin with harpies and the vase rising over it with the oak-leaf border and attached dragon heads, but without the inserted shaft with the dragons' bodies. This conical shaft rising out of the vase is obviously part of the additions, as is all the wall decoration. Neither original parts nor additions are stylistically possible as the work of Verrocchio or of his studio. To keep the lavabo in the list of Verrocchio's works is to falsify the idea of the artist and of his development as a sculptor, and furthermore prevents identification of the real author.

The relief of Alexander in Washington (figs. 48, 50) has none of the signs of an autograph of Verrocchio's, in spite of the at first amazing baroque wealth of forms, in spite of the effective impact of the composition as a whole with its 'classically beautiful' head of the youth turned in profile above the bust projected obliquely into the relief plane. Andrea's characteristic clarity and significance of form is lacking precisely where the sculptor's mastery should be most apparent, in the forms and modelling of the face. The area round the eye with the vertical and straight-contoured eyeball and the puffiness under the lower lid, lies strangely lifeless between socket and cheek. The transition from the eye socket to the nose is only linearly indicated; the plastic values are not understood. The rather bloated jaw and cheek area seems remarkably mediocre in its shaping and in its relation to the neck zone. The neck is rendered very flat, crossed by a number of creases. But it is specially the form of the nose, so classical in effect with the over-long, sharp and smoothly contoured bridge and the slanting end, that gives this face its cold hard expression. It is apparent too from the fantastic armour that Verrocchio cannot have been connected in any way

either with the execution or above all with the design for this relief. Nowhere is the impression given that this breastplate and helmet with their decoration are made of metal; the sculptor obviously had no interest in a realistic portrayal of armour nor does he seem to have been much acquainted with the function or the articulations of the various pieces. Apart from the fact that the shape of the helmet is not quite correctly projected, the dragon crest is fastened too far forwards and appears to have been arranged only for its effectiveness from this particular viewpoint. Planiscig identified the marble relief with one of those works of Verrocchio described by Vasari as idealized portraits of Alexander the Great and Darius to be presented by the Medici to the Hungarian king Matthias Corvinus. This attribution has never been seriously disputed since then. Yet Vasari speaks expressly of bronze reliefs, and this sounds convincing, given the theme (warriors of antiquity in parade armour) and the artist's partiality for this material. A terracotta copy of Verrocchio's lost relief of Darius from the later years of the Della Robbia studio (fig. 51), now in Berlin, gives an idea of the work, though the quality of execution is not very high and the technique of these glazed terracottas necessarily coarsens the forms. It is not difficult however to imagine that the original was in fact a bronze relief. This image of Darius suggested to the young Leonardo his drawing of a warrior in the British Museum (fig. 53). As far as can be judged from the terracotta copy and from Leonardo's version it showed a more convincing treatment of the face and neck and their relation to the torso, and the armour in spite of the wealth of decoration was much more realistic and clear than in the Washington relief. The motifs of decoration on the marble 'Alexander' relief are presented side by side and compete for effect (dragon, Triton-Amymone scene, winged mask), whereas the decoration on Darius' armour is arranged with a maximum of economy, the choice of motifs being regulated and even restricted at times by the structure of the breastplate and its function. One can see at once what Darius would look like from the other side, turned away from us; how we are to imagine the corresponding aspect of Alexander remains rather unclear.

It is also questionable whether this representation of Alexander can possibly have been conceived as a companion piece to the relief of Darius. Apart from the fact that one would expect the companion to be also in complete profile, the repetition of the round arm-plate with its crimped border is disturbing, appearing in the one slightly obliquely in the far corner, and in the other parallel to the picture plane and nearer to the centre. One would surely expect Verrocchio to have varied not only the decorative motifs but the forms of the details of the armour in the two reliefs, as he does so impressively with the five different suits of armour in the Decollation relief.

Indeed there is evidence for the existence of yet another version of a young warrior, different from the Washington relief. Its composition is preserved in three pieces: a glazed terracotta in the Vienna Kunsthistorisches Museum (fig. 52), a very badly preserved stucco relief in the Victoria and Albert Museum (fig. 54) and a marble relief in the Louvre (fig. 55). In this version the bust of the youthful commander appears in complete profile, again in richly decorated armour.

The helmet is crowned by a dragon, the breastplate decorated with a gorgon's head. The arm-plate has no particularly striking motif: bands with bat-wing edges overlapping like scales. The design of this ideal portrait is attributed to Leonardo and it has been thought to be a representation of Scipio, because the marble relief in the Louvre has at the bottom an inscription cartouche entitled P. SCIPIONI. In fact this relief can hardly belong to the quattrocento at all. It may be that this Scipio preserves the form of Verrocchio's lost bronze relief of Alexander, which should not be identified with the Washington piece. The Vienna terracotta, known to have been in the castle of Catáio near Padua before 1806, provides the most reliable idea of the 'Scipio' version and fits better as a companion to the Darius, at least in the form this latter piece has come down to us in the Berlin Museum copy, which is also from the Della Robbia workshop.

IX

VERROCCHIO'S AUTOGRAPH PAINTINGS AND DRAWINGS

FOR several decades Verrocchio's studio in Florence was producing sculpture and paintings side by side. It is clear from documents, references in contemporary sources and verse chronicles that Verrocchio was equally highly regarded in his own time as a painter, and we know that he was influential with the younger generation of painters. Yet only three pictures survive today which can be identified as his work either on documentary evidence or because they are mentioned by Vasari and the authors used by him. One of the two altarpieces which Vasari attributes to Verrocchio, the Budapest Madonna and Saints, is by Biagio d'Antonio who was only fleetingly employed in Verrocchio's studio. It was certainly not designed by Verrocchio, nor does it appear to have been executed under his direction. The only surviving painting which according to documentary proof should be by Verrocchio, the altarpiece at Pistoia, is listed by Vasari as the work of Lorenzo di Credi; the respective contribution of teacher and pupil has therefore long been a matter of dispute. On the other hand there is a great number of mostly small panels, devotional pictures, portraits and religious or secular compositions which have been associated with Verrocchio and his studio during the last hundred years. Which of them are by his hand can only be established on criteria of style, and in view of the quality of the plastic works by his hand the strictest standards must be applied. It would be an insult to Verrocchio's personality and rank as an artist to approach his paintings with any less exacting standards than we apply to his sculptures.

Andrea must have started painting before the middle of the sixties, certainly several years

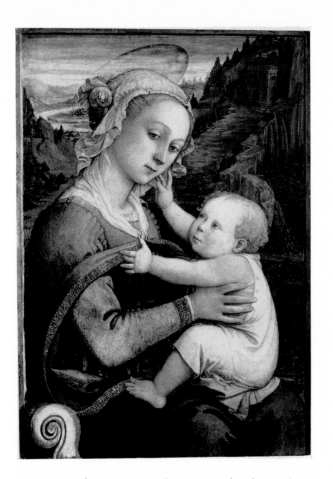

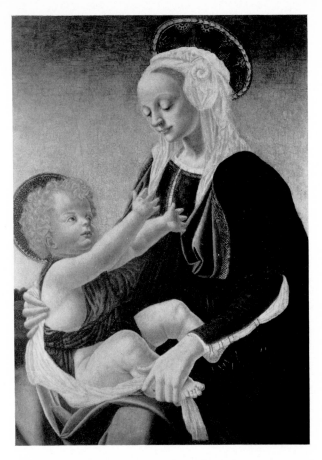

Fig. 32. Copy of Verrocchio's Madonna in Berlin (Plate 74). Washington, National Gallery of Art, Samuel H. Kress Collection (p. 45)

Fig. 33. Fra Filippo Lippi: Madonna. Munich, Alte Pinakothek (p. 46)

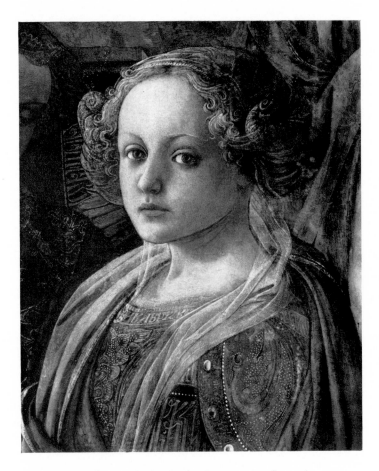

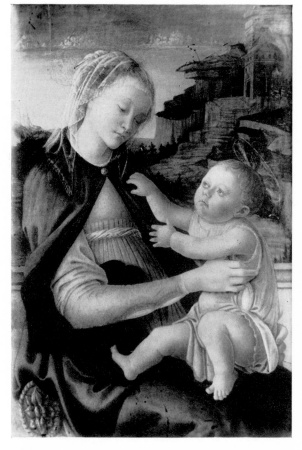

Fig. 34. Fra Filippo Lippi: Head of a woman from the Coronation of the Virgin. Florence, Uffizi (p. 46)

Fig. 35. Botticelli: Guidi Madonna. Paris, Louvre (cf. p. 6)

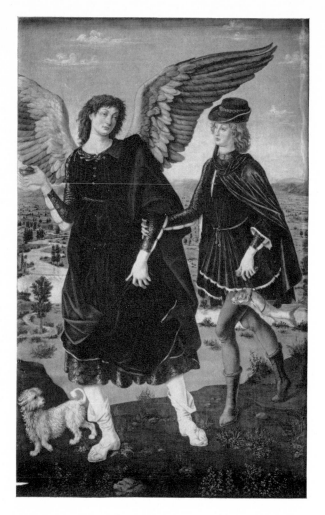

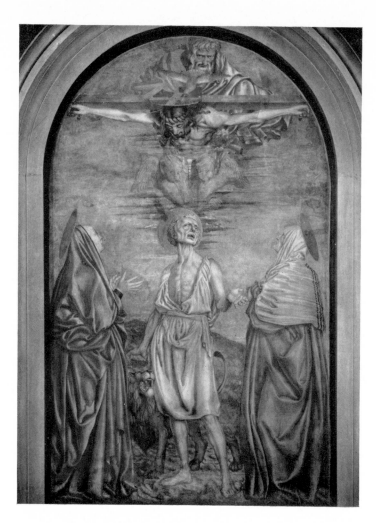

Fig. 36. A. Pollaiuolo: Tobias and the Angel. Turin,
Pinacoteca Sabauda (p. 48)

Fig. 37. Castagno: Fresco of the Trinity. Florence, SS. Annunziata
(p. 51)

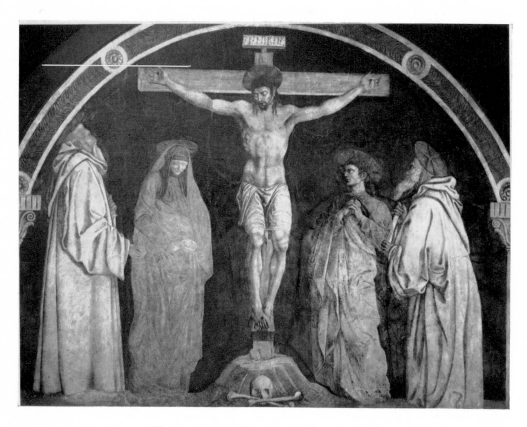

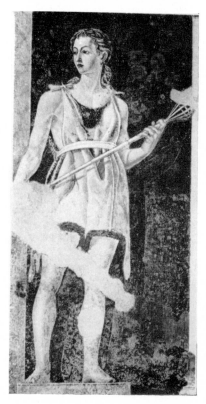

Fig. 38. Castagno: Fresco of the Crucifixion. Florence, S. Apollonia (p. 51)

Fig. 39. Castagno: Fresco of Eve. Legnaia,
Villa Carducci (p. 52)

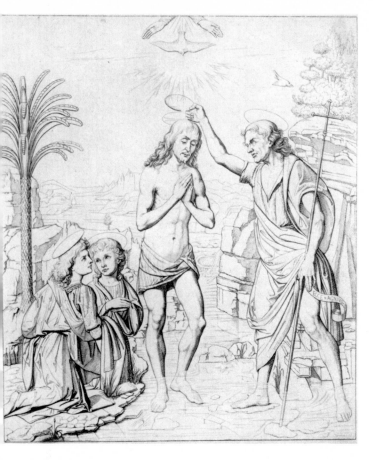
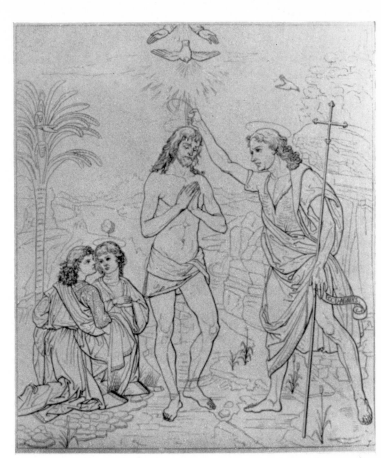

Fig. 40-41 Drawings after Verrocchio's Baptism of Christ (Plate 78) in Giovanni Rosini, 1840, and in Crowe and Cavalcaselle, 1864 (p. 189)

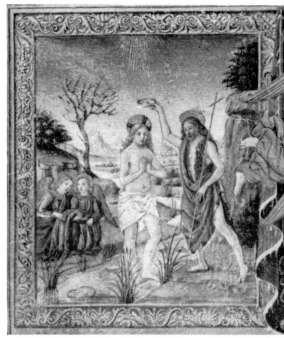

Fig. 42. A. Pollaiuolo: Baptism of Christ. Relief on the silver cross of the Baptistery. Florence, Museo dell'Opera del Duomo (p. 53)

Fig. 43. Attavante: Baptism of Christ. Miniature from the missal of the Bishop of Dol. Le Havre, Musée (p. 54)

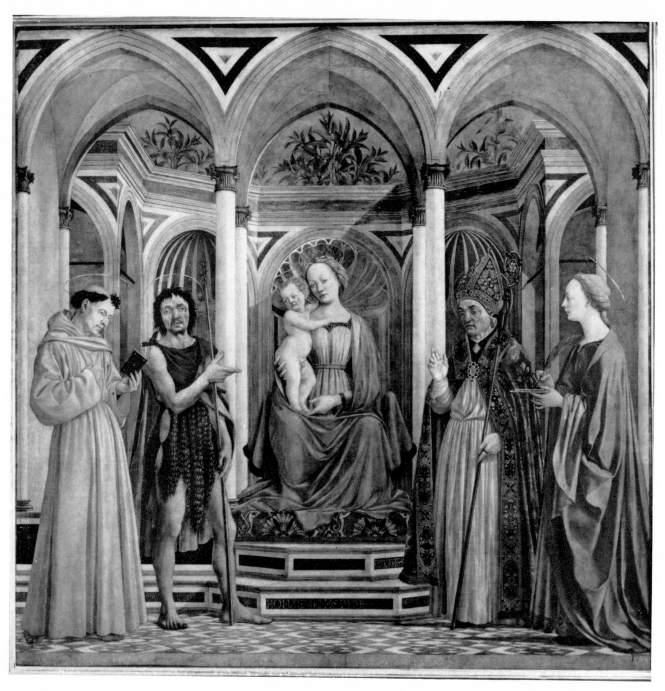

Fig. 44. Domenico Veneziano: Madonna and four Saints. Florence, Uffizi (p. 55)

before the Lippi studio in Prato closed down. Documentary references begin in 1469. In 1472 Leonardo, then twenty years old, joined the Guild of St Luke as Verrocchio's assistant and a member of his studio. By this time the effect of Verrocchio's teaching is recognizable in the early work of Domenico Ghirlandaio and Francesco Botticini. Towards the middle fourteen-seventies, when Verrocchio was working on the great altarpiece of the Baptism of Christ (Plate 78), no other studio in Florence was producing paintings in such quantity or of such importance. The majority of the Verrocchiesque Madonnas found in collections and galleries throughout the world stem from this period. These studio pieces are so strongly affected by the master's style that it is rarely possible to identify any of them as the early work of one or other of the painters of the younger generation. Furthermore the list of Verrocchio's pupils given by Vasari and other sources is evidently incomplete, and does not include such painters as Ghirlandaio, Biagio d'Antonio, Botticini and Cosimo Rosselli who only remained under Verrocchio's influence for a short time and whose style either before or afterwards was determined by the influence of other artists.

The studio was still famous far beyond the borders of Tuscany as an educational centre for young painters in the late seventies, when Verrocchio was occupied with his last painting, the Pistoia altarpiece (Plate 84), the work of his classical phase. But it was just at this time that Leonardo's genius was becoming impressively manifest in his first independent works and beginning to overshadow his teacher's fame as a painter, while Verrocchio was becoming increasingly concerned with sculpture, particularly his great bronzes. About 1478 Leonardo, inspired by Verrocchio's studies for the central group of the Pistoia altarpiece, painted the Madonna with the Carnation (App. 40); the sketches for the Madonna with the Cat of about the same period also show the influence on Leonardo of the Pistoia Madonna. In the late seventies Pietro Perugino worked in the studio and painted a scene for the Pistoia predella. He was absorbing those impressions from the sculpture and painting of his teacher and from the early works of Leonardo which so much affected the development of his style up to the time of his work on the Sistine frescoes. During the same years Lorenzo di Credi was painting his early tender Leonardesque Madonnas.

There is little dependable information on the beginnings of Verrocchio's activity as a painter. None of the paintings usually dated before the Baptism is mentioned in any document or any other source and his early paintings can only be inferred by stylistic analysis.

There is first a largish group of half-length Madonnas which are associated with Verrocchio or attributed to him; only one of this series is of sufficient quality in conception and execution to warrant consideration as an autograph painting. This is the Madonna (Inv. No. 104a) in the Museum in Berlin (Plates 69–71). From its small format one would judge it to be a private devotional picture. It must have been painted between 1468 and 1470. The panel has been much restored in places, particularly round the edges. The contemporary copy preserved in the National Gallery in Washington (fig. 32) shows that some small areas have been wrongly repainted during restoration, particularly the Madonna's halo which originally reached up to the top of the picture; as it is now it rather presses down on her head. The high rounded forehead of

the Virgin is immediately reminiscent of the heads in paintings by Fra Filippo Lippi such as the Coronation of the Virgin (fig. 34) in Florence. Even the general concept of the picture is anticipated in Lippi's Madonna in the Pinakothek in Munich (fig. 33). The agreement in motifs is so strong in places that it is difficult not to think of Verrocchio's painting as directly influenced by Lippi's. But the essential difference of the Berlin composition lies in the spatial quality of the scene, an innovation for which the way had already been paved in plastic art, particularly in the bas reliefs of Antonio Rossellino (App. 5). Verrocchio places the seated figure of the Madonna obliquely in the picture so that its cubic form, its volume, is clearly sensed. The Child is seated on the mother's lap the opposite way round and diagonally and thus also presents a three-quarter profile. These oblique planes meet and are held together at the visible part of the Madonna's hand on the front edge of the picture where it holds the Child's foot. The plastic energy concentrated in this hand is characteristic of the artist's peculiarly sculptural gift and vision; a detail like this is as it were the signature of Verrocchio, the painter-sculptor. The forearms of the Madonna are disposed in parallel, like her legs. Together with her torso and the veil draped between her two hands they create and limit the space within which the Child can move. The legs and arms of the Child too run parallel to each other and almost at right angles to the limbs of the Madonna. This evokes a clear interlocking and tension in space which accentuates the plastic appearance of the figures and the space they occupy in the group as a whole. The intimacy and mutual absorption of Mother and Child is expressed less in the surface pattern than it is in Filippo Lippi's picture, and the protagonists appear rather as elements in a plastic group in a spatial relationship to each other. The contrast of expression between the figures heightens the intensity of the picture as a whole. While the Child is excited and playful, looking gaily up at his mother, she seems to be entirely withdrawn, looking down pensively before her. The landscape is confined as far as possible to a few very clear and relatively nearby motifs, and closely related with the group of figures. The cliff on the left forms the counterweight in the linear composition to the massive upstanding torso of the Virgin, and this cliff and the softly rounded hill on the right form a bond between the scene in the foreground and the landscape behind. There in the background the roofs of scattered houses are seen above rows of trees and small mounds, and among them rises a ribbed and lantern-crowned dome reminiscent of the cathedral in Florence. The mood of this landscape is a direct reflection of the Madonna's expression. It is not so much the invention of new motifs, the mastery of form in the figures, nor the nuances of texture in the hair and clothing that give this early Madonna of Verrocchio's its quality and make it so prophetic of further developments. What is outstanding is that within this small format Verrocchio succeeds in monumentalizing the figures simply by depicting the forms clearly as solid masses, and in their relationships in space, and by placing them memorably so that their impact and tension is immediately apprehended while at the same time intensifying the spiritual contact in the interrelation of the group. This he achieves by introducing plastic formulae into painting, yet without neglecting the specific requirements of picture composition. The two figures are contained firmly within a large all-

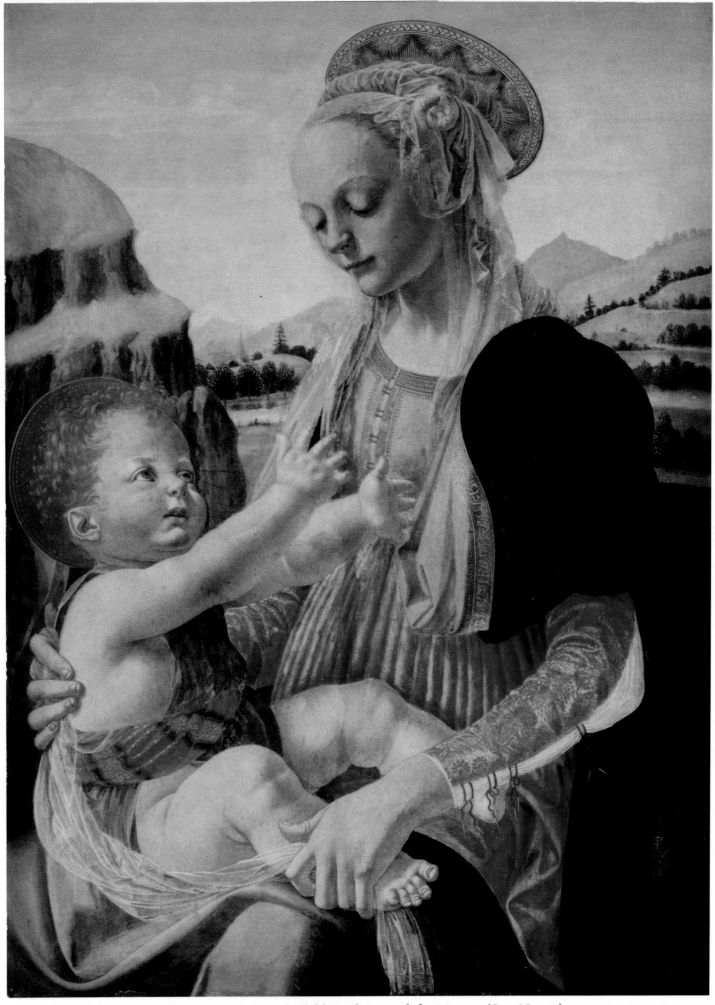

Madonna with Seated Child. Berlin, Staatliche Museen (Cat. No. 18)

embracing outline on the picture surface. As, however, the picture is filled with plastic and spatial tensions which reduce the function of the frame in defining and ordering the picture surface the depicted space is fixed within it for the spectator in a new way. His eye is held by the side contours, planes and angles of the seated figure. It seems possible to walk round the group without upsetting or distorting its special effect. The eye is encouraged to see round the forms. Where they overlap it is made aware of the different planes of recession, looking past the figures into the landscape, which is itself divided into spatial zones. The plastic values and impulses of movement within the group are carefully balanced. Yet these artifices are hidden behind the subject itself. Everything appears fortuitous, motivated by the theme. The happy, serene effect is helped in no small measure by the light, clear palette, which lends the whole an air of lucidity, order and clarity. Mary's cherry-red dress with brocaded sleeves is covered with a light blue mantle lined in moss-green. The Christ-child's tunic of matt Prussian blue is held together with a richly embroidered crimson sash.

The Tobias and the Angel in the National Gallery in London (Plates 72–74) follows close on the Berlin Madonna. Nothing is known of the client or of the purpose of this picture, also presumably a private devotional image. It can be imagined that, when a young Florentine citizen was sent abroad to finish his education, a small picture such as this was commissioned in order to recommend the young man to the protection of the archangel Raphael. The scene comes from the story in the book of Tobit: Tobias, old and blind, sends his son, also named Tobias, to a far-off city to collect money from a debtor. As the boy sets off the archangel Raphael appears as his companion, and protects the young Tobias during his journey. As they rest by the River Tigris he advises Tobias to catch a fish and prepare a salve from its heart, gall and liver, to heal his father's blindness. Tobias' journey is illustrated here. The boy holds the record of the debt with the inscription 'ricordo' in his left hand, as well as the string with the fish. The angel holds in his right hand a golden box containing the healing salve. The faithful dog accompanying his master also appears in the Bible story.

Tobias wears vermilion hose, a short blue-grey tunic with a golden-yellow lining and beneath it a wine-red garment, of which only the brocaded sleeves are visible. Over the tunic is a little cloak of lapis lazuli blue lined with dark green, held in at the waist with a twisted red sash. On his feet are reddish-brown boots trimmed with fur. The white robe of the archangel has sleeves brocaded in gold with a large pattern; it is pulled up in a deep loop round the hips. The outside of the cloak is pink with vague blue shadows. A green-gold sheen lies over parts of the dark-blue lining. As in the Berlin Madonna painting, the flesh of the figures is rendered with a foundation of light sulphur-yellow and modelled in soft pink; the shadows are laid in with transparent layers of grey and ochre mixtures. The composition of this London panel begs comparison with the Tobias of Antonio Pollaiuolo in Turin (fig. 36) painted ten years earlier, which originally hung in Or San Michele in Florence. Verrocchio seems to have adopted the most essential motifs from Antonio's panel: the general arrangement of the figures, their movement forwards out of the

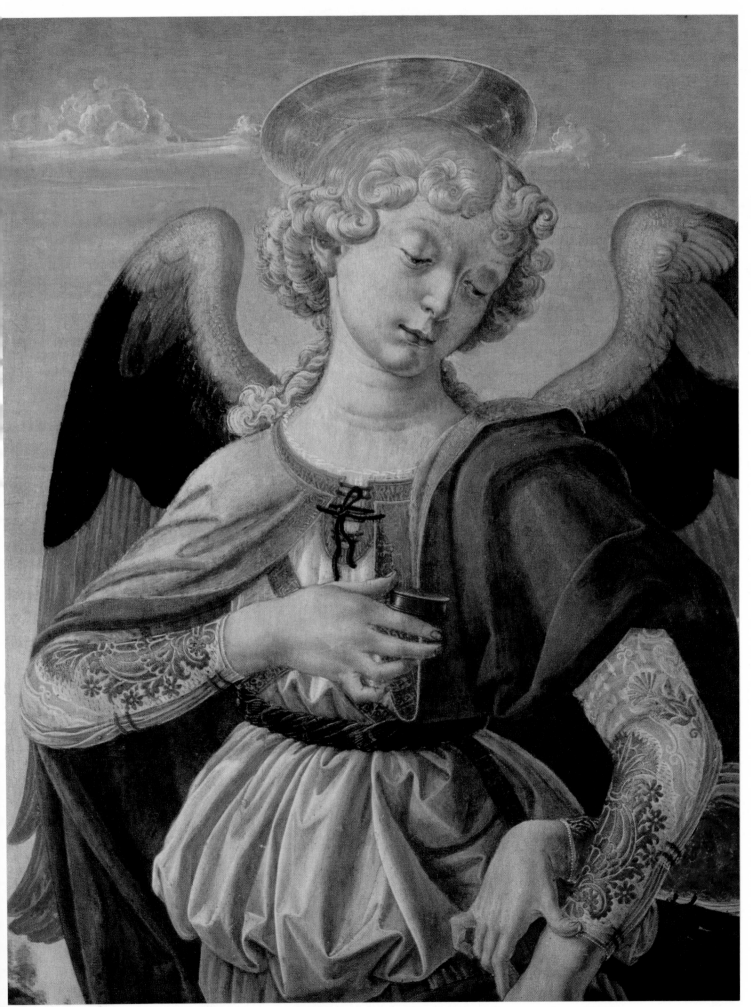

The Archangel Raphael. Detail from the painting in the National Gallery, London. Cf. Plate 72

picture from the back right-hand corner, the land falling away gently to the left; the position of the left arm in both figures is similar and the drapery of Raphael's cloak. The angel has lifted his cloak with his left hand so that he can walk freely. The boy does not clasp the hand of his companion, as in earlier illustrations of the scene, but has linked arms with the angel. In spite of this identity of motifs the differences between the two compositions are great. Pollaiuolo starts with the format of the picture which has to be filled in; he stretches the movements of the figures as far as the scene allows, across the surface. He tries to equalize the different heights of the heads in the general effect; Tobias' hat has a functional purpose in the composition. The connection between the figures is loose, while the surface effect of each individual body is dense. The garments hang smooth and flat, enveloping the limbs. Overlapping of limbs is avoided as far as possible. The bend in the angel's wing starts only above Tobias' head. The dog is seen beside and not between Raphael's feet. The co-ordination of the figures is arrived at not by a plastic spatial grouping within the scene itself but from the pattern on the surface of the picture, from its special shape, from its outside limits. Verrocchio sees his figures first of all within a clear overall outline. The dropped, relatively small wings of Raphael connect the bent right elbow with the head of the angel and lead across from the angel's head to that of Tobias. The positions of the feet of the two figures are reversed from those in Pollaiuolo's picture and thus their relative spatial arrangement is immediately clarified. In the Turin painting it looks as though Tobias would stumble over Raphael's out-turned foot at his next step. In the London picture the boy is stepping out, with widely straddled legs; he has to take big steps to keep up with the angel. This motif expresses perfectly the tense energetic movement, the youth and liveliness of Tobias, looking up alertly at his companion. The angel's gait as he crosses his legs is less firm, a degree less material, more floating, especially as his movement is combined with the peaceful frontality of his torso and wings. In this upper zone of the picture there is scarcely an echo of the stepping movement. The angel's head is turned towards his protégé, yet he is looking pensively at the ground. The contrasted mood of the two figures is expressed further in the general effect of the group as a whole: while the figure of Tobias is free in its spatial and plastic effect and at the right-hand edge beside him the outline of the group is broken up and in movement, the figure of the angel is compact, self-possessed and of immense plastic solidity. The limbs and cloak of the boy are so arranged that glimpses of the sky and landscape can be seen between the limbs and around the figure, and there are frequent overlappings within the figure itself. Not by chance do we see the left arm of Tobias in front of the end of the sash flapping in the wind, and this in turn in front of the boy's tunic which comes over the dark lining of the cloak, and on either side of that the blue of the sky. This overlapping, like the linked arms of the boy and his companion and the glimpses of landscape within the group, are the means whereby the artist shows that space exists not only in front of the figures and behind them, but that it surrounds them directly, encloses each one of their limbs and can be felt even in the hollows of their clothes. In this space the limbs of the figures can move and bend with complete freedom; in this space the dress and mantle of

the angel flutter, the boy's cloak blows in the wind, the fish dangles on the string; through this space the boy looks up at his protector. The small surface of the picture is as though loaded with spatial and plastic momentum; the forms are almost aggressively tense and firm.

The early phase of Verrocchio's painting is represented by a third work, more serious and much more ambitious than the two devotional pictures in Berlin and London with their relaxed and easy grace. This is the altarpiece at Argiano, with Christ on the Cross between St Jerome and St Anthony (Plates 75–77). It has not yet been settled where this Crucifixion was originally intended to hang. It is now in the sacristy of the little church of S. Maria e Angiolo in the small hamlet of Argiano near S. Casciano. The picture has been badly cut along the bottom; a strip of about ten or fifteen centimetres has been sawn off in order to fit the panel over the chest in the sacristy. The area round the shaft of the cross has been overpainted and the shaft now appears too deeply planted in the earth. Nor is any of the sky with storm clouds in its original condition or the vistas of landscape around the figure of St Anthony. Large parts of all the figures have also unfortunately been overpainted. Particularly important is the retouching which has distorted the expressive content of the scene: the crown of thorns and the wounds of Christ; tear drops on the face of Jerome. It is regrettable that it has still not been possible to carry out the long-awaited restoration of the panel. Until then one cannot judge exactly what is Verrocchio's own work and what he left to his pupils. I consider the picture to be designed and laid out entirely by Verrocchio. Furthermore, in spite of the distortions of the overpainting, the quality of the two figures most closely inter-related within the scene, St Jerome and the Crucified Christ, is so high that their execution is to be ascribed to the artist himself.

In this Argiano altarpiece Christ is represented on the cross flanked by two saints, but without Mary and St John. This new type of Crucifixion is anticipated by representations of the Trinity surrounded by saints known from Pesellino's altarpiece in Pistoia, and also from Fra Angelico's grandiose fresco of the Crucifixion with many figures in the Chapter House of San Marco, which gives a symbolic representation of the death of Christ on the Cross with the founders of religious orders and patron saints of the Medici family and of the city of Florence. But Castagno's fresco of the Crucifixion in S. Apollonia in Florence, in which the Madonna and St John are joined by St Benedict and St Romualdo at the foot of the Cross (fig. 38), was foremost in Verrocchio's mind when he designed his picture, as can be seen from the entirely Castagnesque features in the rendering of the figures and the general tenor of the scene. From Castagno also comes the beardless type of Jerome (fig. 37). For the relatively small format here Verrocchio reduces his picture to three figures; he places the cross and the saints standing on either side as near to the foreground of the picture as he can, to make the figures as large and conspicuous as possible. The attempt at monumentalization succeeds at some sacrifice of naturalism. The cross is far too short; it is only big enough to raise the body of Christ a little above the side figures. The arms of Christ are spread wide open – consequently the body does not hang very heavily between them. The head is seen directly against the horizontal bar of the cross, at the same height as the hands.

Verrocchio was not satisfied with the additive arrangement of figures which might be expected in the theme of the Cross flanked by Saints. Within the symmetry of the composition as a whole he moves the focus to the left half of the picture, bringing the penitent St Jerome into a single group with the Crucified Saviour. The body on the cross is presented in three-quarter view, turned towards the saint. Jerome, in contraposto with his right leg stretched backwards, is turned towards the cross with his head turned even further, almost into complete profile. He is represented, as in so many pictures, chastising himself at the sight of the crucifix, but here Christ appears before him life size. This unusual interpretation, in no wise imposed by the subject itself, suddenly transforms the formal effect of such a crucifixion altarpiece into something actual. The expressive values and tensions of a dramatic event pervade the picture. The extent of Verrocchio's debt to Castagno for this, and for the general interpretation of the figures, is shown not only by a comparison with the frescoes in S. Apollonia and SS. Annunziata (figs. 37–38), but by comparing the figure of St Jerome in Argiano with Castagno's fresco of Eve in Legnaia (fig. 39). The almost frontally posed St Anthony, who resembles the Christ in the turn of his head and his facial expression with lowered eyelids, is reminiscent, in pose and even more in the treatment of the draperies, of the Christ figure of the Or San Michele group (Plate 31).

The only autograph painting of Verrocchio's which is universally known is also one of the most debated: the great altarpiece of the Baptism of Christ in the Uffizi (Plates 78–82), which is to be dated about 1474/5. The attribution to Verrocchio is based on Vasari and the local sources used by him, which mention the altar panel in the monastery of San Salvi in Florence. There are no documents concerned with the time and nature of the commission or about where or how the painting was to be hung. Because the panel was to be seen in San Salvi in the first half of the sixteenth century it does not follow that it was intended for that monastery in the first place. Verrocchio's Baptism of Christ is the first independent altarpiece on this theme in Florence; the earlier painted Baptism scenes all belong to series of the life of St John the Baptist or the Youth of Christ. Altarpieces of the Baptism are hardly to be expected in Florence, since christenings were performed exclusively in the Baptistery until well on in the sixteenth century and there were no baptismal chapels in the other churches. The veneration of the patron saint of Florence was concentrated in the church of San Giovanni Battista and here are to be found a number of cycles of the life of St John from different periods, in the mosaics of the cupola, on the silver antependium of the altar, on the font and on two of the bronze doors. There is no possible question of Verrocchio's picture having been intended for the Baptistery itself. The suspicion therefore arises that this altarpiece, though executed in Verrocchio's studio in Florence and perhaps even commissioned by a citizen of Florence, was intended originally for another town.

Vasari reports that Leonardo painted an angel in his teacher's picture of the Baptism. An examination of the painting verifies this fact and adds to it: Leonardo's participation is much greater. The problems concerning the present condition of the picture have not been conclusively solved. The whole picture was laid in by Verrocchio in tempera and the execution carried quite far.

Today the figure of John, on which the final smooth and glossy finish is missing, exemplifies this stage. Leonardo later took over the unfinished picture and went over the major parts in oils. His overpainting includes the figure of the angel in the foreground, the hands of the second angel and the landscape — except for the cliff rising behind the Baptist with the plants growing on it, a part of the right-hand landscape vista, the clods of earth on the bank in front of the kneeling angel and the crest of the palm tree on the right (Plates 81–82). Leonardo also finished, in oils, the head and the unclothed parts of Christ's body, working particularly on narrowing the silhouette of the arms and shoulders and correcting the disposition of the hands. The picture did not start as a work of collaboration in which Leonardo was allotted the execution of an angel; but Leonardo's contribution was a subsequent one, a revision of the painting, undertaken possibly with Verrocchio's knowledge but clearly not under his direction. In place of the foremost angel, now to be seen in back view, which contains the figure composition in the foreground both to the left and towards the spectator, Verrocchio had originally placed an almost frontal figure of an angel beside and on the same level as the second angel; the head of the overpainted angel was presumably turned in complete profile towards the centre of the picture. Leonardo's new concept for the left-hand angel appears to have been inspired by the figure of Mary Magdalen in Roger van der Weyden's Entombment in the Uffizi: not only are both depicted as three-quarter figures seen from the back but their function is the same and there are similarities in certain details of the draperies and even in the style of rendering the folds.

Verrocchio retains the traditional Florentine symmetrical scheme of composition, as it occurs in the reliefs on the doors of the Baptistery; Christ appears as the central figure, the Baptist on the right, the group of angels on the left. In his desire to gain for the main group as much surface space as possible within the upright shape of the altarpiece he now moves the figure of Christ away from the central axis to the left. This is hardly noticeable in the general effect. It is disguised by the surface design of the landscape. The high cliff at the right edge of the picture with its short scrubby trees hides a large proportion of the clear sky. The head of Christ is now seen in the middle of the remaining sky, bent towards the right, thus consciously breaking across any vertical effect down the centre. By means of this complex surface construction Verrocchio gains three-quarters of the width of the picture for the main figures. He combines them into a large group dominating the picture even from afar, as is required by the monumental intent of an altarpiece. This increase in the size of the figures in an altarpiece is characteristic of a certain phase of development in Florentine painting; the trend was already apparent fifteen years earlier in the altar for San Miniato by Antonio Pollaiuolo. Another characteristic of the new style of composition is the spatial and dramatic presentation of the scene, the sharpening of the event illustrated to its climax. But an example of this in Pollaiuolo's work only occurs in decorative art: in the small engraved relief of the Baptism at the foot of the silver cross in the Baptistery (fig. 42): the Baptist steps boldly out from the back right to the bank of the Jordan, which is winding from the left distance to flow forwards out of the scene. Christ, standing in the river bed,

is shown in three-quarter profile, following the flow of water. The angels, in the rôle of attendants, kneel to the left beside and behind him. St John's strong forward movement brings him in naturally to fill the strangely shaped space remaining to the right of the principal figure. A new realism is manifest not only in the use of space in the scene but in the naturalistic rendering of each detail, be it the anatomical precision of the limbs, the individuality given to the heads or the representation of pouring the water. Pollaiuolo's relief and Verrocchio's large painting both exemplify it. Yet the directness of the narrative element is not allowed to obscure the open monumental surface pattern characteristic of the earlier Florentine Baptisms. Pollaiuolo, too, makes Christ stand out as the central figure. The parallels between the two representations express a similarity of aims at a similar stylistic stage. It may be that Verrocchio consciously adopted ideas from Pollaiuolo's little composition. In his Baptism Christ is again seen not frontally but in three-quarter profile, turned towards the Baptist. The angels kneel like attendants or retainers to one side behind Christ, behind his back, suggesting that Christ has come from the left distance with his following. An approximate idea of the original spatial arrangement of the angels can be obtained from a miniature by Attavante. It is obviously based on Verrocchio's composition though the treatment is considerably looser (fig. 43). The pose of the Baptist in Verrocchio's painting, entirely concentrated on the action of his right hand, stresses once again the forward movement. St John has just come up to Christ from the right of the scene in order to perform the act of baptism. The spectator is so directly affected by the realization of this act in space that he is scarcely aware of the specific surface design created by the principal figures. Both figures are carefully harmonized in pose and movement, they stand on the same line and their heads are level. The oblique line of St John's body is compensated for by the slight slope of his staff in the opposite direction towards the right edge of the frame, and this slanting staff simultaneously echoes the gentle inclination of Christ's torso. The left side of the figure of Christ forms a smooth outer contour which serves to divide the principal personages from the angels. His stance and the lines formed by the legs have the effect of opening out the figure towards the right. The cross of the baptismal staff rises above the two heads to the same height as the right hand of the Baptist. The two protagonists are thus drawn together within the picture surface to form a compact, self-sufficient group. The theme is extended beyond the representation of a solitary event to find in this group its universal significance. A group of such clear and monumental impact, however tensely linked to the specific location and scene, rises above time and place, and makes its effect independently of its associations with a particular situation. It is no coincidence that this altarpiece was painted by the same artist to whom we owe the monumental bronze group of Or San Michele.

The colour scheme reinforces the surface tensions of the figure composition. Nearly all the milky vermilion-pink lining of the Baptist's cloak is shown and this colour returns in the garment of Christ held ready by the angel. The light blue of the outside of the Baptist's cloak is taken up again in the garment of the other angel who is facing us. The profile angel has a denser greenish

blue on the outside and matt gold-ochre on the inside of his mantle, while the loin-cloth of Christ is a strong pink with blue-green and black stripes and John's tunic is deep coffee-brown. The basis of the flesh tone is a glowing yellow, muted by sand-coloured glazes in the parts gone over by Leonardo in oils, especially the torso of Christ and the hands of the angel seen full-face. Leonardo's extensive brown overpainting dominates the colour effect of the landscape as we see it today.

The process of monumentalizing the figures in the altarpiece was carried out by Verrocchio energetically and uncompromisingly. There is something violent and hard in the composition of the Baptism. The pre-eminence of figures over space seems excessive. It was a phase which the artist was to surmount in the course of his subsequent development. The Pistoia altarpiece (Plates 83–87) of about four years later shows a new, classical stage in Verrocchio's style. The figures still dominate the picture, but they appear smaller in relation to the format of the panel than in the compositions analysed so far. The architecturally articulated space is harmoniously related in its proportions to Mary and the saints. The screen running parallel to the picture plane separates the landscape from a platform without any lateral boundaries for the scene in the foreground. The figures occupy the allotted space with their movements, gestures and looks; but they do not fill the whole picture area as completely as the protagonists in the Baptism of Christ. They are entirely free in their movements and positions.

The altarpiece must have been commissioned from Verrocchio at the latest between 1477 and 1478. It was intended for an Oratory dedicated to the Virgin which was being built onto the exterior north wall of the choir of the Pistoia Duomo at that time and which now opens into the interior as the Chapel of the Sacrament. The panel still hangs there today. The oratory was built for Donato de' Medici as Bishop of Pistoia, and St Donatus appears in the picture as his patron saint. The painting was done by Verrocchio himself for the most part, but it remained unfinished for a long time and some parts had to be completed by Lorenzo di Credi after 1485. The latter's hand is to be seen mainly in the figure of St John. The special structure of the picture is best understood by comparing it with another representation of the same theme, of more or less the same rank: the Madonna with Saints by Domenico Veneziano in the Uffizi (fig. 44), which also orders the figures in an architecturally articulated space. Though this spatial structure is capable of realization in the imagination of the spectator it is precisely the spatial values which are obscured and repressed as they appear on the picture surface. The front wall of the loggia with its three pointed archways embraces the scene like the frame of a triptych. The function of dividing up the surface is taken over by a triple form of frame which is given a concrete meaning. It assigns their places to the central Madonna figure and the pairs of saints and holds the Madonna and subsidiary figures together in a linear unity. The figures in Verrocchio's altarpiece no longer need this surface scaffolding. The architecture of the screen and, even more, the perspective of the tile pattern on the terrace floor accentuate the illusion of free space created by the statuesque saints themselves with their solid forms, their attitudes and gestures. Only the Madonna group is directly

contained by the niche behind the throne. The artist's delight in ornament is concentrated on the structure of this throne. Here in the centre of the picture the scene is at its most dense, while it thins out towards the sides where there is open space. In it stand the saints at either side of the throne in front of the glimpses of landscape. It is not at first sight apparent how strongly both figures are bound to the centre of the picture by means of the composition, the balanced division of the surface, the tensing of the whole picture through the verticals and horizontals of the architectural members. Even the spatial values are quite unconsciously apprehended. The way the niche with the throne projects in front of the screen architecture itself brings the Madonna group nearer the worshipper. The tendency of this movement, the radiation from the depth of the stage in the picture out to the spectator is strengthened by the motif of the carpet, which is unrolled from the throne, down the steps and forward past the saints, its fringes hanging down over the front edge so near to the spectator that he could touch them. The Madonna group forms a triangle in space with the figures of the saints. The disposition of the Madonna's legs creates a movement towards the bishop; the turn of her head and the pose of the infant Jesus direct the central group primarily towards the Baptist. The figure of St John is turning on its own axis and orientated in various directions; it becomes a second focus of tensions on the left side of the picture, beside the central group. The infant Jesus and the bishop are looking at the Baptist, who stands rather further forward than Donatus and has a closer contact with the worshippers outside the picture. He is looking out to the faithful and bringing their attention into the picture, to the Madonna. The way in which the figures are placed in the form of a triangle with its base running slightly oblique to the foremost picture plane, combined with the idea of a figure whose gesture leads into the picture, was one that continued as the basic scheme for altarpieces in Florentine painting into the Late Renaissance. Leonardo's Adoration of the Kings adopts the scheme, so do his Madonna of the Rocks and Raphael's Madonna della Sedia.

A finely balanced, restrained palette gives a happy, sunny mood to the Pistoia altarpiece. Clear transparent colours – a light carmine in the Baptist's cloak, various tones of matt blue in the mantle and dress of the Madonna and violet on the outer side of the bishop's cloak – are arranged in large areas. A few other, stronger colours – dense vermilion in the bodice of Mary and in the carpet pattern, gold-ochre lining the bishop's cloak, deep-coffee brown in the Baptist's tunic and an opaque olive-green in the lining of his cloak and in the fringe of the bishop's – are repeated several times in smaller areas. The architecture, in places graded in colour according to distance, is pitched in a warm tonal key.

Some drawings by Verrocchio are closely associated with the two works just discussed: the Baptism of Christ and the Pistoia altarpiece. As far as can be judged from the material available today he made few drawings. A badly preserved sheet in the Uffizi gone over in a pupil's hand (Plate 89) shows a study for the head of the full-face angel in the Baptism. The modelling and lighting correspond closely; the divergent motif of the lowered eyelids perhaps represents the original appearance of this part of the painting before Leonardo's intervention. The boy's face is

drawn from the life. In the details of form it is rather harder and less modelled than the face of the angel in the painting: the nose is shorter and thicker; the mouth lies closer to the nose and is hardly wider than the nostrils. The full, soft lips make it look more childish. In the painting the head is less tilted and the hair less luxuriant.

In the Uffizi there is also a black chalk sketch for a seated Madonna in two variants (Plate 88), of which at least the later one seems to be the basis of the design for the central group of the Pistoia altarpiece. The body of the woman is drawn at a slightly oblique angle, though not turned quite as far to one side as the Berlin Madonna, which has been discussed. The oblique view is maintained for the Child's body; the boy sits on Mary's right knee and his look and arm position are directed exactly towards where, in the painting, the figure of the Baptist would appear. The artist has redrawn the sketch in various places afterwards, and gives as a variant the complicated half-lying motif of the Child which was incorporated in the final design; though in the drawing the Child is placed in Mary's lap and not, as in the Pistoia painting, on her right knee. The composition of the painting is in many ways a compromise between the two different poses noted in the sketch; so is the position of the Madonna's head. In the later variant of the drawing Mary no longer bends her head down to the Child but faces out of the picture; the head appears upright and almost frontal, the eyes look straight out at the spectator. In the altarpiece Verrocchio presents the torso and head of Mary almost full face, but the head is turned a little to one side towards her right shoulder and her eyelids are lowered as she looks down at the Child. The interesting motif of the Madonna's left arm movement is suggested in the sketch. The main difference between the Uffizi drawing with its two variants and the painted composition is in the changed disposition of the legs, which are turned the other way. This counter-turn of the lower part of the seated figure in the altarpiece is aimed at creating a spatial link with the figure of the bishop. The Uffizi drawing has been erroneously described as a design for a Holy Family or an early sketch for the composition of the Madonna and Child with St Anne by Leonardo, because of the double Madonna head.

A further sheet in the Uffizi has (on the verso) a black chalk study of the head and torso of a child (Plate 90). It is a study from the life, done by Verrocchio in very firm energetic strokes. The motifs of the hand movement and of the arm lying against the body show it to be a design for the Christ-child in the Pistoia altarpiece. While Verrocchio corrected the proportions of the head in the painting by softening the bold curve of the cheeks, brow and crown, Leonardo's Benois Madonna (App. 46) shows a baby-like, rather unformed Christ-child very similar to the sketch.

There is in the Louvre a study for the figure of the Baptist in the Pistoia altarpiece (Plate 91). Its layout goes back to Verrocchio, but it has been worked over entirely by Lorenzo di Credi and used as a basis for the completion of this part of the painting. From Lorenzo comes the modelling of the head of John as well as the working out of the drapery motifs, which in fact were altered yet again in the painting. The fixing of the leg and arm contours in silverpoint with various

corrections is, as Valentiner recognized, by Verrocchio himself. Furthermore the Louvre drawing must be much closer to Verrocchio's original conception in the rendering of the garments and the characterization of the Baptist's facial type than the figure in the altarpiece as executed.

The British Museum in London preserves a sheet which has on either side a study of the head of a young woman, 'en face' and slightly tilted to one side (Plates 93–94). While we presumably have on the verso a study from the life, modelled in rapid strokes, the strongly idealized head with carefully ordered hair that is derived from it and drawn on the recto, is obviously a drawing for the Mary of the Pistoia altar. The Madonna's face in the painting is however refined still further, the cheeks are more rounded; the whole lower part of the face is more compact, so that the area round the eyes stands out more strongly. The study of the model on the back of the London sheet is also closely related to a drawing in the Uffizi representing Cupid and Venus; the study was doubtless originally prepared in connection with the Venus composition and later used again when work started on the design for the Pistoia altarpiece. In the London drawing the hand is clearly sketched in on which the woman's head is resting; this motif is only made comprehensible by the Uffizi Venus and Cupid drawing (Plate 95). If, as I believe, Emil Möller was right in thinking that this Venus composition was a design for the pennant which Giuliano de' Medici carried in the tournament on 28th January 1475 in honour of Simonetta Vespucci, then we can conclude that we see in the London chalk sketch the features of Simonetta. The attribution of the Venus and Cupid drawing to Verrocchio has, however, been questioned. Venturi gave the sheet to Leonardo, Berenson and recently Dalli Regoli tried to establish it as the work of Credi. The divergencies of hand in the drawing of the different zones shows clearly that as it is now the drawing is not the work of one artist. The rendering of the rush-like plants on the left-hand border, the peculiar projection of the body movement of the Cupid and the left to right downwards hatching in the shaded zones in many places show that Leonardo finished and worked over the sheet. The design of the composition as a whole and the reclining Venus (with the hatching running in the opposite direction) are, in my opinion, Verrocchio's, and are to be dated in the middle seventies.

Apart from the sheets discussed above there are a number of other autograph drawings which do not refer, or at least cannot be proved to refer, to paintings by Verrocchio. The diversity of effect made by these drawings executed in so many different techniques is characteristic of the complicated methods used by Verrocchio's generation in preparation for the final redaction of their works; it is also part of the many-sidedness of the art of Verrocchio himself. The compilation and assessment of a graphic *œuvre* is particularly difficult in the case of the painter-sculptors of Florence in the second half of the quattrocento, such as Antonio Pollaiuolo and Verrocchio; as is to be expected, it contains both sketches and detail studies for paintings, and designs for sculptures and goldsmith's works. It is often uncertain to which field a drawing really belongs. This is equally true of Leonardo's early sketches, which must surely include some designs and ideas for his early sculptural works which can no longer be identified. It must also be borne in

mind that in Verrocchio's studio, studies from the life must have been used repeatedly both by the master and by the pupils, and for both paintings and sculptures at the same time.

Preparatory work for the Forteguerri cenotaph in Pistoia must evidently have included some drawings by Verrocchio himself, apart from the terracotta *bozzetto* in London. There are two studies of heads in the Print Room in Berlin, on the front and back of a sheet (Plates 96–97). The head of a youth or girl looking up to the left is certainly a study for the head of Faith, as reference to the London *bozzetto* will confirm. The verso shows no more than the upper part of a head, which corresponds in type, turn of head and direction of gaze to the head of the lower right-hand mandorla angel of the *bozzetto*. The sheet has been cut down both sides but it is otherwise well preserved, and it is in these two drawings in black chalk with no added shading that the crisp firm line of the Master can be seen at its best. When we see the freshness and direct-ness of a life study like this it is a sad reminder that almost all the other drawings by Verrocchio which have been preserved are spoilt by having been used later as prototype and working draw-ings within the studio and by the whole circle of pupils; often they have been worked over by various hands, the outlines have been traced over, the modelling added to or freshened up, the main lines pricked out. This has been the fate of the Oxford study of a young woman's head in profile, with elaborate hair arrangement (Plate 100). One can see how subsequent working over within the studio has altered and falsified the forms when it is put side by side with comparable heads in the artist's paintings, such as the head of the Berlin Madonna or the head of Raphael in the London Tobias and the Angel. Only in a few areas of the hair and veil do we meet the concise and harsh pinning down of the line characteristic of the master's hand. The fluttering veil suggests that the head on the Oxford sheet was intended for a figure in motion, either hovering or on foot. One thinks of an angel in a Tobias scene or in a group of three Archangels, or of a Virtue in a composition for a funerary monument.

It might at first seem rather strange to try to find autograph drawings by Verrocchio among the quite extensive group of drapery studies attributed partly to Leonardo and partly to Lorenzo di Credi or Fra Bartolomeo. It is of course well known that this new class of drawing was given especial importance in Verrocchio's studio, and there are even reports of the young Leonardo studying different folds by soaking cloths in plaster and draping them over wooden stands. Until now, however, there has been no evidence that Verrocchio himself made studies of drapery of this kind. It might also be expected that the artist's preliminary studies for the drapery motifs in his sculptures would have taken the form of models in clay rather than drawings. In the Uffizi, however, there exists a brush drawing in tempera which is recognizably a study for the mantle of the Christ of the Or San Michele group (Plate 92). The economical brush strokes suggest a rather prominent convex chest-line (found in the Christ of the Careggi Resurrection as well as the Christ of the Or San Michele group; fig. 46 and Plate 31) and this has led to the assumption that it was a study for a female figure. Lorenzo di Credi's drapery study for St Bartholomew in the Louvre treats the chest in exactly the same way. In the Uffizi drawing the position of the hand

is not motivated by holding or lifting the garment; it can only be explained as the laying bare of the wound in the particular circumstances of the scene between Christ and St Thomas. A great many of the essential motifs of the mantle drapery in this drawing correspond to those of the bronze figure, but further folds have been added for the free leg and the bent arm covered by the garment, in order to make the liaison with the drapery of St Thomas, and this has entailed some corrections in the whole system of folds. Verrocchio's drapery study shows not only the plastic values but the surface effects of the material. It includes the whole wealth of nuances in the sharp play of light and deep shadow, in the rise and fall of the folds, and the contrast between surface sheen and matt half-shadow where the light falls direct or is reflected. But however interesting a detail to the painter, no area is ever stressed at the expense of the drapery in its function as a covering for the body. In contrast an early Leonardo drapery study is finished and almost like a still-life; the stuff is deliberately so arranged that wherever possible the interplay of light and shade and the surface effects assume an astonishing fascination and beauty of their own.

Among the few sheets of drawings which have long been recognized as Verrocchio's autograph there exists one in the Louvre which is covered on both sides with rapid pen sketches of naked putti in changing poses and movements (Plates 98–99). On the back another hand – probably in the early sixteenth century – has added a poem in praise of the master in somewhat inadequate Latin verse. The sketches are mostly ideas for the movement of a Christ-child sitting on its mother's knee or in her lap. On the back is a drawing of a child lying almost on its front, leaning on the right elbow and turning its head back over the left shoulder; this is similar to the position used by Leonardo for the Christ-child in the sketches for the Adoration of the Shepherds, now in Hamburg and Venice. On the front there is also a design for a Christ-child standing in benediction, of the type that recurs constantly in quattrocento half-length Madonna paintings and reliefs, and also as a single figure for ciboria and tabernacle compositions, very closely related to the tabernacle of Verrocchio's pupil Francesco di Simone in Santa Maria Monteluce in Perugia. A comparison with the Christ-child in Verrocchio's terracotta relief in the Bargello shows that a more graceful and less babyish stance on a narrow base has been chosen in the sketch; the general pose of the figure with the torso twisted to three-quarter profile and the head turned in the opposite direction is much freer and more appealing in effect. Two further sketches on the same side of the sheet show naked putti in vigorous movement, who appear to be fleeing from danger or escaping from a pursuer. What is striking in all these sketches of children on the Louvre sheet is the artist's interest in the effect of the changes of direction in the turns and counter-turns on different zones of the body. The new wealth of movement, and to a lesser extent the concern with the details of the body's form, link these drawings, which cannot be earlier than the end of the fourteen-seventies, closely with such approximately contemporary drawings of Leonardo as the sketches for a kneeling Madonna nursing the Child, in Windsor Castle, and the pen and wash drawings for a Madonna with a Cat, in the British Museum.

Lastly the design by Verrocchio for a Doge's tomb, in the Victoria and Albert Museum (Plate

101), must date from the early eighties. It is almost certainly identical with the design mentioned by Vasari as being in the possession of Vincenzo Borghini. In this drawing the 'atlantes' under the foot of the sarcophagus and the figure decoration at the top of the round arch are provided by naked putti, whose strongly twisted and vigorously moving bodies are directly reminiscent of the various sketches on the sheet in the Louvre already described. Verrocchio's design adopts the console type of tomb long in favour in Venice and hardly used at all in Florence in the second half of the fifteenth century. The monument does not stand on a platform resting on the ground but lies against the wall, raised up on one or several consoles. The form of the container for the remains of the deceased has nothing in common with the chest or bath-shaped sarcophagus adopted from antiquity and used repeatedly in Florentine tombs of the quattrocento; it is more reminiscent of goldsmith's work such as a richly decorated double goblet, a lidded bowl or a tureen made of precious metal: a form of vessel which appears occasionally for reliquaries or ciboria. Many of the ornamental motifs for the decoration of the sarcophagus, particularly the ropes, knotted where they meet, that frame the oval fields on the outside walls of the container, point to the conclusion that bronze was to be used in the construction of the tomb. Possibly Verrocchio even intended to cast the whole sarcophagus in bronze. In contrast to the Medici monument in the Old Sacristy of San Lorenzo it is noticeable that the sarcophagus of the Doge's tomb is thickly covered all over with ornament, and the effect was to be obtained otherwise than by the combination of different-coloured finely polished marbles and bronze. The most striking contrast with the Medici tomb, however, is in the lavish figural ornament of the project. The richly moulded foot of the sarcophagus is borne by three putti each standing with only one foot on the very narrow base provided by the lower capital-shaped console. In the centre of the oval sarcophagus lid, on the curve of which sit two more putti holding shields, rises the circular plinth for the figure of Justice; two further female allegorical figures float to left and right of Justice, who overtops them by a head. The left-hand figure holds a sheaf of corn in her right hand and a cornucopia in her left, and must be Abundance; the right-hand figure, who holds out a laurel wreath, is presumably Honour or Glory. Obviously both these allegorical Virtues must refer to the particular personality and ambitions of the deceased: according to the calendar of Virtues one might have expected rather the figures of Fortitude and Temperance or Constancy on a Doge's tomb. The structure of the tomb unfolds more and more broadly as it rises upwards and it is topped with a moulded arch, coffered on the inside and resting at the sides on scrolled consoles. Pairs of putti play tumbling on the strongly projecting imposts above the consoles. It is not clear whether these lively boys are holding festoons or busy with the curtain, which is hung up on rings under the arch and falls behind the ensemble of sarcophagus and figures. While on a niche tomb of the Florentine Humanist type the different parts of the monument are held together by the recess in the wall and the architectural elements framing it at the sides, Verrocchio's project uses the curtain to set off and draw together the sarcophagus and figures into a unity, and to ensure to the whole structure of the console tomb a prominent place within the surrounding

free wall surface. As Möller was first able to establish, on the basis of the lion of St Mark in the centre and the arms on the shields, the project was destined for the tomb of the Doge Andrea Vendramin, who died in 1478. His tomb was not erected until the fourteen-nineties by Tullio Lombardi and was still unfinished in 1493. Verrocchio's design was done in Venice in or shortly before 1485. We can assume that at first Verrocchio was to receive the commission for the tomb and that the surviving project was done for the client; but there is no evidence for this.

X

THE PRINCIPAL WORK OF HIS LAST PERIOD: THE EQUESTRIAN STATUE OF COLLEONI IN VENICE

FIVE years before his death Verrocchio received the commission for what was to be the crowning of his artistic achievement, and his last work. About the middle of the eighties he moved to Venice to execute the bronze equestrian statue of Bartolomeo Colleoni. When he died in the summer of 1488 the final model of horse and rider was completed and the casting had been prepared. The statue, cast and gilded by Alessandro Leopardi of Venice, was not unveiled until eight years later (Plates 62–68). If today Verrocchio is considered one of the great representatives of Italian quattrocento sculpture, our judgment is essentially influenced by this masterpiece, which gives justification to the artist's fame, which already in his own day had spread far beyond the frontiers of Tuscany. In the Colleoni the creative energy of a century which was nearing its end found yet one more convincing manifestation of its power. It is the first public equestrian monument of post-antique art which is not also a tomb, and it far surpasses anything the century had yet aspired to or thought possible in sculpture.

Bartolomeo Colleoni, to whose posthumous glory the monument was erected, was born in 1400 in the region of Bergamo into a family of the landed nobility; he campaigned for many decades with his troop of mercenaries for the Venetian republic against the Duke of Milan and, from time to time, in the service of the latter against Venice. This *condottiere*, who for a time had served his apprenticeship in the art of war under the famous Gattamelata, reached the peak of his military career in 1454 with his appointment as Captain-General of the Republic. In 1467 certain exiled Florentines persuaded him to lead their army against the Medici in Florence. The attempt was foiled by the successful defence of the troops fighting for Florence and her allies, led by the Duke of Milan. The last years of his stirring life were passed by Colleoni at his castle in Malapaga, surrounded by a brilliant and luxurious court. He died on 1st February 1475 and bequeathed considerable sums of money to Venice, some of which was to be used to support the

Republic's fight against the Turks. In his will he expressed the wish that an equestrian statue be erected to him in the Piazza San Marco in recognition of his services to the Republic. It was four years after his death, on 30th June 1479, that the discussions began for the fulfilment of this behest. A competition was announced, in which Leopardi and Bartolomeo Vellano of Padua took part as well as Verrocchio; Vellano had once collaborated in the casting of the Gattamelata statue as assistant to Donatello. In the summer of 1481 Verrocchio's full-size model for the horse was completed in wood. He then made a request to the Ferrarese ambassador for free passage for the transport of the model to Venice across the state of Ferrara. In 1483 the three models for the horse by the competing artists were publicly exhibited in Venice. One was of wax, the other of terracotta; Verrocchio's wooden horse was on view in the church of the Minorites, where it was seen in 1483 by the Dominican monk Felix Faber from Ulm, who noted in the report of his journey that it was entirely covered in black leather. This curious technique is evidence of the importance Verrocchio and his contemporaries attached to the true imitation of nature. It is this attitude to art which made sculptors at that time take life- or death-masks of wax to help them in creating true likenesses in their portrait busts.

Just as the wish of the deceased Capitano to be immortalized in a bronze equestrian statue was doubtless inspired by the example of Gattamelata, so Verrocchio's conception was certainly affected by study and emulation of Donatello's work in Padua (fig. 31), which in the technical field alone must have presented Verrocchio with a challenge to find a more imposing and more difficult interpretation. Vasari reports furthermore that while working for Sixtus IV in Rome Verrocchio was extremely impressed with the bronze statue of Marcus Aurelius (fig. 30). The true artistic roots of the Colleoni monument, however, are to be found neither in the antique original nor in Donatello's version in the antique manner, but in the painted monuments of condottieri in the Duomo in Florence. Castagno's fresco of Niccolò da Tolentino (fig. 29) is an important forerunner of the Colleoni. We see there the forward-pressing movement, the turn of the horse's head, and the realistic portrayal of the rider in armour seated in the saddle with stiff outstretched legs. In contrast Donatello's bronze horse in Padua is an entirely static conception; we are not made to feel that Gattamelata is riding into battle but rather that he is sitting on his charger bareheaded and about to review his troops.

The differences between the Gattamelata and Colleoni statues are not to be explained by the different characters of the men portrayed – here the superior aristocratic self-possession of a Roman commander, there the expansive, domineering mentality of an unscrupulous conqueror and adventurer. Donatello has a quite different approach to the theme of a condottiere monument from Verrocchio, who aims at counteracting the tendency of the previous generation to create in the manner of the antique and at excelling them by a new direct attack on reality. The Gattamelata is an idealized monument to a leader in the antique sense, and comparable to the statue of Marcus Aurelius. Verrocchio fashions a life-size bronze statue of a contemporary condottiere, and gives him the features of Colleoni. Inflexible ambition and willpower, authority and that

terribilità in the expression of the head – echoed in the Bologna Proculus figure by the young Michelangelo – are portrayed less as personal features of the deceased than as characterizing a particular type of Renaissance man to whom a monument is being erected here in the person of Colleoni. All the elements and motifs we have learnt to recognize as essentially characteristic of Verrocchio's figures are once more present, and in enhanced form, in the Colleoni monument. But now instead of the two-figure group which so often occupied Verrocchio both in sculpture and his altarpieces, we find him rethinking the general theme of the equestrian statue; the problem of how to bring horse and rider together in a sculptural whole, how to particularize and combine the different expressive values of man and animal, assumes especial importance. For the Or San Michele Christ and St Thomas the artist set aside the usual formal presentation of the two figures side by side in favour of a group which forms a single unity, now in the Colleoni statue he strives for more than co-ordination, for a real fusion of the figure of the rider with the body of the horse. Donatello's Gattamelata might equally well be sitting in a triumphal car, as Piero della Francesca portrayed the Duke of Urbino in the picture in the Uffizi. The horse of the Padua statue, too, is quite conceivable without the Gattamelata; it could be placed beside the antique horses on the façade of St Mark's. Horse and rider are viable independently of each other; each is complete on its own. In Verrocchio's monument the horse would lose its effect if it were separated from the figure of the *condottiere*, and vice versa. It is not only that the relative size of the rider has been increased, compared with Donatello's statue; the movement of the horse contributes to the characterization of Colleoni and only receives its meaning when related to his domineering strength. The trusting expression of the horse's head (Plate 66) has to be seen together with the *terribilità* of its rider's head, bursting with titanic power and energy. The horse does not belong to the same noble thoroughbred race as the horses of the Gattamelata or San Marco; they look much more fiery and animal, with their large eyes and distended nostrils. The Colleoni horse is highly-bred and nervous; its sensitive, intelligent expression has something human and reassuring: the horse as man's faithful companion. This too seems to have been Dürer's feeling about the horse when he engraved his 'Knight, Death and the Devil' and revived his memory of Verrocchio's monument in Venice.

Verrocchio further achieves an enhancement of the movement of horse and rider by effects of contrast. The hardness and stiffness of Colleoni's armour is set against the 'steaming' body of the horse lunging forward so full of life and movement. The rich modelling of the play of muscles, the detailed rendering of the folds in the skin and the veins standing out on the horse's head, the feeling for texture in the wavy tail hairs, the forelock plaited high between the ears and the carefully dressed mane combed to one side with its ends in an agitated rather untidy pattern of curls – in all this arresting naturalism Verrocchio goes far beyond anything Donatello achieved or even attempted thirty years before in the Gattamelata monument. The stiff-legged seat of Colleoni is a consequence of the constriction on movement dictated by the armour. The saddle with its high pommel and cantle guards against the rider's being unhorsed by his enemy's lance

in battle. The long lances with which the cavalry was usually armed at that time dictated too the asymmetrical form of the armour. Since the lance was carried near the right hip in fighting, the left shoulder was twisted forwards and had to be protected with thicker and broader plating. Verrocchio gives new significance to a formula of expression he has used twice before, once in the bust of Giuliano and once in the Decollation relief: here the head turned energetically over one shoulder corresponds to the asymmetrical appearance of the armour and this 'naturalism' heightens the aggressive effect of the motif. The left shoulder of Colleoni being thrust forward in battle position makes the face appear almost frontal even though the head is expressively and violently turned to one side. The penetrating, petrifying, gorgon-like gaze of the wide-spaced eyes is directed obliquely forward past the crest of the horse's mane straight at his opponent. In contrast the horse's look is tame, almost reflective in effect, and cast down to take cognizance of the spectator as he respectfully approaches the monument from below.

The Colleoni equestrian statue is a free-standing figure in the full sense: it is valid from every view. But it is so in a different sense from the *figura serpentinata* of the Putto with a Dolphin. If it is to be apprehended with the full force its maker intended it needs a large space in front and, even more important, behind it. Leopardi and the men responsible for the final erection of the monument realized Verrocchio's intention in an exemplary manner. The forward lunge of the horse – some critics have been reminded of a straining cart-horse – is given meaning from its direction, from the placing of the statue between two spaces of regular and clearly delimited form and extent. Without this arrangement we should lose the fascinating effect of immediacy, the sense that the Capitano of the Venetian Republic is riding out to battle at the head of his troops, that he is leading the whole body of his horsemen and drawing them forward. The Colleoni has to be seen as it is placed in the Campo SS. Giovanni e Paolo, to one side and with its rear on a line with the façade of the church, with the narrower square behind closed in on three sides by the nave and by the surrounding houses, and with the piazza before the church opening out suddenly in front of the monument. No photograph can convey the slightest idea of the true effect of the figure in its setting. The forward charge is expressed primarily in the horse's move-ment, in the wide extension of the right hind-leg and the sharply oblique line of the right foreleg, and the raised left foreleg projecting over the plinth. It is not so much the action of the horse that is important as the exact stage at which the movement is caught, giving the impression that the horse is on the point of setting down its lifted leg as it moves forward. The Gattamelata's horse does not convey this sense of movement, because the raised foreleg there is supported by a cannonball pushed in under it. Comparison with Donatello's statue makes it immediately clear how strongly the effect of the Colleoni is heightened by its unusual setting on the short marble plinth above the architecture of the broader base. It is not known how far the appearance of the completed monu-ment was laid down by Verrocchio in sketches or models, nor how closely Leopardi followed any such in designing the base. There is no question, however, that the magnificent sense of move-ment of this figure is shown to superb advantage in its present setting. The projection of the

horse's head and foreleg beyond the edge of the plinth and the way this position accentuates the transitory moment in the forward impetus of horse and rider contributes tremendously to the characterization of the man: the victorious *condottiere* who will trample any opposition underfoot. Verrocchio's monument leaves us in no doubt that battle at the head of his mercenaries was the breath of life to Bartolomeo Colleoni, his glorious destiny.

The Colleoni monument is the last of Verrocchio's works known to posterity and preserved; it is not a late work, but the creation of a fifty-year old man at the height of his development. Verrocchio's working life was some twenty-seven years shorter than Donatello's and thirty-six less than Michelangelo's. His art has a mature style but no late style. The Colleoni cannot even be termed a new 'baroque' phase in Verrocchio's development, rather does his grappling with the problems posed by an equestrian monument bring out once again, and unusually forcefully, those essential features of his art which sometimes make his works appear so Castagno-like. Once again in the Colleoni monument he gives us one of those heroic and dramatic representations of man which can be matched in the monumental paintings of Castagno. But this revival of Castagno's style takes place on a new level of realism, modified and refined by the rules of art constructed on the nature study of the past decades. The Colleoni monument is the outcome of that classical, measured and balanced phase in Verrocchio's style which produced such works as the Berlin Lamentation or the Pistoia altarpiece; it made possible the fertile interchange of influence between Verrocchio and Leonardo, and indeed it was the collaboration in one studio of master and pupil which gave it its decisive impetus.

The heightened, explosive plasticity of the Colleoni statue, the arrogance and defiance in the attitude of the rider, and his titanic, terrifying appearance are all important stylistic elements which differentiate it from the artist's earlier figurative plastic works. But this Colleoni style arises from the particular requirements of a memorial to a *condottiere* which, unlike Donatello's Gattamelata, is not a tomb effigy but a profane monument. The surviving drawing for a tomb by Verrocchio from his Venetian period demonstrates how he was simultaneously producing work in the fourteen-eighties which was a development of his classical style of the late seventies; the figures show more strongly than ever a similarity to the contemporary drawings of Leonardo. We must bear in mind the variety and the wide range of potentialities of an artist within the same phase of his development if we are to seek to define the relationship of the Colleoni to the rest of Verrocchio's *œuvre*. Leonardo too produced side by side works in which the completely heterogeneous elements of style can only be explained by the widely differing artistic problems involved; we have only to compare, for instance, the Mona Lisa with his contemporary composition of the Battle of Anghiari.

Heinrich Wölfflin is not sympathetic to the 'heroic' style of the Colleoni statue, perhaps inevitably, given the premisses of his *Classic Art*. He writes: 'The truly distinguished man is mild in his behaviour and movements, he does not strike postures, he does not draw himself up to his full height in order to cut a figure; he is what he is and he is always perfectly in place. Castagno's

heroes are for the most part vulgar bravos, no true gentleman would wish to look like that. Even the type of the Colleoni in Venice must have seemed ostentatious to the sixteenth century.' No other conclusion is possible if we apply Castiglione's standards to Castagno's frescoes of the 'Uomini famosi', to Verrocchio's equestrian statue or even to his bust of Giuliano de' Medici. They would not have satisfied the standards he set in the 'Cortegiano' for the behaviour of a gentleman at the princely courts of the High Renaissance. But this is to ignore the historical significance of these works, and the true reaction to them of the sixteenth century. Nothing reflects the divergence of opinions on Verrocchio better than a comparison of Wölfflin's criticism of the Colleoni with the judgement expressed in later versions of Jakob Burckhardt's *Cicerone* as revised and edited by Wilhelm Bode. In the ninth edition, published in 1904, we read 'Even as we see it today, the statue would be justified in laying claim to the title of the most splendid equestrian monument in the world. Never again were horse and rider to be conceived so absolutely as parts of a single cast, and given a form at once so individual and yet so powerful. The great violent age of the Quattrocento, of which the *condottieri* were one of the most characteristic manifestations, has nowhere been brought to life so convincingly as in this figure.'

PLATES

SCULPTURES

PLATES 1–68

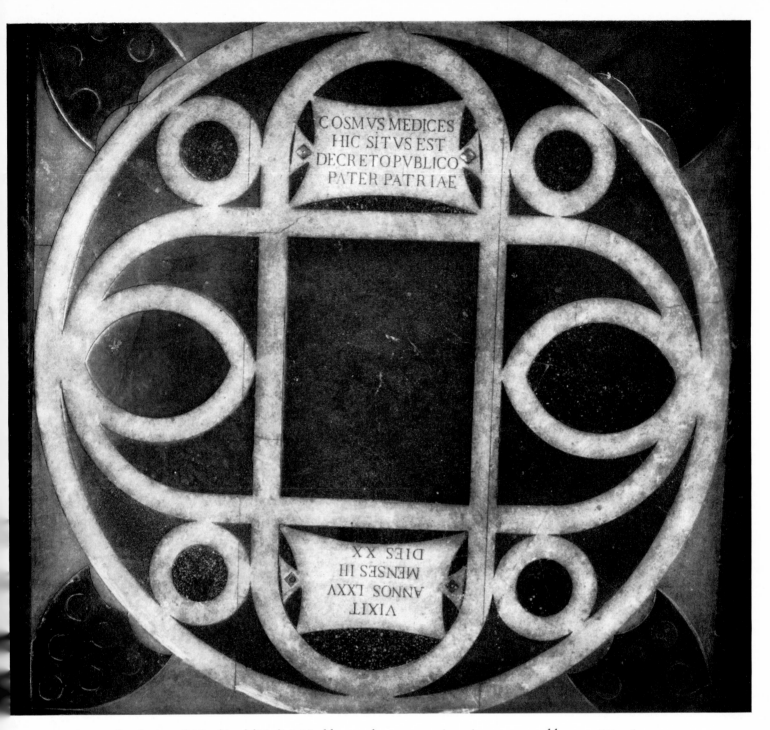

1. Tombstone for Cosimo il Vecchio de'Medici. Marble, porphyry, serpentine, pietra serena and brass, 336×336 cm.
Florence, San Lorenzo (Cat. No. 1)

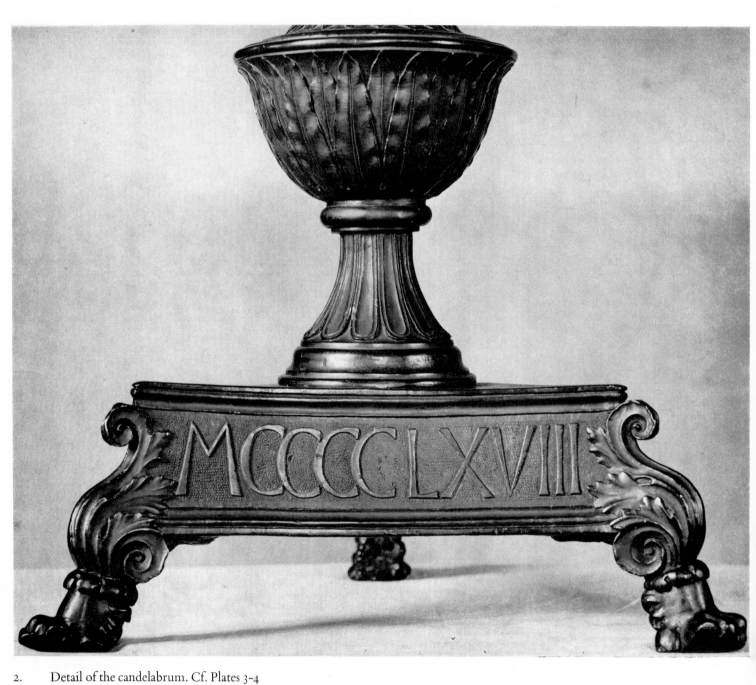

2. Detail of the candelabrum. Cf. Plates 3-4

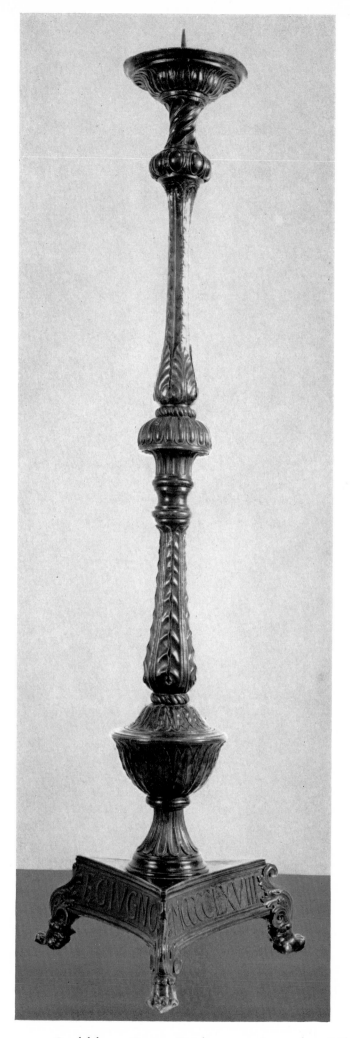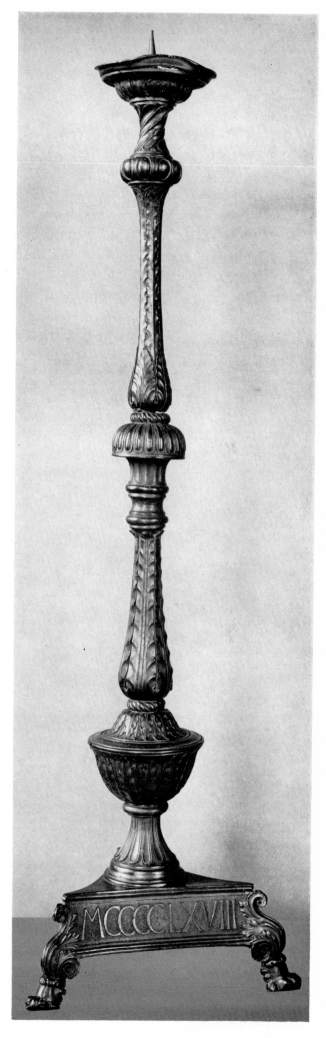

3-4. Candelabrum. Bronze. Height 157 cm. Amsterdam, Rijksmuseum (Cat. No. 2)

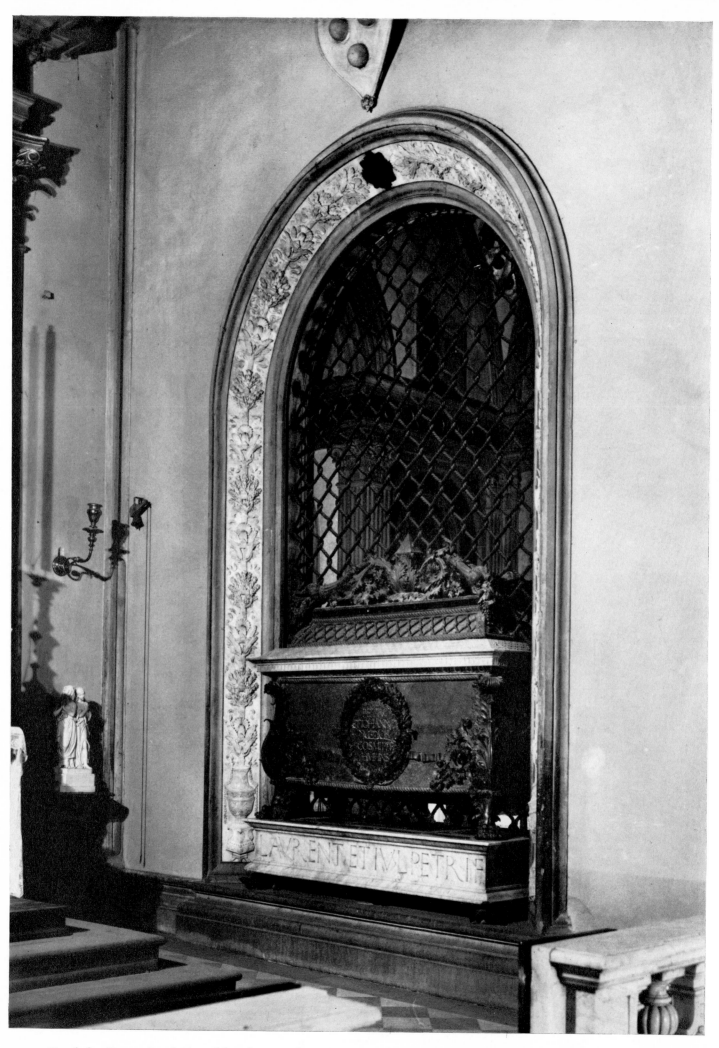

5. Tomb for Giovanni and Piero de'Medici' seen from the Chapel of the Madonna. Pietra serena and marble (framing arch), porphyry, serpentine, marble and bronze (net, on sarcophagus and plinth). Internal height of arch c.450 cm. Florence, San Lorenzo, Old Sacristy (Cat. No. 3)

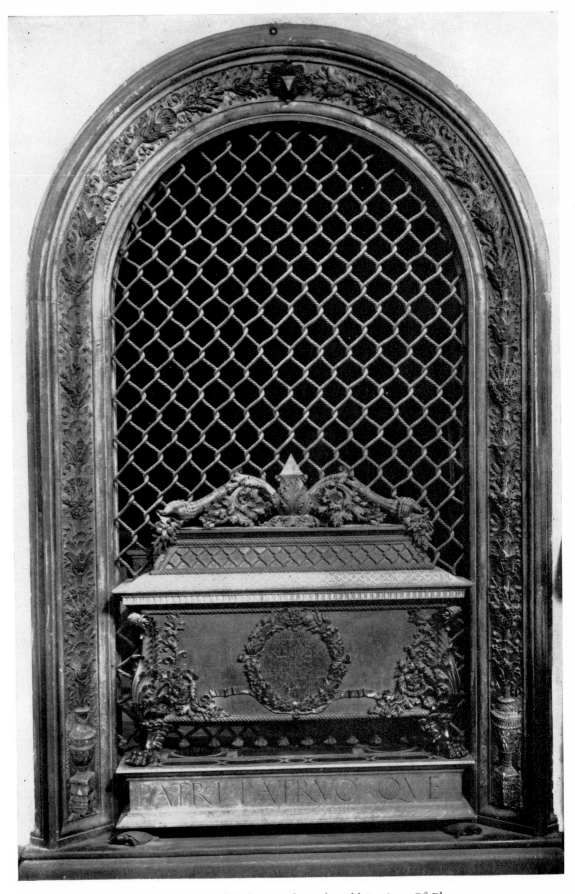

6. Tomb for Giovanni and Piero de' Medici seen from the Old Sacristy. Cf. Plate 5

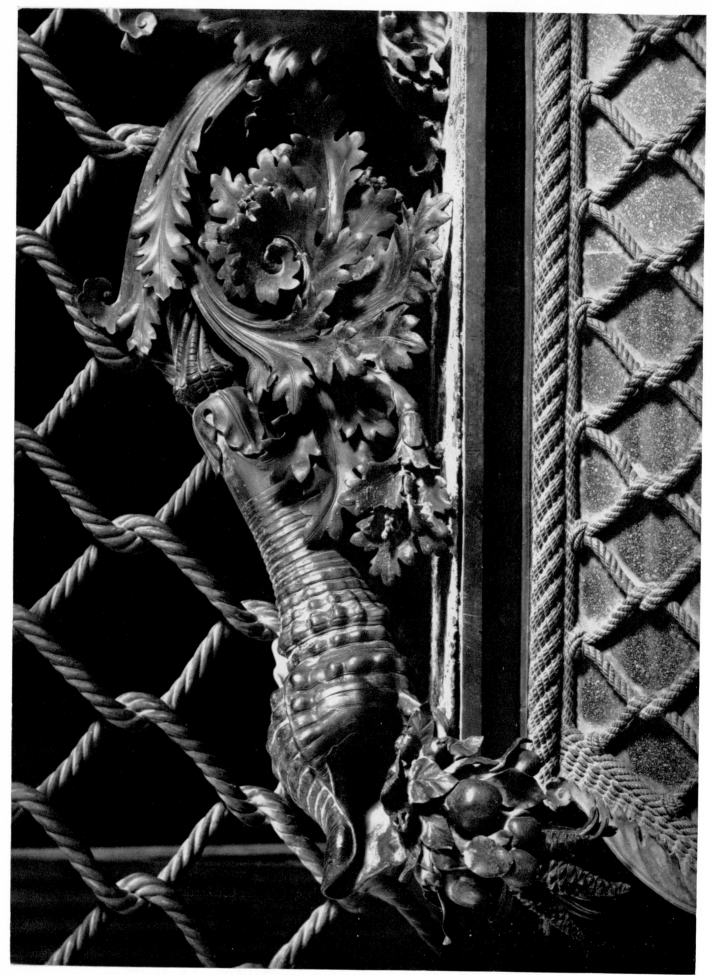

7. Detail of bronze net and of decoration surmounting the Tomb of Giovanni and Piero de' Medici. Cf. Plate 5

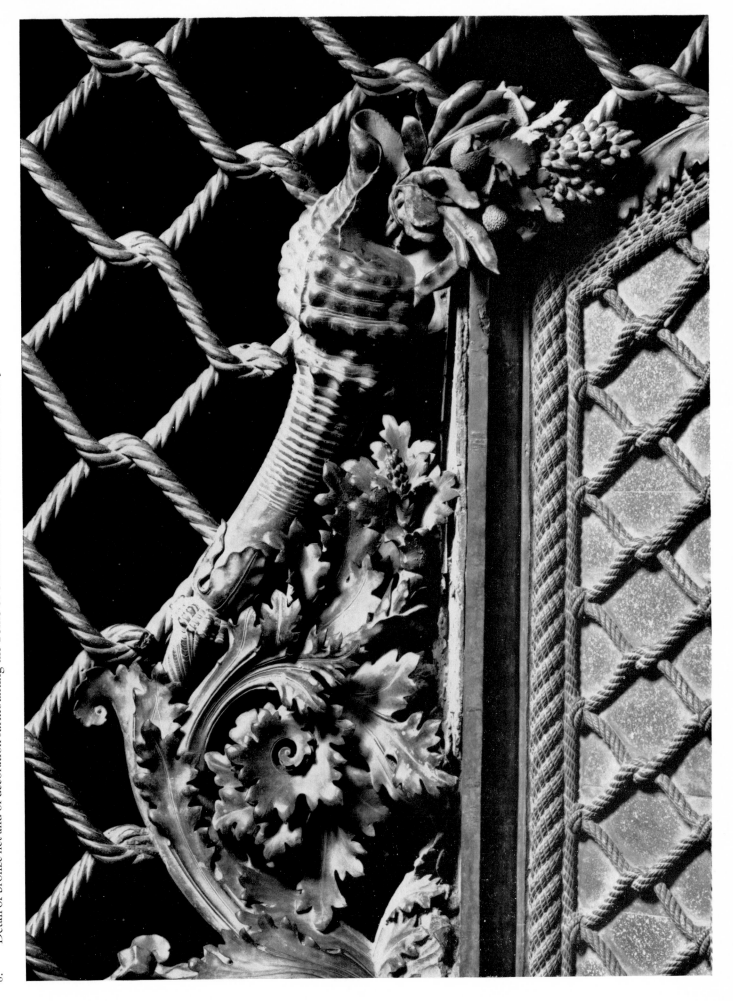

8. Detail of bronze net and of decoration surmounting the Tomb of Giovanni and Piero de' Medici. Cf. Plate 5

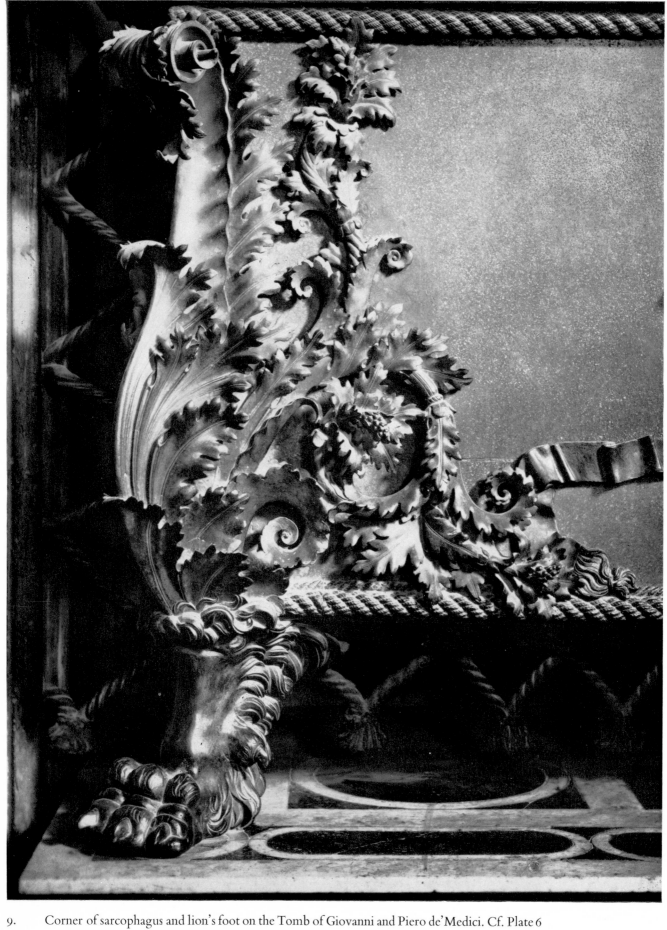

9.　　　Corner of sarcophagus and lion's foot on the Tomb of Giovanni and Piero de' Medici. Cf. Plate 6

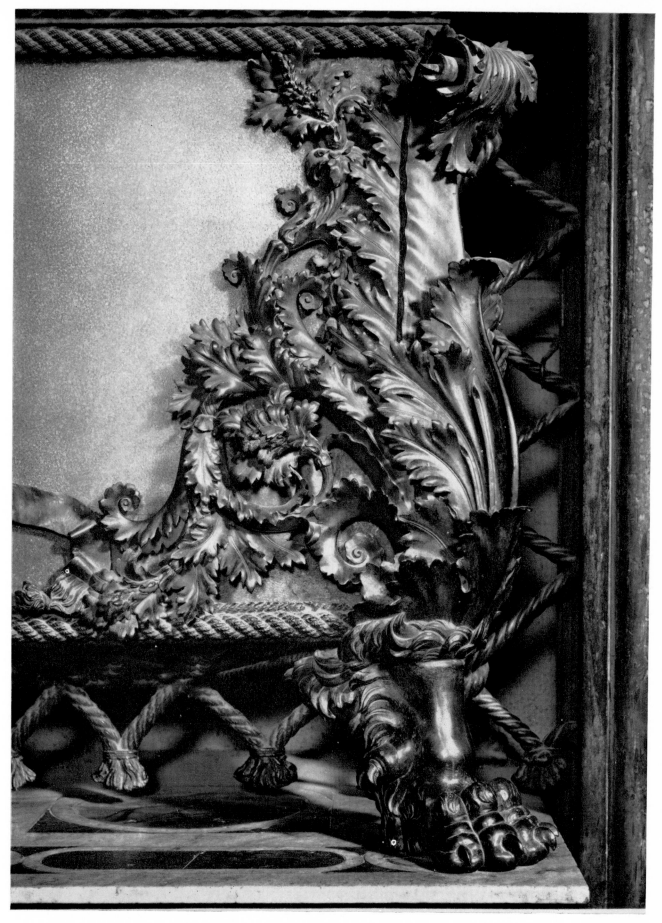

10. Corner of sarcophagus and lion's foot on the Tomb of Giovanni and Piero de' Medici. Cf. Plate 6

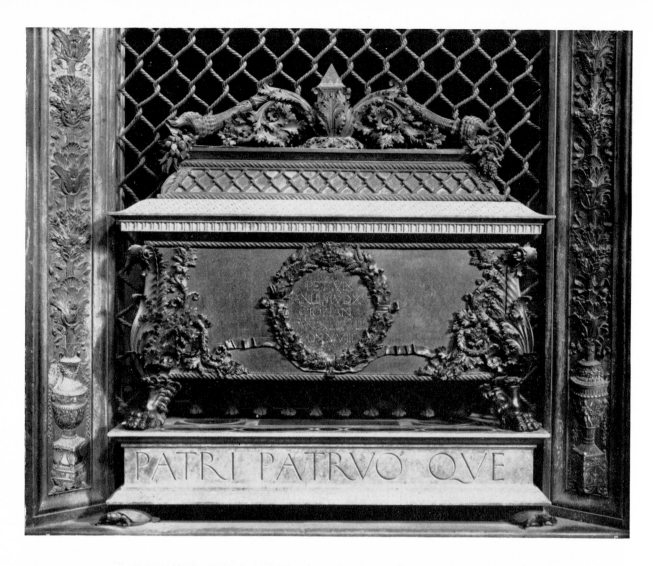

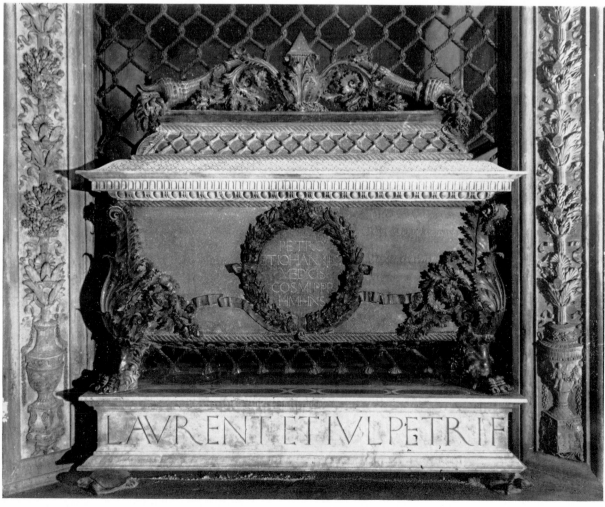

11-12. Sarcophagus and plinth seen from both sides. Cf. Plates 5-6

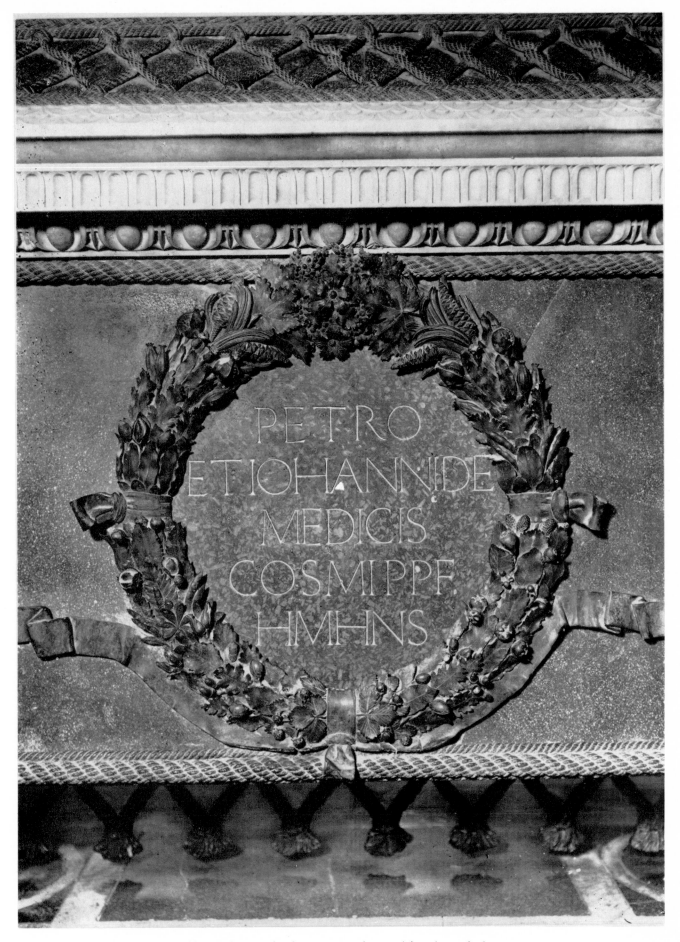

PETRO
ETIOHANNIDE
MEDICIS
COSMIPPF
HMHNS

13. Serpentine inscription tablet on the Tomb of Giovanni and Piero de'Medici. Cf. Plate 5

14. Head of the Madonna seen in profile. Cf. Plate 15

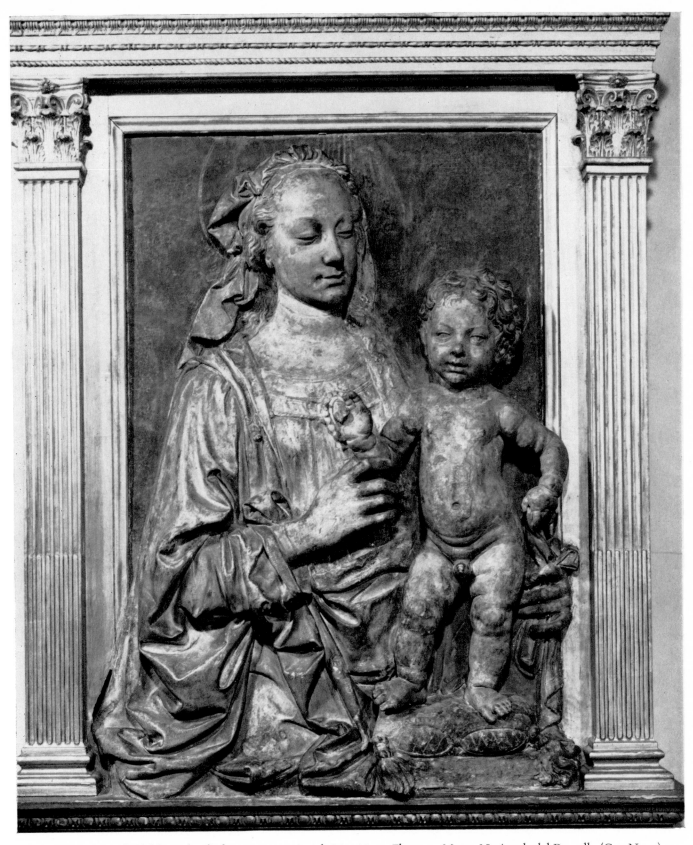

15. Madonna and Child. High relief, terracotta, painted, 86 × 66 cm. Florence, Museo Nazionale del Bargello (Cat. No. 4)

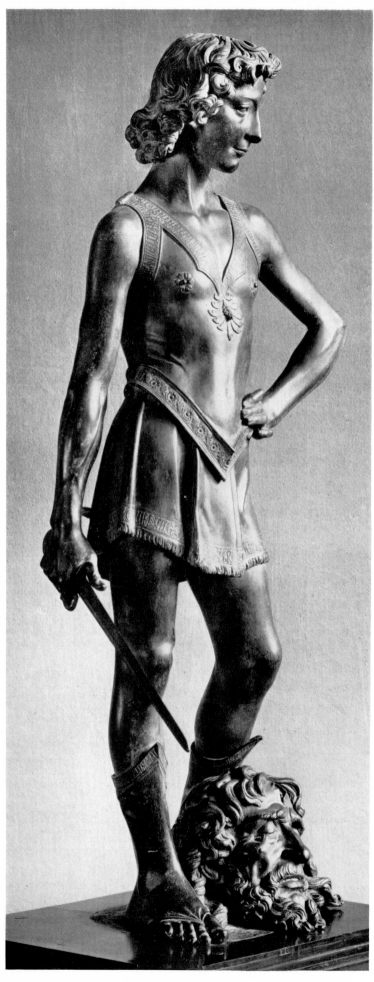

16. David. Bronze. Height 126 cm. Florence, Museo Nazionale del Bargello
 (Cat. No. 5)

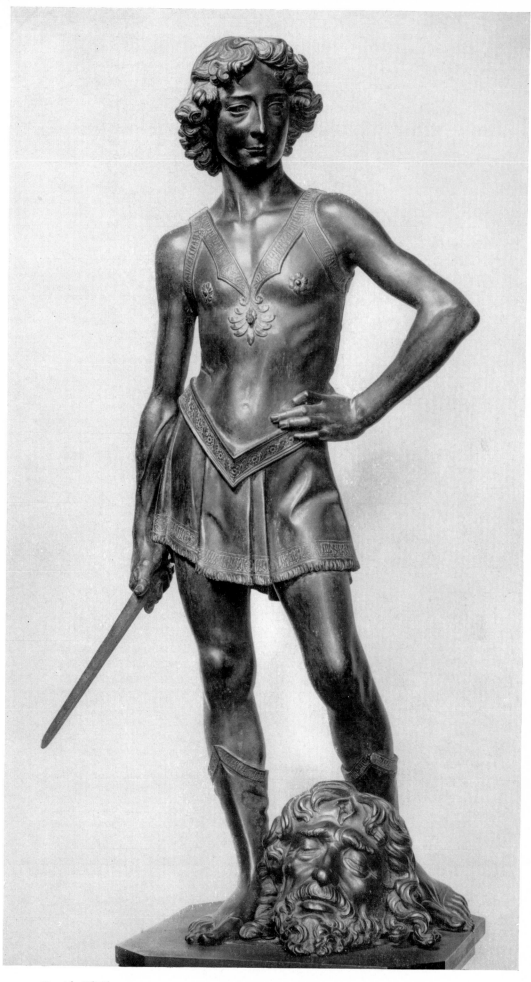

17. David. Cf. Plate 16

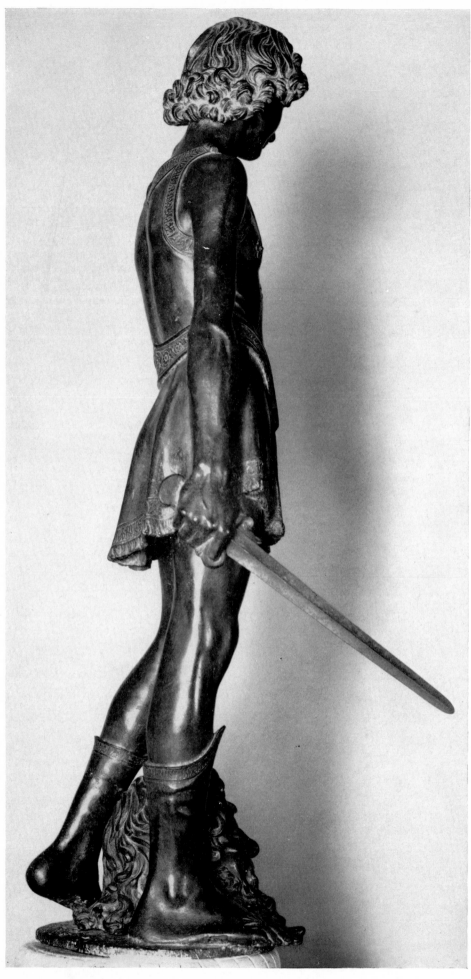

18. David. Cf. Plate 16

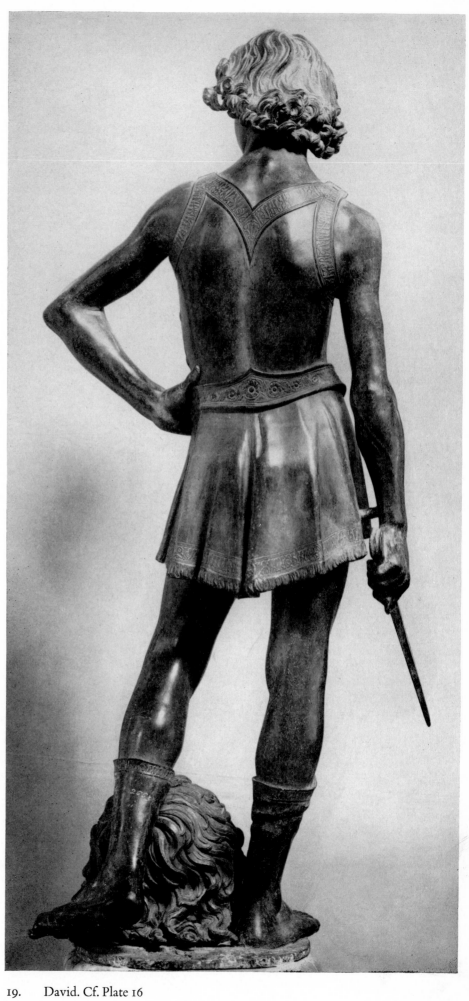

19. David. Cf. Plate 16

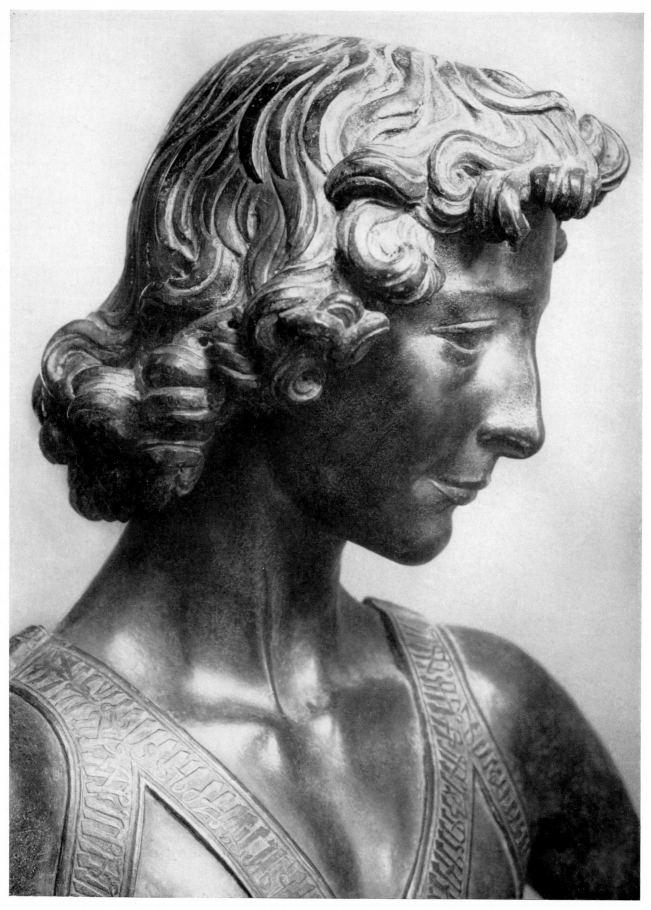

20.　　Head of David. Cf. Plate 16

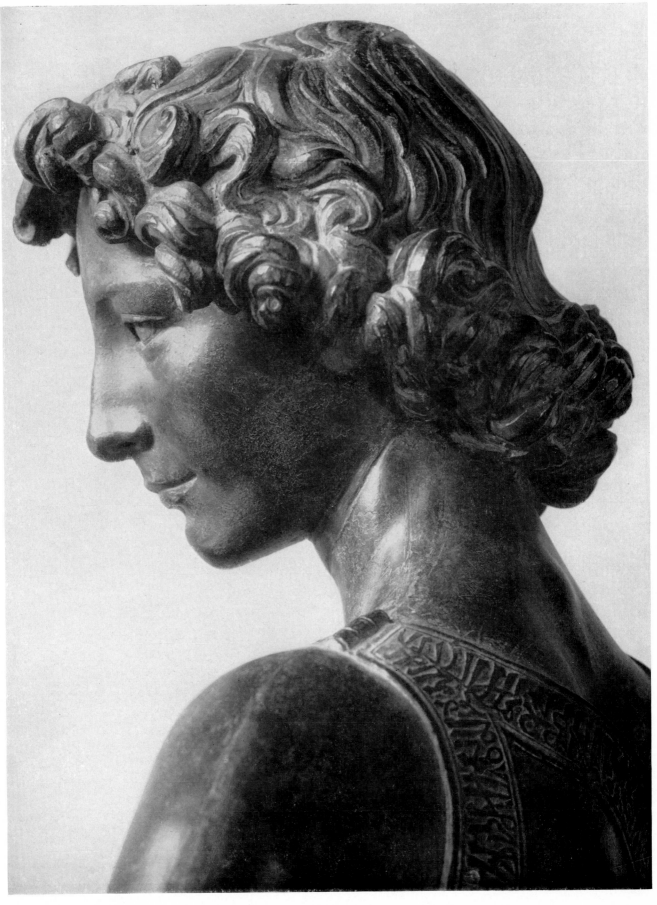

21.　　Head of David. Cf. Plate 16

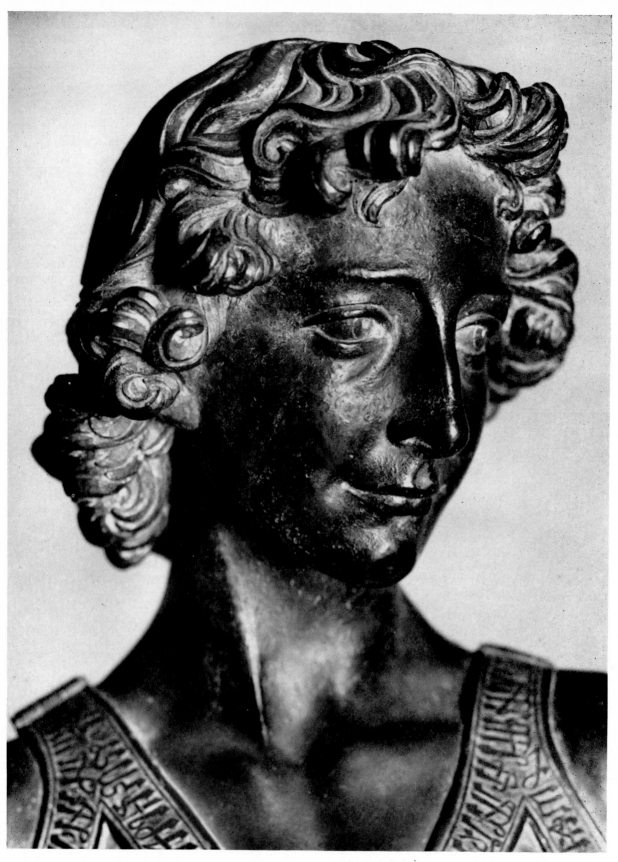

22. Head of David. Cf. Plate 16

23. Head of Goliath. Cf. Plate 16

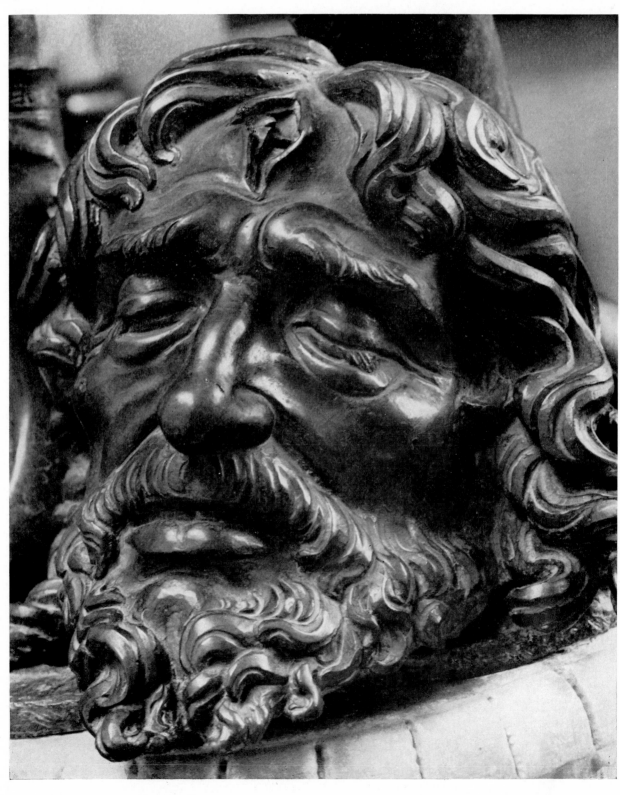

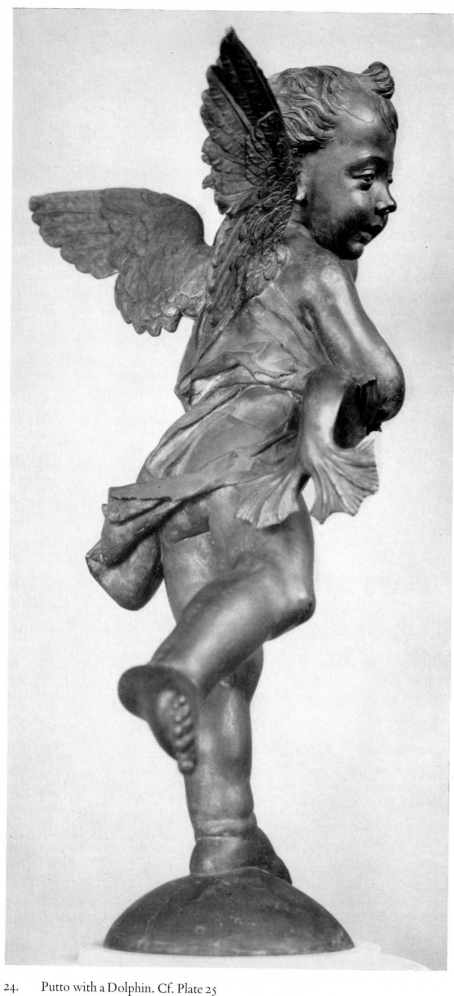

24. Putto with a Dolphin. Cf. Plate 25

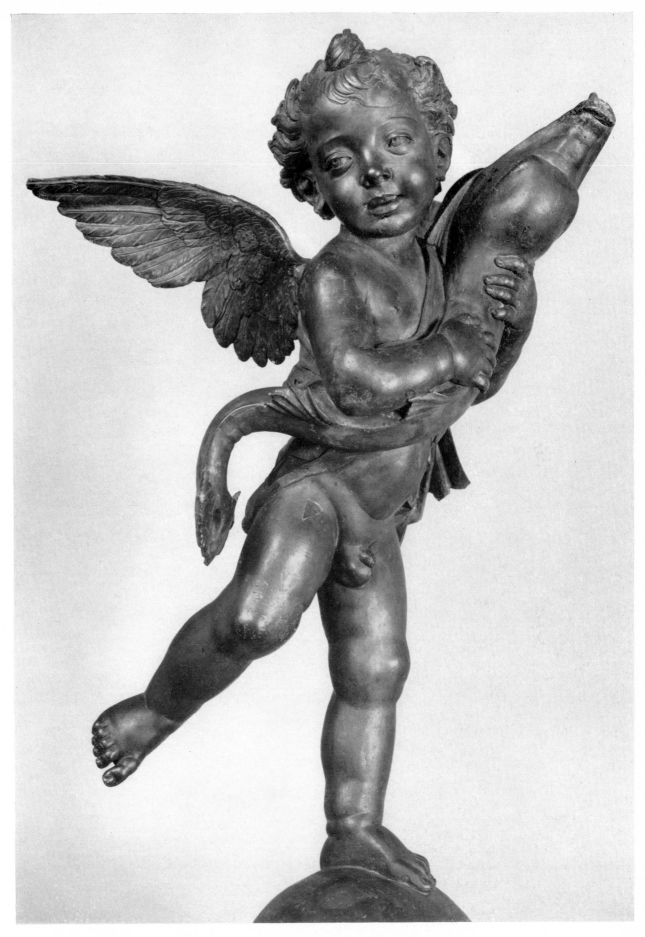

25. Putto with a Dolphin. Bronze. Height 67 cm. Florence, Palazzo Vecchio (Cat. No. 6)

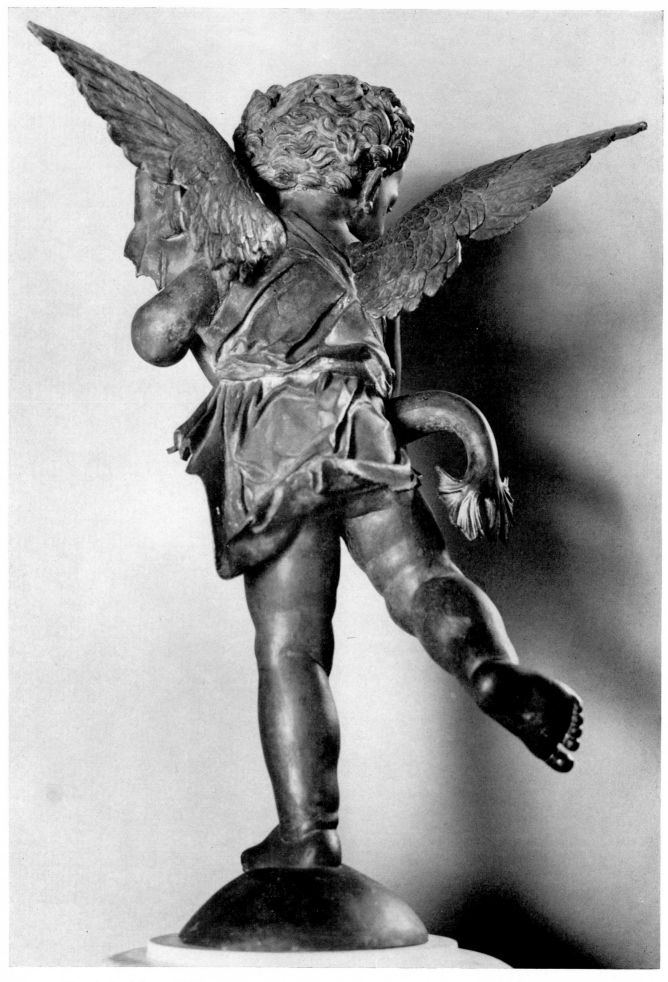

26. Putto with a Dolphin. Cf. Plate 25

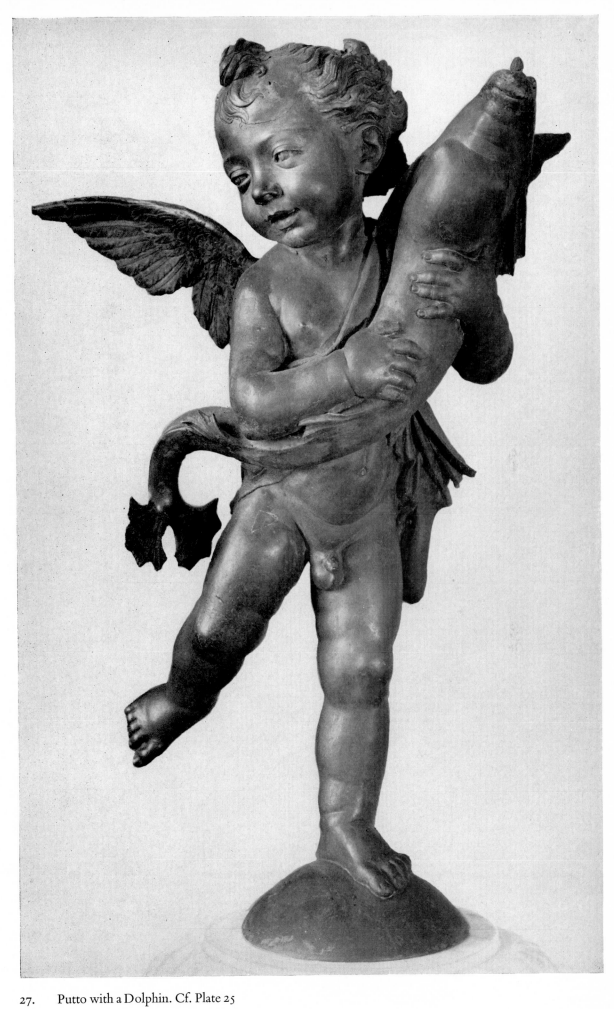

27. Putto with a Dolphin. Cf. Plate 25

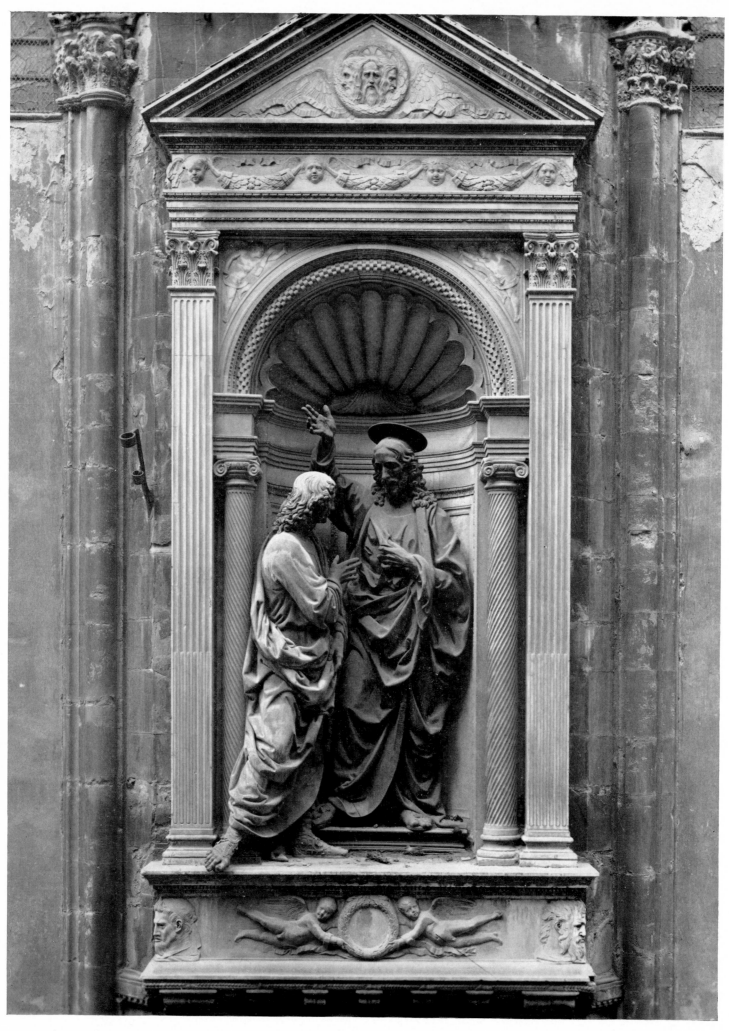

28. Christ and St. Thomas. Bronze. Height of the figure of Christ 230 cm. Florence, Or San Michele. Central niche on the East façade (Cat. No. 7)

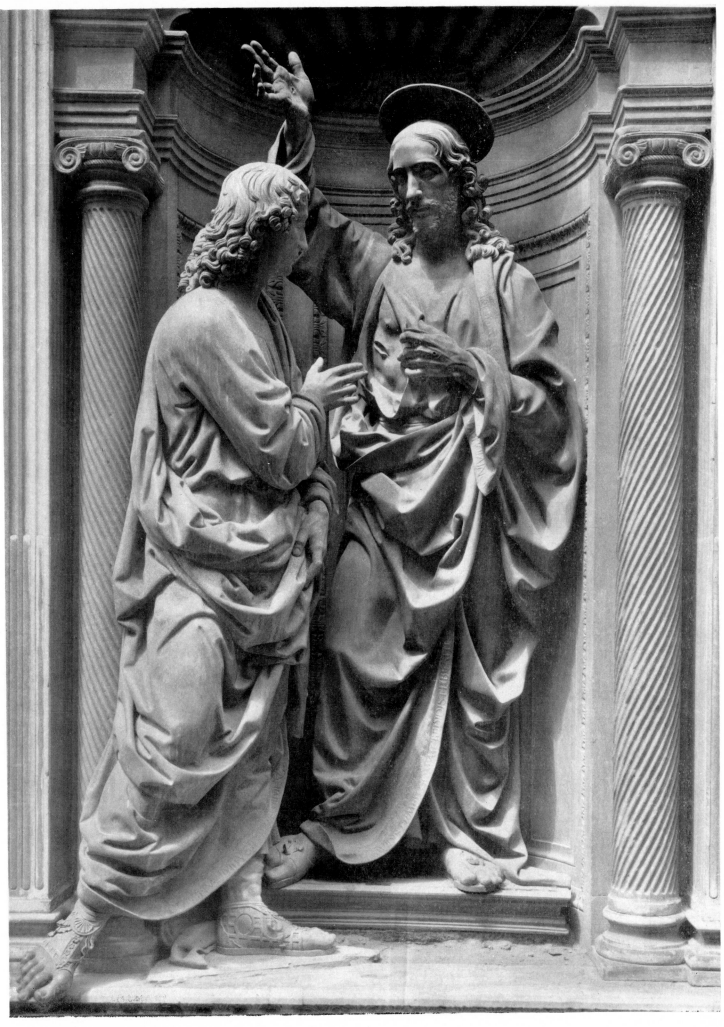

29. Christ and St. Thomas. Cf. Plate 28

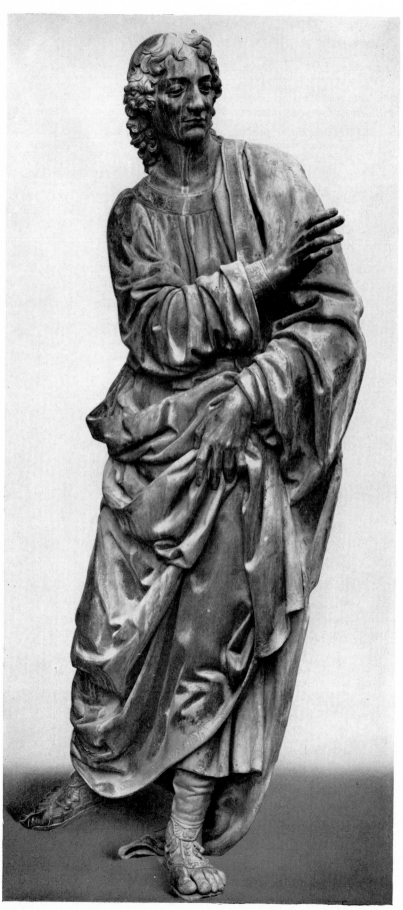

30. St. Thomas. Cf. Plate 28

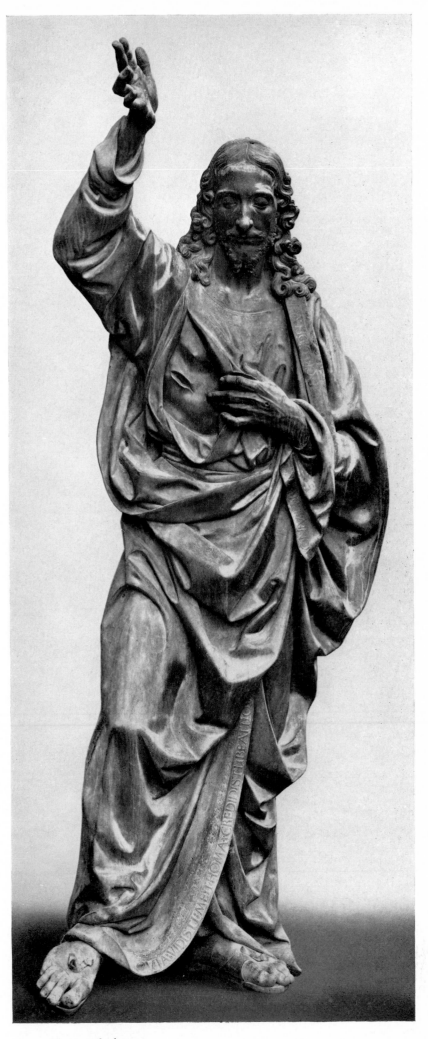

31. Christ. Cf. Plate 28

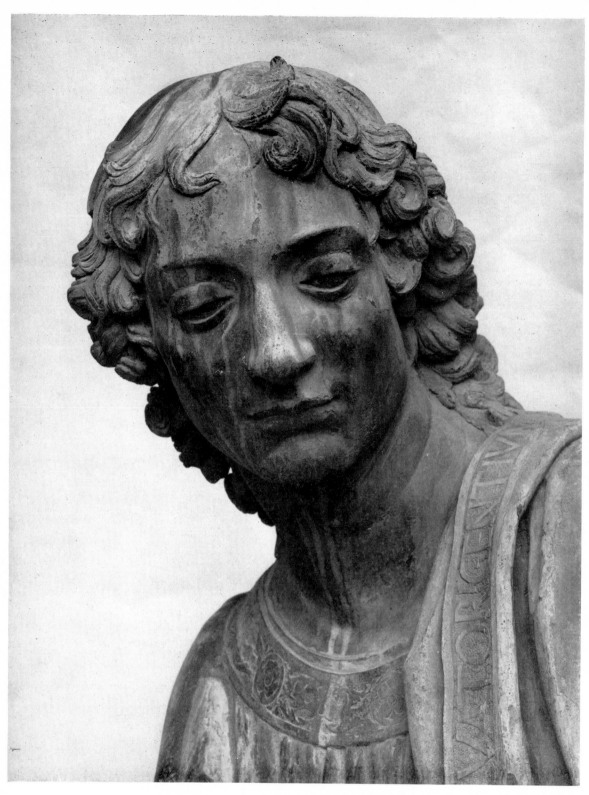

36. Head of St. Thomas. Cf. Plate 28

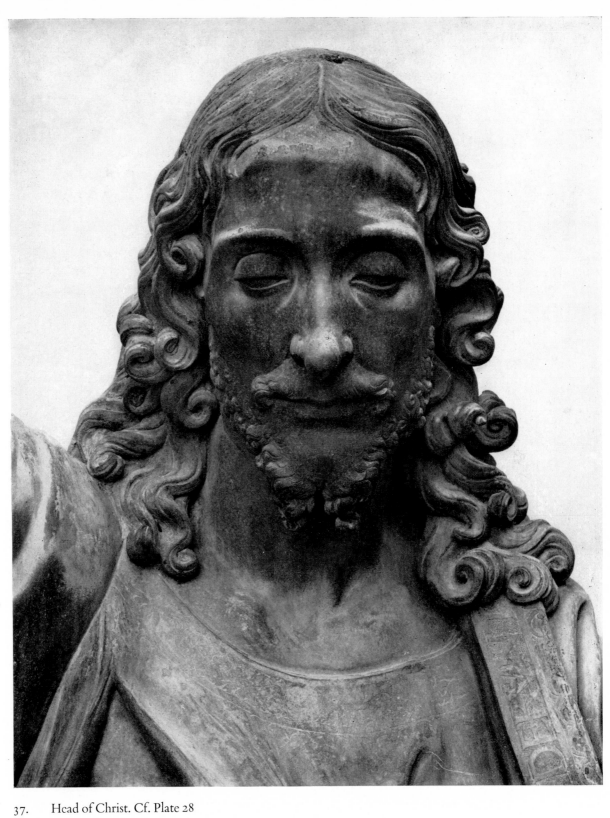

37. Head of Christ. Cf. Plate 28

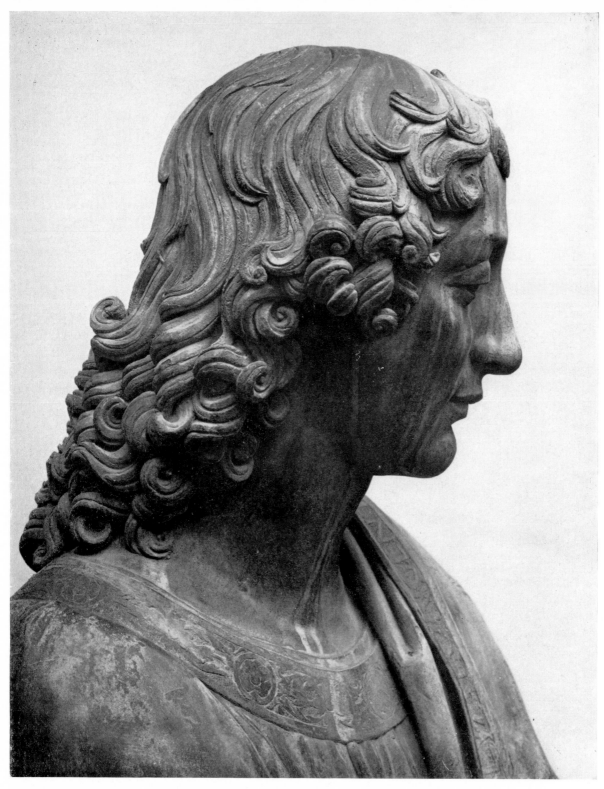

38. Head of St. Thomas. Cf. Plate 28

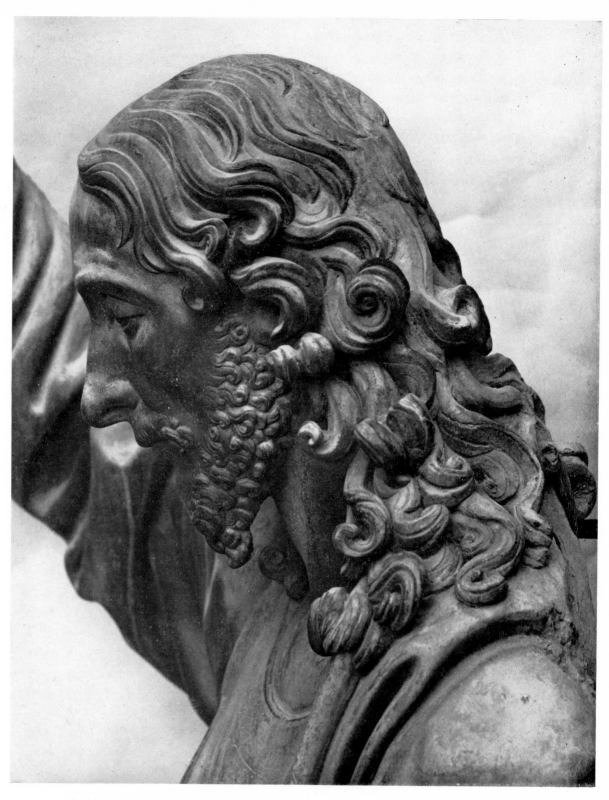

39. Head of Christ. Cf. Plate 28

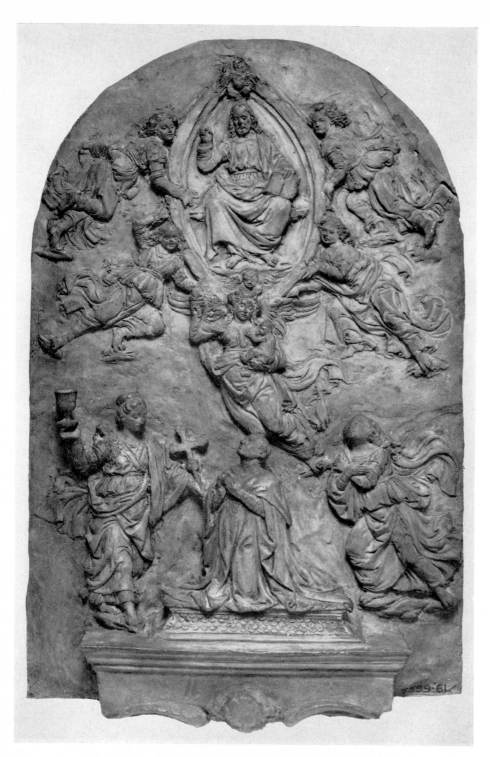

40. Bozzetto for the Cenotaph of Cardinal Niccolò Forteguerri. Terracotta, unpainted. 39.4 × 26.7 cm. London, Victoria and Albert Museum (Cat. No. 9)

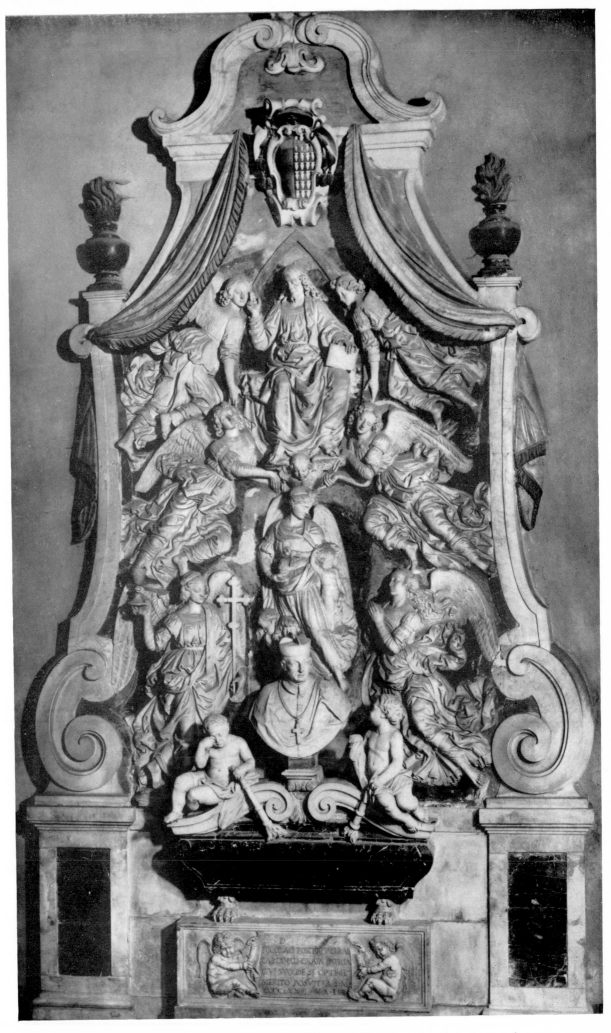

41. Cenotaph for Cardinal Niccolò Forteguerri. Marble. Workshop execution. In its present form, as set up
in the mid-eighteenth century. Pistoia, Cathedral (Cat. No. 8)

44. Portrait bust of a Lady with a Bunch of Flowers. Marble.
 Height 61 cm. Florence, Museo Nazionale del Bargello (Cat. No. 10)

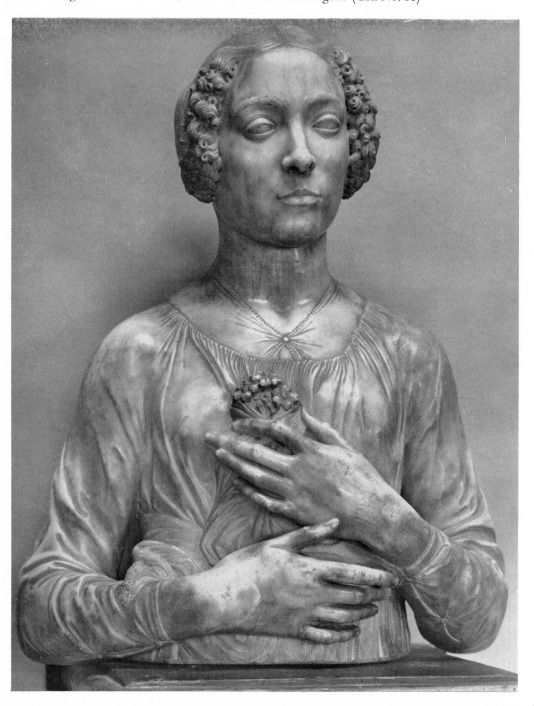

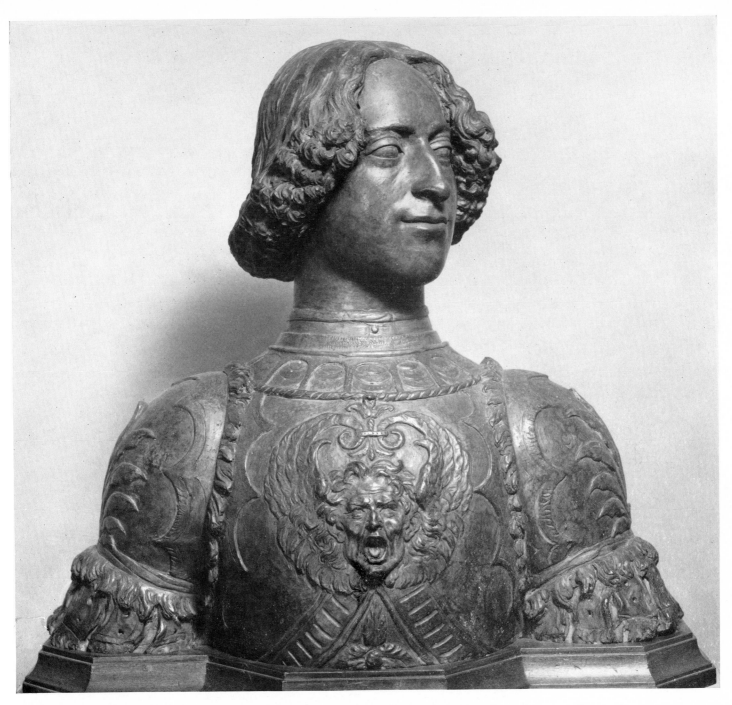

45. Bust of Giuliano de'Medici. Terracotta. Height 61 cm. Washington, National Gallery of Art, Mellon Collection
(Cat. No. 12)

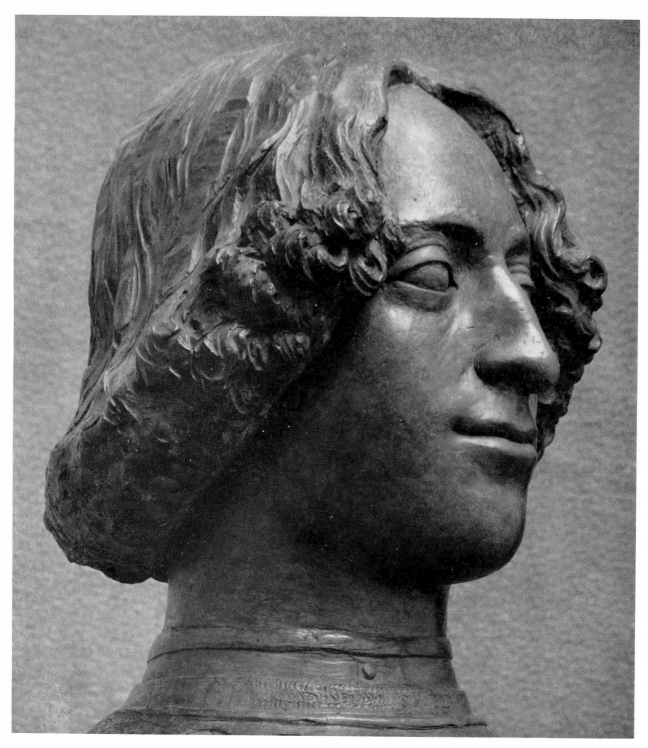

46. Head of Giuliano de' Medici. Cf. Plate 45

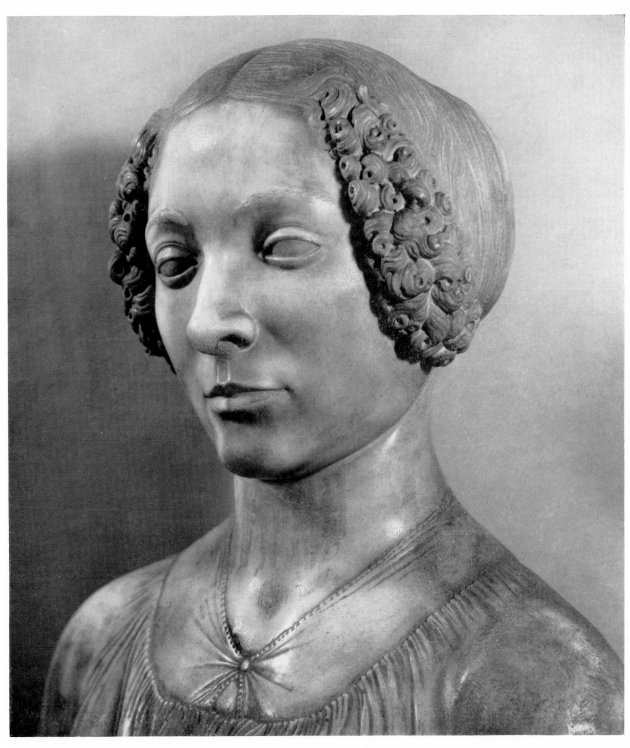

47. Head of the Lady with a Bunch of Flowers. Cf. Plate 44

48. Detail of the armour of Giuliano de' Medici. Cf. Plate 45

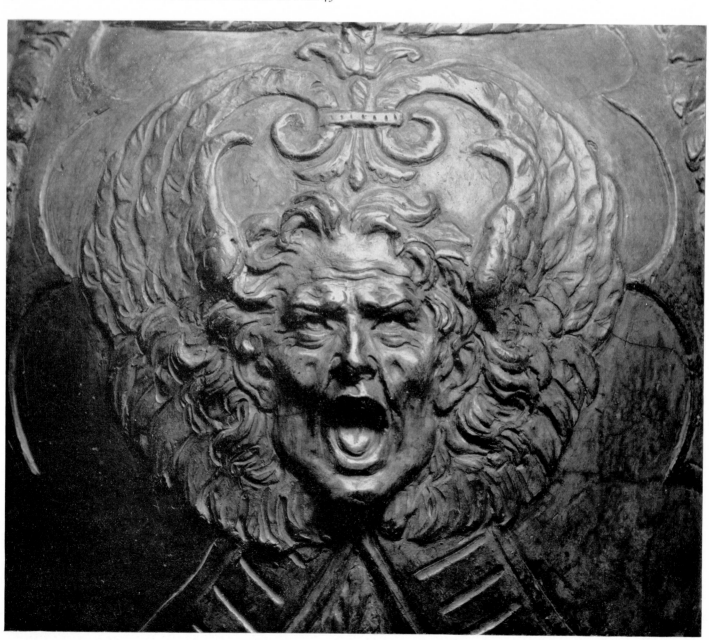

49. Hands of the Lady with a Bunch of Flowers. Cf. Plate 44

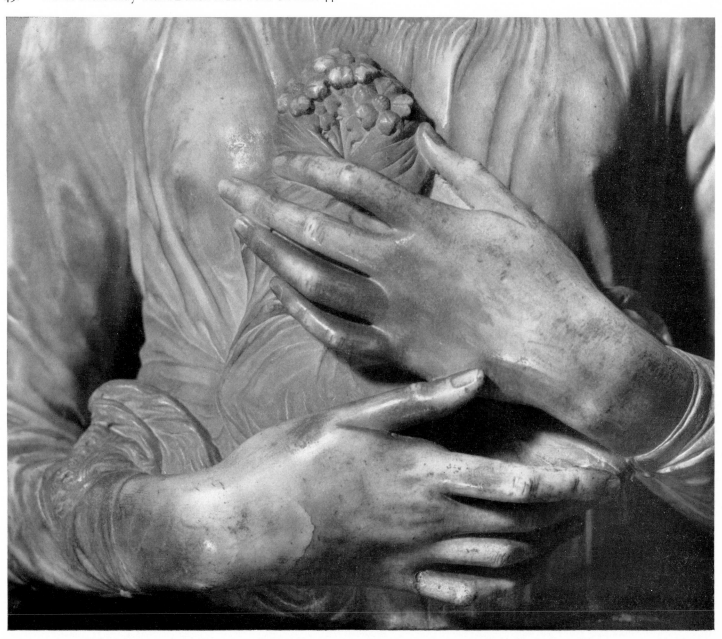

50. Marble relief from the tomb of Francesca Tornabuoni. Left half: Giovanni Tornabuoni receives the news of the death of his wife. Workshop execution. Height 45.5 cm. Florence, Museo Nazionale del Bargello (Cat. No. 11)

51. Marble relief from the tomb of Francesca Tornabuoni. Right half: The Death of Francesca Tornabuoni. Workshop execution. Height 45.5 cm. Florence, Museo Nazionale del Bargello (Cat. No. 11)

52. The Death of Francesca Tornabuoni. Detail of Plate 51

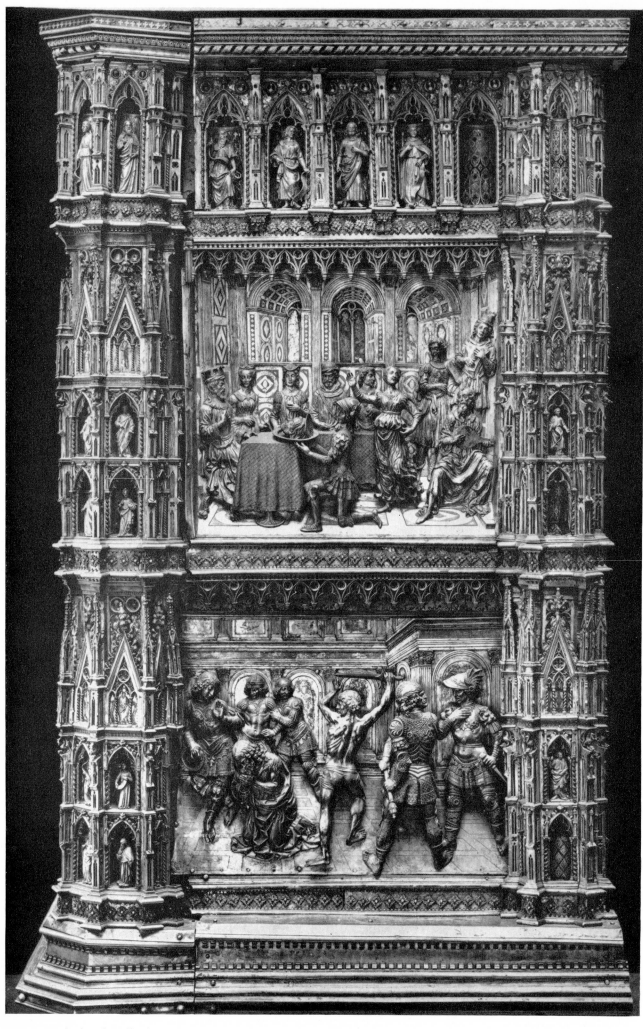

53. Right-hand wall of the silver antependium of the Baptistery altar. Florence, Museo dell'Opera del Duomo. Cf. Plate 54 (Cat. No. 13)

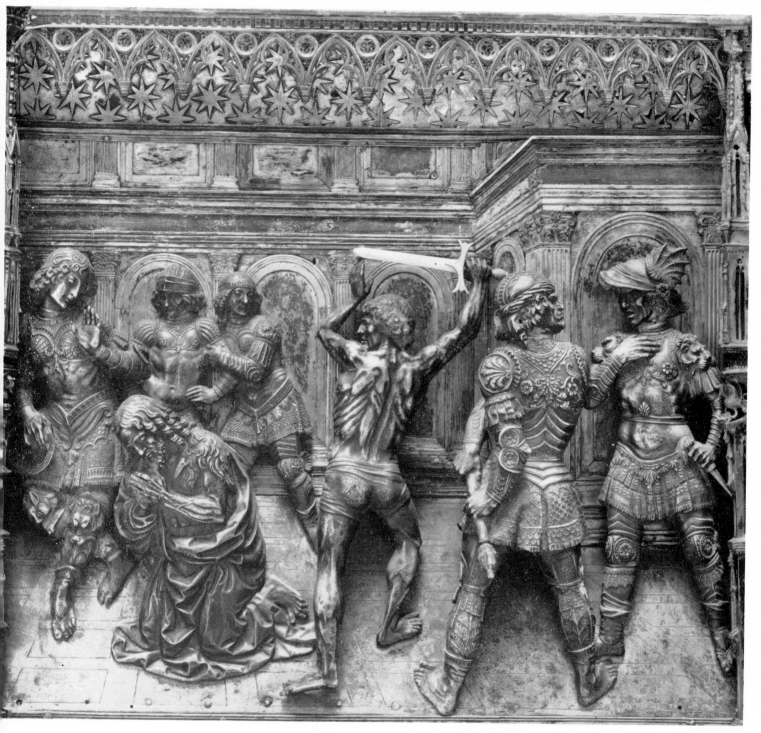

54. The Decollation of St. John the Baptist. Silver relief, ground embossed and chased. 31.5×42 cm. Florence, Museo dell'Opera del Duomo. (Cat. No. 13)

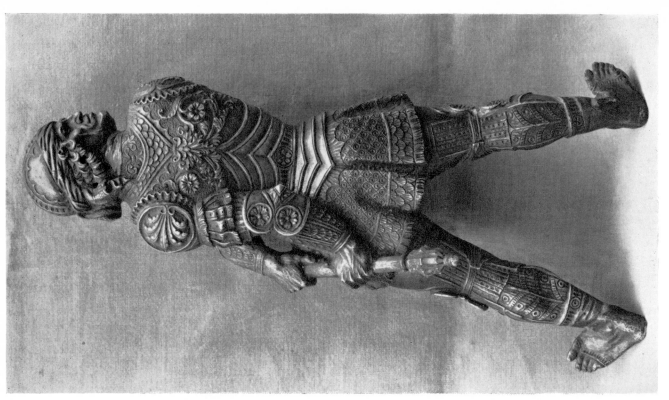

56. An officer. Cf. Plate 54

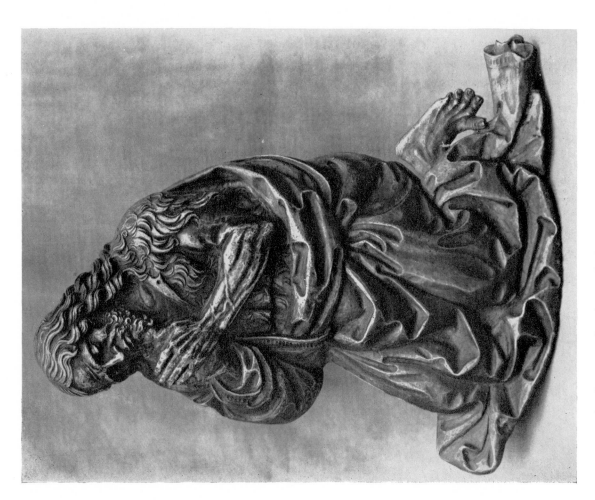

55. St. John the Baptist kneeling. Cf. Plate 54

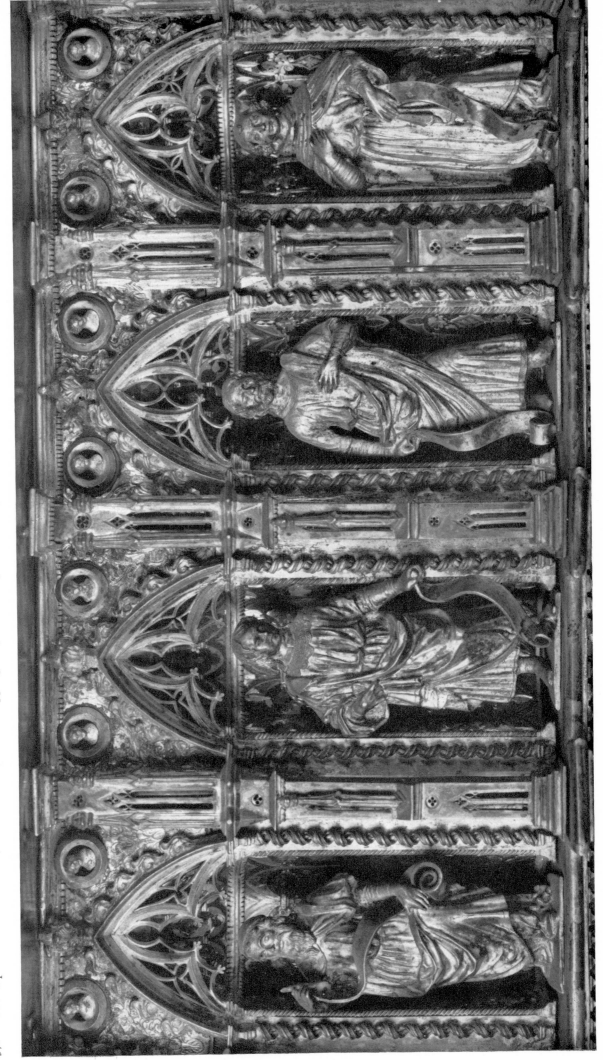

57. Four Apostles. Silver statuettes, cast and chased, from the upper gallery of the antependium. Height of figures c. 9 cm. Cf. Plate 53.

58. Angel. Bas-relief, terracotta, unpainted. 38 × 35 cm. Paris, Louvre (Cat. No. 14)

59. Leonardo da Vinci: Angel. Bas-relief, terracotta, unpainted. 38 × 35 cm. Paris, Louvre (Cat. No. 14)

60. Sleeping Youth. Terracotta, unpainted. Height 36 cm. Berlin, Staatliche Museen (Cat. No. 15)

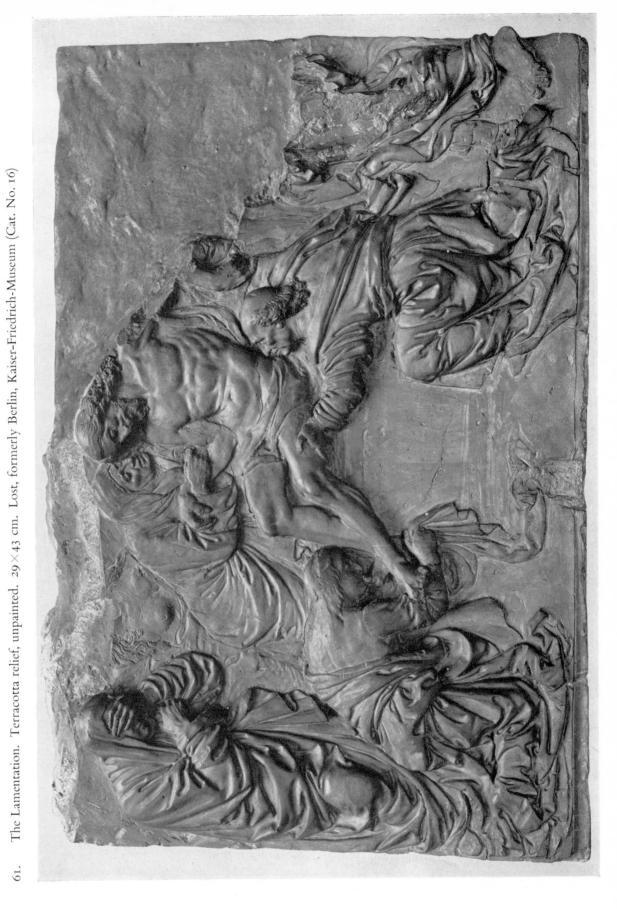

61. The Lamentation. Terracotta relief, unpainted. 29×43 cm. Lost, formerly Berlin, Kaiser-Friedrich-Museum (Cat. No. 16)

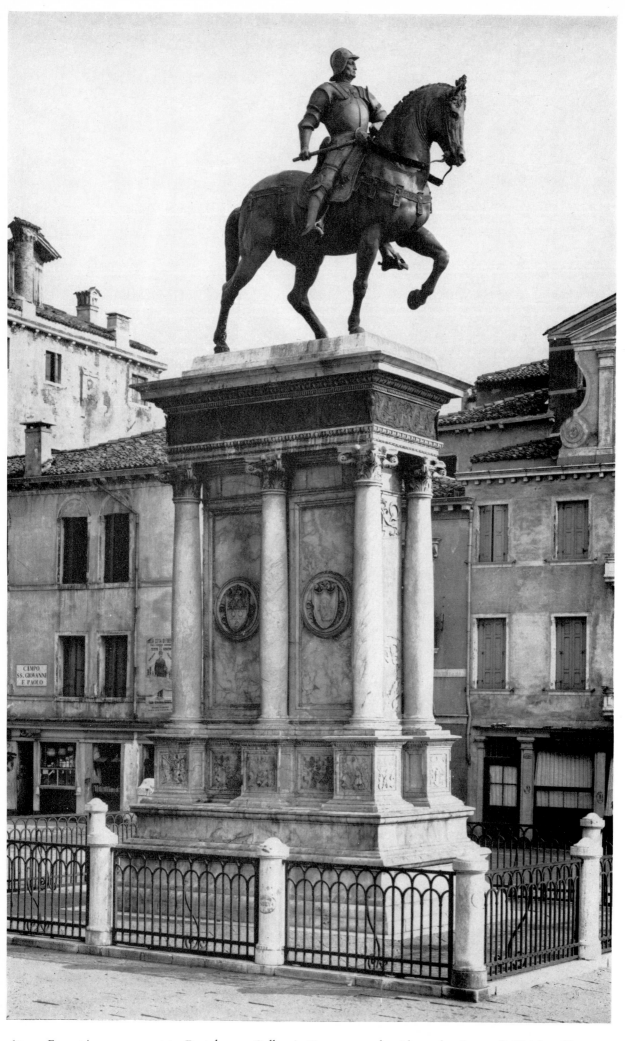

62. Equestrian monument to Bartolomeo Colleoni. Bronze, cast by Alessandro Leopardi. Height of horse
and rider (without marble plinth) 395 cm. Venice, Campo SS. Giovanni e Paolo (Cat. No. 17)

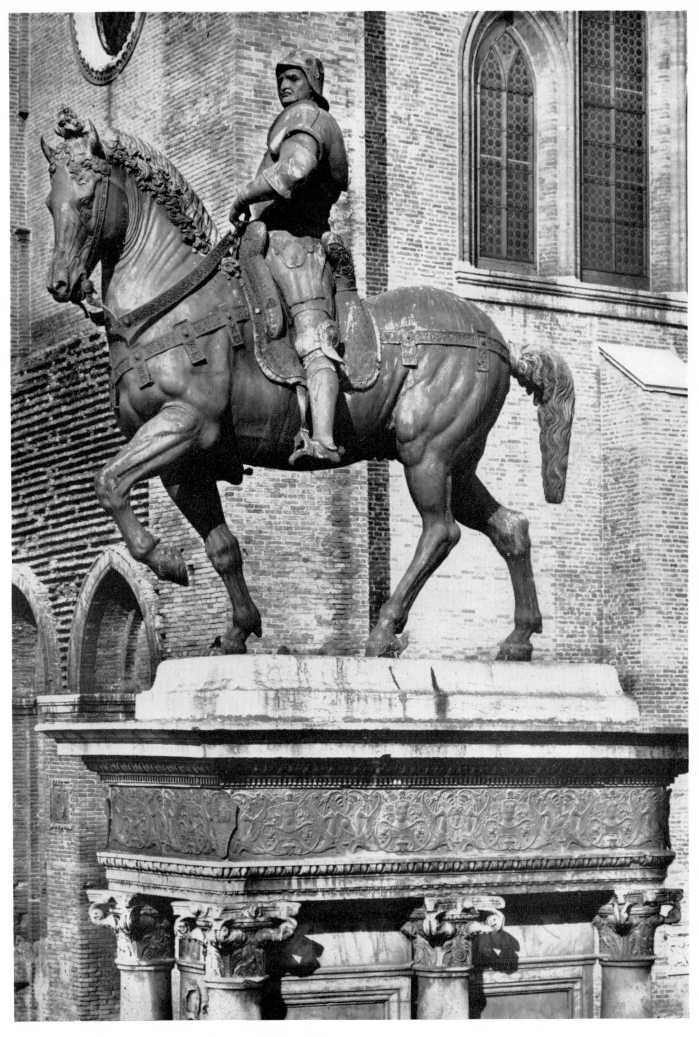

63. Equestrian monument to Bartolomeo Colleoni. Cf. Plate 62

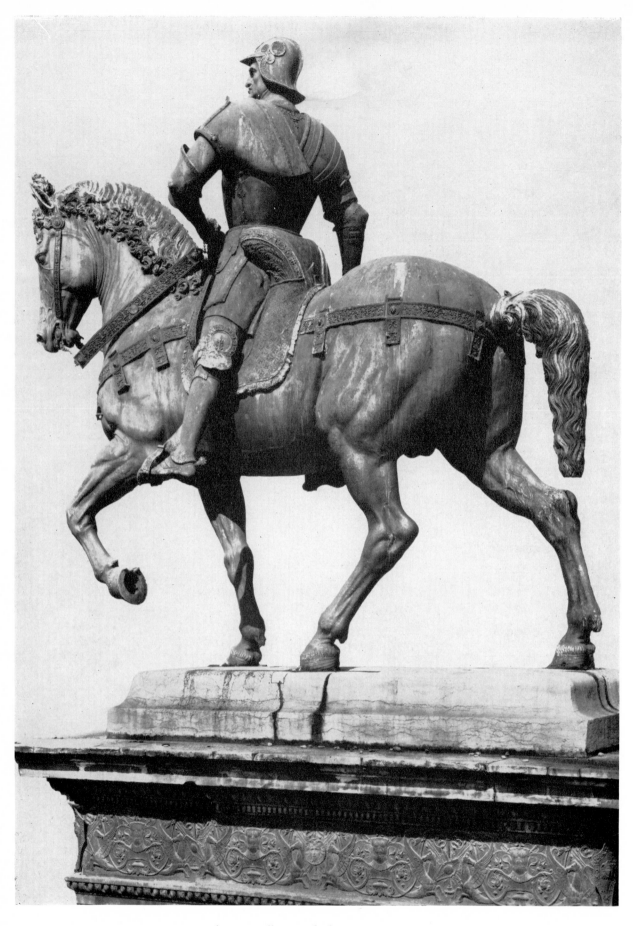

64. Equestrian monument to Bartolomeo Colleoni. Cf. Plate 62

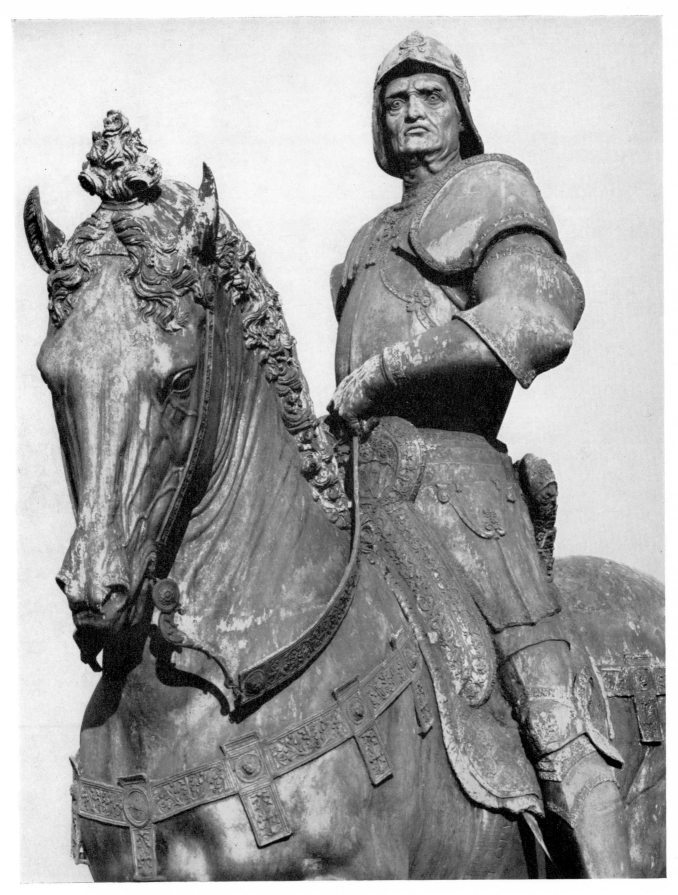

65. Equestrian monument to Bartolomeo Colleoni. Cf. Plate 62

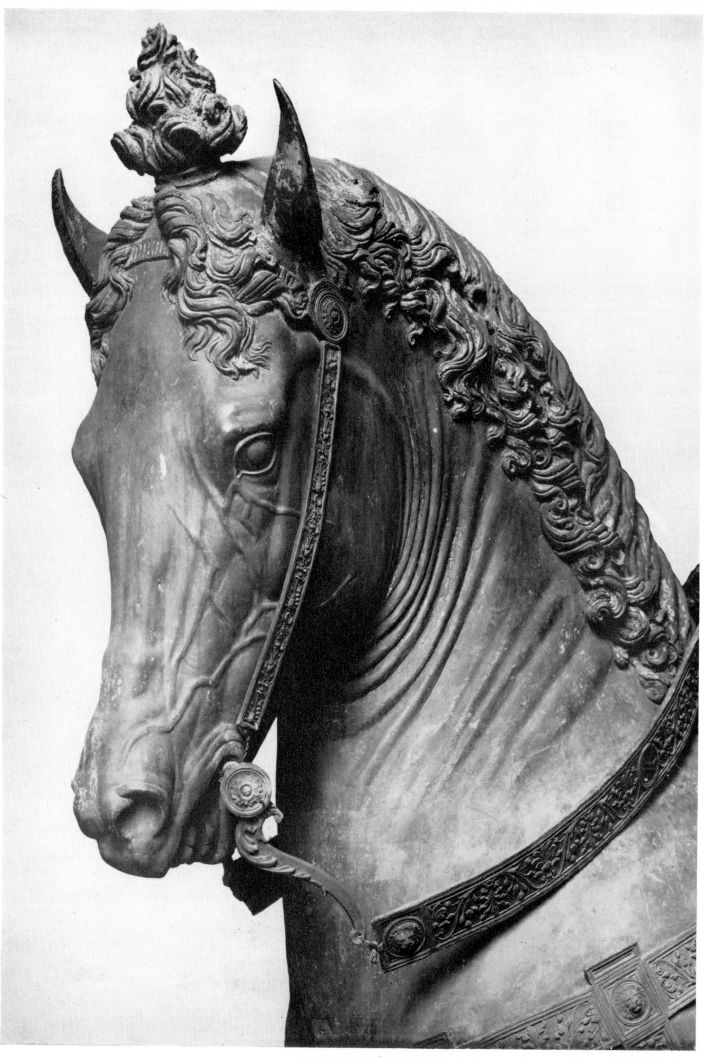

66. Horse's head. Cf. Plate 62

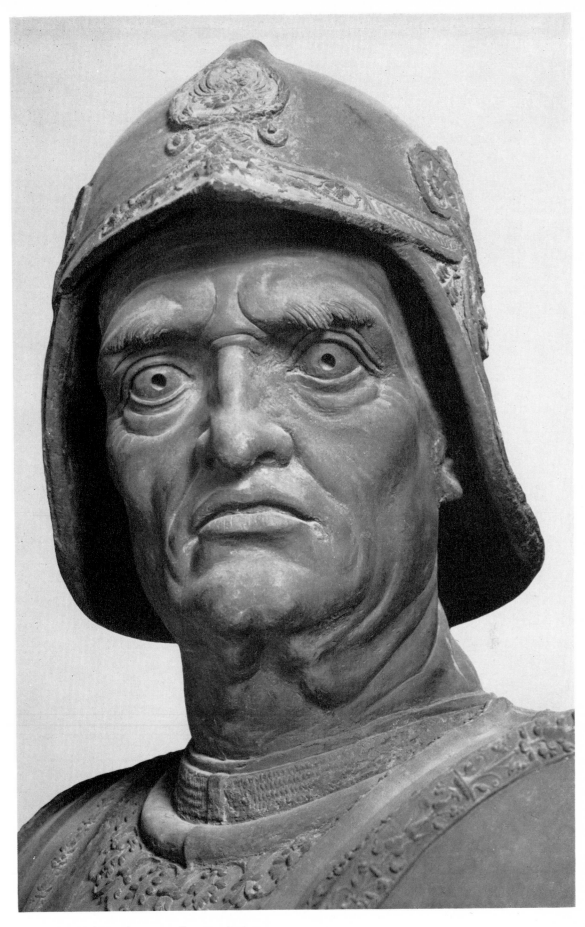

67. Head of Bartolomeo Colleoni. Cf. Plate 62

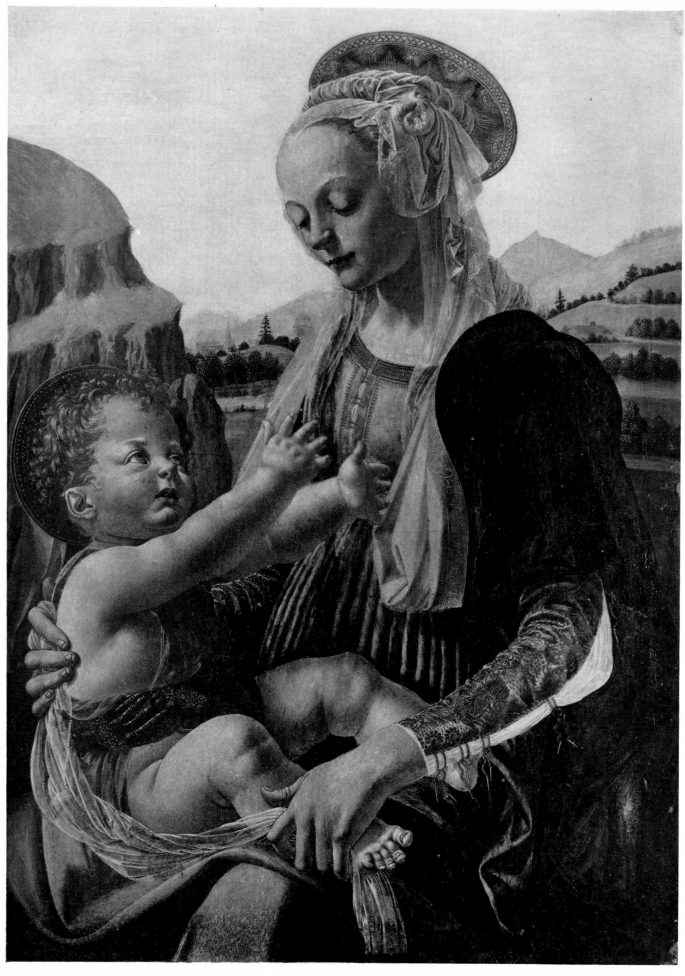

69. Madonna with Seated Child. Tempera on wood. 72 × 53 cm. Berlin, Staatliche Museen (Cat. No. 18)

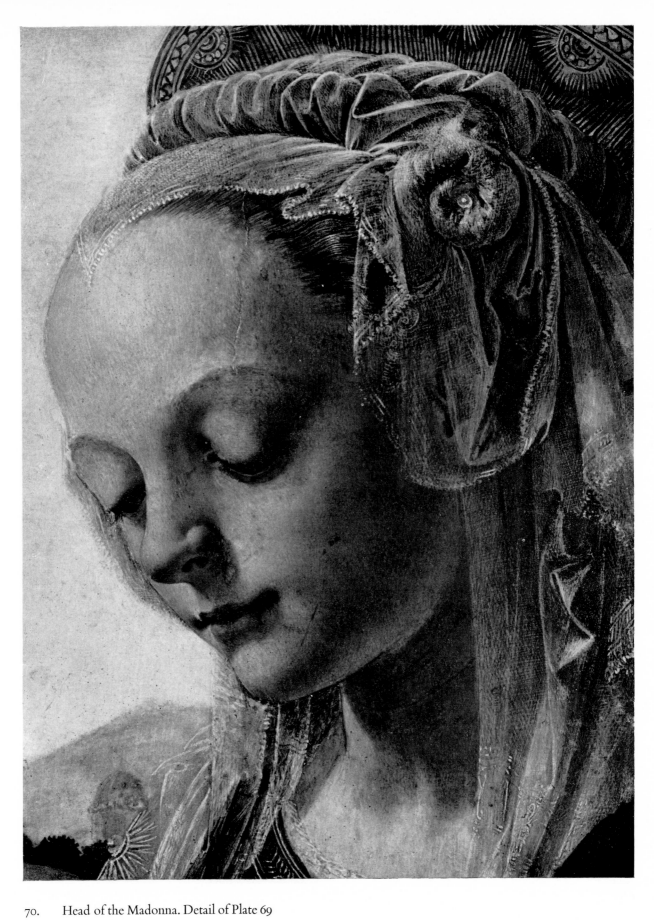

70. Head of the Madonna. Detail of Plate 69

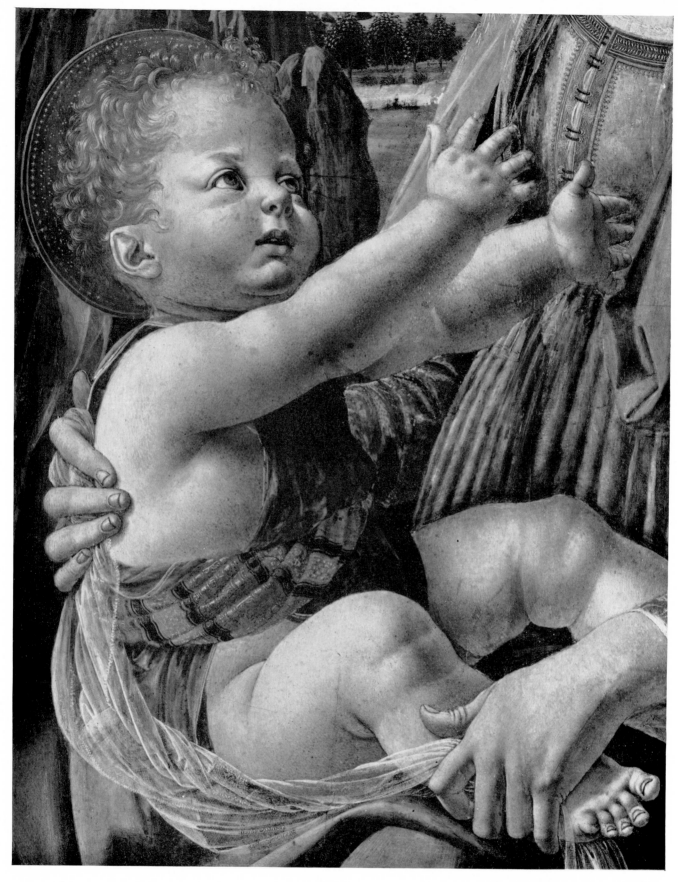

71. Christ Child. Detail of Plate 69

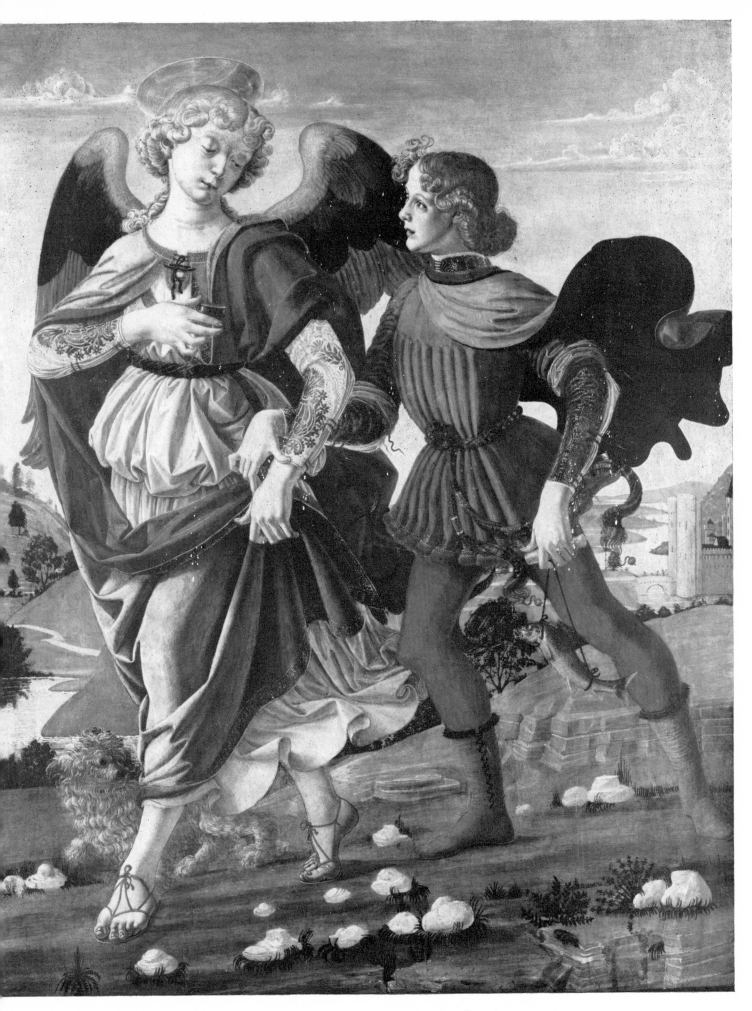

72.　Tobias and the Angel. Tempera on wood. 84×66 cm. London, National Gallery (Cat. No. 19)

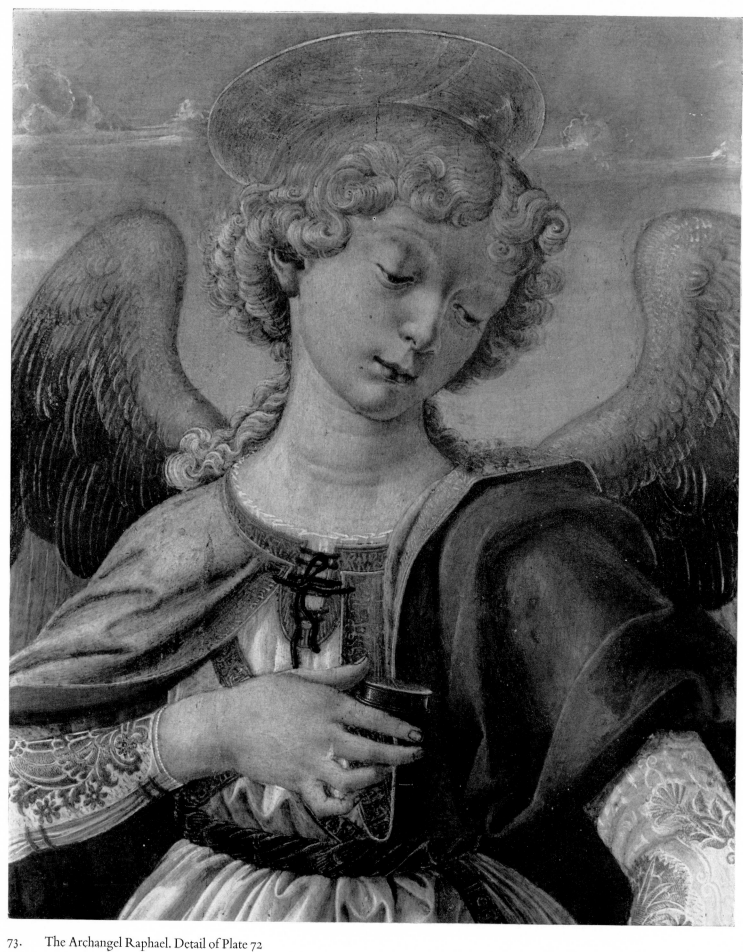

73. The Archangel Raphael. Detail of Plate 72

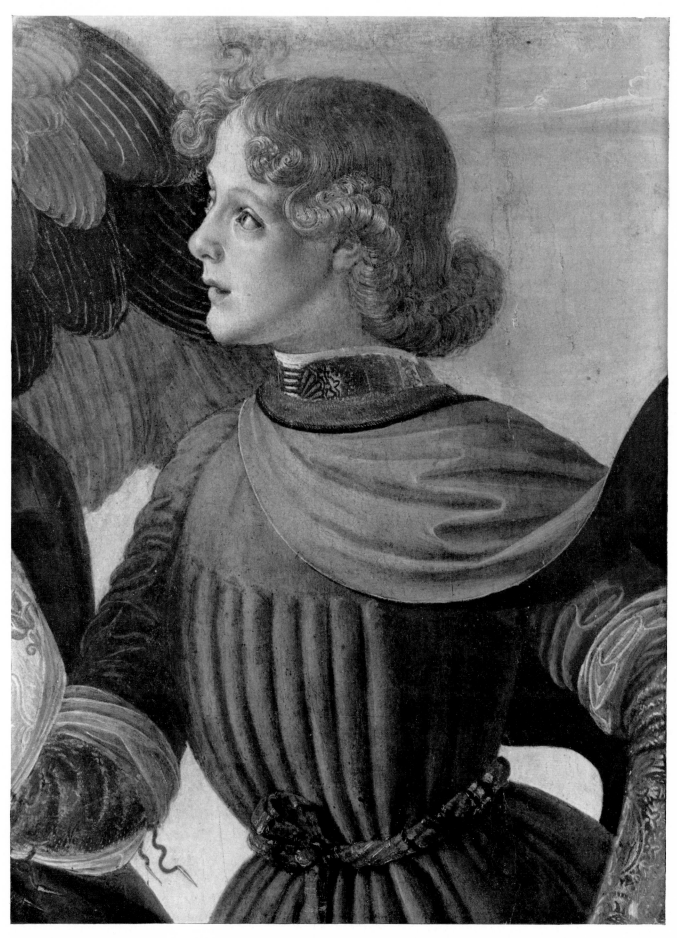

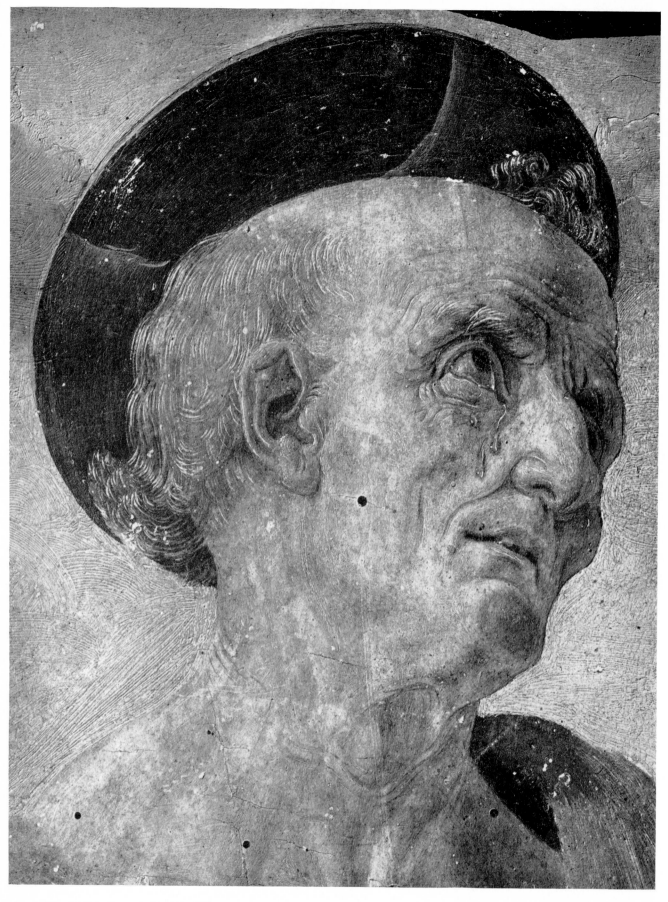

75. Head of St. Jerome. Detail of Plate 76

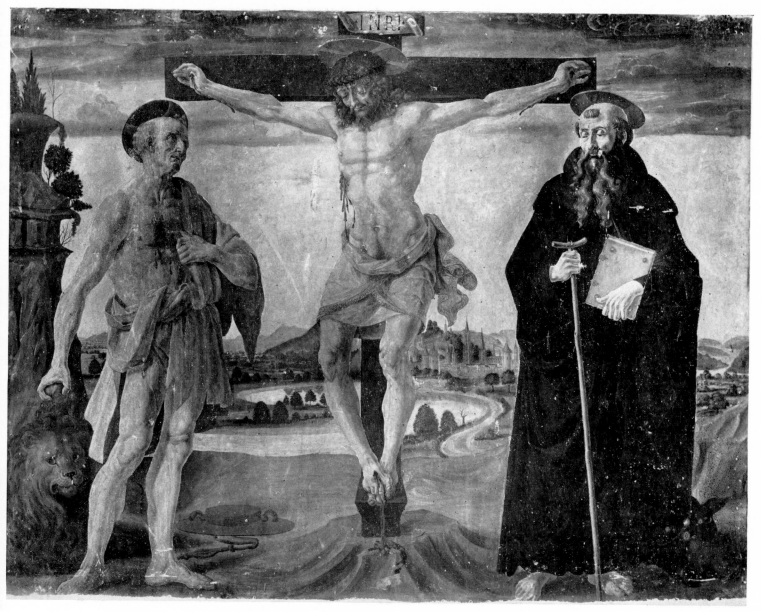

76. Christ on the Cross between St. Jerome and St. Anthony. Tempera on wood. 115×150 cm. Argiano, S. Maria e Angiolo, Sacristy. (Cat. No. 20)

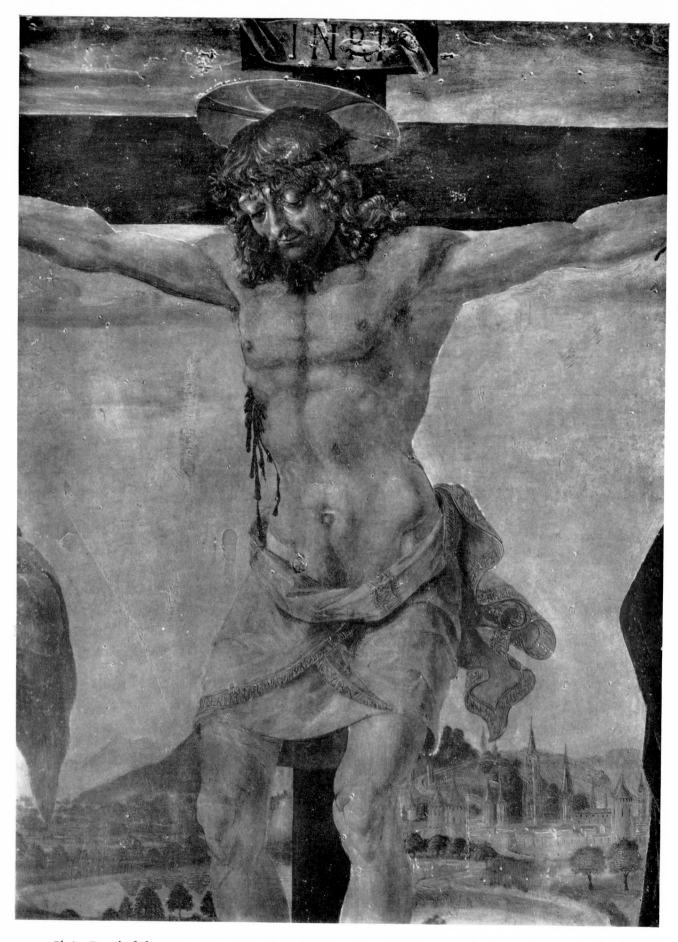

77. Christ. Detail of Plate 76

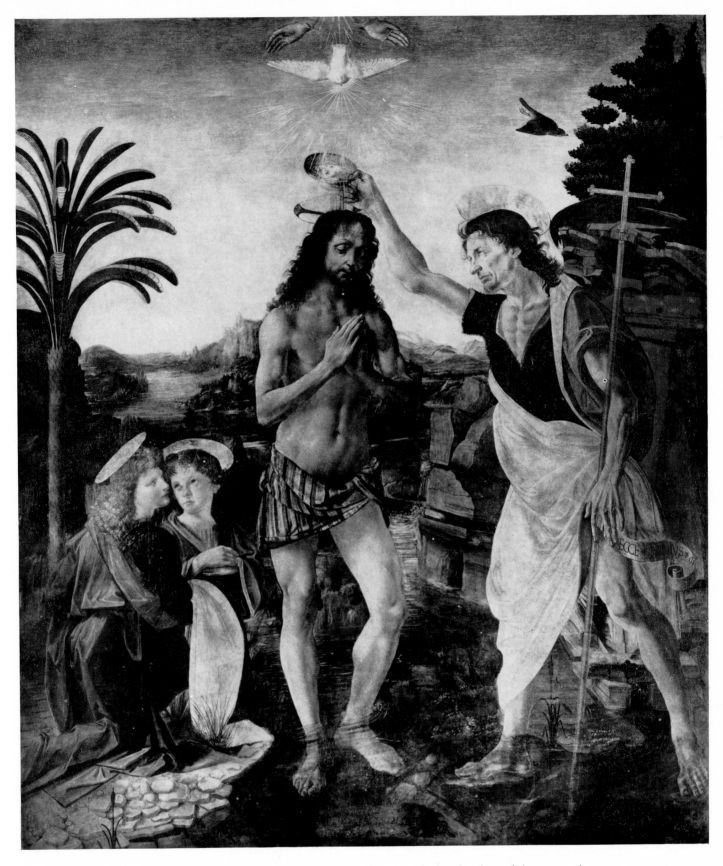

78. The Baptism of Christ. Tempera on wood, partly painted over and completed in oils by Leonardo. 177×151 cm.
Florence, Uffizi (Cat. No. 21)

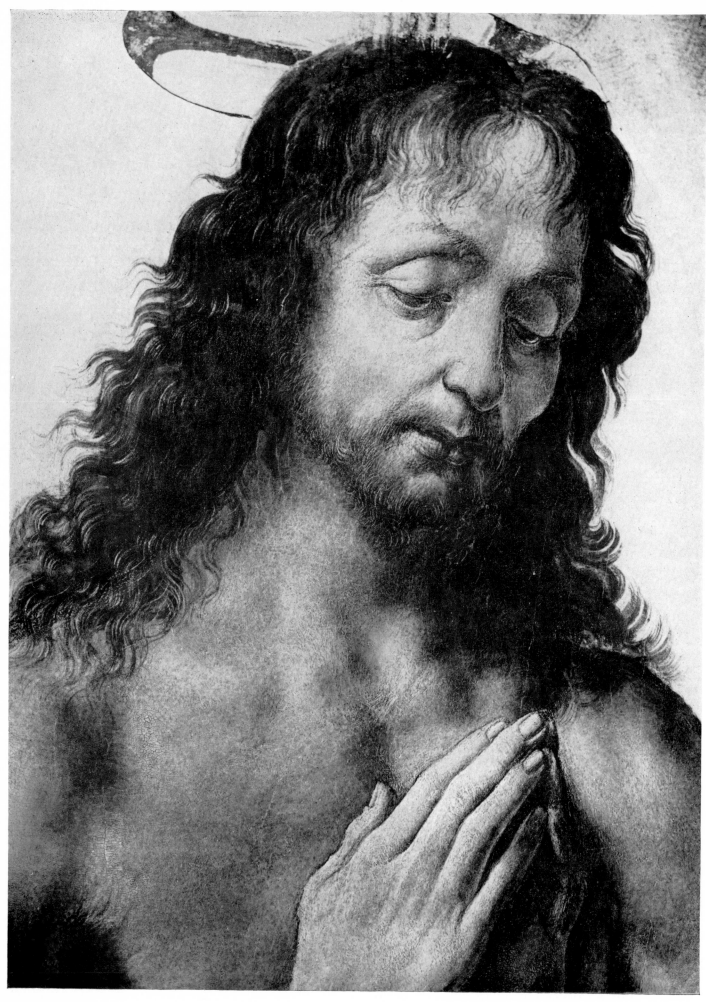

79. Head of Christ. Detail of Plate 78

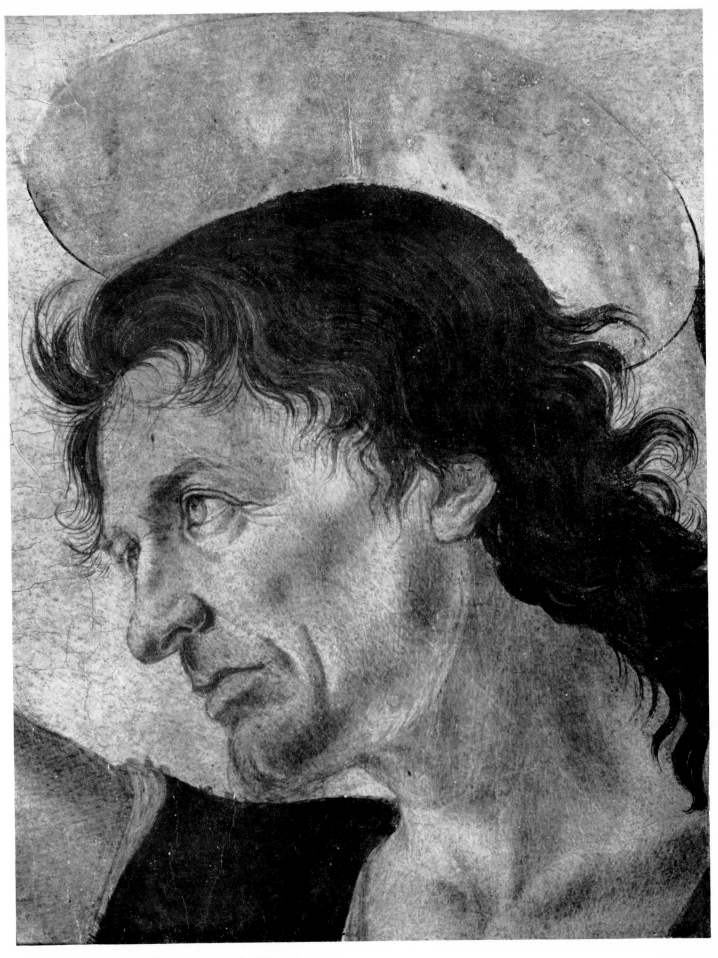

80. Head of St. John the Baptist. Detail of Plate 78

81. Landscape. Detail of Plate 78

82. Kneeling angels. Detail of Plate 78

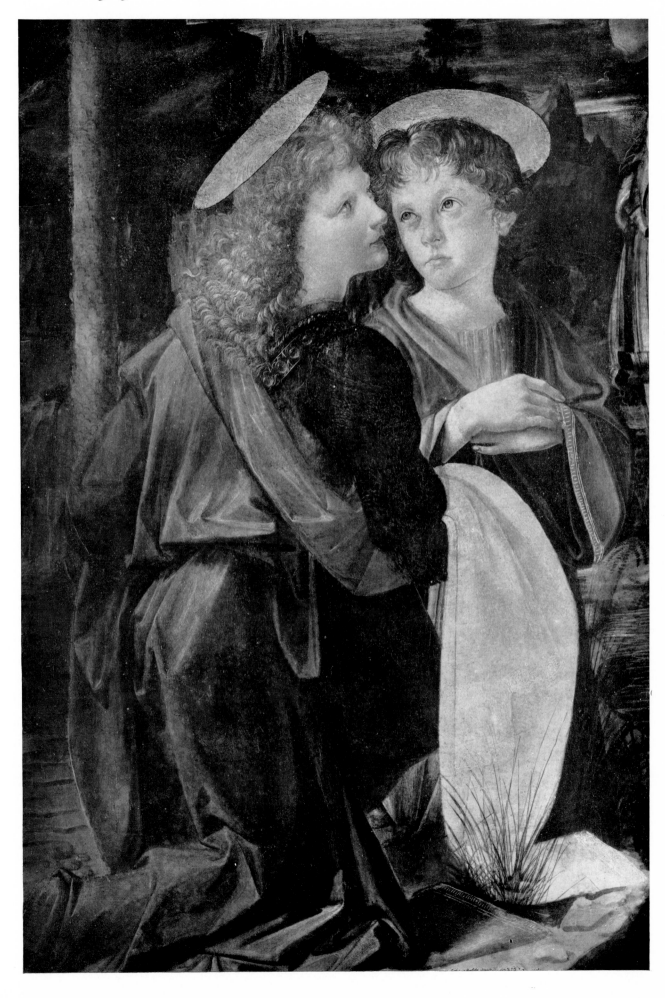

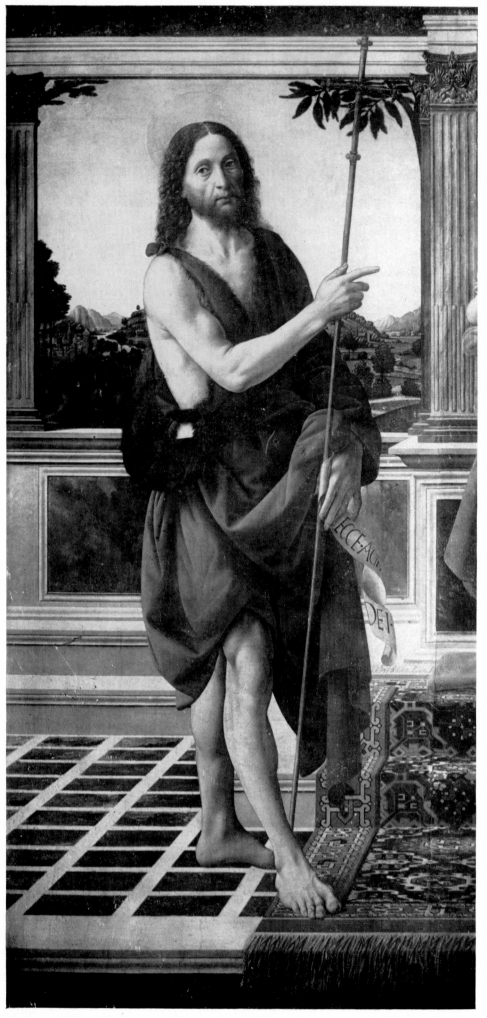

83. St. John the Baptist. Detail of Plate 84

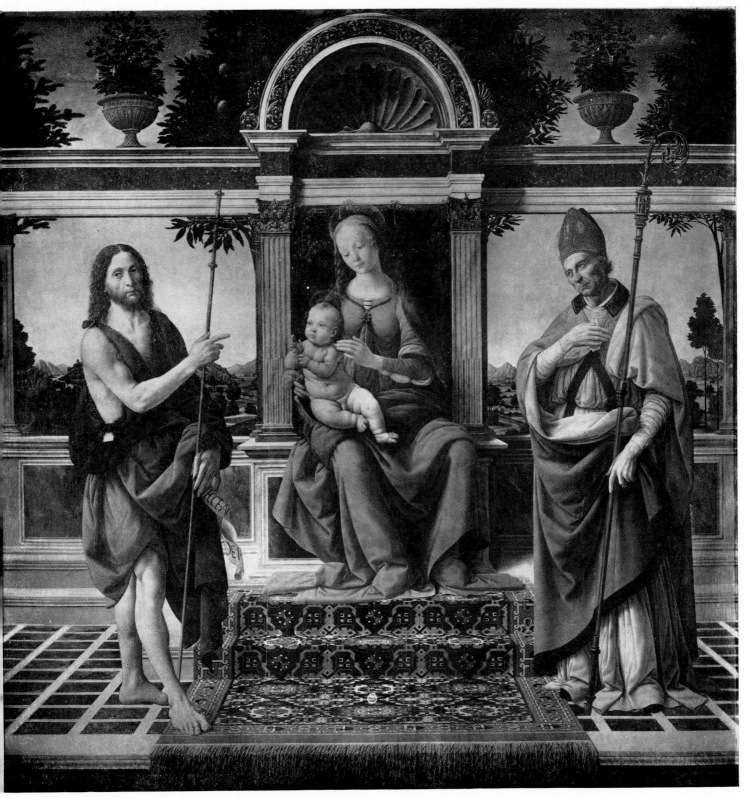

4. Madonna enthroned between St. John the Baptist and St. Donatus. Completed by Lorenzo di Credi. Oil on wood. 189 × 191 cm. Pistoia, Duomo, Chapel of the Sacrament (Cat. No. 22)

85. Landscape. Detail of Plate 84

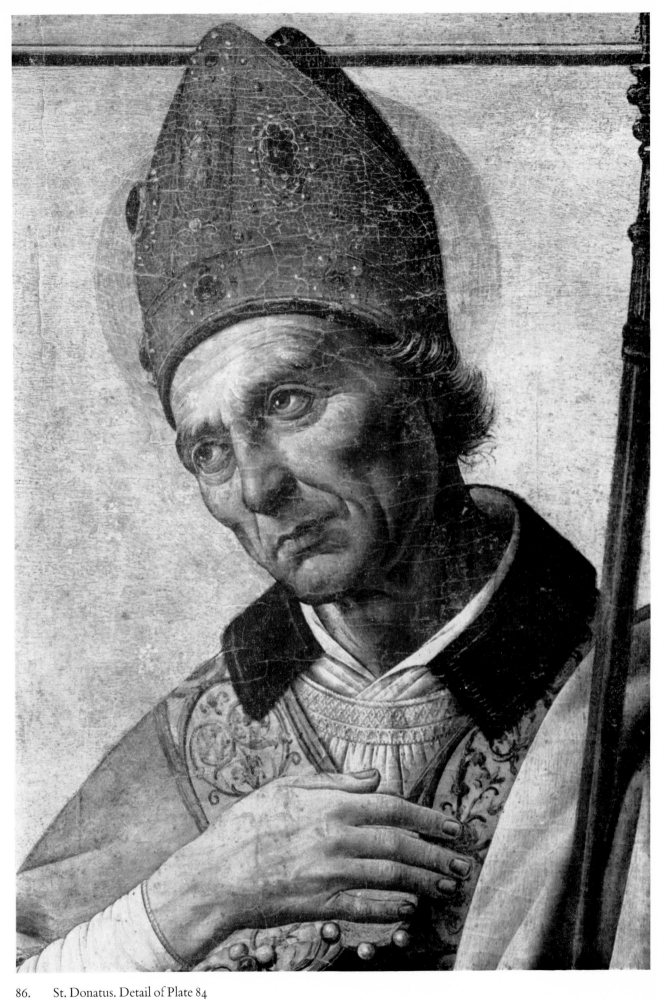

86. St. Donatus. Detail of Plate 84

89. Head of an Angel. Black chalk, gone over in sepia. 21 × 18.3 cm. Florence, Uffizi (Cat. No. D 1)

90. Three-quarter view of the head and torso of a naked child. Black chalk. 28 × 20 cm. Florence, Uffizi
(Cat. No. D 3 *verso*)

91.　St. John the Baptist. Silver point, gone over with ink by Lorenzo di Credi, bistre wash
heightened with white. 27×13 cm. Paris, Louvre (Cat. No. D 4)

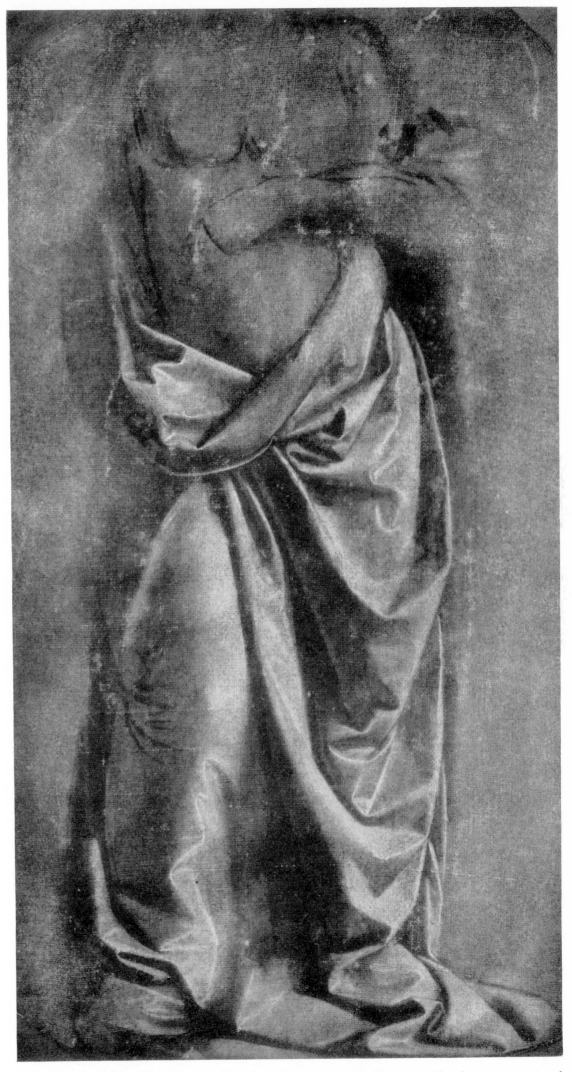

92. Drapery of the cloak on a standing figure. Umber wash heightened with white on grey tinted
linen. 28.2 × 15.7 cm. Florence, Uffizi (Cat. No. D 9)

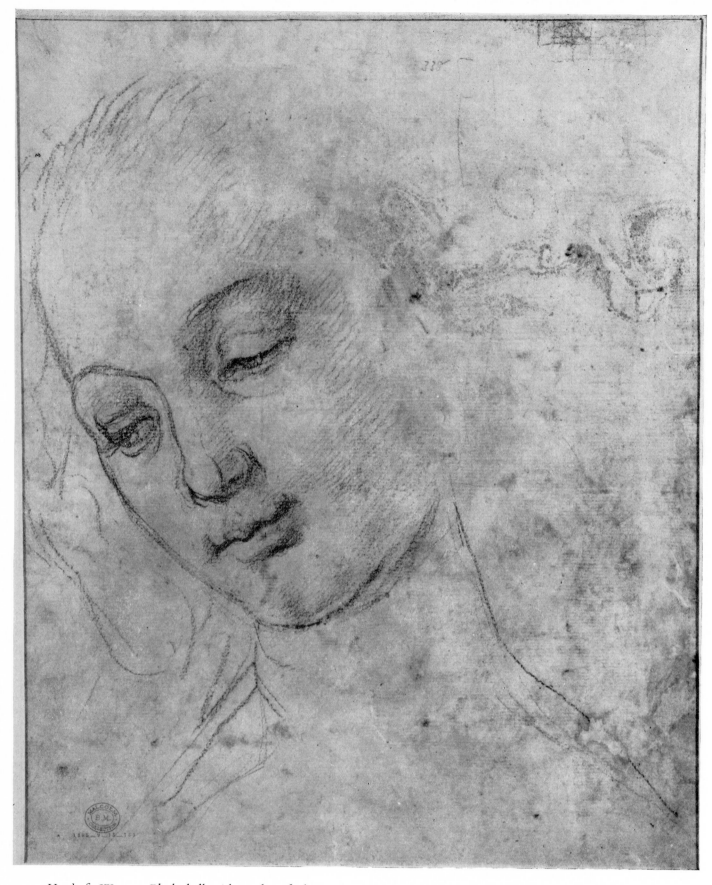

93. Head of a Woman. Black chalk with touches of white. 32.5 × 27.3 cm. London, British Museum (Cat. No. D 5 *verso*)

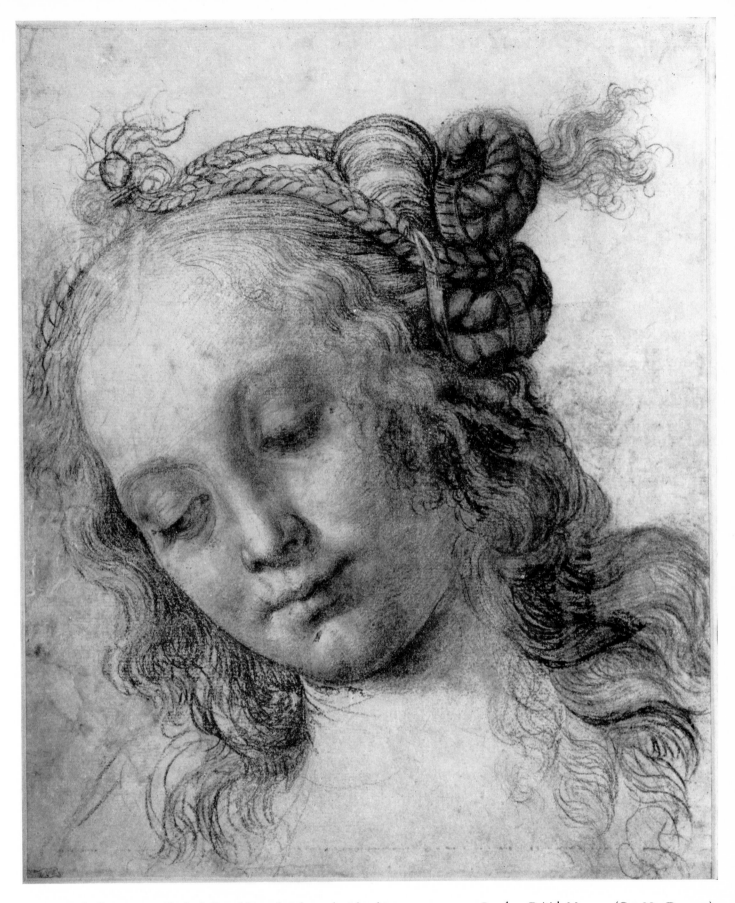

94. Head of a Woman. Black chalk and bistre heightened with white. 32.5 × 27.3 cm. London, British Museum (Cat. No. D 5 *recto*)

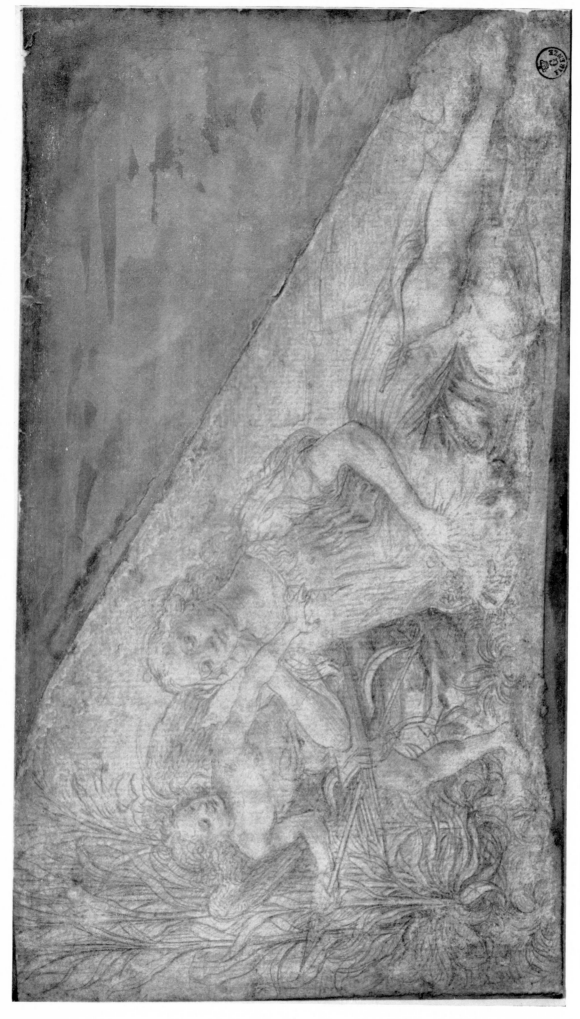

95. Venus and Cupid. Silver point and bistre. 15.2 × 26.3 cm. Florence, Uffizi (Cat. No. D 6)

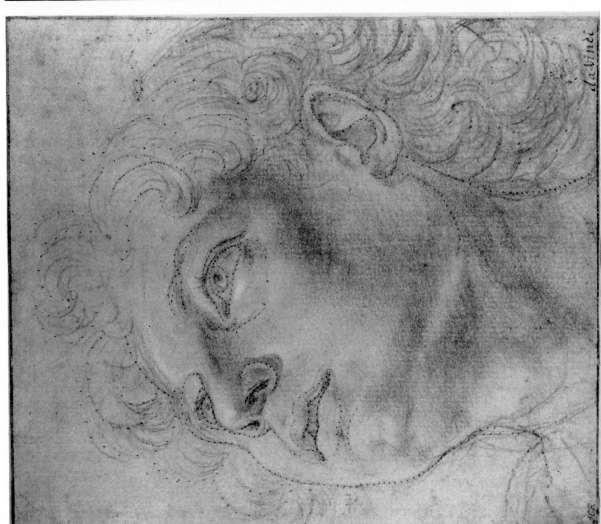

96. Head of a Girl or Boy. Black chalk heightened with white. 18.5 × 15.7 cm.
Berlin, Staatliche Museen (Cat. No. D 7 recto)

97. Head of a Girl or Boy. Black chalk. 18.5 × 15.7 cm. Berlin, Staatliche Museen
(Cat. No. D 7 verso)

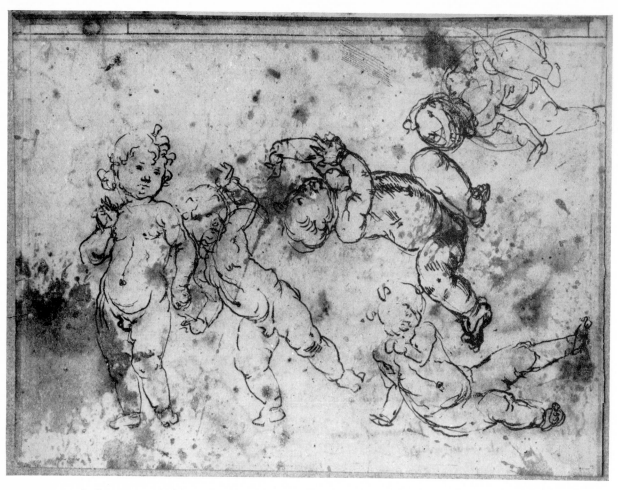

98. Five naked Putti. Pen and bistre. 14.5 × 20 cm. Paris, Louvre (Cat. No. D 10 *recto*)

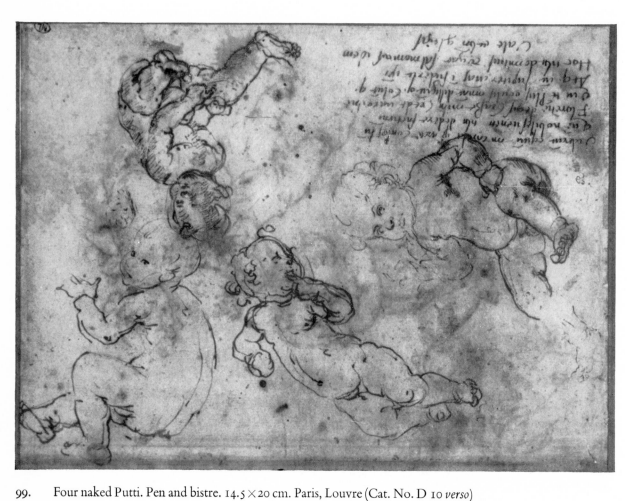

99. Four naked Putti. Pen and bistre. 14.5 × 20 cm. Paris, Louvre (Cat. No. D 10 *verso*)

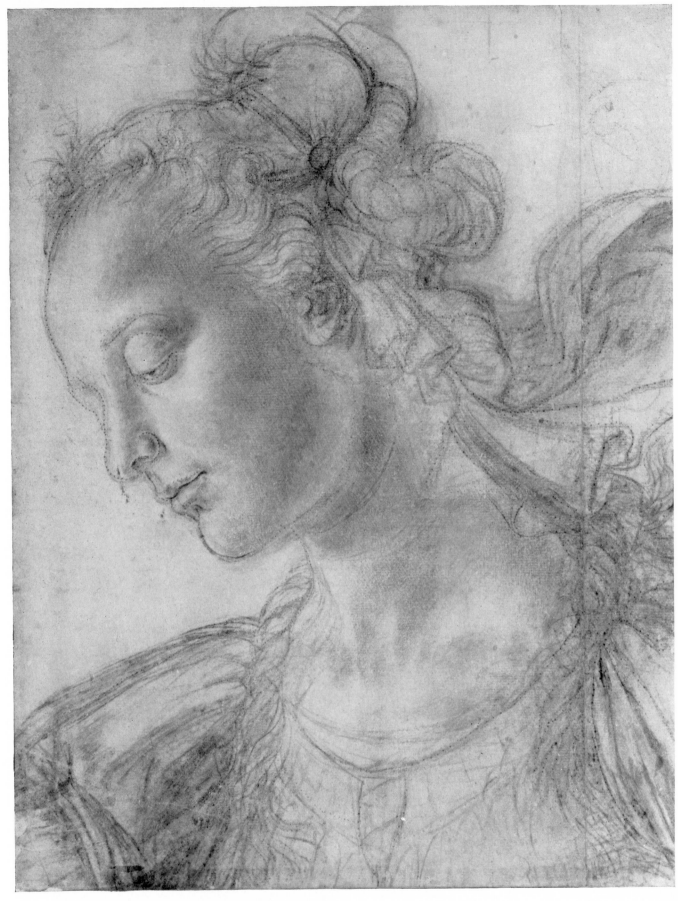

100. Head of a Woman. Black chalk heightened with white. 40.8 × 32.7 cm. Oxford, Christ Church (Cat. No. D 8)

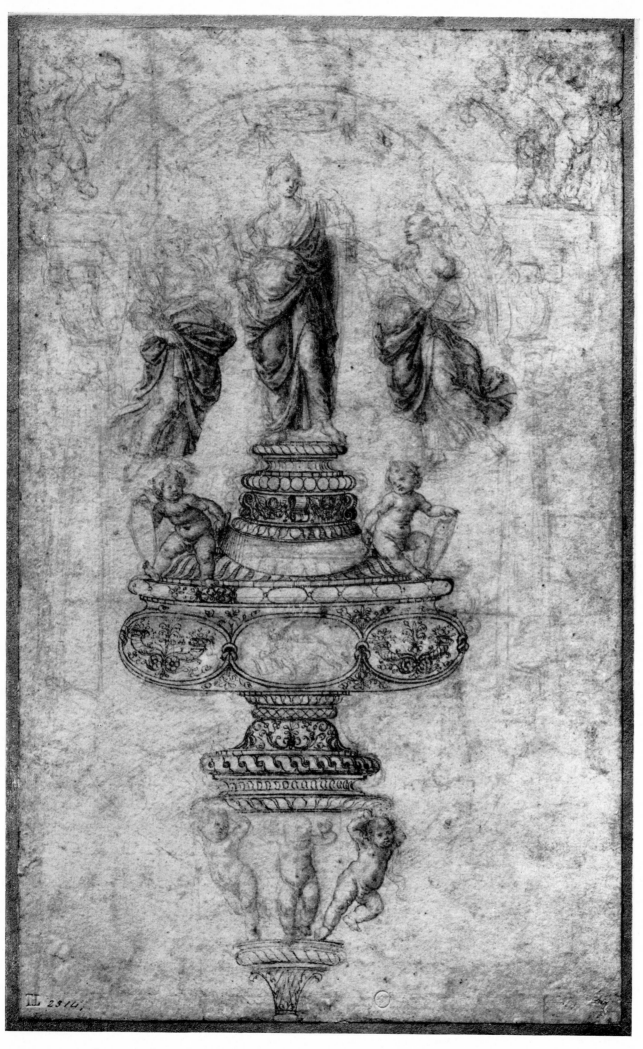

101. Drawing for a Console Tomb. Black lead, gone over with a pen by a later hand. 27 × 19.5 cm.
London, Victoria and Albert Museum (Cat. No. D 11)

CATALOGUE

BIBLIOGRAPHICAL ABBREVIATIONS

1–17

SCULPTURES

18–22

PAINTINGS

D1–D11

DRAWINGS

A1–A5

WORKS ERRONEOUSLY ATTRIBUTED
TO VERROCCHIO

BIBLIOGRAPHICAL ABBREVIATIONS

Albertini, *Memoriale*, 1510 (ed. 1863) – *Memoriale di molte statue e pitture della città di Firenze fatto da Francesco Albertini Prete. Firenze (Antonio Tubini), 1510.* New edition by Gaetano Milanesi, Cesare Guasti and Carlo Milanesi. Florence, 1863.

Andreucci 1871 – Andreucci, *Della Biblioteca e Pinacoteca dell'Arcispedale di S. Maria Nuova.* Florence, 1871.

Baldinucci I – Filippo Baldinucci, *Notizie de' professori del disegno da Cimabve in qva.* Vol. I. Florence, 1681.

Balniel 1931 – London, Royal Academy of Arts. *A Commemorative Catalogue of the Exhibition of Italian Art held in the Galleries of the Royal Academy, Burlington House, London, January–March 1930.* Edited by Lord Balniel and K. Clark with the advice of E. Modigliani. 2 vols. London, 1931.

Balogh 1966 – Jolán Balogh, *A müvészet Mátyás király udvarában.* 2 vols. Budapest, 1966.

Bayersdorfer (ed. 1902) – *Adolph Bayersdorfers Leben und Schriften.* Edited by Hans Mackowsky, August Pauly and Wilhlem Weigand. Munich, 1902.

Berenson 1896 – Bernard Berenson, *The Florentine Painters of the Renaissance.* London, 1896.

Berenson 1903 – Bernard Berenson, *The Drawings of Florentine Painters.* London, 1903.

Berenson 1912 – Bernard Berenson, *The Florentine Painters of the Renaissance.* London, 1912.

Berenson 1933/34 – Bernard Berenson, 'Verrocchio e Leonardo, Leonardo e Credi', in *Bollettino d'arte*, XXVII, 1933/34, p. 193 ff. and p. 241 ff.

Berenson 1938 – Bernard Berenson, *The Drawings of the Florentine Painters.* Enlarged edition. 3 vols. Chicago, 1938.

Berenson 1954 – Bernard Berenson, *Disegni di maestri fiorentini del Rinascimento in Firenze.* Turin, 1954.

Berenson 1961 – Bernard Berenson, *I disegni dei pittori fiorentini.* Revised and enlarged edition. 3 vols. Milan, 1961.

Berenson 1963 – Bernard Berenson, *Italian Pictures of the Renaissance. Florentine School.* London, 1963.

Bertini 1935 – Aldo Bertini, 'L'arte del Verrocchio', in *L'Arte*, XXXVIII, 1935, p. 433 ff.

Billi (ed. Frey) – Carl Frey, *Il libro di Antonio Billi.* Berlin, 1892.

Bode 1882 – Wilhelm Bode, 'Die italienischen Skulpturen der Renaissance in den Königlichen Museen. II. Bildwerke des Andrea del Verrocchio', in *Jahrbuch der Königlich Preußischen Kunstsammlungen*, III, 1882, p. 91 ff. and p. 235 ff.

Bode 1887 – Wilhelm Bode, *Italienische Bildhauer der Renaissance.* Berlin, 1887.

Bode 1899 – Wilhelm Bode, 'Verrocchio und das Altarbild der Sakramentskapelle im Dom zu Pistoja', in *Repertorium für Kunstwissenschaft*, XXII, 1899, p. 390.

Bode 1892–1905 – Wilhelm Bode, *Denkmäler der Renaissance-Sculptur Toscanas.* Vols. I–XI, plates, Vol. XII, text. Munich, 1892–1905.

Bode 1904 – Wilhelm Bode, 'Leonardo als Bildhauer', in *Jahrbuch der Königlich Preußischen Kunstsammlungen*, XXV, 1904, p. 125 ff.

Bode 1909 – Wilhelm Bode, 'Die Wachsbüste der Flora im Kaiser-Friedrich-Museum zu Berlin – ein Werk des Leonardo da Vinci?', in *Jahrbuch der Königlich Preußischen Kunstsammlungen*, XXX, 1909, p. 303.

Bode 1915 – Wilhelm von Bode, 'Leonardos Bildnis der jungen Dame mit dem Hermelin aus dem Czartoryski-Museum in Krakau und die Jugendbilder des Künstlers', in *Jahrbuch der Königlich Preußischen Kunstsammlungen*, XXVI, 1915, p. 189 ff.

Bode 1921 – Wilhelm von Bode, *Studien über Leonardo da Vinci.* Berlin, 1921.

Bongiorno 1962 – Laurine Mack Bongiorno, 'A Fifteenth-Century Stucco and the style of Verrocchio', in *Allen Memorial Art Museum Bulletin* (Oberlin), XIX, 1962, p. 115 ff.

Borghini (ed. Bottari) – Raffaello Borghini, *Il Riposo, in cui della pittura e della scultura si favella (Firenze, 1584).* Second annotated edition by Giovanni Bottari. Florence, 1730.

Bradshaw 1949 – Percy V. Bradshaw, *The Magic of Line – A Study of Drawing through the Ages.* London-New York, 1949.

Burckhardt 1855 – Jacob Burckhardt, *Der Cicerone.* Basel, 1855. [Quoted from Krönert's Pocket Edition, Vol. 154, Stuttgart.]

Burger 1904 – Fritz Burger, *Geschichte des florentinischen Grabmals von den ältesten Zeiten bis Michelangelo.* Strassburg, 1904.

Camesasca 1959 – Ettore Camesasca, *Tutta la pittura del Perugino.* Milan, 1959.

Cartwright 1910 – Julia Cartwright, *The Painters of Florence.* London, 1910.

Catalogo 1898 – *Catalogo del R. Museo Nazionale di Firenze.* Rome, 1898.

Chiappelli and Chiti 1899 – Alessandro Chiappelli and Alfredo Chiti, 'Andrea del Verrocchio in Pistoia', in *Bollettino storico Pistoiese*, I, 1899, p. 41 ff.

Chiappelli 1925 – Alessandro Chiappelli, 'Il Verrocchio e Lorenzo di Credi a Pistoia', in *Bollettino d'arte*, XIX, 1925/26, p. 49 ff.

Cicognara 1823 – Conte Leopoldo Cicognara, *Storia della scultura dal suo risorgimento in Italia fino al secolo di Canova*. Second emended and enlarged edition. Vol. IV. Prato, 1823.

Clark 1935 – Kenneth Clark, *A Catalogue of the Drawings of Leonardo da Vinci in the Collection of His Majesty the King at Windsor Castle*. London, 1935.

Cod. Magl. (ed. Frey) – Carl Frey, *Il Codice Magliabechiano*. Berlin, 1892.

Commissione Vinciana I 1928 – Reale Commissione Vinciana. *I disegni di Leonardo da Vinci*. Vol. I. Rome, 1928.

Covi 1966 – Dario A. Covi, 'Four new Documents Concerning Andrea del Verrocchio', in *The Art Bulletin*, XLVIII, 1966, p. 97 ff.

Crowe and Cavalcaselle, II, 1864 – J. A. Crowe and G. B. Cavalcaselle, *A new History of Painting in Italy*. Vol. II. London, 1864.

Crowe and Cavalcaselle, III, 1870 – J. A. Crowe und G. B. Cavalcaselle, *Geschichte der italienischen Malerei*. Vol. III. Leipzig, 1870.

Crowe and Cavalcaselle, VI, 1894 – J. A. Crowe e G. B. Cavalcaselle, *Storia della Pittura in Italia*. Vol. VI. Florence, 1894.

Cruttwell 1904 – Maud Cruttwell, *Verrocchio*. London-New York, 1904.

Dalli Regoli 1966 – Gigetta Dalli Regoli, *Lorenzo di Credi*. Milan, 1966.

Degenhart 1932 – Bernhard Degenhart, 'Di alcuni problemi di sviluppo della pittura nella bottega del Verrocchio, di Leonardo e di Lorenzo di Credi', in *Rivista d'arte*, XIV, 1932, p. 263 ff. and p. 403 ff.

Degenhart, *Müncher Jahrbuch*, 1932 – Bernhard Degenhart, 'Die Schüler des Lorenzo di Credi', in *Münchner Jahrbuch der bildenden Kunst* (new series), IX, 1932, p. 95 ff.

Degenhart 1933 – Bernhard Degenhart, 'Das Forteguerri-Monument – zur Publikation von Clarence Kennedy', in *Pantheon*, XI, 1933, p. 179 ff.

Degenhart 1934 – Bernhard Degenhart, 'Eine Gruppe von Gewandstudien des jungen Fra' Bartolomeo', in *Münchner Jahrbuch der bildenden Kunst* (new series), XI, 1934, p. 222 ff.

Disegni Uffizi I, 1912 – I disegni della R. Galleria degli Uffizi in Firenze. I. Florence, 1912.

Dussler 1940 – Luitpold Dussler, 'Andrea del Verrocchio', in U. Thieme und F. Becker, *Allgemeines Lexikon der bildenden Künstler von der Antike bis zur Gegenwart*. Vol. XXXIV, 1940, p. 292 ff.

Dvořák 1927 – Max Dvořák, *Geschichte der italienischen Kunst*. Vol. I. Munich, 1927.

Ede 1926 – Harold Stanley Ede, *Florentine Drawings of the Quattrocento*. London, 1926.

Fabriczy 1895 – Cornelius von Fabriczy, 'Andrea del Verrocchio ai servizi de' Medici', in *Archivio storico dell'arte*, I, 1895, p. 163 ff.

Fabriczy 1909 – Cornelius von Fabriczy, 'Kritisches Verzeichnis toskanischer Holz- und Tonstatuen bis zum Beginn des Cinquecento', in *Jahrbuch der Königlich Preußischen Kunstsammlungen*, XXX, 1909, Supplement.

Frey 1929 – Dagobert Frey, *Gotik und Renaissance als Grundlagen der modernen Weltanschauung*. Augsburg, 1929.

Frizzoni 1904 – Gustavo Frizzoni, 'L'arte toscana studiata nei disegni dei maestri antichi a proposito della pubblicazione di Bernardo Berenson (I)', in *Rassegna d'arte*, IV, 1904, p. 97 ff.

Galassi 1949 – Giuseppe Galassi, *La scultura fiorentina del Quattrocento*. Milan, 1949.

Gaye 1839 – Giovanni Gaye, *Carteggio inedito d'artisti dei secoli XIV, XV, XVI*. Vol. I. Florence, 1839.

Grassi 1961 – Luigi Grassi, *I disegni italiani del Trecento e Quattrocento – Scuole fiorentina, senese, marchigiana e umbra*. Venice, 1961.

Gronau 1913 – Georg Gronau, 'Lorenzo di Credi', in U. Thieme and F. Becker, *Allgemeines Lexikon der bildenden Künstler von der Antike bis zur Gegenwart*, Vol. VIII, Leipzig, 1913, p. 73 ff.

Heydenreich 1954 – Ludwig Heinrich Heydenreich, *Leonardo da Vinci*. 2 vols. Basle, 1954.

Kennedy, Wilder and Bacci 1932 – *The unfinished Monument by Andrea del Verrocchio to the Cardinal Niccolò Forteguerri at Pistoia*. Studies in the History and Criticism of Sculpture. Vol. 7. Photographs by Clarence Kennedy, Text by Elizabeth Wilder, Appendix of Documents by Peleo Bacci. Smith College, Northampton, Mass., 1932.

Landucci (ed. Del Badia) – Luca Landucci, *Diario fiorentino dal 1450 al 1516*. Published by Iodoco del Badia. Florence, 1883.

Lermolieff 1880 – Ivan Lermolieff (Giovanni Morelli), *Die Werke italienischer Meister in den Galerien von München, Dresden und Berlin*. Leipzig, 1880.

Lermolieff 1891 – Ivan Lermolieff (Giovanni Morelli), *Kunstkritische Studien über italienische Malerei – Die Galerien zu München und Dresden*. Leipzig, 1891.

Lermolieff 1893 – Ivan Lermolieff (Giovanni Morelli), *Kunstkritische Studien über italienische Malerei – Die Galerie zu Berlin*. Leipzig, 1893.

Liphart 1912 – Ernst von Liphart, 'Kritische Gänge und Reiseeindrücke', in *Jahrbuch der Königlich Preußischen Kunstsammlungen*, XXXIII, 1912, p. 193 ff.

Mackowsky 1896 – Hans Mackowsky, 'Das Lavabo in San Lorenzo zu Florenz', in *Jahrbuch der*

Königlich Preußischen Kunstsammlungen, XVII, 1896, p. 239 ff.

Mackowsky 1901 – Hans Mackowsky, *Verrocchio*. Berlin and Bielefeld, 1901.

Maclagan and Longhurst 1932 – London, Victoria and Albert Museum. *Catalogue of Italian Sculpture*. By Sir E. R. D. Maclagan and M. H. Longhurst. 2 vols. London, 1932.

Malaguzzi-Valeri 1922 – Francesco Malaguzzi-Valeri, *Leonardo da Vinci e la scultura*. Bologna, 1922.

van Marle, XI, 1929 – Raimond van Marle, *The Development of the Italian Schools of Painting*. Vol. XI. The Hague, 1929.

Marrai 1907 – Bernardo Marrai, *La Primavera del Botticelli* (and other essays). Florence, 1907.

Middeldorf 1934 – Ulrich Middeldorf, Review of: Cl. Kennedy, E. Wilder and P. Bacci, 'The unfinished Monument by Andrea del Verrocchio to the Cardinal Niccolò Forteguerri at Pistoia', Northampton (Mass.), 1932, in *Zeitschrift für Kunstgeschichte*, III, 1934, p. 54 ff.

Middeldorf 1935 – Ulrich Middeldorf, 'Frühwerke des Andrea del Verrocchio' (Résumé of lecture), Report on the 51st Session on 29th May 1935, in *Mitteilungen des Kunsthistorischen Institutes in Florenz*, vol. V, 1937/40, p. 209.

Migliarini 1858 – A. Michele Migliarini, *Museo di sculture del risorgimento raccolto e posseduto da Ottavio Gigli*. Illustrated by Cav. Prof. A. M. Migliarini, Florence, 1858.

Moreni 1795 – Domenico Moreni, *Notizie istoriche de' contorni di Firenze*. VI. Florence, 1795.

Moreni 1817 – Domenico Moreni, *Continuazione delle memorie istoriche dell'Ambrosiana imperial Basilica di S. Lorenzo di Firenze*. I. Florence, 1817.

Müller-Walde 1889 – Paul Müller-Walde, *Leonardo da Vinci*. Munich, 1889.

Müntz 1888 – Eugène Müntz, *Les Collections des Medicis au XV^e siècle*. Paris, 1888.

Müntz, I, 1889 – Eugène Müntz, *Histoire de L'Art pendant la Renaissance. I. Italie. Les Primitifs*. Paris, 1889.

Müntz, II, 1891 – Eugène Müntz, *Histoire de l'Art pendant la Renaissance. II. Italie. L'Age d'Or*. Paris, 1891.

Paatz, II, 1941 – Walter und Elisabeth Paatz, *Die Kirchen von Florenz – ein kunstgeschichtliches Handbuch*. Vol. II: *D-L*. Frankfurt, 1941.

Paatz, IV, 1952 – Walter und Elisabeth Paatz, *Die Kirchen von Florenz – ein kunstgeschichtliches Handbuch*. Vol. IV: *SS. Maccabei–S. Maria Novella*. Frankfurt, 1952.

Passavant 1959 – Günter Passavant, *Andrea del Verrocchio als Maler*. Düsseldorf, 1959.

Passavant 1960 – Günter Passavant, 'Beobachtungen am Verkündigungsbild aus Monte Oliveto', in *Mitteilungen des Kunsthistorischen Institutes in Florenz*, IX, 1960, p. 71 ff.

Passavant 1966 – Günter Passavant, 'Beobachtungen am Silberaltar des Florentiner Baptisteriums', in *Pantheon*, XXIV, 1966, p. 10 ff.

Perkins 1864 – Charles C. Perkins, *Tuscan Sculptors: their Lives, Works, and Times*. Vol. I. London, 1864.

Planiscig 1933 – Leo Planiscig, 'Andrea del Verrocchios Alexander-Relief', in *Jahrbuch der Kunsthistorischen Sammlungen in Wien* (new series), VII, 1933, p. 89 ff.

Planiscig 1941 – Leo Planiscig, *Andrea del Verrocchio*. Vienna, 1941.

Pope-Hennessy 1958 – John Pope-Hennessy, *An Introduction to Italian Sculpture. II: Italian Renaissance Sculpture*. London, 1958.

Pope-Hennessy 1964 – John Pope-Hennessy (with the assistance of Ronald Lightbown), *Catalogue of Italian Sculpture in the Victoria and Albert Museum*. Vol. I, Text: *Eighth to fifteenth century*. London, 1964.

Popham 1931 – London, Royal Academy of Arts. A. E. Popham, *Italian Drawings exhibited at the Royal Academy, Burlington House, London 1930*. Oxford, 1931.

Popham and Pouncey 1950 – A. E. Popham and P. Pouncey, *Italian Drawings in the Department of Prints and Drawings in the British Museum*. 2 vols. London, 1950.

Ragghianti 1935 – Carlo Ludovico Ragghianti, 'La giovanezza e lo svolgimento artistico di Domenico Ghirlandaio', in *L'Arte*, XXXVIII, 1935, p. 167 ff. and p. 341 ff.

Ragghianti 1954 – Carlo Ludovico Ragghianti, 'Inizio di Leonardo', in *Critica d'arte*, 1954, p. 102 ff. and p. 302 ff.

Reymond, II, 1898 – Marcel Reymond, *La sculpture florentine*. Vol. II: *Première moitié du XV^e siècle*. Florence, 1898.

Reymond, III, 1899 – Marcel Reymond, *La sculpture florentine*. Vol. III: *Seconde moitié du XV^e siècle*. Florence, 1899.

Reymond 1906 – Marcel Reymond, *Verrocchio*. Paris, 1906.

Richa, I, 1754 – Giuseppe Richa, *Notizie istoriche delle chiese fiorentine divise ne' suoi quartieri*. Vol. I: *Del quartiere di Santa Croce*. Florence, 1754.

Richa, V, 1757 – Giuseppe Richa, *Notizie istoriche delle chiese fiorentine divise ne' suoi quartieri*. Vol. V: *Del quartiere di S. Giovanni*. Florence, 1757.

Ridolfi 1899 – Enrico Ridolfi, 'La Galleria dell'Arcispedale di S. Maria Nuova in Firenze', in *Le Gallerie Nazionali Italiane. Notizie e documenti*. 6th year, 1899, p. 162 ff.

Robinson 1862 – London, South Kensington Museum. J. C. Robinson, *Italian sculpture of the Middle Ages and period of the revival of art. A descriptive catalogue of the works forming the above section of the Museum, with additional illustrative notices.* London, 1862.

Rumohr (ed. 1920) – Carl Friedrich von Rumohr, *Italienische Forschungen* (1827–31). Edited by Julius von Schlosser. Frankfurt, 1920.

Schmarsow 1897 – August Schmarsow, 'Italienische Malerschulen in der Londoner Nationalgalerie', in *Festschrift zu Ehren des Kunsthistorischen Institutes in Florenz, dargebracht vom Kunsthistorischen Institut Leipzig.* Leipzig, 1897, p. 122 ff.

Schottmüller 1913 – Berlin, Königliche Museen zu Berlin. *Beschreibung der Bildwerke der christlichen Epochen.* Second edition, Volume 5: *Die italienischen und spanischen Bildwerke der Renaissance und des Barocks in Marmor, Ton, Holz und Stuck.* Revised by Frida Schottmüller. Berlin, 1913.

Schottmüller 1933 – Berlin, Staatliche Museen zu Berlin. *Bildwerke des Kaiser-Friedrich-Museums. Die italienischen und spanischen Bildwerke der Renaissance und des Barock.* Volume 1: *Die Bildwerke in Stein, Holz, Ton und Wachs.* Second edition, revised by Frida Schottmüller. Berlin and Leipzig, 1933.

Schubring 1904 – Paul Schubring, *Das italienische Grabmal.* Berlin, 1904.

Schubring 1915 – Paul Schubring, *Die italienische Plastik des Quattrocento.* Berlin, 1915.

Seidlitz 1909 – Woldemar von Seidlitz, *Leonardo da Vinci.* I. Berlin, 1909.

Semper 1875 – Hans Semper, *Donatello, seine Zeit und Schule.* Quellenschriften für Kunstgeschichte IX. Vienna, 1875.

Semper 1877 – Hans Semper, *Andrea del Verrocchio.* Kunst und Künstler des Mittelalters und der Neuzeit: Number 49. Leipzig, 1877.

Seymour 1949 – Charles Seymour, jr., *Masterpieces of Sculpture from the National Gallery of Art.* New York, 1949.

Steingräber 1955 – Erich Steingräber, 'Studien zur Florentiner Goldschmiedekunst', I, in *Mitteilungen des Kunsthistorischen Institutes in Florenz*, VII, 1955, p. 87 ff.

Stites 1963 – Raymond S. Stites, 'Leonardo scultore e il busto di Giuliano de' Medici del Verrocchio' I. 2., in *Critica d'arte*, X, 1963, Nos. 57/58, p. 1 ff.; Nos. 59/60, p. 25 ff.

Suida 1929 – Wilhelm Suida, *Leonardo und sein Kreis.* Munich, 1929.

Suida 1954 – Wilhelm Suida, 'Leonardo's Activity as a Painter – a Sketch', in *Leonardo. Saggi e ricerche.* Libreria dello Stato, 1954, p. 317 ff.

Swarzenski 1943 – Georg Swarzenski, 'Some Aspects of Italian Quattrocento Sculpture in the National Gallery. II', in *Gazette des Beaux-Arts*, XXIV, 1943, p. 283 ff.

Thiis 1913 – Jens Thiis, *Leonardo.* London, 1913.

Valentiner 1930 – W. R. Valentiner, 'Leonardo as Verrocchio's Co-worker', in *The Art Bulletin*, XII, 1930, p. 43 ff.

Valentiner 1933 – W. R. Valentiner, 'Verrocchio's Lost Candlestick', in *The Burlington Magazine*, LXII, 1933, p. 228 ff.

Valentiner 1941 – W. R. Valentiner, 'On Leonardo's Relation to Verrocchio', in *The Art Quarterly*, IV, 1941, p. 3 ff.

Valentiner 1944 – W. R. Valentiner, 'Two Terracotta Reliefs by Leonardo', in *The Art Quarterly*, VII, 1944, p. 3 ff.

Valentiner 1950 – W. R. Valentiner, *Studies of Italian Renaissance Sculpture.* London, 1950.

Vasari-Milanesi – *Le vite de' più eccellenti pittori scultori ed architettori scritte da Giorgio Vasari pittore aretino.* With new notes and commentary edited by Gaetano Milanesi. 9 vols. Florence, 1878–85.

Venturi, I–XI, 1901–40 – Adolfo Venturi, *Storia dell'arte italiana.* 11 vols. in 25. Milan, 1901–40.

Venturi 1925 – Adolfo Venturi, 'Leonardiana', III, in *L'Arte*, XXVIII, 1925, p. 137 ff.

Venturi 1926 – Adolfo Venturi, 'Per Antonio Pollaiuolo', in *L'Arte*, XXIX, 1926, p. 179 ff.

Venturi 1927 – Adolfo Venturi, *Studi dal Vero.* Milan, 1927.

Venturi 1928 – Adolfo Venturi, 'Leonardiana', IV, in *L'Arte*, XXXI, 1928, p. 230 ff.

Vitry 1907 – Paul Vitry, 'La Collection de M. Gustave Dreyfus. I: La sculpture', in *Les Arts*, No. 72, Décembre 1907, p. 2 ff.

Wackernagel 1938 – Martin Wackernagel, *Der Lebensraum des Künstlers in der florentinischen Renaissance.* Leipzig, 1938.

Wilder see Kennedy.

Wiles 1933 – Bertha Harris Wiles, *The Fountains of Florentine Sculptors and their Followers from Donatello to Bernini.* Cambridge (Mass.), 1933.

Wölfflin 1899 – Heinrich Wölfflin, *Die klassische Kunst.* Munich, 1899.

Zeri 1953 – Federico Zeri, 'Il maestro dell'annunciazione Gardner', in *Bollettino d'arte*, XXXVIII, 1953, p. 125 ff.

SCULPTURES

1. TOMBSTONE FOR COSIMO IL VEC-CHIO DE' MEDICI.

Plate 1

Florence, S. Lorenzo.

Inlay of various coloured stones and brass.
Length of sides of square: 3·36 m.
Inscription at head: COSMVS MEDICES / HIC SITVS EST / DECRETO PVBLICO / PATER PATRIAE.
Inscription at foot: VIXIT / ANNOS LXXV / MENSES III / DIES XX.

The geometric pattern is picked out in broad bands of white marble. The four small *tondi*, the two mandorla and the semicircles round the inscription tablets are filled in with serpentine; everything else is filled in with porphyry. The spandrel-shaped slabs of *pietra serena* in the four corners contain metal shields, each with the six *palle* of the Medici arms inlaid in porphyry. The shields were renewed, probably after 1532, in an amalgam of high copper content. Originally they may have been of brass like the nails still to be seen in the inscription tablets. Brass and porphyry would have approximated most nearly to the Medici colorus.

There has been much dispute about its state of preservation. Müntz was the first to quote a decree issued by the Signoria dated 22nd November 1495, from which we learn that after the expulsion of the Medici, offence was taken at the honorific PATER PATRIAE, which appears with Cosimo's name on the tombstone, and it was decided to remove the inscription. Fabriczy erroneously concluded from the wording of the decree that the tombstone had been entirely destroyed in the middle fourteen-nineties and replaced by a copy after the restitution of the Medici in 1532. Bode at first accepted this contention, but Cruttwell convincingly disproved it, arguing from the condition of the work itself. The traces of deliberate damage done to the tombstone in 1495 and possibly again during the troubles of 1527 are very small, they can be clearly recognized in detail from the very clean later restoration of small pieces of porphyry and serpentine. The geometric pattern worked on the three large combined slabs of white marble shows cracks in a few places but no subsequent repair. The only obvious replacement is the inscription tablet at the foot end, while the tablet at the head, on which appears the epithet PATER PATRIAE, is still in its original, i.e. un-damaged setting and all in one with the surrounding bands of marble. It is therefore impossible that this tablet was removed from the tomb and destroyed at the end of the quattrocento. On the other hand the inscription in its present form is unlikely to be original on either tablet. A comparison with the inscriptions on the tomb of Piero and Giovanni de' Medici shows up the weaknesses here in the arrangement of the lines of lettering within the available space and the poor, monotonous, formation of the letters themselves. This inscription must have been carved subsequently, either in the cinquecento or later, and it is noticeable that every word is written in full, though lack of space would call for abbreviations. Where then was the original inscription which it was decided to remove in 1495? These implied contradictions can be resolved if we assume that the original inscription tablets, like the shields, consisted of brass plates covering the marble (now carrying the inscription) of the same shape, so that the white of the marble showed through the stamped-out letters. This suggestion is supported by the fact that brass nails still survive with which the marble tablets appear, optically, to be fastened. These tablets are, incidentally, the only forms in the general pattern except the Medici shields which are not strictly geometric, so that there would have been a special purpose in making them similarly brass-covered.

The tombstone must have been made between 1465 and 1467. Cosimo died on 1st August 1464. His grandson Lorenzo notes in his *Ricordo*: 'Cosimo nostro avolo uomo sapientissimo mori a Careggi a di primo di agosto 1464 d'età d'anni 76 in circa . . . fu seppelito in Sto Lorenzo, non volle fare testamento ne volle pompa funebre, nondimeno tutti i Signori d'Italia mandorno a honorarlo. . . .' (Ricordo del Magnifico Lorenzo di Piero de' Medici; Cod. Misc. Bibl. Naz. di Firenze, II, IV, 309 ac. 1, 2.) The noble simplicity of the monument which was later commissioned answered to the personality of the deceased. Yet at first it was intended to express the general grief and deep respect for Cosimo in a much more magnificent and imposing monument. On 7th August the Signoria appointed a commission of ten citizens who were to consider where and in what form a tomb should be erected. Even after long deliberations they could not choose between a monument

with the statue of Cosimo or a special chapel for his last resting place. It was decided first of all to honour his memory by conferring on him the title of Pater Patriae. This was formally proclaimed on 20th March 1465 by Donato Acciaiuoli; so the decision over the place and type of tomb was apparently also taken in the spring of 1465. Two and a half years later, on 22nd October 1467, the mortal remains of Cosimo were transferred to the tomb, commissioned and paid for by his son Piero, under the crossing of S. Lorenzo.

The tombstone is let into the floor in front of the steps now leading up to the main altar, directly under the lantern of the dome above the crossing. It seals a shaft which reached down into the vault of the crypt and into a central pillar. This central pillar is faced on its four sides with architecturally articulated walls: above a powerfully moulded plinth rise horizontal rectangular zones with central recessed panels, and over them an architrave with two fasciae, a frieze with wave moulding and finally a strongly salient entablature sharply cut in steps (fig. 1). The facing gives the pillar the cubic form of a parallelepiped, which viewed from the sides looks like a large tumba. This sarcophagus with its serious, heavy architectural forms is seen as the main support of the crypt. Thus the tomb of the founder appears symbolically too as the fundament or foundation stone of the choir of S. Lorenzo which owed its erection primarily to the initiative of Cosimo. In my opinion the tumba of Cosimo's grave was not designed by Verrocchio. The inscription is identical along two sides and reads PETRVS MEDICES PATRI FACIVNDVM CVRAVIT. This shows that it was set up under Piero's orders at the same time as Verrocchio's cover slab, i.e. in 1465/67. According to a verbal suggestion from Professor Heydenreich, it could possibly have been designed by Leon Battista Alberti; the Rucellai chapel built to Alberti's plans during the same years in S. Pancrazio has very close similarities. The tumba of the Holy Sepulchre tempietto in particular should be compared (illustrated in Ludwig H. Heydenreich, 'Die Cappella Rucellai von San Pancrazio', in *Essays in Honor of Erwin Panofsky*, New York 1961, Volume of Plates, p. 79, fig. 11). A complete study of the tomb of Cosimo needs to be undertaken. In the eighteenth and nineteenth centuries it was thought to be the work of Donatello (Fabroni, Moreni). Even after the publication of the list prepared by Tommaso Verrocchio, in which the tomb is entered as a work by Andrea, its attribution was contested. The entry in the inventory reads: '11. Per la sepoltura dj Chosimo appie del altare magiore in san Lorenzo . . . fj.' This word-

ing does not make it clear whether both tumba and tombstone or only the latter is by Verrocchio. Fabriczy in his commentary on Tommaso's list maintains that Verrocchio designed the whole. Pope-Hennessy evidently believes the same. In the monographs on Verrocchio by Mackowsky, Cruttwell and Planiscig only the tombstone is mentioned.

BIBLIOGRAPHY: Albertini, *Memoriale*, 1510 (ed. 1863), p. 11; Richa, v, 1757, p. 30 and p. 80; Fabroni, *Magni Cosmi Medicei Vita*, Pisa 1789, II, p. 257 ff.; Domenico Moreni, *Continuazione delle memorie istoriche dell'Ambrosiana imperial Basilica di S. Lorenzo di Firenze*, I, 1817, p. 108 ff.; Hans Semper, *Donatello, seine Zeit und Schule* (Quellenschriften für Kungstgeschichte IX), Vienna 1875, p. 288; Bode 1882, p. 252; Müntz 1888, p. 104; Bode 1892–1905, p. 142; Fabriczy 1895, p. 173 f.; Mackowsky 1901, p. 20; Cruttwell 1904, p. 75 ff.; Schubring 1904, p. 15 and p. 18; Reymond 1906, p. 37; Bertini 1935, p. 435; Wackernagel 1938, p. 258 f.; Dussler 1940, p. 294; Planiscig 1941, p. 14 f. and p. 49; Paatz, II, 1941, p. 495; Pope-Hennessy 1958, p. 310.

2. CANDELABRUM, from the chapel of the Sala dell'Udienza in the Palazzo della Signoria, Florence.

Plates 2–4

Amsterdam, Rijksmuseum.

Bronze. The candlestick consists of several sections separately cast, which are held together inside with an iron rod. This rod branches into three at the bottom inside the base; its upper end is shaped into a spike to hold the candle.

Height: 1·57 m.; width: 0·46 m.

Date on the base: MAGGIO E GIVGNO MCCCCLXVIII.

In the early decades of the nineteenth century the candelabrum is noted as being in the treasury of the Hohenzollerns in Berlin. About 1935 it was sold by the Berlin Schlossmuseum to Fritz Mannheimer in Amsterdam, two years after Valentiner had published it as an authentic work of Verrocchio. In 1939 Planiscig stated only that it was in private hands in Rotterdam. In 1952 it passed into the possession of the Rijksmuseum through the 'Dienst voor's Rijks Verspreide Kunstvoorwerpen', in The Hague.

The work is confirmed as Verrocchio's by three notes of payment: on 29th June 1468, 23rd September 1469 and 20th April 1480. These records were first published by Gaye, I, n. 569, 570 and 575, repeated in Cruttwell 1904 (p. 246 f.) and in Passavant 1959, p. 225. The candelabrum must therefore have been set up in the

chapel of the Sala dell'Udienza in the Palazzo della Signoria in Florence, for which it was commissioned, in 1480 at the latest. It is recorded as being 'lavorato e scolpito a similitudine di certo vaso'. It is not clear why the artist put the designation of the months as well as the year on the base. One could think that, conscious of his skill as a bronze worker, he wished his contemporaries and posterity to know that the work was all done in only two months, but then he would surely have added a signature. The note of payment for 29th June 1468, stating that the candelabrum is 'cominciato', seems to exclude the interpretation that the reference to the months indicates the time taken in completing the work. Professor Nicolai Rubinstein has drawn my attention to the possibility of a connection between the naming of the months in the inscription and the fact that at that time the Priori were changed every two months. The office-holders for the various districts for May and June 1468 were: S. Spirito – Piero di Carlo M Ristoro Carigiani and Giudetto di Francesco di Giudetto Giudetti; S. Croce – Zanobi di Simone di Salamone di Torello and Ginoro di Marcho di Bellanino Bellani; S. Maria Novella – Riniero d'Andrea di Naldo da Ricasoli and Scolaco di Salvestro Pucci; S. Giovanni – Giuliano di Buonacorso di Piero, while the Gonfaloniere di Giustizia was Carlo di Nicola de' Medici. The latter, a grandson of Vieri de' Medici, was also a member of the Balià and appears again in 1475 as one of the five Accoppiatori. It is therefore quite conceivable that these eight Priori ordered the bronze candelabrum for the audience chamber to commemorate their term of office; nothing however is known for certain.

BIBLIOGRAPHY: Katalog der Schätze der Kunstkammer, Berlin 1825; item 1838, no. 177; Aurelio Gotti, *Storia del Palazzo Vecchio*, 1889, p. 99; W. R. Valentiner, 'Verrocchio's Lost Candlestick', *The Burlington Magazine*, LXII, 1933, p. 228 ff.; Planiscig 1933, p. 90; Dussler 1940, p. 294; Planiscig 1941, p. 15 and p. 49; Valentiner 1950, p. 98 ff.; Cat. The Detroit Institute of Arts, Exhib. Nov. 1958–Jan. 1959: Decorative Arts of the Renaissance 1400–1600, no. 231; Cat. Amsterdam, Rijksmuseum, Exhib. Oct. 1961–Jan. 1962: Meesters van het Brons der Italiaanse Renaissance, no. 10; Cat. Florence, Palazzo Strozzi, Exhib. Febr.–March 1962: Bronzetti Italiani del Rinascimento, no. 10.

3. TOMB FOR GIOVANNI AND PIERO DE' MEDICI. Plates 5–13
Florence, S. Lorenzo, Old Sacristy.

Porphyry, serpentine, marble and bronze (sarcophagus and plinth), pietra serena and marble (framing arch).
Internal height of round arch: *c.* 4·50 m.
Height of pietra serena threshold on either side of the arch: 0·46 m.
Height of marble plinth with tortoise feet: 0·51 m.
Height of sarcophagus from marble plinth to lower edge of the lid: 1·14 m.
Area of marble plinth: 2·41 m. × 1·08 m.
Inscriptions:
In the tondo on the sarcophagus facing the Cappella della Madonna: PETRO/ET IOHANNI DE/MEDICIS COSMI P. P. F./H. M. H. N. S.
In the corresponding tondo facing the Old Sacristy: PET. VIX./AN.LIII. M.V. D.XV./IOHAN. AN.XLII. M.IIII./D.XXVIII.
Round the four sides of the plinth: LAVRENT. ET IVL. PETRI F./POSVER./PATRI PATRVOQVE/ MCCCCLXXII.

The tomb is dated by the inscription to 1472 and must have been started immediately after the death of Piero de' Medici (2. XII. 1469); Giovanni de' Medici had died in 1463. Lorenzo de' Medici notes in his *Ricordo* (Florence, Bibl. Naz., Cod. Miscellaneo II, IV, 309 ac. I, 2): 'Pietro nostro padre passò di questa vita alli 2 di Dicembre 1469 d'età d'anni . . . molto afflitto dalle gotte; non volle fare testamento, ma facesi l'inventario, e trovammoci hallora il valsente di fiorini dugento trenta mila novecento ottanta nove come appare a un libro verde grande di mia mano in carta di capretto a 31. Fu seppelito in San Lorenzo, e del continuo si fa la sepultura et di Giovanni suo fratello, più degna che sappiamo per mettervi le loro ossa.' The tomb is unanimously referred to, in the Libro di Antonio Billi, by Anonimo Magliabechiano and by Vasari, as Verrocchio's work; in Tommaso's inventory it is entered under no. 12 'Per la sepoltura dj Piero e Giovannj de Medicj' and under no. 13 'Per intagliatura dj 80 lettere intagliate in su el serpentino in due tondj in detta sepoltura'. Vasari writes: '. . . fece di bronzo tutta tonda, in San Lorenzo, la sepoltura di Giovanni e di Piero di Cosimo de' Medici; dove è una cassa di porfido, retta da quattro cantonate di bronzo, con girari di foglie molto ben lavorate e finite con diligenza grandissima: la quale sepoltura è posta fra la cappella del Sagramento e la sagrestia. Della qual opera non si può, nè di bronzo nè di getto, far meglio; massimamente avendo egli in un medesimo tempo mostrato l'ingegno suo nell'architettura, per aver la detta sepoltura collocata nell'apertura

d'una finestra larga braccia cinque e alta dieci in circa, e posta sopra un basamento che divide le detta cappella del Sagramento dalla sagrestia vecchia. E sopra la cassa, per ripieno dell'apertura insino alla volta, fece una grata a mandorle di cordoni di bronzo naturalissimi, con ornamenti in certi luoghi d'alcuni festoni, ed altre belle fantasie tutte notabili, e con molta pratica, giudizio ed invenzione condotte.'

After the death of the two donors Giuliano (1478) and Lorenzo (1492) their remains were also first placed in the tomb. In 1559 the Grandduke Cosimo I had these taken out and buried in the floor of the New Sacristy, below the figure of the Madonna by Michelangelo.

The Medici monument has from the first been considered one of the most important and characteristic of Verrocchio's works. That the sarcophagus with its bronze ornament was executed by Andrea himself has never been seriously disputed. Venturi in 1935 advanced the thesis (untenable on chronological grounds alone) that Leonardo participated in and decisively influenced the design and execution. The collaboration of Francesco di Simone in the execution of the marble facings of the embrasures on either side of the framing arch was, as far as I know, first suggested by Dussler, and most scholars have accepted it.

The observation that Verrocchio's adoption of the special type of tomb with two new view points was based on a return to the idea of the trecento tombs in S. Croce (mentioned above, p. 12) appears in Fritz Burger, *Geschichte des florentinischen Grabmals von den ältesten Zeiten bis Michelangelo.* Strassburg 1904, p. 209. An important link is provided by two lunette tombs with double view point of the early fifteenth century, cited by Walther Paatz, 'Ein frühes donatellianisches Lünettengrabmal vom Jahre 1417', in *Mitteilungen des Kunsthistorischen Institutes in Florenz*, Bd. III, 1932, p. 539 f.). One is the tomb of Maso degli Albizzi, no longer preserved as a whole, dated 1417 and previously in S. Pier Maggiore, and the other is the tomb of Onofrio Strozzi in the sacristy of S. Trinità, also from the first quarter of the fifteenth century.

BIBLIOGRAPHY: Albertini, *Memoriale*, 1510 (ed. 1863), p. 11; Billi (ed. Frey), p. 47; Cod. Magl. (ed. Frey), p. 90; Vasari-Milanesi, III, p. 361 f.; Richa, v, 1757, p. 31 f.; Cicognara 1823, p. 261 f.; Fabriczy 1895, p. 174; Bode 1892–1905, p. 142; Reymond, II, 1898; p. 124; Mackowsky 1896, p. 243 f.; Reymond, III, 1899, p. 201 f.; Mackowsky 1901, p. 26 ff.; Schubring 1904, p. 18 f.; Cruttwell 1904, p. 77 ff.; Reymond 1906, p. 37 ff.; Venturi, VI, 1908, p. 707 f.; Venturi, x, 1, 1935, p. 19 ff.; Bertini 1935, p. 435 ff.; Middeldorf 1935, p. 209; Dussler 1940, p. 294; Paatz, II, 1941, p. 499; Planiscig 1941, p. 17 ff. and p. 50; Pope-Hennessy 1958, p. 50 f.

4. MADONNA AND CHILD. Plates 14–15

Florence, Museo Nazionale del Bargello.

Terracotta.

Height: 0·86 m.; width: 0·66 m.

Remaining traces of pigment show that the relief, except for the smooth ground, was painted in yellow-white and sand colours, to give the impression of marble. The Madonna's cloak was kept darker than the flesh, and decorated with lighter, egg-shell coloured borders, which are clearly visible in places. The background was also probably dark blue, but certainly not with the present green tinge.

The relief came originally from the Spedale di S. Maria Nuova in Florence, where it hung in an anteroom to the gallery in the nineteenth century. It came to the Uffizi in 1901 and to the Bargello in 1903. The fact, recorded by Vasari, that Verrocchio was for a time a patient in the hospital, may be relevant to its origin. On the other hand Cruttwell suggests that Tommaso Portinari, to whom the hospital owed several important gifts, commissioned the relief for the chapel of S. Maria Nuova.

Dating: Cruttwell: between 1475 and 1480; Reymond: about 1478; Dussler: 1475/77; Planiscig: about 1480; Pope-Hennessy: before 1476.

BIBLIOGRAPHY: Vasari-Milanesi, III, p. 361 n. 2; Andreucci 1871, p. 50; Bode 1892–1905, p. 143 f.; Berenson 1896, p. 131; Ridolfi, IV, 1899, p. 179 f.; Reymond, III, 1899, p. 214; Mackowsky 1901, p. 52 ff.; Cruttwell 1904, p. 116 f.; Reymond 1906, p. 50 ff.; Marrai 1907, p. 78; Venturi, VI, 1908, p. 718; Schubring 1915, p. 140; van Marle, XI, 1929, p. 488; Bertini 1935, p. 446 f.; Dussler 1940, p. 294; Planiscig 1941, p. 32 f. and 54 f.; Galassi 1949, p. 215 f.; Paatz, IV, 1952, p. 34; Pope-Hennessy 1958, p. 38 and p. 311 f.

5. DAVID. Plates 16–23

Florence, Museo Nazionale del Bargello.

Bronze.

Height: 1·26 m.

Remains of original gilding are to be seen only on the borders of the garment (imitating Arabic lettering) but not on the decoration of the belt or the trimmings of the boots. The bronze is almost black, and after successive

restorations the surface effect of the figure is now excessively shiny, as though varnished. This makes it difficult to photograph, especially as the work stands very close to the window and photographs can only be taken with artificial illumination.

Vasari dates the figure after Verrocchio's stay in Rome, a period which he records without dating more closely: 'Ritornato poi a Firenze con danari, fama ed onore, gli fu fatto fare di bronzo un Davit di braccia due e mezzo; il quale finito, fu posto in palazzo al sommo della scala, dove stava la catena; con sua molta lode.' The bronze David also appears in the list compiled by Tommaso Verrocchio in 1495 which assembles all the work done for the Medici by his brother Andrea: '1. Per uno davitte e la testa dj ghulia.' A note in the margin 'Per a Charegj' was taken by Cruttwell in her study of Verrocchio as applying to the David, and this error has been consistently repeated in the literature (including Passavant, 1959, p. 19). In fact the note first appears in the inventory in connection with the Putto with a Dolphin, applying also to the two following works. Cruttwell (1904, p. 242 ff.) obviously made a slip in transcribing the text of the inventory, published by Fabriczy in 1895, and repeated her mistake in the chapter discussing the bronze David. The faulty reading was adopted by Passavant (1959, p. 221), when he re-published Tommaso Verrocchio's list. The possibility that Piero de' Medici intended Verrocchio's figure as a replacement for Donatello's bronze David in the court-yard of the Medici palace cannot be excluded. It could also have been designed from the first to stand in the Palazzo Vecchio as a gift from Piero. This would explain the fact that in 1476, probably shortly after it was finally finished, the Signoria of Florence purchased the figure from Piero's heirs, Lorenzo and Giuliano de' Medici, for 150 florins and placed it on the landing of the staircase in front of the Sala del Orologio. It was set on a pedestal column, which later supported a bust of the Grandduke Ferdinand I for many years. This porphyry column with an ornamented marble capital has now been re-united with the David in the Museum, but in my opinion it is not by Verrocchio or from his workshop. In the early seventeenth century the David was moved into the Guardaroba Ducale and in 1777 to the Uffizi, where Jacob Burckhardt refers to it in 1855 as in the first bronze room. It was moved thence into the Bargello before 1898.

Dating: Reymond: about 1476; Venturi: 1472; Dussler: 1473–75; Planiscig: before 1476; Pope-Hennessy: 1473–1475.

BIBLIOGRAPHY: Vasari-Milanesi, III, p. 360; Catalogue: Galerie Impériale et Royale de Florence, Florence (Albizzi) 1823, p. 81; Burckhardt 1855, p. 569; Crowe and Cavalcaselle, II, 1864, p. 404 f.; Perkins 1864, p. 177; Crowe and Cavalcaselle, III, 1870, p. 144 and note 8; Bode 1892–1905, p. 142; Fabriczy 1895, p. 167 f.; Catalogo del R. Museo Nazionale di Firenze, Roma 1898, p. 385; Wölfflin 1899, p. 12; Reymond, III, 1899, p. 202 f.; Mackowsky 1901, p. 20 ff.; Cruttwell 1904, p. 64 ff.; Reymond 1906, p. 41 ff.; Venturi, VI, 1908, p. 708; Dvořák 1927, p. 132 ff.; Bertini 1935, p. 445 f.; Dussler 1940, p. 294; Planiscig 1941, p. 21 ff. and 51; Galassi 1949, p. 213; Pope-Hennessy 1958, p. 39 f. and 312.

For the problem of the correct main view point for the figure cf. in particular, besides Mackowsky and Cruttwell, Heinrich Wölfflin, 'Wie man Skulpturen aufnehmen soll', *Zeitschrift für bildende Kunst*, VII, 1896, p. 224 ff.; Bernhard Berenson (*Aesthetics and history in the visual arts*, New York 1948, p. 224) speaks of the importance of Leonardo's contribution to the figure of David.

6. PUTTO WITH A DOLPHIN. Plates 24–27
Florence, Palazzo Vecchio.

Bronze, no trace of gilding.
Height: 0·67 m.

The original on the fountain in the first cortile was replaced in 1959 by a copy in bronze, by Bruno Bearzi, the Director of the Gabinetto dei Restauri di Bronzi. It is now exhibited in a room adjoining the Sala dei Gigli. The work appears in no. 3 of Tommaso's inventory: 'Per el banbino dj bronzo chon 3 teste dj bronzo e 4 boche dj lione dj marmo.' This and the two following works listed there have a marginal note added by Tommaso 'Per a Charegj'. Accordingly the figure must have been made for a fountain at Careggi, the decoration of which also included three bronze heads and four marble lion heads executed by the artist. While Vasari does not mention the Putto at all in his first edition of the *Lives*, he records in the 1568 edition that the Grandduke Cosimo de' Medici had Verrocchio's figure brought from Careggi to Florence and set up on a new fountain in the first courtyard of the Palazzo della Signoria. This fountain was worked by Francesco Tadda in porphyry and marble. It replaced Donatello's bronze David which decorated the courtyard until the fifties of the cinque-cento, as we learn from Condivi's *Life* of Michelangelo.

The new fountain was seen by the German traveller Georg Ernstinger at the end of the sixteenth or beginning of the seventeenth century. In his 'Raisbuch' (ed. by Walther, Tübingen, 1877) he notes: '... ein mermelsteinernen Röhrbrunnen, darauf die Cupido vom Wasser umbgetrieben wirt, und geußt sich das Wasser aus etlichen Orten in der Brunnencor'. It is quite obvious from his description of the device operated by water in the villa at Pratolino (a mechanism also recorded by Schickhardt in the sketch book of his travels) that Ernstinger was particularly interested in unusual inventions and modes of operation in the science and art of hydraulics. It is therefore most unlikely that he should have exaggerated or misrepresented the striking design of the Putto with a Dolphin. Whether the removal of Verrocchio's Putto included the fountain belonging to it is a matter for speculation; there is no trace of the bronze and marble heads previously mentioned. The lion heads let into the shaft of the fountain in the Palazzo Vecchio have erroneously been identified with three of the 'boche dj lione' of the inventory, but they are quite certainly sixteenth-century work. The fact that these heads are not carved in one piece with the shaft of the fountain but are added afterwards is adequately explained by the fact that such a marble baluster is made by a process of turning. The entry in the inventory suggests that Verrocchio's fountain for Careggi was intended, like the Medici sarcophagus in S. Lorenzo, to make its effect through the use of different kinds and colours of materials. We may suppose that apart from the bronze and marble for the putto, masks and lion heads, much use was made of porphyry, above all in those parts where the effect of the precious smooth polished material would be shown to best advantage, such as the basin of the fountain and possibly the shaft. The baroque layout of the second inner cortile in the Palazzo Vecchio includes two wall fountains which are each comprised of a free-standing basin combined with waterspitting masks of white marble. Each fountain is flanked by a pair of lions. Of these basins one (1·42 m. in diameter) is fashioned with taut and vital lines and is of typical antique dark-red porphyry (fig. 11); the other – only an imitation of the same precious quality of porphyry – was evidently made as a companion-piece for it in the baroque period, judging by its rather doughy and swollen contours. The basins rest upon identical baluster supports with polygonal bases which are also baroque. Now equally spaced around the outside rim of the basin of genuine porphyry are fourteen notches and inside four pairs of holes, arranged one above the other. Unlike those above, the lower holes are drilled right through the porphyry, as if they were intended for waterspitting masks. All the holes have at some time been filled with putty. There are also inside the remains of bronze rivets, in two places at the same level in the upper zone of the basin, and these also cannot be explained in terms of the present use of the fountain. While there is no documentary or other certain evidence at present, it seems none the less highly probable that this porphyry basin originally belonged to the Careggi fountain that was decorated both with the bronze Putto and with the marble lion heads and bronze masks also made by Verrocchio. Since the basin for the fountain does not appear in Tommaso's inventory we may surmise that it was not made in Verrocchio's studio but that it may very well have been an antique porphyry original put to a new use.

In the Palazzo Pitti, in the vestibule of the Gallery rooms on the Piano Nobile, stands a marble fountain, quattrocento apart from the small upper basin and figure which are later. Peter Meller has recently attempted to prove – by extensive and mostly iconological research starting from a Latin verse on the foot of the basin – that this fountain, which came to the Palazzo Pitti from the Medici Villa at Castello, was originally crowned by Verrocchio's Putto with a Dolphin. But the style of decoration dominating the foot, the outer wall of the large basin and the shaft, with its overall and unaccented ornamental pattern and its avoidance of the effect of smooth marble with empty spaces, is foreign to any work from the studio of Verrocchio. The present condition of the fountain excludes the possibility too that the bronze masks or the lion heads mentioned in the inventory could have been attached to it as additional decoration. A reconstruction of the composition of the complete fountain must include all the constituent parts for which there is documentation. Meller maintains that on the marble fountain of the Palazzo Pitti the dolphin motif, which also appears in the decoration of the exterior of the basin, must have dominated the subject of the crowning figure or group. But even if this theory were entirely convincing in this respect it still would not serve to connect it with any special figure with a dolphin and in particular with Verrocchio's putto. Nothing conclusive can at present be said about the form of the Careggi fountain either on the basis of Meller's arguments or of those previously advanced.

As in the case of almost every piece of sculpture by Verrocchio, Venturi thought it possible to recognize a strong influence from the young Leonardo in the idea

and the realization of the Putto with a Dolphin. Caval-caselle had indeed expressed similar views in 1894. In 1925 Venturi ascribed to Leonardo a terracotta putto in the collection of Prof. Giuseppe Grassi in Rome which is almost identical with Verrocchio's bronze. He advanced the thesis that the wax model from which the Putto with a Dolphin was cast was taken from the Grassi figure.

The dating of the bronze varies between 1465/68 or 'the sixties' (Dussler, Middeldorf), 'after 1476' (Reymond 1906) and 'about 1480' (Planiscig); Pope-Hennessy dates it 'about 1470'.

BIBLIOGRAPHY: Vasari-Milanesi, III, p. 364; Rumohr ed. 1920, p. 412 f.; Perkins 1864, p. 177 f.; Crowe and Cavalcaselle, III, 1870, p. 143; Bode 1882, p. 92; Bode 1892–1905, p. 142; Crowe and Cavalcaselle, VI, 1894, p. 154 f. (Engl. edition, IV, 1894, p. 181 f.); Fabriczy 1895, p. 169; Reymond 1899, p. 203; Mackowsky 1901, p. 34 ff.; Cruttwell 1904, p. 68 ff.; Reymond 1906, p. 46 ff.; Frida Schottmüller (reference to the 'Raisbuch' of Georg Ernstinger) in *Mitteilungen des Kunsthistorischen Institutes in Florenz*, I, 1908/II, p. 41; Venturi, VI, 1908, p. 708; Adolfo Venturi, 'Leonardiana III', in *L'Arte*, XXVIII, 1925, p. 147; van Marle, XI, 1929, p. 487; B. Wiles, *The Fountains of Florentine Sculptors and their Followers from Donatello to Bernini*, Harvard University Press 1933, p. 3; Middeldorf 1935, p. 209; Dussler 1940, p. 294; Planiscig 1941, p. 33 f. and p. 55; Galassi 1949, p. 217; Pope-Hennessy 1958, p. 40 f. and p. 310; Peter Meller, *Verrocchio e la fontana per la Villa di Careggi*, Lecture, Florence, 7th July 1959, Kunsthistorisches Institut (unpublished).

7. CHRIST AND ST THOMAS. Plates 28–39

Florence, Or San Michele, Central niche on the East front.
Bronze.
Height of the figure of Christ (to the top of the raised right hand): 2·30 m. Height of the figure of St Thomas: 2·00 m.
On the border of Christ's robe appear the words from John 20, 29: QVIA VIDISTI ME THOMA CREDIDISTI BEATI QVI NON VIDERVNT ET CREDIDERVNT.
The inscription on St Thomas's robe runs: DOMINVS MEVS ET DEVS MEVS (John 20, 28) and ET SALVATOR GENTIVM.

The central niche on the main façade of Or San Michele was originally intended in Donatello's design for the Parte Guelfa, and was to contain Donatello's bronze statue of St Louis of Toulouse, which was later set up over the main portal of S. Croce. After three years of negotiations the Parte Guelfa, who was hostile to the Medici, was forced on 26th March 1463 to declare themselves willing to cede the empty niche for 150 gold ducats to the Mercanzia, the Commercial Tribunal which presided over all Guilds. A few days later the Mercanzia nominated a committee of five, among them Piero de' Medici, to see that the emblem of the Parte Guelfa was removed from over the niche and replaced by that of the Mercanzia, and a new figure commissioned for the niche itself ('. . . aliqua statua et seu figura aliqua digna et venerabilis ut est in alio tabernaculo ibidem circhum circa positum.'). Luca della Robbia received the commission for the new emblem on 28th September 1463. On 15th January 1466 (N.S. 1467) there was a payment to 'Andrea di Michele vocato Verrocchio, intagliatore, lire 300 piccole, dovute a lui dagli operai del pilastro seu tabernacolo per una statua di bronzo a lui allogata dagli anzidetti operai'. On 30th March 1468 the clients undertake to pay a monthly sum of 25 lire on account to Andrea 'ad faciendum figuras hereas mictendas et collocandas in dicto tabernaculo'. On 2nd August 1470 instructions were issued to weigh out the bronze necessary 'pro faciendo figuram seu statuam ponendam in pilastro'.

The final contract for the bronze group or perhaps at that stage for one figure only must have been issued to Verrocchio by the end of 1466 at the latest. The file containing the decisions of the Mercanzia for 1465 and 1466 (A.S.F. Delib. della Mercanzia, *filza* 297) was not to be found in Fabriczy's time but has recently been rediscovered by Dario A. Covi. With the publication of the documents concerning the group in his forthcoming monograph on Verrocchio, it is to be expected that more will be known about the exact date and conditions of the commission. In *filza* 298 the aforementioned first payments to Verrocchio are entered. Further records of payment increase markedly in 1476 and again in 1480. There can be no foundation for Vasari's story that the Mercanzia were undecided as to whether to place the commission with Donatello or Ghiberti, as the latter was no longer alive after the middle fifties. However, we must accept that in the early years of the sixties, at the time when Luca della Robbia was given the commission for the Mercanzia coat of arms, they considered offering the commission for the bronze figure for the niche to Donatello. It is indeed remarkable that it was not for several years after the contract with della Robbia – and probably in consequence of the

death of Donatello in 1466 – that Verrocchio was commissioned with the bronze work.

The main period of activity on the Christ and St Thomas group can be deduced from a register of 1479 quoted (though with the wrong date of 1476) by Milanesi. There it is noted that the figure of Christ is already cast and completed and the casting of the St Thomas is about to begin. On 23rd March 1483 the Signoria decided to buy the model of the (already cast) figure of St Thomas from the artist for 40 gold ducats and 200 denare, to set up in the Council Chamber of the Università de' Mercatanti. A further document of 22nd April 1483 mentions both bronze figures as 'quasi condotte alla loro intera perfectione'. According to this the figure of Christ was being worked on in the years before 1479, that of St Thomas before 1483, and the actual beginning of work on the group, corresponding to the frequency of payments registered, can be placed about 1476. On 21st June 1483 Verrocchio's group was set up in the niche on Or San Michele. This is recorded in the Florentine diary of the apothecary Luca Landucci, who also remarks that Verrocchio's is the most beautiful head of Christ ever made. Among the numerous studies of draperies attributed to Leonardo there is one preserved in the Uffizi done with the brush on linen, which in my opinion is an early original drawing by Verrocchio for the drapery of the mantle of the Christ figure (cf. No. D 9 in the catalogue of drawings).

BIBLIOGRAPHY: Albertini, *Memoriale 1510* (ed. 1863), p. 14; Luca Landucci, *Diario dal 1450 al 1516* (ed. Jodoco del Badia, Florence 1883), p. 45; Billi (ed. Frey), p. 47; Cod. Magl. (ed. Frey), p. 89 f.; Vasari-Milanesi, III, p. 362 f.; Baldinucci, II, p. 423; Richa, I, 1754, p. 20; Cicognara 1823, p. 261; Gaye, I, 1839, p. 370 ff.; Burckhardt 1855, p. 602; Rumohr (ed. 1920), p. 412; Alfred von Reumont, 'Del Gruppo di Cristo con S. Tommaso', *Estratto dal Giornale arcadico*, CXXXVII, Rome 1855; Crowe and Cavalcaselle, II, 1864, p. 405 f.; Bode 1882, p. 92; August Schmarsow, 'Die Statuen an Orsanmichele', in *Festschrift zu Ehren des Kunsthistorischen Instituts in Florenz*, Leipzig 1897, p. 37 ff.; Wölfflin 1899, p. 194 n. 1; Reymond, III, 1899, p. 204 ff.; Cornelius von Fabriczy, 'Der hl. Ludwig und sein Tabernakel an Or San Michele', in *Jahrbuch der Königl. Preuß. Kunstsammlungen*, XXI, 1900, p. 242 ff.; Bode 1892–1905, p. 147 f.; Mackowsky 1901, p. 65 ff.; B. Marrai, 'Il tabernacolo col gruppo del Verrocchio in Or San Michele', in *L'Arte*, IV, 1901, p. 346 ff.; Cornelius de Fabriczy, 'Ancora del tabernacolo col gruppo del Verrocchio in Or San Michele', in *L'Arte*, V, 1902, p. 46 ff. and 336 ff.; in the same volume and under the same title further opinions by I. B. Supino and B. Marrai (p. 185 ff.), and by Gerspach (p. 254); B. Marrai, 'Il tabernacolo col gruppo del Verrocchio in Or San Michele', in *Miscellanea d'Arte*, I, 1903, p. 36 ff.; Cruttwell 1904, p. 158 ff.; Curt Sachs, *Das Tabernakel mit Andrea's del Verrocchio Thomasgruppe an Or San Michele zu Florenz*, Strassburg 1904 (reviewed by Ernst Steinmann in *Deutsche Literatur-Zeitung* 1905, no. 2); Reymond 1906, p. 84 ff.; Venturi, VI, 1908, p. 707 and 714; Schubring 1915, p. 136; van Marle, XI, 1929, p. 487 and 504; Kennedy, Wilder and Bacci 1932, p. 24; Bertini 1935, p. 459 f.; Dussler 1940, p. 292 and 294; Planiscig 1941, p. 37 ff. and p. 55 f.; Galassi 1949, p. 215 f.; Paatz, IV, 1952, p. 493 f. and n. 103 (p. 534); Pope-Hennessy 1948, p. 40 and p. 312 f.; Bongiorno 1962, p. 1927.

8. CENOTAPH FOR CARDINAL NICCOLÒ FORTEGUERRI. Plates 41–43

Pistoia, Duomo. Marble.

In its present form set up in the middle of the eighteenth century.

Inscription: NICOLAO FORTEGVERRAE / CARDINALI GRATA PATRIA / CIVI SVO DE SE OPTIME / MERITO POSVIT A.S.M / CCCCLXXIII. V. A. LIIII.

The inscription is on the plinth of the sarcophagus, on a marble relief (worked in the studio of Verrocchio); it shows two seated winged putti holding an open scroll between them.

The origin of the cenotaph is well documented, thanks to the source material compiled by Peleo Bacci for the monograph on the work by C. Kennedy and E. Wilder. On 2nd January 1474 the City Council of Pistoia discussed how best to honour the memory of the deceased cardinal. Shortly before his death Niccolò Forteguerri had endowed a college for poor students in his home town, the 'Pia Casa di Sapienza'. A committee was formed of four representatives of this college, four delegates from the Pistoia Opera del Duomo and other members of the Council 'pro construenda archa honorabilis seu monumentum cum epithaphio in litteris in memoriam sui nominis et honorem civitatis'. 300 florins were allocated for the execution and erection of the monument; the artist to be entrusted with the commission was to be chosen by a competition. Over two years later, on 25th May 1476 four artists (whose names are not recorded in the documents) besides Verrocchio

submitted designs for consideration. The Council voted by a narrow majority for Verrocchio's model 'in quo est Deus Pater cum Virtutibus cardinalibus'; but the artist required 350 florins to execute the work.

The committee responsible for the erection of the monument then asked Piero Pollaiuolo to prepare another, less expensive project, probably under particular pressure from the Forteguerri family. On 23rd January 1477 the sum set aside for the cenotaph was raised to 380 florins. Although the Council had officially entrusted Verrocchio with the execution of the work in November, the committee sent his model and the counter-project of Piero Pollaiuolo's to Lorenzo de' Medici in March 1477 with the request that he should make the final decision between the two designs. The accompanying letter is preserved; it informs Lorenzo that the relatives of the cardinal, particularly his brother Piero, prefer Pollaiuolo's model. Lorenzo de' Medici decided in favour of Verrocchio's design; on 17th March there was a letter from the committee thanking Lorenzo for his answer which is unfortunately lost.

There is no evidence of when work on the cenotaph started in Verrocchio's studio. The first reference is in 1483: in April it appears as 'sepultura jam incepta'; in July it is 'in buona parte tracto a fine' and in November 'quasi conducta . . . ad finem suum'. After Verrocchio moved to Venice the work seems to have stagnated. At his death in the summer of 1488 the figures of Hope and Faith and the figure of Christ with the four angels surrounding it were for the most part completed, i.e. in the state in which we now see them in Pistoia. After Verrocchio's death Lorenzo di Credi undertook to finish the monument. He had first taken over responsibility for storing the seven figures executed in Verrocchio's lifetime ('dictas septem figuras marmoreas factas et fabricatas per dictum olim Andream, videlicet una figura di Cristo cum quatuor angelis et una Fede et una Speranza omnes de marmore . . . pro dicta communitate Pistorii eas tenere, salvare et custodire promisit dictus Laurentius'). The wording of the contract made with Credi, published recently for the first time by Dario A. Covi, shows further that Verrocchio's working model for the cenotaph provided for a decoration with *nine* marble figures. This invalidates one of the main arguments against identifying the Victoria and Albert terracotta *bozzetto* as the original model. These arguments are based on the contract concluded by the Pistoia Council on 17th June 1514 with Lorenzetto Lotti for the completion of the cenotaph, because Credi had not advanced the work substantially. The contract refers to

a model which is obviously identical with Verrocchio's original model; the passage runs: '. . . Et el quale modello promesse decto m° Lorenzo ristituire a' decti ufficiali, et con quelle figure modi et qualità in decto modello designate. In el quale modello sono et anno a essere da piè di decta sepoltura dua bambini di marmo, con dua armi d'epso Cardinale et dua agnolecti da chapo con due chandeglieri di sopra al cornicione di marmo'

Lorenzetto is here put under contract to return a certain model to the commissioners and 'con quelle figure modi et qualità in decto modello designate'. This somewhat puzzling formulation suggests that the model is not Lorenzetto's, but that he is to restore, alter or complete it, in such a fashion and quality as befits this model. In this model 'are and have to be', at the foot of the tomb, i.e. the sarcophagus, two figures of boys each holding the cardinal's coat of arms, and up on the framing two torch-bearing angels. These two pairs of figures are clearly additional to the nine figures of Verrocchio's design named in the contract with Credi, and their arrangement is probably similar in plan to that on the Marzuppini tomb by Desiderio. Lorenzetto Lotti is also to execute the architectural frame in marble instead of in *pietra serena* as originally intended, and also finally to complete the marble ground. Even in the sixteenth century the Forteguerri monument was not finished. Lorenzetto executed the figure of Charity to a new design of his own, and also the kneeling figure of the cardinal, which was not used for the monument in the Baroque period but was exhibited in the college endowed by Forteguerri (now Liceo Forteguerri). It is now to be seen in the Museo Civico in Pistoia (fig. 22). The figure of the cardinal is stylistically very different from the Charity and from other sculptures by Lorenzetto, and it is thought now that after Lorenzetto left for Rome the figure was worked over or completed by Giovanni Francesco Rustici. Rustici appeared at the signing of the contract with Lorenzetto as a guarantor.

BIBLIOGRAPHY: Gaye, I, 1839, p. 256 ff., no. CVI and no. CVII; Migliarini 1858, p. 52, pl. LX (clay model); Perkins, I, 1864, p. 183, no. 2; Gaetano Beani, *Notizie storiche su Niccolò Forteguerri*, Pistoia 1891, p. 127; Bode 1882, p. 92 f.; Bode 1887, p. 88; Reymond, III, 1899, p. 206 ff.; Bode 1892–1905, p. 145; Chiappelli and Chiti 1899, p. 44 ff.; Mackowsky 1901, p. 55 ff.; Berenson 1903, p. 43 f.; Cruttwell 1904, p. 125 ff. and p. 172; Schubring 1904, p. 20 f.; Reymond 1906, p. 80 ff.; Venturi, VI, 1908, p. 715, n. 5; Thiis 1913, p. 52 and

261, n. 57; Schubring 1915, p. 137 f.; Chiappelli 1925, p. 49 ff.; van Marle, XI, 1929, p. 495 f.; Maclagan and Longhurst, *Catalogue of Italian Sculpture*, London 1932, p. 58 f.; Clarence Kennedy, Elizabeth Wilder and Peleo Bacci, *The Unfinished Monument by Andrea del Verrocchio to the Cardinal Niccolò Forteguerri*, Northampton (Mass.) 1932, for the London model esp. p. 16 ff.; reviewed by Bernhard Degenhart in *Pantheon*, 11, 1933, p. 179 ff., by Middeldorf 1934, p. 54 ff., and by Frederick Jochem in *The Art Bulletin*, XVII, 1935, p. 233 ff.; Dussler 1940, p. 294 f.; Planiscig 1941, p. 53 f.; Valentiner 1944, p. 3 ff.; Valentiner 1950, p. 182 ff.; Pope-Hennessy 1958, p. 49 f. and p. 314 f.; Pope-Hennessy 1964, p. 164 ff., cat. 140; Covi 1967, p. 100 ff.

9. BOZZETTO FOR THE CENOTAPH OF CARDINAL NICCOLÒ FORTEGUERRI.

Plate 40

London, Victoria and Albert Museum (Inv. 7599–1861).

Terracotta, unpainted.

Height: 39·4 cm.; width: 26·7 cm.

The relief shows traces of repeated restorations, the earliest of which are probably of the beginning of the sixteenth century. At that time the goblet, the right hand and forearm of Faith, the head of Faith and also the heads of the cardinal and of Hope were renewed in clay, when the relief was broken right across at the level of the heads of the figures in the lower zone. The place where the join was repaired shows now in the form of fine cracks in the ground. It is an irregular curved line, beginning at the left edge at about the height of the foot of the goblet, falls obliquely from the head of Faith to the head of the cardinal, cuts through the front foot of Charity and then rises above the shoulder of Hope away to the right edge. A later addition in stucco is the broad console which bears the plinth with the kneeling cardinal. The motif decorating the console, a wreath of leaves flanked by wings, is evidently taken over from Donatello's Cavalcanti altar. The cardinal's hands and the cherub's head directly above the Charity have also been restored (probably in the nineteenth century) in red wax. The middle and forefinger of Christ's right hand raised in benediction are broken off. A crack in the ground to the right above the right-hand upper angel holding the mandorla is partly filled in with putty. On the back of the relief there are traces towards the upper edge which can be explained as a framing architectural element or an indication of curtains. They are probably derived from a triumphal arch or tabernacle type of

frame which was made separately and originally completed the *bozzetto*.

The relief was in the possession of the Marchese Ottavio Gigli in 1855 and was bought for the Museum in London from the Gigli-Campana collection in 1860 (for the sum of £80). The work is probably identical with a *bozzetto* mentioned in 1845 as a new acquisition of the collection of Niccolò Puccini in Pistoia; it is expressly described as an original design by Verrocchio for the Forteguerri monument (*Monumenti del Giardino Puccini*, Pistoia 1845, p. 139).

There are no documentary references which assist in a reconstruction of the original appearance of the lower zone of the *bozzetto*. As is explained in the text of the catalogue entry for the cenotaph itself, the torch-bearing angels and the boys holding the coats of arms named in the source of 17th June 1514 as components of the model are additions which Lorenzetto undertook or was to undertake to the original design. The console in stucco which now forms the base of the relief in no way corresponds to Verrocchio's project. The plinth covered with tile pattern on which the cardinal kneels is reminiscent of the marble zone on the lid of the Medici sarcophagus in S. Lorenzo. It is possible that the figure of the cardinal was originally intended to be set on a sarcophagus-like base, but it can hardly have had the breadth of the present console. The hovering of Faith and the impression of movement out of depth of the figure of Hope, placed quite deliberately somewhat higher so that it seems further away, are spoilt by the later introduction of a ramp cutting right across the composition. The effect is in any case lost in the Pistoia monument as we see it today by the exactly symmetrical positioning of Faith and Hope.

Lastly the placing of the (restored) head of the cardinal is problematical. The figure is looking past the head of Faith into space. The marble statue in the Museo Civico in Pistoia does not correspond to the figure in the model, but must have been newly designed as a frontal figure. These discordances arose because after Verrocchio's death, when there were so many attempts to complete the monument, not only was the general design altered but also the decision as to the position of the monument must have been changed several times. On 22nd April 1489 it was even suggested that the cenotaph be placed outside on the northern wall of the Duomo, facing the Piazza. The three-quarter profile of the kneeling cardinal seems occasioned by the fact that the figure is turning towards Faith as she approaches with goblet and cross. The special motif of the deceased represented as

in life and in eternal prayer, which the artist has adopted here, would, however, require an orientation of the figure of the cardinal towards the choir and the high altar of the church, and not towards the entrance wall, which would be the case if the terracotta model were to be realized in the position where the monument is at present. The London *bozzetto* thus evidently reckons on the cenotaph being placed opposite, on the wall of the south aisle of the Pistoia Duomo.

Attribution of the London *bozzetto* has been far from unanimous since its appearance in the nineteenth century. Robinson, Bode, Mackowsky, Schubring, Thiis and Valentiner accept it as an original model by Verrocchio himself. Pope-Hennessy thinks that studio assistants may have executed the relief. This, however, is unlikely in view of the relatively short time needed to produce it and of the importance of a design for a competition of this kind; and above all the quality of the work speaks against this probability. Wilder sees in the work the counter-project by Piero Pollaiuolo mentioned in the sources, and Jochem the model by Andrea Ferrucci of 1514, also referred to in the documents. Dussler is undecided as to whether to follow the opinion of Wilder or of Jochem. Berenson tentatively ascribed the model to Lorenzo di Credi. Reymond, Cruttwell, Venturi, Chiappelli and Planiscig regard it as a modern forgery; Perkins and van Marle are also sceptical.

BIBLIOGRAPHY: see previous entry.

10. PORTRAIT BUST OF A LADY WITH A BUNCH OF FLOWERS. Plates 44, 47, 49

Florence, Museo Nazionale del Bargello.

Marble; no trace of pigment.
Height: 0·61 m.

The bust is approximately life-size, and is in an excellent state of preservation. It was in the possession of the Medici, and in the 1880s was transferred from the Palazzo Medici to the Bargello. It does not, however, appear to have been commissioned by the Medici, since it is not entered in Tommaso's inventory. The entry no. 7, 'Per uno quadro dj legname drentovj la fighura della testa della Lucherezia de Donatj', cannot refer to a marble bust but must mean a panel painting, inlay or relief. There is no means of deciding whether it is a portrait of Lucrezia Donati, the beloved of Lorenzo de' Medici, as was thought earlier, or of Ginevra Benci, whose portrait by Leonardo in Washington (formerly in the Liechtenstein collection) it resembles in the

features. But the latter picture has not yet been proved to be a portrait of Ginevra Benci. The question of the identity of the sitter for the Liechtenstein portrait and the Bargello bust must continue unsolved – particularly while the entry in the inventory of the Palazzo Medici for 1492: 'una testa di marmo sopra l'archo dell'uscio di chamera ritratto al naturale mona Lucretia' remains to be identified convincingly with one of the marble busts preserved from the Medici collection.

It is of a type found among Roman busts, which includes the arms and hands, used only rarely in the Middle Ages and then for bust reliquaries; cf. Eva Kovács, *Kopfreliquiare des Mittelalters*, Insel-Verlag 1964. The bust of Matidia (fig. 23) is discussed in Guido A. Mansuelli, *Galleria degli Uffizi, Le Sculture* (Cataloghi dei Musei e Gallerie d'Italia), II, Florence 1961, p. 84, no. 86; fig. 86. For the inclusion of hands in painted portraits, cf. Jakob Burckhardt, *Das Porträt*, p. 285 ff. in *Beiträge zur Kunstgeschichte von Italien*, 1911 (2nd ed.). In Florentine early Renaissance portrait busts Desiderio took the first step from stiff immobility and frontality to a new more life-like form, in his portrait of Marietta Strozzi (Staatl. Mus., Berlin). There we find the slight turn of the head so characteristic of Verrocchio's bust in the Bargello with its inclination to the right shoulder so that the silhouette of neck, shoulders and upper arms loses its symmetry. Verrocchio's work was probably consciously modelled on Desiderio's portrait. Up to now it has not been possible to establish what flowers or blossoms the sitter is holding in her hand. Professor Lottlisa Behling's opinion that no definite identification can be made is confirmed by the eminent botanist Professor Wilhelm Troll, of Mainz. Both are in complete agreement that whatever the flowers may be they are not primroses, as they have usually been designated by Verrocchio scholars. In the primrose the stamens are grown together with the tubular lower part of the corolla and can never protrude above the corolla. It seems most probable that the flowers are a species of rose, either dog-roses in view of the ragged edges of the petals, or else *Althaea officinalis*, a mallow of the genus Malvaceae.

Because of the 'Leonardesque' beauty and expressiveness of the hands the Bargello bust has been attributed by some, notably Mackowsky, Suida and Möller, to Leonardo; Cruttwell and later Dussler emphatically refuted this. Venturi gave it to Verrocchio in 1908, noting that the Gioconda smile was foreshadowed here, but in 1935 he discussed it as a work of collaboration between Verrocchio and Leonardo. The dating of the

work varies between 1472 (Bode 1909) and 1480 (Planiscig). Dussler and Pope-Hennessy put it in the late seventies or in the second half of the eighth decade.

A pigmented plaster replica of the Bargello bust was acquired by the Metropolitan Museum, New York, in 1966 through Parke-Bernet; no scholarly study has so far appeared on the bust, which the museum kindly allowed me to inspect in their depot.

BIBLIOGRAPHY: Paul Müller-Walde, *Leonardo da Vinci*, Munich 1889, p. 66 f.; Bode 1892–1905, p. 143; Müntz, II, 1891, p. 503; *Catalogo del R. Museo Nazionale di Firenze*, Rome 1898, p. 417; Mackowsky 1901, p. 45 f.; Cruttwell 1904, p. 107 ff.; Reymond 1906, p. 59 ff.; Venturi, VI, 1908, p. 718; Wilhelm Bode, 'Die Wachsbüste einer Flora im Kaiser-Friedrich-Museum zu Berlin – ein Werk des Leonardo da Vinci?', in *Jahrbuch der Königlich Preußischen Kunstsammlungen*, XXX, 1909, p. 303 ff.; Schubring 1915, p. 134 f.; van Marle, XI, 1929, p. 488; Suida, *Leonardo und sein Kreis*, Munich, 1929, p. 34 f.; K. Clark, *A Catalogue of the Drawings of Leonardo da Vinci in the Collection of His Majesty the King at Windsor Castle*, London 1935, p. 89, no. 12558; Venturi, X, 1, 1935, p. 12 ff.; Dussler 1940, p. 294; Planiscig 1941, p. 35 ff. and p. 55; Galassi 1949, p. 212 f.; Emil Möller, *La gentildonna dalle belle mani di Leonardo da Vinci*, Bologna 1954; Pope-Hennessy 1958, p. 61 f. and p. 312.

11. RELIEF FROM THE TOMB OF FRANCESCA TORNABUONI. Plates 50–52

Florence, Museo Nazionale del Bargello.

Marble.

Height: 0·455 m.; width: 1·695 m.

The relief comes from the Medici possessions; it is named in the inventory of the Medici collections of 1666 (n. 758, c. 18): 'Un basso-rilievo di marmo bianco, alto br. ⅔, lungo br. 2¾, entrovi una storia d'una donna partoriente sopra un letto, con molte figure, dicesi esser di mano di Donatello . . .' (cf. Cruttwell 1904, p. 150, and Passavant 1959, p. 172, note 118). In the eighteenth century the work was for a time in the Palazzo Pitti, in the 'Scrittoio delle R. Fabbriche', and in 1805 came into the Uffizi, where Jakob Burckhardt saw it before 1855 in the Tuscan Sculpture corridor; thence, probably in 1874, it came to the Bargello.

Vasari says of the work: 'Onde essendo morta sopra parto in que' giorni la moglie di Francesco (sic) Tornabuoni, il marito, che molto amata l'aveva, e morta

voleva quanto poteva il più onorarla, diede a fare la sepoltura ad Andrea: il quale sopra una cassa d mar mo intagliò in una lapida la donna, il partorire, ed ili passare all'altra vita; ed appresso in tre figure, fece tre Virtù, che furono tenute molto belle, per la prima opera che di marmo avesse lavorato: la quale sepoltura fu posta nella Minerva'. Vasari, and later the Roman guide-book writers of the seventeenth and eighteenth centuries, wrongly thought that the deceased was the wife of Francesco Tornabuoni (d. 1481) whose tomb by Mino da Fiesole was also to be seen in the Minerva. In fact it was Francesca Tornabuoni, the daughter of Luca Pitti, who married Giovanni Tornabuoni in 1466; he was the uncle of Francesco. The father of Giovanni, who was also called Francesco, died in 1436 and was buried in S. Cecilia in Trastevere, also in a tomb by Mino da Fiesole. As we learn from Albertini (*Opusculum*, ed. Schmarsow 1886, p. 17) and from Vasari's Life of Ghirlandaio (Vasari, ed. Milanesi, III, p. 260) the Tornabuoni had a family chapel in S. Maria sopra Minerva which was decorated with frescoes by Domenico Ghirlandaio. Heemskerck saw the monuments of Francesca and of her nephew there and drew parts of them. The Tornabuoni chapel was dedicated to St John the Baptist, patron of Florence and name-saint of the founder Giovanni. In the last quarter of the sixteenth century it was transferred to the Naro family, who rearranged it and had the Tornabuoni tombs removed. A quattrocento reduction in the height of Francesca's tomb, involving the removal of a plinth with the relief, may have been necessary in the eighties, when Francesco's tomb was, as Egger has shown, introduced above hers. As Giovanni had left Rome it would have been returned to him in Florence. In the seicento both tombs were placed in the north aisle of the Roman church, between the west front and the first chapel. They are mentioned there by Filippo Titi in his guide to the churches of 1675 and also in eighteenth-century guides; the tomb of Francesco is still to be seen there. It has not yet been discovered where the sarcophagus with the recumbent figures of the deceased and the stillborn child (possibly cast in bronze) were put when the monument of Francesca was finally dismantled in the late eighteenth or early nineteenth century. Parts of the fittings of the Tornabuoni chapel were evidently used again in other places in S. Maria sopra Minerva, e.g. the marble figures of two naked boys (figs. 18–19) which now flank the entrance arch to the Caraffa chapel, which were probably carved by the same pupil of Verrocchio who also did greater parts of the Bargello relief. Accord-

ing to Reymond (1906, p. 75, note 2) this supposition was already advanced by Stanislao Fraschetti (Flegrea 1900). Attribution of the Bargello fragment from the tomb has always been subject to much uncertainty. Burck-hardt, following Vasari, considered it to be a work of Verrocchio, but censured the poor quality of the execution. Reumont in 1873 was able to publish a letter from Giovanni informing his nephew Lorenzo de' Medici of the confinement and death of his wife; this corrected Vasari's mistake about the identity of the deceased. Reumont, however, doubted whether a tomb for Francesca had ever existed in Rome. Bode in 1882 attributed the execution of the marble relief, which he accepted as a fragment of the tomb in the Minerva, to a pupil of Verrocchio's. Müntz in his *Histoire de l'Art pendant la Renaissance* speaks once of Verrocchio's tomb for Giovanna (sic) Tornabuoni, and later in the same volume of the tomb of Francesca, which could not be regarded as an autograph by Andrea, since as it was erected after 1477 it was not an early work of the artist. But in the course of writing this volume and between these two references Müntz had examined the question more closely and published the result of his research in an article in the *Gazette des Beaux-Arts*, also in 1891. In 1899 Reymond described the Bargello relief as the earliest marble work by Verrocchio, unskilful because of the new technique. Bode had earlier classified four reliefs with figures of the Virtues in the collection of Gustave André in Paris as further fragments of the Tornabuoni monument to be added to the relief in Florence. Although he makes reference to Vasari's description he none the less thinks it possible that the tomb was never erected in Rome. Mackowsky ignores Vasari's report entirely and maintains that Francesca's body was brought to Florence and laid in S. Maria Novella, where the Tornabuoni had a family vault. The Florentine tomb of Francesca would probably have been removed in 1565 when the rood loft of S. Maria Novella was re-designed. He attributed the surviving parts of this tomb, among which he included the Virtues in the André collection, to Verrocchio for the design, but to his pupils for the execution. Vasari's information about the tomb in the Minerva was proved, however, when Egger found in the register of the 'Fraternità dei rac-commandati del SS. Salvatore ad Sancta Sanctorum' an entry confirming it. Egger also recognized that Heemskerck had reproduced details of both Tornabuoni monuments in his Roman sketch-book. Heemskerck's drawing of the figure lying on a bier which crowns the sarcophagus of the tomb of Francesca is directly remi-niscent of the corresponding part of the Forteguerri tomb (reconstructed by Gnoli) by Mino da Fiesole in S. Maria in Trastevere. Hence Egger also thought it necessary to ascribe the tomb of Francesca to Mino and not Verrocchio. This thesis has not, however, been accepted by Verrocchio scholars, although there is as yet no unanimity as to whether the Bargello relief is an autograph of the artist or pupils' work. While Planiscig in his monograph on Verrocchio of 1941 does not include the relief at all, Valentiner, and then Galassi in 1949, believed it to be an autograph by Andrea. Galassi speaks erroneously of the representation of the death of 'Lucrezia Tornabuoni'. The execution of the Bargello relief is generally placed in 1478/79 because of the date of the death of Francesca.

BIBLIOGRAPHY: Vasari-Milanesi, III, p. 359 f.; A. Filippo Titi, *Studio di Pittura Scoltura & Architettura nelle Chiese di Roma*, Rome 1675, p. 101; Gregorio Roisecco, *Roma antica e moderna o sia nuova descrizione*, I, 1750, p. 505; Nicola Roisecco, *Roma antica, e moderna o sia nuova descrizione*, 1765, p. 521; Burckhardt 1855, p. 569; Alfred von Reumont, 'Il monumento Tornabuoni del Verrocchio', in *Giornale di Erudizione Artistica*, II, 1873, p. 167 f.; Bode 1882, p. 92 ff. and p. 96; *Guida per il visitatore del R. Museo Nazionale*, Florence 1884, p. 137; Enrico Ridolfi, 'Giovanna Tornabuoni e Ginevra Benci nel coro di S. Maria Novella in Firenze', in *Arch. stor. it.*, 1890, p. 426 ff.; Müntz, II, 1891, p. 468 + n. 4, and p. 501 f.; Eugène Müntz, 'Andrea Verrocchio et le tombeau de Francesca Tornabuoni', in *Gazette des Beaux-Arts* 1891, 3ᵉ pér., VI, p. 277 ff.; *Catalogo del R. Museo Nazionale di Firenze*, Rome 1898, p. 406 ff., n. 146; Reymond, III, 1899, p. 203 f.; Bode 1892–1905, p. 144; Mackowsky 1901, p. 60 ff.; Frida Schottmüller, 'Zwei Grabmäler der Renaissance und ihre antiken Vorbilder', in *Repertorium für Kunstwissenschaft*, XXV, 1902, p. 401 ff.; Cruttwell 1904, p. 140 ff.; Reymond 1906, p. 74 ff.; Venturi, VI, 1908, p. 710 ff.; Schubring 1915, p. 136 f.; van Marle, XI, 1929, p. 496; Dagobert Frey, *Gotik und Renaissance als Grundlagen der modernen Welt-anschauung*, Augsburg 1929, p. 145; Hermann Egger, *Francesca Tornabuoni und ihre Grabstätte in S. Maria sopra Minerva*, Vienna 1934; Dussler 1940, p. 294; Valentiner, 1941, p. 13; Galassi 1949, p. 214; P. Vincenzo Chiaroni, O.P., 'Il Vasari e il monumento sepolcrale del Verrocchio per Francesca Tornabuoni', in *Studi Vasariani, Atti del convegno internationale per il centenario della prima edizione delle 'Vite' del Vasari*, Florence 1952, p. 144 f.; Pope-Hennessy 1958, p. 311; Passavant 1959, p. 23 f., n.

III–II9; Erwin Panofsky, *Grabplastik*, Köln 1964, p. 80; Passavant 1966, p. 17 ff.

12. BUST OF GIULIANO DE' MEDICI.

Plates 45, 46, 48

Washington, National Gallery of Art (no. A–16; Mellon Collection).

Terracotta.

Height: 0·61 m.

The now brown painted, waxed bust does not show any trace of an original pigmentation. The interior hollow is not closed at the back (fig. 25).

The bust is not mentioned in documents or sources, nor in the inventories of the Medici collections. The piece was bought by Eugène Piot in Italy in 1846, passed with the Piot collection into the possession of the painter Charles Timbal before 1870 and from the end of the nineteenth century was among the most famous pieces in the Paris collection of Gustave Dreyfus; in the Mellon collection since 1937.

Since Bode's attribution to Verrocchio the bust has been generally accepted as an autograph work of the artist. However, Stites has recently advanced the scarcely tenable thesis that the head of Giuliano is modelled by Verrocchio but the execution of the armour clearly betrays the hand of Leonardo.

BIBLIOGRAPHY: *Le Magasin pittoresque*, no. 34, 1866, p. 41; Bode 1892–1905, p. 142 f.; Mackowsky 1901, p. 42; Cruttwell 1904, p. 88 f.; Reymond 1906, p. 63; Vitry 1907, p. 22; Venturi, VI, 1908, p. 715; Trifon Trapesnikoff, *Porträtdarstellungen der Mediceer des XV. Jahrhunderts*, Strassburg 1909, p. 68 ff.; van Marle, XI, 1929, p. 481; National Gallery of Art (Washington), *Preliminary Catalogue of Paintings and Sculpture, Descriptive List with Notes*, Washington 1941, p. 239; Planiscig 1941, p. 28 f. and 53; Georg Swarzenski, 'Some aspects of Italian Quattrocento Sculpture II', in *Gazette des Beaux-Arts*, 1943, Vol. 24, p. 298; Charles Seymour jr., *Masterpieces of Sculpture from the National Gallery of Art*, New York 1949, p. 179; Galassi 1949, p. 214; Pope-Hennessy 1958, p. 62; Raymond S. Stites, 'Leonardo scultore e il busto di Giuliano de' Medici del Verrocchio', in *Critica d'arte*, x, 1963, (1) no. 57/58, p. 1 ff., (2) no. 59/60, p. 25 ff.

13. DECOLLATION OF JOHN THE BAP-TIST.

Plates 53–57

Florence, Museo dell'Opera del Duomo.

Silver relief, ground embossed and chased; figures cast single or in pairs in silver, engraved and attached to the relief ground with pegs.

Height: 31·5 cm.; width: 42 cm.

The relief is placed in the lower part of the right-hand side panel of the silver antependium of the Baptistery altar. In 1477 it was decided to complete the main side of the antependium, which dates from the trecento, with two narrow side panels each with two relief scenes in an architectural frame. The commission for the reliefs, which were to represent scenes from the beginning and the end of the life of John the Baptist, was awarded on the basis of a competition; the other competitors besides Verrocchio were Antonio Pollaiuolo, Bernardo Cennini and Antonio di Salvi in collaboration with Francesco di Giovanni. Verrocchio submitted two models, for which he received payment on 2nd August 1477. He was, however, only assigned the execution of the Decollation relief, as transpires from an entry of 13th January 1478. More details of the commission and of the technique of production are in Passavant 1966, p. 13 ff. In the same article the author published four silver statuettes from the upper gallery of niches in the architectural frame of the antependium, of which at least the two central ones show themselves to be Verrocchio's autograph by their quality. These four small figures, about 9 cm. high, must have been produced in Verrocchio's studio at the same time as the Decollation scene, in 1478/79. In 1480 the artist was paid for delivery of the relief. Doubt has often been cast on the supposition that Verrocchio not only designed but himself executed the Decollation scene; firstly by Bode (1892–1905), who accepted two terracotta copies of the youth with the salver and the officer with the baton, then owned by Baroness Adolphe de Rothschild in Paris, as detail models by Verrocchio himself, which were used by his assistants, who – in Bode's opinion – executed the silver relief. A terracotta replica of the whole scene in the possession of M. A. de Eperzesy in Rome, which is probably also by a late imitator of Verrocchio, was published in 1894 by Ulmann as the original model by Verrocchio. Ulmann's suggestion was emphatically rejected by Venturi (1902 and 1908), and then again by Cruttwell, who considered the silver relief to be an autograph of the artist. Reymond (1899) recognized in the Decollation scene 'tous les raffinements de l'art de Verrocchio, ses goûts d'orfèvre dans les armures si brillamment ornées, sa science d'anatomiste dans les nus du bourreau, ses recherches expressives dans les figures du saint et des divers groupes

de spectateurs qui l'entourent'. Mackowsky, however, following Bode, believed that the relief was executed by pupils; and Planiscig held the same view still in 1941. Lipinsky erroneously attributed the relief with the Dance of Salome placed above the Decollation scene to Verrocchio as well.

BIBLIOGRAPHY: Albertini, *Memoriale* 1510 (ed. 1863), p. 9; Billi (ed. Frey), p. 47; Cod. Magl. (ed. Frey), p. 89; Vasari-Milanesi, III, p. 359; Richa, v, 1757, p. XXXI; C. J. Cavalucci, in *La Nazione* of 23 June 1869; François Anatole Gruyer, *Les Œuvres d'Art de la Renaissance Italienne au Temple de Saint-Jean*, Paris 1875, p. 223 ff.; Bode 1882, p. 92 f.; Bode 1892–1905, p. 145; Hermann Ulmann, 'Il modello del Verrocchio per il rilievo del dossale d'argento', in *Archivio storico dell'arte*, VII, 1894, p. 50 f.; Pietro Franceschini, *Il dossale d'argento del tempio di San Giovanni in Firenze*, Florence 1894, p. 22 ff.; reviewed by C. de Fabriczy in *Archivio storico dell'arte*, 1895, p. 469 ff.; Reymond, III, 1899, p. 204; Mackowsky 1901, p. 63 ff.; Adolfo Venturi, 'Un bronzo del Verrocchio', in *L'Arte*, v, 1902, p. 44; Cruttwell 1904, p. 166 ff.; Giovanni Poggi, *Catalogo del Museo dell'Opera del Duomo*, Florence 1904, p. 46 f. and p. 69 ff.; Reymond 1906, p. 66 ff.; Venturi, VI, 1908, p. 714 f.; Schubring 1915, p. 138 f.; van Marle, XI, 1929, p. 488 ff.; Cyril G. E. Bunt, 'Die silberne Altarfront des Baptisteriums in Florenz', in *Pantheon*, v, 1930, p. 224; Bertini 1935, p. 455; Dussler 1940, p. 294; Paatz, II, 1941, p. 208 f.; Planiscig 1941, p. 24 ff. and p. 51 f.; Galassi 1949, p. 214 f.; Steingräber 1955, p. 94 ff.; Angelo Lipinsky, 'Das Antependium des Baptisteriums zu Florenz', in *Das Münster*, 1956, p. 134 and p. 138 ff.; Passavant 1966, p. 13 ff.

14. TWO ANGELS.　　　　Plates 58–59

Paris, Louvre (Collection Thiers).

Terracotta, unpainted.

Height: 0·38 m.; width: 0·35 m.

The two reliefs, which were probably intended to flank a tondo with the representation of Christ or the Madonna, were in my opinion produced in Verrocchio's studio about 1480, the artist himself executing the left-hand angel, while Leonardo did the right-hand companion to his own design. The reliefs agree closely as to motif with the angels bearing the mandorla in the Forteguerri cenotaph and in the terracotta model belonging to it in the Victoria and Albert Museum; however, they cannot be regarded as designs for parts of the Pistoia monument. Whether they were intended as models for bronze or marble reliefs, or whether they were to be used as they were, as terracotta reliefs in relatively small format and probably painted, cannot be decided today. The earlier condition of both reliefs is reproduced in the photographs published by Bode (1892–1905). They have been restored more than once, and the broken-off edges and missing parts of the terracotta plaques have been incorrectly replaced and aligned in various forms. In both pieces the 'ground zone' formed of bands of cloud now runs slightly obliquely; the right-hand relief in particular should be tilted more to the left. In both angels the furthest projecting parts of the wings were broken off. On the left-hand angel a wide (original) piece of the front wing has been stuck on, from the right-hand angel the curve of the wing that was broken off was evidently lost. The missing part has been restored several times in various ways. The latest restoration has doubtless falsified the original impression most, in that the still existing traces of a ring of cloud near the angel's hands have been multiplied into thick layers of clouds arranged in parallel bands. In both reliefs small parts of the draperies have been restored. On the left-hand angel the toes of the backward stretching foot were broken off; they have been relatively well restored. The thumb of the left hand of the Leonardo angel has also been renewed.

The traditional designation of the Louvre reliefs as models for two of the marble angels of the Forteguerri monument has been accepted even quite recently (by Pope-Hennessy and others), although Wilder had treated it with considerable misgiving in his monograph on the Pistoia monument (p. 46: 'Whatever their original intention, the Thiers reliefs cannot be the actual models from which the existing figures were carved'). Valentiner ascribed both angels to Leonardo in 1944; he thinks that the reliefs were done as designs for the cenotaph but were then rejected, because the master could not understand Leonardo's much more advanced style of figure representation (p. 184: '... the models are so superior in every way – not least in the charm and beauty of the heads and in the ease of their movements – that it is difficult to understand why they were not simply copied by those who executed the marble reliefs. We can explain this only by supposing that the creator of the monument had no understanding for the advanced style of the models and preferred his own more reactionary formulas ...').

BIBLIOGRAPHY: Bode 1892–1905, p. 145; Eugène Müntz, *Leonardo da Vinci, artist, thinker and man of*

science, New York 1898, I, p. 44; Mackowsky 1901, p. 58; Cruttwell 1904, p. 134 f.; Reymond 1906, p. 83 f.; Venturi, VI, 1908, p. 715, n. 5; Schubring 1915, p. 138; van Marle, XI, 1929, p. 496; Kennedy, Wilder and Bacci 1932, p. 45 f. and p. 55; Dussler 1940, p. 294; Planiscig 1941, p. 30 and p. 54; Valentiner 1944, p. 6 ff.; Valentiner 1950, p. 182 ff.; Pope-Hennessy 1958, p. 314.

15. SLEEPING YOUTH. Plate 60

Berlin, Staatliche Museen (Inv. no. 112).
Terracotta, unpainted.
Height: 0·36 m.; width: 0·58 m.
Well preserved, only some toes are restored.

The statuette came to the Berlin museum in 1885 from the possession of the Marchese Spinola in Genoa. According to the inventory of the collection in Genoa it originated in Florence (cf. Cruttwell) and was designated as 'Abel'. Venturi interprets the figure as 'Endymion'; Burger calls it 'Adam sleeping'. According to Maud Cruttwell it is a nude study for the young sleeping warrior in the Resurrection relief from Careggi. The more important refutation of Cruttwell's suggestion was by Frida Schottmüller in 1913, on the ground that the style of the statuette is more mature than that of the Careggi relief which she – like Gamba, Bode and others – classed as an early work of Verrocchio's. Venturi in 1908 questioned Bode's attribution and rejected the statuette as an autograph of the artist; in 1926 he attributed it to Antonio Pollaiuolo. It is considered by Planiscig, as already by Cruttwell, to be a very early work of Verrocchio's produced 'about 1465'.

BIBLIOGRAPHY: Bode 1887, p. 103 ff.; Berenson 1896, p. 131; Bode 1892–1905, p. 148; Burger 1904, p. 277, n. 1; Cruttwell 1904, p. 61; Venturi, VI, 1908, p. 723; Cornelius von Fabriczy, 'Kritisches Verzeichnis toskanischer Holz- und Tonstatuen bis zum Beginn des Cinquecento', in *Jahrbuch der Königlich Preußischen Kunstsammlungen*, XXX, 1909, additional volume, p. 20 f., no. 31; Schottmüller 1913, p. 73, no. 173; Adolfo Venturi, 'Per Antonio Pollaiuolo', in *L'Arte*, XXIX, 1926, p. 181; the same: *Studi dal Vero*, Milan 1927, p. 51; van Marle, IX, 1929, p. 486; Valentiner 1930, p. 43 ff.; Schottmüller 1933, p. 59, no. 112; Bertini 1935, p. 441; Dussler 1940, p. 294; Planiscig 1942, p. 13 f. and 48 f.

16. THE LAMENTATION. Plate 61

Formerly *Berlin, Kaiser-Friedrich-Museum* (Inv. no. 117).
Terracotta relief, unpainted.
Height: 0·29 m.; width: 0·43 m.

The work has disappeared since the evacuation of the museum contents during the last war; it was probably destroyed by fire in 1945. The state of preservation of the relief was not very good. The upper edge with the head of the young woman (Magdalen?) and the right-hand upper corner with the torso of St John were broken off. The lower edge was injured. Fine cracks in the surface were particularly visible on the sarcophagus. The work came into the possession of the museum in 1888 as a gift from Dr James Simon. He had acquired it from the collection of F. v. Pulszky, who had bought it in 1865 from Foresi in Florence. Several views have been expressed as to the original intention of the work. Mackowsky thought it was the design for a sarcophagus relief planned first as decoration for the lower register of the Forteguerri monument. He claims to recognize a portrait of Niccolò Forteguerri in the figure of Nicodemus. This suggestion, supported by Schubring, was rightly rejected by Cruttwell and later by Wilder. The features portrayed on the marble figure of the kneeling cardinal in the Museo Civico in Pistoia and on the recumbent figure on the Forteguerri tomb in S. Cecilia in Trastevere in Rome do not correspond to those of the Nicodemus figure. Cruttwell and following her van Marle consider that the Lamentation relief might be a model for the lower part of a Doge's tomb in view of the fact that Vasari mentions a design for a Doge's monument made by Verrocchio. The drawing (D11) for the Vendramin tomb (Victoria and Albert Museum, no. 2314) had not then been identified. Bode's attribution of the Berlin relief to Verrocchio has only been questioned by Venturi.

BIBLIOGRAPHY: Bode 1892–1905, p. 145 f.; Berenson 1896, p. 131; Mackowsky 1901, p. 60; Schubring 1904, p. 26; Burger 1904, p. 177 ff.; Cruttwell 1904, p. 156 f.; Reymond 1906, p. 69; Venturi, VI, 1908, p. 723; Schottmüller 1913, p. 72 f., no. 172; Schubring 1915, p. 138; van Marle, XI, 1929, p. 494 f.; Kennedy, Wilder and Bacci 1932, p. 46 f.; Schottmüller 1933, p. 60, no. 117; Dussler 1940, p. 294; Valentiner 1941, p. 19; Planiscig 1941, p. 23 f. and p. 51; Valentiner 1950, p. 124.

17. THE EQUESTRIAN MONUMENT TO BARTOLOMEO COLLEONI. Plates 62–68

Venice, Campo SS. Giovanni e Paolo.
Bronze.
Height of horse and rider (without marble plinth): 3·95 m.

No exact dates or details are known either for the terms and details of the competition or for the final award of the commission to Verrocchio. On 16th July 1481 the Ferrarese ambassador in Florence, Antonio di Montecatini, requested free passage through the territory of Ferrara for the transport of the life-size model of a horse packed in several pieces, from Florence to Venice. The letter addressed to Ercole d'Este only states that a Florentine artist wishes to compete for the commission for the Colleoni monument with this model. That this request referred to Verrocchio's model, and that this horse, made in wood and later covered with black leather, was exhibited to the public in Venice together with the competition models of Leopardi and Vellano, is confirmed by a description in the travels of Felix Faber and in Vasari's Life of Verrocchio. According to these it was not in any way decided before 1483 that Verrocchio would receive the commission for the equestrian statue. This is contradicted by a passage in a minute from a Florentine notary's office of 8th November 1490, recently discovered by Dario A. Covi. In connection with disputes over inheritance between Tommaso Verrocchio, Andrea's brother, and Lorenzo di Credi, Andrea's designated executor, Lorenzo was asked to answer to a number of asseverations and statements by Tommaso. Tommaso had affirmed 'che insino del mese d'aprile 1480 havendo decto Andrea tolto dalla communità di Venetia una statua d'uno cavallo di brongo con la figura di Bartolomeo di Bergamo, esso Andrea per fare tale opera andò a Venegio. Item che decto Andrea stete in decta città insino al tempo della morte sua.' If we follow these declarations, which Lorenzo di Credi according to the minutes denied, Andrea had already received the commission for the Colleoni monument in the spring of 1480 and had lived in Venice until his death in 1488, more than eight years. This is countered, apart from the date of the Venetian competition, on the one hand by what we know of the completion and erection of the Christ and St Thomas group in Florence, and on the other by a later passage in the same notary's register, which runs: 'Item che decto Andrea stete in Venegio mesi 26 e decto Lorenzo ste' cum lui'. In view of these contradictions, we cannot rate the documentary value of the notary's minutes very high particularly where the facts in question were denied by Credi. From a memorandum made by Lorenzo di Credi on 7th October 1488 which was seen by Milanesi but has since vanished, it appears further that Verrocchio had before his death finished the full-size clay models of horse and rider, from which the bronze was to be cast,

but that the casting had not yet been done. Of the agreed total price of 1800 Venetian ducats for the finished monument only 380 had been paid to the artist. In his will drawn up on 25th June 1488 Verrocchio determined: 'Etiam relinquo opus equi per me principiati ad ipsum perficiendum, si placuerit illmo. Duci Do. Venetiarum ducale dominium humiliter supplico, ut dignetur permittere dictum Laurentium perficere dictum opus, quia est suffitiens ad id perficiendum.' Lorenzo di Credi thereupon, as we learn from the Ricordo of October 1488 already mentioned, entered into negotiations immediately after Verrocchio's death with a Florentine sculptor, Giovanni d'Andrea di Domenico, and assigned the casting of the Colleoni to him. But apparently the Signoria of Venice thought it too risky to leave the responsibility for the completion of the monument to Lorenzo; they entered on their own part into negotiations with Alessandro Leopardi, who had participated in the competition for the commission in 1483 and meanwhile had been exiled to Ferrara for forging documents. In January 1489 Leopardi was persuaded, with promise of a safe-conduct, to return to his home town and undertake the completion and erection of the Colleoni. By the summer of 1492 both horse and rider were cast, each separately. On 19th November 1495 the monument stood in its place on the Campo SS. Giovanni e Paolo; on 21st March 1496 the ceremonial unveiling took place, as we learn from the diary of Marin Sanudo.

Leopardi put his signature on the girth of the horse: ALEXANDER LEOPARDVS V. F. OPVS. The abbreviation V. F. can be interpreted either VENETVS FVDIT or VENETVS FECIT. This ambiguity is perhaps intentional, or at any rate not avoided by Leopardi. The fame of 'Alessandro del Cavallo', based on the completion of the Colleoni monument, allowed the name of Verrocchio to be soon forgotten in Venice. Already in 1494 Luca Pacioli was praising Leopardi in the dedication to his Summa de Arithmetica geometrica as the genius who created the equestrian statue, and in the eighteenth and early nineteenth century the monument in Venice was still considered as his work – despite the circumstantial report, decked out with anecdotes, which Vasari gives of the making of the work in his Life of Verrocchio. Even today the Colleoni is justly considered as a technical masterpiece by Leopardi; yet there remains no vestige of doubt that the Venetian used the unaltered original model of Verrocchio for the casting of the figure. Possibly he had no choice, for the instructions of the commissioners were to hand. Leopardi took over

together with the special artistic conception its premises for construction which Verrocchio had worked out in lengthy experiments and statistical calculations. The ornamentation of harness and armour, which was carried out after the casting when the piece was worked over, betrays unambiguously Leopardi's own artistic taste, as Bode in particular established clearly in his comparison with the ornament on the Christ and St Thomas group.

BIBLIOGRAPHY: *The Book of the Wanderings of Felix Fabri*, 1483, ed. London, I, 1892, p. 95 f.; *I Diarii di Marino Sanuto* (1496–1533), ed. by Federico Stefani, Rinaldo Fulin, Guglielmo Berchet and Marco Visentini, Venice 1879–1902, vol. I, i; Vasari-Milanesi, III, p. 367 ff.; Vasari-Milanesi, IV, p. 565, n. 1; T. Temanza, *Vite dei più celebri architetti, e scultori veneziani*, I, Venice 1778, p. 110 ff.; E. A. Cicogna, *Delle Inscrizioni Veneziane*, II, Venice 1827, p. 297 ff.; Giuseppe Orlandelli, *Monumento di Bartolomeo Colleoni nella Piazza dei SS. Giovanni e Paolo di Venezia*, Venice 1831; P. Paoletti di Osvaldo, *L'architettura e la scultura del Rinascimento in Venezia*, II, Venice 1893, p. 263 ff.; E. Duhousset, 'Un dernier mot à propos du "Colleone" de Verrocchio', in *Gazette des Beaux-Arts*, XX, 1898, p. 149 ff.; Bode 1892–1905, p. 148; Mackowsky 1901, p. 70 ff.; Jacob Burckhardt, *Der Cicerone*, 9th ed. revised by W. Bode and C. v. Fabriczy, vol. II, Leipzig 1904, p. 447; Cruttwell 1904, p. 177 ff.; Georg von Graevenitz, *Gattamelata und Colleoni und ihre Beziehungen zur Kunst*, Leipzig 1906; Reymond 1906, p. 91 ff.; A. E. Brinckmann, *Platz und Monument als künstlerisches Formproblem*, Berlin, 3rd edition 1923 (1st ed. 1908), p. 18 ff.; Venturi, VI, 1908, p. 720; Schubring 1915, p. 139 f.; B. Belotto, *La Vita di Bartolomeo Colleoni*, Bergamo 1923; Paul Clemen, 'Bartolomeo Colleoni, Bilder und Studien aus drei Jahrhunderten' in: *Eberhard Gothein zum 70. Geburtstage als Festgabe*, Munich and Leipzig 1929, p. 109 ff.; Dussler 1940, p. 295; Planiscig 1941, p. 39 ff. and p. 56 f.; Galassi 1949, p. 216 f.; Pope-Hennessy 1958, p. 65 ff. and p. 315; Juan Dalma, 'La estatua ecuestre del Colleoni y su enigma', in *Cuadernos de humanitas*, 8, Universidad nacional de Tucumán-Publicación 835, Tucumán 1961 (Dalma's discussion is summarized by David Cugini, 'Il maestro Andrea Verrocchio eresse un monumento al suo scolaro Leonardo da Vinci?', in *Bergomum* 37, 1963, no. 2, p. 89 f.); Christian Adolf Isermeyer, *Das Reiterdenkmal des Colleoni*, Werkmonographien zur Bildenden Kunst in Reclams Universalbibliothek, no. 93, Stuttgart 1963; Dario A. Covi, 'Four new Documents concerning Andrea del Verrocchio', in *The Art Bulletin*, XLVIII, 1966, p. 97 ff.

PAINTINGS

18. PRIVATE DEVOTIONAL PAINTING: MADONNA WITH SEATED CHILD.

Plates 69–71

Berlin, Staatliche Museen (no. 104A).

Tempera on wood.

Height: 0·72 m.; width: 0·53 m.

There are narrow strips all round the surface of the painting which have been repaired and in places incorrectly restored; on certain parts of the child's body the brownish tone used for the underpainting of the shadows (containing too high a percentage of oil of resin?) is now visible through the glazes; otherwise the picture is in fairly good condition. (For further details see Passavant 1959, p. 96 ff. and 236.) The Madonna was bought in Florence for the Berlin Museum in 1873 from the collection of Prince Jérôme Napoléon, who is said to have bought it in Florence. A contemporary copy, but without a landscape background except in the extreme left-hand margin, is in the National Gallery of Art in Washington (no. 502; Samuel H. Kress Collection K 1282; fig. 32). Bode's early attribution of the Berlin painting to Verrocchio has frequently been questioned, first by Morelli ('a bad imitator of Pollaiuolo') and then by Cruttwell, Reymond and Venturi. On the other hand Berenson agreed with him as early as 1896, considering it an early work by Verrocchio. This opinion is supported by Mackowsky and Planiscig, while Degenhart puts the picture relatively late in Verrocchio's development as a painter, about 1475.

BIBLIOGRAPHY: Semper 1877, p. 47; Bode 1882, p. 242 ff.; Lermolieff 1893, p. 33 ff.; Berenson 1896, index, p. 130; Mackowsky 1901, p. 80 ff.; Cruttwell 1904, p. 118 ff.; Reymond 1906, p. 129; Venturi, VII, I, 1911, p. 781; van Marle, XI, 1929, p. 526 ff.; Degenhart, 1932, p. 80; Dussler 1941, p. 295; Planiscig 1941, p. 45; Passavant 1959, p. 95 ff., n. 291–302, p. 235 f.

19. PRIVATE DEVOTIONAL PAINTING: TOBIAS WITH THE ARCHANGEL RAPHAEL ON THE JOURNEY. Plates 72–74

London, National Gallery (no. 781).

Tempera on wood.
Height: 0·84 m.; width: 0·66 m.

The panel is fairly well preserved, with no edges cut; for details of repairs cf. Passavant 1959, p. 106 and n. 320. The effect of the flesh tones, particularly in the angel's face, is no longer original; owing to drastic cleaning of the surface the underpainting now shows through too strongly. In the nineteenth century the picture was in Florence in the collection of Conte Angiolo Galli Tassi, was included in a bequest to the Arcispedale S. Maria Nuova and other Florentine hospitals in 1863 together with other items, and shortly afterwards was sold to G. Baslini in Milan. There the National Gallery was able to buy it in 1867 as a work of Antonio Pollaiuolo. On the question of the particular theme, the type of picture and its chronological position among Florentine representations of Tobias and the Angel cf. Passavant 1959, p. 109 ff. The painting was first thought to be Umbrian by Crowe and Cavalcaselle, but later they held it to be a work of the Verrocchio–Pollaiuolo circle; Cruttwell agreed. Morelli inclined more towards the Pollaiuolo studio, A. Venturi attributed it to Antonio Pollaiuolo himself. Mackowsky considers it to be a work of Francesco Botticini; Ragghianti, Zeri and most recently Camesasca attribute it to the young Perugino. Bode's early opinion that it is an autograph of Verrocchio is upheld by Schmarsow, Ortolani and Passavant. Berenson thinks an unknown pupil participated in the execution with Verrocchio; Suida considers it a work of collaboration between Verrocchio and Leonardo.

BIBLIOGRAPHY: Crowe and Cavalcaselle, III, 1870, p. 133, n. 32; Lermolieff 1880, p. 391, n. 1; Bode 1882, p. 247 f.; Crowe and Cavalcaselle, VI, 1894, p. 143; Schmarsow 1897, p. 126; Mackowsky 1901, p. 86; Cruttwell 1904, pp. 118, 121; Venturi 1926, p. 56; van Marle, XI, 1929, p. 539; Berenson 1933–34, p. 202 f.; Ragghianti 1935, p. 196, n. 1; Sergio Ortolani, *Pollaiuolo*, 1948, p. 192; National Gallery Catalogues: The Earlier Italian Schools, by Martin Davies, London 1951, p. 428 f.; 2nd ed. 1961, p. 555 ff.; Zeri 1953, p. 134 ff.; Suida 1954, p. 317; Passavant 1959, p. 103 ff., n. 303–348, p. 237; Camesasca 1959, p. 12 f. and 40 f.

20. ALTARPIECE: CHRIST ON THE CROSS BETWEEN ST JEROME AND ST ANTHONY. Plates 75–77

Argiano (near S. Casciano), S. Maria e Angiolo, Sacristy.

Tempera on wood.
Height: 1·15 m.; width: 1·50 m.

The panel has been badly cut along the bottom edge. There has been extensive overpainting and the surface is very dirty so that it is impossible to decide finally the question of authorship. As far as one can see in its present condition, the design of the whole composition and the execution of the figures of Christ and of St Jerome are by Verrocchio himself; the figure of St Anthony and large parts of the landscape are obviously by the hand of a pupil. The panel is first mentioned in 1892 by Guido Carocci in the (nineteenth-century) church in Argiano and described as 'ispirata dalla maniera del Perugino'. (For the unsolved question of the original destination of the picture, for its attribution, dating and influence cf. Passavant 1959, p. 122 ff. and 235.) Marangoni who was the first to draw attention to the importance of the panel in 1927 calls it the work of an anonymous 'eclettico fiorentino del '400'. Van Marle presumes the painter to be a member of the circle of Pollaiuolo. Gamba would see a mixture of elements of style from Baldovinetti, Verrocchio, Pollaiuolo and Domenico Ghirlandaio; he attributes it, with a date of 'about or before 1470', to the young Ghirlandaio. Ragghianti, Zeri and recently Camesasca support an attribution to the young Perugino and thus return approximately to the opinion of Carocci.

BIBLIOGRAPHY: Guido Carocci, *Il comune di S. Casciano in Val di Pesa*, Florence 1892, p. 52; Matteo Marangoni, 'Un Eclettico Fiorentino del Quattrocento', in *L'Arte*, XXX, 1927, p. 256 ff.; van Marle, XI, 1929, p. 418; Catalogue: Mostra del Tesoro di Firenze Sacra, Convento di S. Marco, Florence 1933, p. 126, no. 324; Carlo Gamba, 'La Mostra del Tesoro di Firenze Sacra, La Pittura', in *Bollettino d'arte*, XXVII, 1933–34, p. 157 ff.; Richard Offner, 'The Mostra del Tesoro di Firenze Sacra, II', in *The Burlington Magazine*, 1933, vol. LXIII, p. 166 ff.; Ragghianti 1935, p. 182 ff.; Ruth Wedgwood Kennedy, *Alesso Baldovinetti*, New Haven 1938, p. 229, n. 335; Zeri 1953, p. 134 ff.; Passavant 1959, p. 122 ff., n. 349–360, p. 235; Camesasca 1959, p. 14 and 39 f.; Bernard Berenson, *Italian Pictures of the Renaissance, Florentine School*, 1963, pl. 763 ('between Castagno and Botticini').

21. ALTARPIECE: BAPTISM OF CHRIST.

Plates 78–82

Florence, Uffizi (no. 8358).

Tempera on wood, partly painted over and completed in oils.

Height: 1·77 m.; width: 1·51 m.

The panel is well preserved, apart from the lower third of the picture and the hair of the angel seen in profile. The original destination of the altarpiece is unknown. The suggestions of Billi, Anonimo Gaddiano and Vasari that Verrocchio painted the Baptism for the monks of S. Salvi are clearly based only on the fact that the panel was to be seen there in the monastery in the sixteenth century. Whether the well-known passage in Albertini's *Memoriale*, '. . . Lascio in Sancto Salvi tavole bellissime, et uno Angelo di Leonardo Vinci . . .', really refers at all to the Baptism cannot be proved with certainty, but it is probable. The panel must have been removed from S. Salvi before 1730 and transferred to S. Verdiana; thence it came to the Accademia in 1810 and finally in 1919 to the Uffizi.

Opinions vary as to the extent of the restoration undertaken, presumably in the Accademia, in the early nineteenth century. In my view the lowest register with the foreground is the part most affected. The engraving of the Baptism on Plate 47 of the *Storia della pittura italiana* by Giovanni Rosini published in Pisa in 1840 shows it in its present condition; but the outline drawing reproduced by Crowe and Cavalcaselle in 1864 shows the ground zone strikingly free of the overpainting which has so disfigured it (figs. 40, 41). Whether this latter is based on a much older drawing of the picture, or whether the draughtsman is trying to reconstruct the 'original' state of the picture from the information gained by a temporary cleaning or uncovering of the lower third of the painting, cannot be decided. The descriptions of the painting surviving from the nineteenth century differ in a number of details. Cavalcaselle speaks of the 'stream bed of crystal pebbles', which is somewhat incomprehensible to anyone looking at the picture at the present time, while Bayersdorfer complains of the brown overpainting in the ground zone and wonders if it is due to later discoloration and darkening of varnish. Venturi on the other hand sees all the oil overpainting as the work of a restorer who went over the panel with soupy yellow oils after it had come into the Accademia, presumably in a rather ruinous condition. This layer would then have been removed from the right-hand side of the

picture. On the manifold problems of production and preservation of the work cf. Passavant 1959, p. 62 ff. and its review by Martin Davies in *The Burlington Magazine*, vol. 102, 1960, p. 542. The probable history is this: Verrocchio began the Baptism before the middle seventies and took it so far that little more was left to do than the top glazes; this is the present condition of the figure of the Baptist and the rock on the right hand edge of the picture. Leonardo was not at first involved in the execution of the panel, but much later, say in the early eighties, he took on the completion and made a considerable change in the general effect of the composition by overpainting large parts of the landscape, especially the view away to the distance on the left, and by altering the position of the left-hand angel to a three-quarter view seen from the back. An approximate impression of the original appearance of this angel can perhaps be gained from Attavante's miniature (fig. 43), although here the head – like that of St John the Baptist – seems to be turned too far out of profile. It also errs in placing the two angels too far back. Leonardo also finished the modelling of the figure of Christ in oils and in so doing narrowed the silhouette of the torso and corrected the hands held in prayer. At the same time he altered the face of Christ, stressing the eyes more strongly, narrowing the nose, broadening the upper lip and fining down the chin and jaw to give it that mild unmanly expression which is not to be seen at all in Verrocchio's underpainting (visible in an X-ray photograph).

Morelli, Reymond, Cruttwell and Thiis question any participation by Leonardo in the execution or in the completion of the panel. Ragghianti in 1954 explained the Baptism as a work of collaboration between Botticelli and Leonardo. A moderately well-preserved drawing by Verrocchio, worked over by a student's hand, of the head of the angel seen facing out of the picture is in the Uffizi; the angel is represented there with dropped eyelids (cf. the Catalogue of autograph drawings no. D1).

BIBLIOGRAPHY: Albertini, *Memoriale*, 1510 (ed. 1863). p. 13; Billi (ed. Frey), p. 47; Cod. Magl. (ed. Frey), p, 89; Vasari-Milanesi, III, p. 366; Borghini, *Il riposo* (ed. Bottari), p. 288 f., n. 1; Domenico Moreni, *Notizie istoriche de' Contorni di Firenze*, VI, 1795, p. 173; Crowe and Cavalcaselle, II, 1864, p. 407 ff.; Bayersdorfer (ed. 1902), p. 72 ff.; Lermolieff 1893, p. 35 f.; Josef Strzygowski, 'Studien zu Leonardos Entwickelung als Maler', in *Jahrbuch der Königl. Preuß. Kunstsammlungen*, XVI, 1895,

p. 168 ff.; Mackowsky 1901, p. 77 ff.; Cruttwell 1904, p. 42 ff.; Reymond 1906, p. 103 ff.; Woldemar von Seidlitz, *Leonardo da Vinci*, Berlin 1909, I, p. 40 ff.; Jens Thiis, *Leonardo* (Christiania 1909), Eng. trans. London 1913, I, p. 67 f.; Berenson 1912, p. 146 and p. 187; Wilhelm von Bode, *Studien über Leonardo da Vinci*, Berlin 1921, p. 10 ff.; Aldo de Rinaldis, *Storia dell'opera pittorica di Leonardo da Vinci*, Bologna 1922, p. 4 ff.; (Uffizi catalogue:) Elenco dei principali dipinti, Florence 1925, no. 8358; van Marle, XI, 1929, p. 510 ff.; Berenson 1933–34, p. 198; Planiscig 1941, p. 44 f. and p. 57; Ludwig Baldass, 'Zu den Gemälden der ersten Periode des Leonardo da Vinci', in *Zeitschrift für Kunstwissenschaft*, VII, 1953, p. 170; Ludwig H. Heydenreich, *Leonardo da Vinci*, Basle 1954, I, p. 27 f.; Piero Sanpaolesi, 'Il "Battesimo di Cristo" del Verrocchio e Leonardo', in *Leonardo, Saggi e Ricerche*, Libreria dello Stato 1954, p. 29 ff.; Carlo L. Ragghianti, 'Inizio di Leonardo', in *Critica d'Arte*, 1954, p. 102 ff.; Passavant 1959, p. 58 ff., n. 205–260, p. 236 f.

22. ALTARPIECE: MADONNA ENTHRONED BETWEEN JOHN THE BAPTIST AND ST DONATUS. Plates 83–87

Pistoia, Duomo, Chapel of the Sacrament.

Oil on wood.

Height: 1·89 m.; width: 1·91 m.

The picture is in a very good state of preservation. The three panels for the predella belonging to it, painted by Perugino and Lorenzo di Credi, are now dispersed between Liverpool, Paris and Worcester (App. 48, 49, 54). From a document of the Pistoia Council of November 1485, first published by Chiappelli and Chiti, we learn that Verrocchio received the commission for the altarpiece at the latest in 1478. It was destined for an Oratory dedicated to the Virgin built on to the Pistoia Duomo, endowed by Bishop Donato de' Medici who died at the end of 1474. The document refers to the panel as: '. . . la quale si dice essere facta o mancarvi pocho et è più di sei anni l'harebbe finita se da detti executori havesse avuto interamente el debito suo'. It can be seen from the style that the final completion of the picture was done after 1485 by Lorenzo di Credi, who was in charge of the Florentine studio when Verrocchio was working on the Colleoni monument. Credi then probably delivered the panel to Pistoia. This explains why in the sixteenth century, when Vasari was collecting the material for his *Lives*, the altarpiece was according to local Pistoian

tradition a work of Credi's. The Oratory was opened into the Duomo in 1593 and provided with a new altar; it now serves as a chapel of the Sacrament. Verrocchio's panel, protected by a curtain, is let into the wall separating the chapel of the Sacrament from the central choir chapel.

That the Pistoia altarpiece was not only designed but laid in and for the most part painted by Verrocchio himself is still doubted by many scholars today. In my opinion Credi's contribution is confined mainly to the execution of the Baptist and the landscape and the finishing of the central group (especially the Christ child and various details of drapery). The waxy surface gloss which Credi gave to these parts with the final glazes has somewhat spoilt Verrocchio's intended effect. Crowe and Cavalcaselle, Bode, Berenson, Mackowsky, Cartwright, Bertini and Planiscig consider the Pistoia altarpiece as a picture executed by Lorenzo di Credi under Verrocchio's supervision. On the other hand Morelli, v. Fabriczy, Cruttwell, van Marle and Valentiner hold it to be an autograph of the master which was produced with the assistance of Credi or was completed by him. Valentiner also believes there was some participation by Leonardo. Suida thinks it a work of collaboration between Verrocchio and Leonardo (without the assistance of Credi). The picture was prepared in a number of Verrocchio's drawings: in the Uffizi an early draft of the composition of the central group is preserved, and also a child study for the Christ. A sheet with two drawings of a woman's head, from which the Madonna type was developed, is in the British Museum. The Louvre preserves a drawing for the figure of St. John completely worked over by Credi (cf. the catalogue of autograph drawings no. D2–D5; Plates 88, 90, 91, 93, 94).

BIBLIOGRAPHY: Vasari-Milanesi, IV, p. 566; Crowe and Cavalcaselle, II, 1864, p. 407 f.; Bayersdorfer (ed. 1902), p. 111 f.; Lermolieff 1893, p. 37; Berenson 1896, p. 110; Alessandro Chiappelli and Alfredo Chiti, 'Andrea del Verrocchio in Pistoia', in *Bollettino storico Pistoiese*, 1899, p. 41 ff.; Cornelius von Fabriczy, 'Verrocchio und das Altarbild der Sakramentskapelle im Dom zu Pistoja', in *Repertorium für Kunstwissenschaft*, XXII, 1899, p. 338 f.; Bode 1899, p. 390 ff.; Alessandro Sozzifanti, 'Una tavola del Verrocchio nella Cattedrale di Pistoia', in *Arte e Storia*, XIX, 1900, p. 19 f.; Mackowsky 1901, p. 96; Gaetano Beani, *La cattedrale pistoiese*, Pistoia 1903, p. 65; Cruttwell 1904, p. 173 ff.; Odoardo H. Giglioli, *Pistoia nelle sue opere d'arte*, Florence 1904, p. 153 ff.; Julia Cartwright, *The Painters*

of Florence, London 1910, p. 272 f.; Venturi, VII/I, 1911, p. 781; Liphart 1912, p. 202 f.; Georg Gronau, article on Lorenzo di Credi in *Thieme-Becker's Künstlerlexikon*, vol. 8, 1913, p. 74; van Marle, XI, 1929, p. 536 ff.; Valentiner 1930, p. 54; Berenson 1933/34, p. 210; Bertini 1935, p. 469; Dussler 1940, p. 295; Planiscig 1941, p. 40 and p. 45 f.; Wilhelm Suida, 'Kooperation in alten Gemälden', in *Festschrift W. Sas-Zaloziecky zum 60. Geburtstag*, Graz 1956, p. 163 ff.; Passavant 1959, p. 29 ff., n. 141–204, p. 238.

DRAWINGS

D 1. *Florence, Uffizi, Gabinetto Disegni e Stampe* (no. 130E). Plate 89

Berenson 2781

Front view of a girl's or boy's head tilted slightly to one side, looking down; study for the head of the front-facing angel in the Baptism from San Salvi.

Black chalk, gone over in sepia with the brush; outlines pricked for transfer.

Height: 21 cm.; width: 18·3 cm.

BIBLIOGRAPHY: Lermolieff 1891, p. 349 f.; Mac-kowsky 1901, p. 88 f.; Berenson 1903, no. 2781; Crutt-well 1904, p. 46 f.; Disegni Uffizi, I, 1912, iii, 12; Venturi 1925, p. 137; Ede 1926, p. 12 and p. 24; van Marle, XI, 1929, p. 514; Popham 1931, no. 53; Berenson 1938, I, p. 47, II, p. 359; Dussler 1940, p. 295 (questions connection with the Baptism); Berenson 1954, Pl. XI; Passavant 1959, p. 76 and p. 237; Berenson 1961, I, p. 85 ff., II, p. 607.

D 2. *Florence, Uffizi, Gabinetto Disegni e Stampe* (no. 444E). Plate 88

Berenson 2795.

Seated Madonna, the child resting on her right knee or on her lap; preparatory drawing for the central group of the Pistoia altarpiece. The artist has subsequently altered the pose of the child and the head and torso position of the Madonna.

Black chalk.

Height: 28 cm.; width 19 cm.

BIBLIOGRAPHY: Disegni Uffizi, I, 1912, iii, 14; Sirén 1917, Pl. 15; Adolfo Venturi, 'Leonardiana, IV', in *L'Arte*, 1928, p. 232 f. (as Leonardo's first drawing for a Madonna and Child with St Anne); van Marle, XI, 1929, p. 516 f. (as Verrocchio); Degenhart 1932, p. 271 (as 'Disegno per una Sacra Famiglia' by Verrocchio); Berenson 1938, I, p. 65, II, p. 360; Berenson 1961, I, p. 106, II, p. 609 ('Attribuito al Verrocchio, ma potrebbe essere del giovane Domenico Ghirlandaio').

D 3. *Florence, Uffizi, Gabinetto Disegni e Stampe* (no. 212F). Plate 90

Berenson 2798.

(*Recto*: Silver-point study for a front view of a girl's head with lowered eyelids; by a different artist, possibly by Francesco Botticini; App. 35.)

Verso: Three-quarter view of the head and torso of a naked child.

Black chalk on pale buff prepared paper.

Height: 28 cm.; width: 20 cm.

BIBLIOGRAPHY: Disegni Uffizi, I, 1912, iii, 17; Venturi 1925, p. 137 ff. (as Leonardo); Venturi, IX, i, 1925, p. 86 ff.; Commissione Vinciana, I, 1928, no. 8; van Marle, XI, 1929, p. 514 f. (as Verrocchio); Berenson 1933/34, p. 255; Passavant 1959, p. 51 f. and p. 238; Berenson 1961, I, p. 105 f., II, p. 610.

D 4. *Paris, Louvre, Cabinet des dessins* (no. 455).

Plate 91

Berenson 725.

Study for the figure of St John for the Pistoia altarpiece; laid in by Verrocchio, drawn over strongly by Lorenzi di Credi and altered, particularly in the drapery motifs.

Silver point, gone over with pen, washed with bistre and heightened with white, on pink tinted paper.

Height: 27 cm.; width: 13 cm.
(On provenance cf. Dalli Regoli 1966, p. 105, cat. 13.)

BIBLIOGRAPHY: L. Both de Tauzia, *Notice des dessins de la collection His de la Salle*, Paris 1881, p. 34 f. (as Lorenzo di Credi entirely); Charles Ephrussi, 'Les dessins de la collection His de la Salle', in *Gazette des Beaux-Arts*, XXV, 1882, p. 242; Mackowsky 1901, p. 96; Berenson 1903, no. 725; Frizzoni 1904, p. 98; Liphart 1912, p. 202; Gronau 1913, p. 74; Chiappelli 1925/26, p. 60; Valentiner 1930, p. 57 f.; van Marle, XIII, 1931, p. 321 f.; Degenhart 1932, p. 412 ff. (Verrocchio and Credi); Berenson 1938, I, p. 66, II, p. 75; Valentiner 1950, p. 142 f.; Passavant 1959, p. 53 f. and p. 238; Berenson 1961, I, p. 114, II, p. 135; Dalli Regoli 1966, p. 15 f. and p. 105 f., cat. 13.

D 5. *London, British Museum* (no. 1895–9–15–785; Malcolm 338). Plates 93, 94
Berenson 2782.

Recto: Front view study of a woman's head slightly tilted to one side, with decoratively arranged hair. Life size. Study for the head of the Madonna in the Pistoia altarpiece, developed from the sketch on the back of the sheet.
Black chalk and bistre, heightened with white, on pale brown paper.
Verso: Woman's head, slightly turned away from front view and tilted towards the right shoulder (indication of the hand on which the head is leaning). Life size. Study for the head of Venus in the Venus and Cupid composition (cf. D 6).
Black chalk with touches of white.
Height: 32·5 cm.; width: 27·3 cm.

BIBLIOGRAPHY: J. C. Robinson, *Descriptive catalogue of the drawings by old masters, forming the collection of John Malcolm of Poltalloch Esq.*, London 1869, no. 338; Lermolieff 1891, p. 350 (for the first time as Verrocchio); Mackowsky 1901, p. 89 f.; Berenson 1903, n. 2782; Cruttwell 1904, p. 112 ff.; Frizzoni 1904, p. 98, n. 1; Reymond 1906, p. 117; Liphart 1912, p. 202 f.; Bode 1915, p. 202 f.; Old Master Drawings, II, 1927/28, p. 35 (text by Anny E. Popp to Plate 38); van Marle, XI, 1929, p. 529 ff.; Valentiner 1930, p. 50 ff.; Degenhart 1932, p. 408; Berenson 1933/34, p. 205 f.; Bertini 1935, p. 470 f.; Berenson 1938, I, p. 47 f., p. 55, p. 75, II, p. 359; Dussler 1940, p. 295; Bradshaw 1949, p. 47; Valentiner 1950, p. 147; Popham and Pouncey 1950, p. 160 f.; Passavant 1959, p. 50 f., p. 238; Grassi 1961, p. 26; Berenson 1961, I, p. 99, II, p. 608.

D 6. *Florence, Uffizi, Gabinetto Disegni e Stampe* (no. 212E). Plate 95
Berenson 674A (former 2788).

Venus and Cupid. Venus is leaning against a rocky ledge, reclining in a meadow beside high rush-like plants. Her head is resting in her right hand; the right elbow is supported on the filled quiver, which lies in the grass beside the bow. With her left hand Venus holds her veil (or a part of her dress) into which she has gathered flowers or fruit. Cupid is climbing up from behind the rock, looking at Venus and holding on to the neck of her garment with his left hand while he draws an arrow from the quiver with his right.
Silver-point and bistre on yellowish tinted paper.
Height: 15·2 cm.; width: 26·3 cm.
A very similar drawing of rushes by Leonardo on a sheet in Windsor; cf. Clark 1935, I, p. 59, II, no. 12428.

BIBLIOGRAPHY: Berenson 1903, no. 2788 ('school of Verrocchio'); Cruttwell 1904, p. 56 (as Verrocchio); Venturi, VII, 1, 1911, p. 780 (Verrocchio); Thiis 1913, p. 75 (School of Verrocchio or Leonardo); Charles John Holmes, 'The shop of Verrocchio', in *The Burlington Magazine*, XXIV, 1913/14, p. 287; Walter Bombe, 'Uffizien-Zeichnungen', in *Der Cicerone*, VII, 1915, p. 142; Venturi, IX, 1, 1925, p. 50 f. (Leonardo); Commissione Vinciana, I, 1928, no. 1 (earliest of Leonardo's drawings); reviewed by Emil Möller in *Zeitschrift für bildende Kunst*, 1928/29, Kunstchronik u. Kunstliteratur, p. 58 (Verrocchio); Edward McCurdy, 'The drawings of Leonardo da Vinci', in *Apollo*, XII, 1930, p. 177 (Verrocchio); Degenhart 1932, p. 432 f. (Leonardo); Berenson 1933/34, p. 263 (Credi); Wackernagel 1938, p. 207 (Verrocchio); Berenson 1938, I, p. 68, II, p. 71 (Credi); W. R. Valentiner, 'Der rote Marsyas des Verrocchio', in *Pantheon* 1937, p. 332 (Verrocchio); Dussler 1940, p. 295 (Verrocchio); Passavant 1959, p. 26 and n. 128; Berenson 1961, I, p. 114 f., II, p. 128 ('ascribed to Verrocchio'); Dalli Regoli 1966, p. 22 and p. 109 f., cat. 24 (Credi).

D 7. *Berlin, Staatliche Museen, Kupferstichkabinett* (no. 5093; previously A. v. Beckerath Coll.).
Berenson 2780E (former 2784). Plates 96, 97
Recto: Three-quarter front view of a girl's or boy's head looking up to the left.
Black chalk heightened with white on white paper; outlines pricked for transfer.
Verso: Front view of the upper parts of a girl's or youth's head.

Black chalk.

Height: 18·5 cm.; width: 15·7 cm.

BIBLIOGRAPHY: Mackowsky 1901, p. 89; Adolf von Beckerath, 'Notes on some Florentine drawings in the Print Room, Berlin', in *The Burlington Magazine*, VI, 1904/05, p. 239 f.; van Marle, XI, 1929, p. 534, n. 2, and p. 580; Popham 1931, no. 52; Bertini 1935, p. 471; Berenson 1938, I, p. 59 f.; II, p. 359 (on Verrocchio as the author of the Madonna no. 296 in the National Gallery, London); Dussler 1940, p. 295 (in connection with the London Madonna 296); Berenson 1961, I, p. 99, II, p. 607 (as a study for a Madonna with Angels projected shortly after the Berlin Madonna no. 104A).

D 8. *Oxford, Christ Church* (no. A5). Plate 100
Berenson 2782A (former 2800).

Study of the head of a young woman bent and turned almost into profile with decoratively arranged hair. Life size.

Black chalk heightened with white; outlines pricked for transfer.

Height: 40·8 cm.; width: 32·7 cm.

The drawing was attributed by Berenson in 1903 to the School of Verrocchio, but in 1938 to the artist himself ('Surely one of the boldest and most inspiring achievements of Quattrocento draughtsmanship').

BIBLIOGRAPHY: Sidney Colvin, *Drawings of the Old Masters in the University Galleries and the Library of Christ Church*, I, Oxford 1903, Pl. I; Berenson 1903, no. 2800; C. F. Bell, *Drawings by the Old Masters in the Library of Christ Church, Oxford*, 1914, p. 92; van Marle, XI, 1929, p. 534; Catalogue: London, Royal Academy of Arts, Exhibition of Italian Art 1200–1900, London 1930, p. 243, no. 452; Popham 1931, p. 16, no. 51; Berenson 1938, I, p. 59, II, p. 359 (as fragment of a cartoon of an Adoration, drawn by Verrocchio probably between the early Berlin Madonna no. 104A and the Altman Madonna of the Metropolitan Museum); Dussler 1940, p. 295; Gerald Kelly, Catalogue: Drawings by Old Masters, Royal Academy of Arts, Diploma Gallery, London 1953, p. 16, no. 42; Berenson 1961, I, p. 99, II, p. 608.

D 9. *Florence, Uffizi, Gabinetto Disegni e Stampe* (no. 433E). Plate 92
Berenson 1015B (former 2792).

Drapery of the cloak on a standing figure seen front view. Study for the bronze statue of Christ on Or San Michele.

Umber wash on greyish tinted linen, heightened with white.

Height: 28·2 cm.; width: 15·7 cm.

The study has until now been classified in the group of autograph drawings of drapery by Leonardo.

BIBLIOGRAPHY: Berenson 1933/34, p. 246 ff.; Degenhart 1934, p. 223; Berenson 1938, I, p. 61, II, p. 111; Catalogo: Mostra di Disegni, Manoscritti e Documenti, Quinto Centenario della nascita di Leonardo da Vinci, a cura di Giulia Brunetti, Teresa Lodi e Francesca Morandini, Biblioteca Laurenziana, Florence 1952, p. 13, no. 8; Berenson 1961, I, p. 101 ff., II, p. 194.

D 10. *Paris, Louvre, Cabinet des dessins* (no. 2.R.F.).
Berenson 2783. Plates 98, 99

Recto: Five naked putti in various poses.
Verso: Four naked putti in various poses, a child's head (?); in the bottom left hand corner seven lines of verse in another, contemporary hand.

Pen and bistre on white paper.

Height: 14·5 cm.; width: 20 cm.

The verse on the verso of the sheet runs:

'Viderunt equum mirandaque arte confectum
Quem nobiles Veneti tibi dedere facturum,
Florentiae decus crasse mihi crede, Varochie,
Qui te plus oculis amant diliguntque coluntque
Atque cum Jupiter animas infuderit ipsi
Hoc tibi Dominus rogat Salmonicus idem
 Vale et bene qui legis.'

The sheet was acquired for the Louvre in 1871 (Vente Wetheimber); previously it had been for a time in the Richardson, Comte Nils Bark and Comte Thibaudeau collections. Morelli's assertion that he was the first to discover the drawing in the reserve collections of the Louvre is misleading; the sheet had already been shown as an autograph of Verrocchio as early as 1879 in the exhibition of Old Master Drawings in the École des Beaux-Arts in Paris. The Marquis de Chennevières, who published the wording of the verses on the verso of the sheet when reviewing the Exhibition, observes that the attribution of the drawing, indicated by the verse in praise of Verrocchio, can be traced back to the Marquis de la Salle.

BIBLIOGRAPHY: M. de Chennevières, 'Les Dessins de Maîtres anciens à l'École des Beaux-Arts', in *Gazette des Beaux-Arts*, XIX, 1879, p. 515 ff.; Lermolieff 1891, p. 351; Mackowsky 1901, p. 90 f.; Berenson 1903, no. 2783; Cruttwell 1904, p. 70 f.; van Marle, XI, 1929,

p. 532 f.; Berenson 1938, I, p. 46 f., II, p. 359; Dussler 1940, p. 295; Berenson 1961, I, p. 85 and p. 98, II, p. 608.

D 11. *London, Victoria and Albert Museum (no. 2314).*
Berenson 699B (once in Sir Thomas Lawrence's collection). Plate 101
Drawing for a console tomb with much figure decoration.
Black lead gone over with a pen by a later hand.
Height: 27 cm.; width: 19.5 cm.

After the sheet had been attributed by Clark to Benedetto da Maiano, not without justification, van Marle and Degenhart were the first to stress the close connection of the drawing with Verrocchio. Berenson (1933/34, 1938 and 1961) assigns it to Lorenzo di Credi; recently Dalli Regoli has followed him in her monograph on Credi. Middeldorf proposed the attribution to Verrocchio himself, recognizing at once that the project dates from the Venetian period of the artist. Möller finally was able to prove that the drawing is a design for the tomb of the Doge Andrea Vendramin and that it is probably identical with the project for the Doge's tomb by Verrocchio mentioned by Vasari as being in the possession of Vincenzo Borghini. Vasari's *Life* of Verrocchio has the following passage: '. . . e di rilievo di terra cotta è appresso di me una testa di cavallo ritratta dall'antico, che è cosa rara; ed alcuni altri, pure in carta, n'ha il molto reverendo Don Vincenzio Borghini nel suo Libro, del quale si è di sopra ragionato; e fra gli altri, un disegno di sepoltura, da lui fatto in Vinegia per un doge'.

BIBLIOGRAPHY: Vasari-Milanesi, III, p. 364; Kenneth Clark, in *The Vasari Society for the Reproduction of Drawings of Old Masters*, reprod. X, 3, ii (Oxford 1929); van Marle, XI, 1929, p. 582 n.; Degenhart, *Münchner Jahrbuch*, 1932, p. 105, n. 2; Berenson 1933/34, p. 262 f.; Middeldorf 1934, p. 57 f.; Emil Möller, 'Verrocchio's last drawing', in *The Burlington Magazine*, LXVI, 1935, p. 193 ff.; Berenson 1938, I, p. 67 f., II, p. 73; Dussler 1940, p. 295; Berenson 1961, I, p. 117, II, p. 132; Dalli Regoli 1966, p. 133 f., cat. 66.

CATALOGUE OF WORKS DOUBTFULLY OR ERRONEOUSLY ATTRIBUTED TO VERROCCHIO WHICH ARE DISCUSSED IN THE TEXT

A 1. THE RESURRECTION OF CHRIST.

Florence, Museo Nazionale del Bargello. Figs. 45, 46

Terracotta; in most places remains of the original polychrome pigmentation and much gilding.
Height: 1·35 m.; width: 1·50 m.

The relief, broken in many fragments, was discovered at the end of the last century by Carlo Segré, who was at that time the owner of the Medici villa in Careggi, in a room in the attic. After repair it was first let into a wall of the inner courtyard of the villa. Fabriczy and Gamba saw it there and agreed on an attribution to Verrocchio. In 1930 the work came to the Bargello after the owner had sold it to the State for the sum of 300,000 lire. It is assumed that the relief was originally set over the door into the chapel of the villa to decorate the tympanum, and was later taken down when a new window was opened at that place. The fluctuating and often contradictory opinions on the work show straight away that there are peculiar difficulties in including it in the autograph *œuvre* of Verrocchio. While Gamba, who first published the relief, sees in it a very early work by the artist, about 1460, Cruttwell is of the opinion that it must be later than the Baptism 'from the superior excellence and freedom of execution, the flexibility of the figures and the assurance and even audacity of the treatment'. Venturi shares Gamba's opinion; Reymond dates the work to the period of the Baptism, which he places in 1470. Bertini admits there are archaisms in the relief, but sees close connections with the Baptism and the Christ of the Or San Michele group, which he claims as mature works of the artist; nevertheless he supports an early dating because the general style of the relief differs from what we find in the works produced by Verrocchio in the seventies. Valentiner in 1930 maintained that the Careggi relief was a work of collaboration between Verrocchio and Leonardo, produced in the late seventies. In a second discussion of the Resurrection relief (which had meanwhile come to the Bargello) Gamba in 1931 revised his earlier opinion of the date of the work and now thought a date after 1478 possible. Cruttwell's suggestion that the statuette of a Sleeping

Youth in Berlin (Plate 60) was a study from the life for the soldier sleeping in the foreground of the Resurrection, is contradicted by Schottmüller. He demonstrates that the Berlin figure of the youth has none of the passionate expressive force of the figures in the Careggi Resurrection; Schottmüller, supporting Valentiner, considers it likely that Leonardo collaborated extensively on the relief. Dussler, who also finds the utmost force of expression in the relief ('the daring movement and gesture of the right hand figure anticipate the aims of the sixteenth century'), believes in a strong influence from Leonardo, but can find no indications of the personal intervention of Leonardo ('The proportion of the relief must be considered, which allowed an enhanced breadth of plastic execution; the types and the modelling agree with the other works of Verrocchio when seen in this light.'). Dussler dates the work in the second half of the seventies. Planiscig, however, upholds a return to the early dating 'about 1465'; Pope-Hennessy considers the relief to be a mature work of Verrocchio's 'from the late seventies or early eighties'.

Gamba pointed out in 1904 that in Tommaso's inventory, in connection with the works delivered by Andrea for Careggi, there appears under no. 5 the entry 'per una storia dj rilievo chon più fighure' which could refer to this relief (particularly since there is no indication of the material). Gamba also quotes from a passage in the 1492 inventory of the Medici villa, where the composition of a Deposition or Lamentation of Christ is described as being on the altar of the chapel. Inventories of this kind being very often so inexact, this entry may quite possibly refer to the relief of the Resurrection. Cruttwell accepted both these hypotheses, but meanwhile Warburg has proved convincingly (*Gesammelte Schriften*, Vol. 1, 1932, p. 215 f.) that the entry in the 1492 inventory must refer to the small Entombment picture by Roger van der Weyden which is now in the Uffizi. Further, Gamba in 1931 suggested that the Resurrection relief was donated by Lorenzo de' Medici as a kind of votive offering at the time of his miraculous escape from the Pazzi conspiracy on 26th April 1478; Lorenzo was able to avoid the murderous attack destined

for him and his brother by fleeing from the choir of the Duomo through the Sacristy door, which had Luca della Robbia's Resurrection relief above it. This would explain the close and quite undisguised reference of the composition of the Careggi relief to Luca's. Gamba also claimed to recognize the features of Lorenzo de' Medici in the face of the sleeping soldier in the foreground of the Careggi relief. These suggestions, which Planiscig dismissed as 'guides' tales for foreign visitors' since they did not coincide with his dating of the work 'about 1465', should not in my opinion be excluded from the discussion of the authorship and dating of the relief.

BIBLIOGRAPHY: Carlo Gamba, 'Una terracotta del Verrocchio a Careggi', in *L'Arte*, VII, 1904, p. 59 ff.; Cruttwell 1904, p. 57 ff.; Bode 1892/1905, p. 178 f.; Reymond 1906, p. 71 f.; Venturi, VI, 1908, p. 708, n. 2; Schottmüller 1913, p. 73, no. 173; Francesco Malaguzzi-Valeri, *Leonardo da Vinci e la scultura*, Bologna 1922, p. 15; van Marle, XI, 1929, p. 486; Valentiner 1930, p. 74 ff.; Carlo Gamba, 'La Resurrezione di Andrea Verrocchio al Bargello', in *Bollettino d'Arte*, XXV, 1931/1932, p. 193 ff.; Schottmüller 1933, p. 59, no. 112; Bertini 1935, p. 438; Dussler 1940, p. 294; Planiscig 1941, p. 10 ff. and p. 48; Galassi 1949, p. 210 ff.; Valentiner 1950, p. 166 ff.; Pope-Hennessy 1958, p. 131; Stites 1963, p. 13 f.

A 2. SAINT JEROME. Fig. 49

London, Victoria and Albert Museum (Inv. 7578–1861; Cat. no. 141).

Terracotta.

Height (with base): 0·51 m.; width (with base): 0·45 m.

The terracotta figure still possesses its original wooden base, which is painted to look like porphyry; it must once have been broken off from the base in the past. It cannot be decided with certainty whether it is a model for a bronze statuette or a maquette for a larger figure. The clay is left rough at the back of the figure. This, and the curious curve of the back (also the fact that the figure is hollowed out behind under the seat) indicate that the work was to be put in a niche. The toes of the left foot and a corner of the book are broken off; breaks can also be recognized through the right foot and the part of the drapery lying on the floor. The figure was acquired for £50 in 1861 from the Gigli–Campana Collection. It is accepted as an autograph work by Verrocchio by Robinson, Bode, Fabriczy, Mackowsky, Maclagan and Longhurst, Berenson, Dussler and Planis-

cig; Reymond, Cruttwell and Venturi consider it a fake. Pope-Hennessy thinks it the work of an imitator of Verrocchio. Bode believes the statuette to be a model for a larger figure. Planiscig sees a close connection with the Resurrection relief from Careggi, and dates it about 1465. Dussler considers it a work of Verrocchio's mature period 'about 1480'; he thinks it is a detail study for a larger group. Pope-Hennessy considers that the treatment of the drapery anticipates the style of the figure of St Thomas in the Or San Michele group; he assigns the work to a member of Verrocchio's studio 'active in the last decade of the fifteenth or the first years of the sixteenth century, perhaps Giovanni Francesco Rustici'. The element of mannerism which the pose of the figure creates, emphasized by Robinson and Cruttwell and explained by Mackowsky as derived from the classical 'spinario', seems to be also the result of a none too happy influence on the artist of Leonardesque principles of form. The closest parallel to the drapery style of the statuette is in the silver relief of the Decollation of St John of 1478/79 (in the kneeling figure of the Baptist); it is not yet the 'padded' folds of the Or San Michele St Thomas, later imitated in the figures of the Virtues by Francesco di Simone.—The identification of the figure as St Jerome remains uncertain, since there are no attributes apart from the book.

BIBLIOGRAPHY: Migliarini 1858, p. 53, Pl. LXI; Robinson 1862, p. 38 f.; Bode 1882, p. 101; Bode 1887, p. 104; Bode 1892/1905, p. 148; Reymond, III, 1899, p. 209; Bode 1899, p. 394; Mackowsky 1901, p. 49; Fabriczy 1909, p. 43, no. 154; Cruttwell 1904, p. 217 f.; Venturi, VI, 1908, p. 723, n. 3; van Marle, XI, 1929, p. 556, n.; Maclagan and Longhurst 1932, p. 59 f.; Bertini 1935, p. 438; Berenson 1938, p. 61; Dussler 1940, p. 294; Planiscig 1941, p. 14 and p. 49; Pope-Hennessy 1958, p. 311; Pope-Hennessy 1964, I, p. 167.

A 3. RUNNING PUTTO POISED ON A GLOBE. Figs. 56, 57

Washington, National Gallery of Art (A–17; Mellon Collection).

Terracotta.

Height: 0·75 m.; width: 0·38 m.; depth: 0·30 m.

The figure came at the end of the nineteenth century from the possession of the painter Charles Timbal into the collection of Gustave Dreyfus in Paris, was for a time with Duveen in New York, and from there went to the Andrew Mellon Collection in 1937.

Fig. 45. Christ. Detail from the Careggi Resurrection (Fig. 46)

Fig. 46. Workshop of Verrocchio (Leonardo da Vinci and collaborators?): The Resurrection. Terracotta relief, pigmented and gilded, from Careggi. Florence, Museo Nazionale del Bargello (Cat. No. A1 and p. 38)

Fig. 47. Luca della Robbia: The Resurrection. Glazed terracotta relief. Florence, Duomo (p. 38)

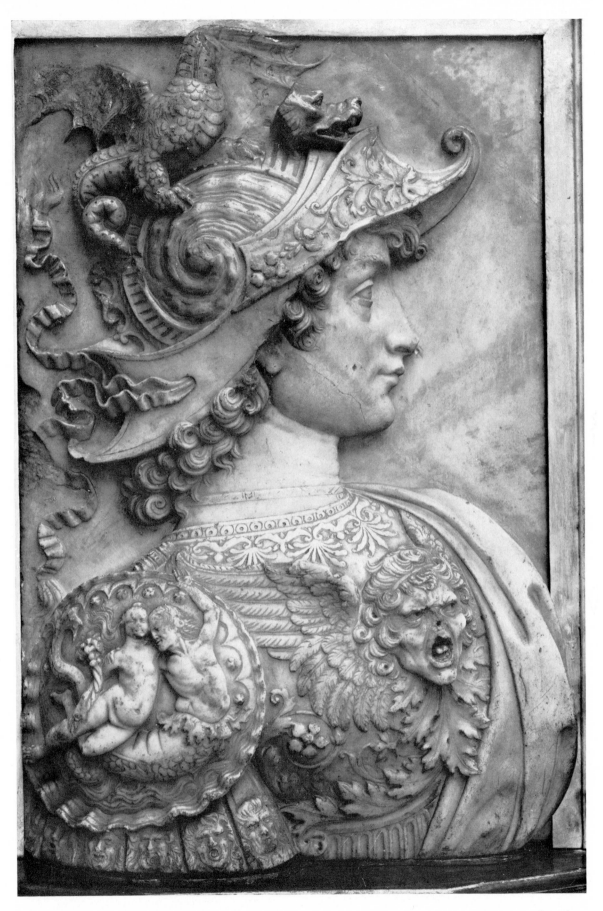

Fig. 48. Verrocchio Imitator: Alexander. Marble relief. Washington, National Gallery of Art (Cat. No. A5 and p. 42)

Fig. 49. Workshop of Verrocchio (Lorenzo di Credi?): St. Jerome. Terracotta
statuette. London, Victoria and Albert Museum (p. 39 and Cat. No. A2)

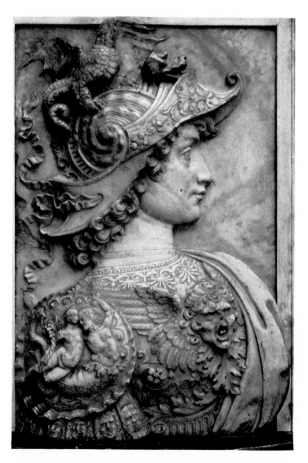

Fig. 50. Verrocchio Imitator: Alexander. Marble relief.
Washington, National Gallery of Art (p. 42 and
Cat. No. A5)

Fig. 51. Della Robbia Workshop: Darius. Glazed terracotta
relief. Berlin, Staatliche Museen (cf. p. 42 and Cat.
No. A5)

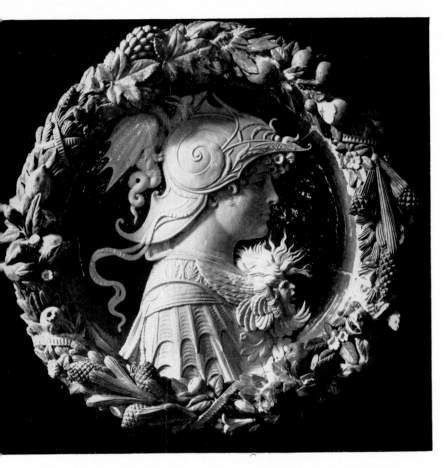

Fig. 52. Della Robbia Workshop: A Warrior. Glazed terracotta relief. Vienna, Kunsthistorisches Museum (cf. p. 43 and Cat. Nr. A5)

Fig. 53. Leonardo da Vinci: A Warrior. Drawing. London, British Museum (cf. p. 43 and Cat. No. A5)

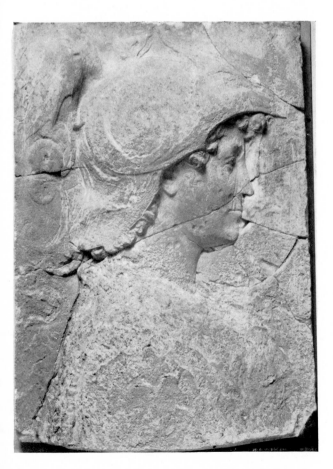

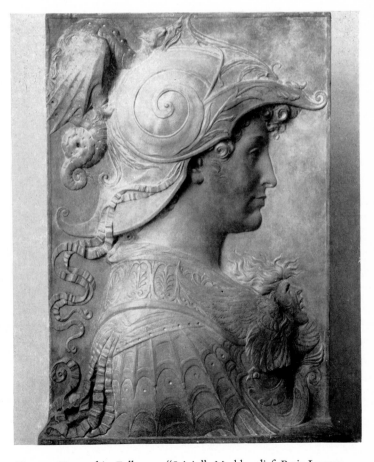

Fig. 54. Verrocchio Follower: A Warrior. Stucco relief. London, Victoria and Albert Museum (cf. p. 43 and Cat. No. A5)

Fig. 55. Verrocchio Follower: "Scipio". Marble relief. Paris, Louvre (cf. p. 43 and Cat. No. A5)

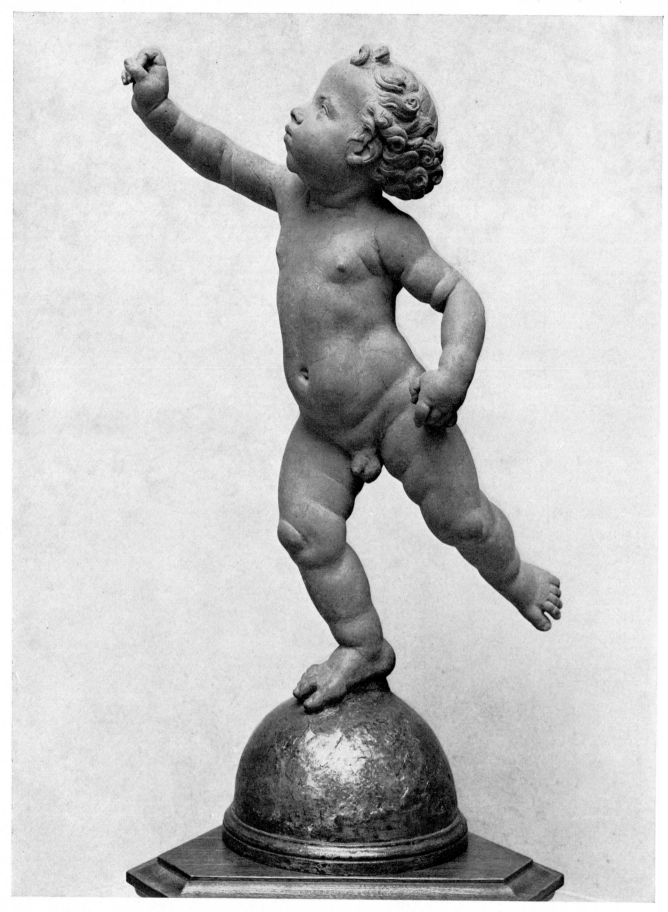

Fig. 56. Workshop of Verrocchio (Benedetto da Maiano?): Putto. Terracotta figure. Washington, National Gallery of Art, Mellon Collection (Cat. No. A3)

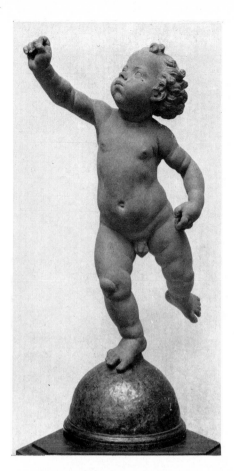

Fig. 57. Workshop of Verrocchio (Benedetto da Maiano?): Putto. Terracotta figure. Washington, National Gallery of Art, Mellon Collection (Cat. No. A3)

Fig. 58. Benedetto da Maiano: Angel. Terracotta figure. Bergamo, Accademia Carrara (cf. Cat. No. A3 and p. 197)

Fig. 59. Head of a Harpy, from the lavabo in the inner Old Sacristy of San Lorenzo (Fig. 60)

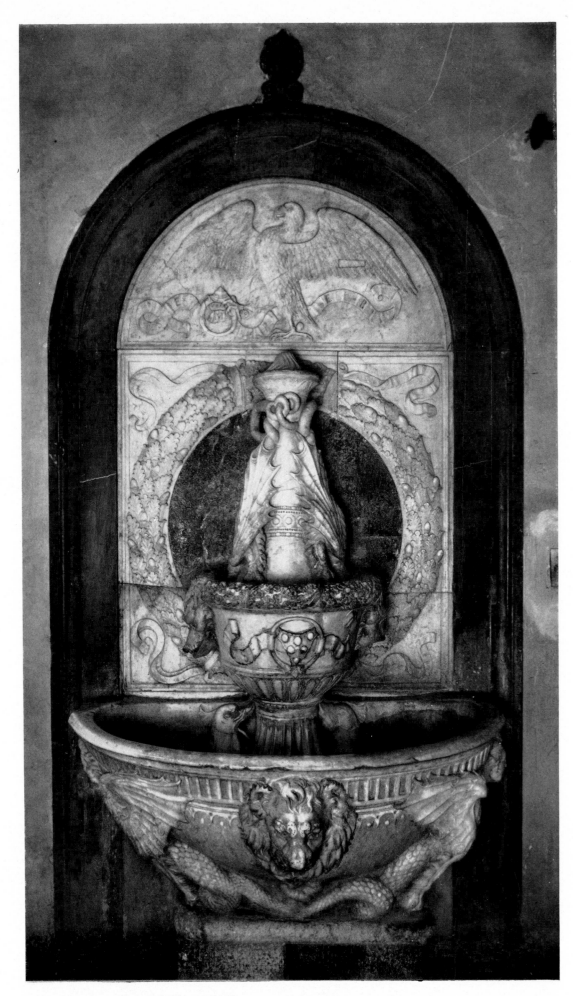

Fig. 60. Lavabo in the inner Old Sacristy. Florence, San Lorenzo (Cat. No. A4)

It cannot be definitely established what the Putto is represented as doing, since it is not known what he originally held in its right hand. In connection with the figure Vasari's statement has been recalled that Verrocchio made a bronze putto with mechanically movable arms which was set up to strike the hours on the clock of the Mercato Nuovo in Florence. However, the Washington putto cannot be the model for this vanished bronze figure; the turn of the right hand in no way corresponds to the action of holding a hammer for striking a bell. Mackowsky, Cruttwell, Planiscig and others believed that the putto was once blowing a trombone or a tuba. The formation of the mouth and the puffed out cheeks support this interpretation, but again the hand position speaks against it: it would at best be suitable for holding to the mouth a hunting horn of a later period; but a curved instrument of this kind is not usually held with a raised and out-stretched arm. Lastly Balogh has noted the close relationship of the terracotta with a drawing by Jacopo Sansovino of a winged naked putto chasing a butterfly with outstretched arms. I think it possible that the Washington putto originally held a toy windmill which he was trying to set in motion by blowing and by running along with it. This would explain the point at which his gaze is directed. Giovan Francesco Rustici's bronze figure of Mercury, as described by Vasari, held in his hand just such a toy, which was made to revolve by a jet of water issuing from his mouth. (Vasari-Milanesi VI, p. 602; Wiles drew attention to a possible similarity of the motif with the terracotta putto.) In any case the setting of the figure on a half-sphere indicates that it is a model for a fountain. Seymour wondered if the figure might be intended for the fountain which Verrocchio was to erect in Florence under commission to Matthias Corvinus; no answer to this question can yet be given. The commission for the fountain must have been given in the middle eighties. It is probable that at this period, while Verrocchio was in Venice to prepare the casting of the Colleoni monument, the master's designs for the Hungarian king's fountain were being worked out in his Florentine studio. Further it is not unlikely that after his death Verrocchio's pupils competed to take over the commission.

For decades scholars have more or less unanimously accepted Bode's attribution of the terracotta to Verrocchio. Only Venturi, who at first (1908) put the work 'posteriore al Verrocchio', tried in 1925 to include the figure in the sculptural œuvre of Leonardo which he had compiled. Schubring called the putto 'no more than a feeble echo of the winged messenger of the Villa Careggi', and considered it an obvious studio product. An early dating suggested by Wilder (before the Putto with a Dolphin) was rightly rejected by Dussler. While Galassi and Planiscig treated the putto as Verrocchio's autograph, Pope-Hennessy expressed his doubts about ascribing it to the artist himself ('It is difficult to reconcile this attractive statuette with Verrocchio's authenticated works'). Recently Balogh has given the probability of authorship to Jacopo Sansovino.

The Washington putto must in my opinion have been made in the middle or the second half of the eighties. In spite of all the weaknesses in the design one has a sense of calm and certainty in the treatment of the body and in the realization of the very unconstrained movement motif with its free use of the spatial concept, which have their beginnings in the style of Verrocchio in and after 1480, in the style of the St Thomas statue of Or San Michele. Not least because of the close relationship with the terracotta angel by Benedetto da Maiano in Bergamo (Fig. 58) an attribution of the Washington putto to Benedetto should be given due consideration.

BIBLIOGRAPHY: Charles Ephrussi, 'Appendice à l'étude sur les Dessins de Maîtres', in *Gazette des Beaux-Arts*, XX, 1879, p. 311; Bode 1892–1905, p. 142; Mackowsky 1901, p. 38; Cruttwell 1904, p. 70; Reymond 1906, p. 50, n. 1; Vitry 1907, p. 24; Venturi, VI, 1908, p. 715, n.; Schubring 1915, p. 133; Venturi 1925, p. 146 f.; van Marle, XI, 1929, p. 487; Kennedy, Wilder and Bacci 1932, p. 55; Bertha Harris Wiles, *The Fountains of Florentine Sculptors and their Followers from Donatello to Bernini*, Harvard 1933, p. 9; Bertini 1935, p. 447 f.; Dussler 1940, p. 294; National Gallery of Art, Preliminary Catalogue of Paintings and Sculpture, Descriptive List with Notes, Washington 1941, p. 239; Planiscig 1941, p. 35 and p. 55; Seymour 1949, p. 178 f., no. 34; Galassi 1949, p. 217; Pope-Hennessy 1958, p. 312; Jolán Balogh, 'Studi sulla collezione di sculture del Museo di Belle Arti di Budapest', IV, in *Acta Historiae Artium Academiae Scientiarum Hungaricae*, XII, 1966, p. 290 ff.

A 4. LAVABO. Fig. 59, 60

Florence, S. Lorenzo, in a side room of the Old Sacristy.

Marble; the tondo in the wall-facing and the plinth under the basin of serpentine.

Height of basin and fountain shaft (without plinth): 1·67 m.

Height of serpentine plinth: 0·34 m.

Width of basin (with ends in original condition): 1·53 m.

Depth of basin, from front edge to wall: 0·60 m.

Height of marble wall-facing (from edge of basin): 1·76 m.; width: 1·22 m.

Inner diameter of wreath at upper edge of vase: 0·46 m.

As was indicated in the text (p. 42) the work must have been originally intended for a different use and a different position. The vase-shaped pedestal which rises up from the basin, its rim surrounded with an oak leaf garland, was clearly made completely circular, though now it is let deep into the wall. The vase is not carved from the same block of marble as the shaft with dragons which rises from it in a tapering cone shape. It is hollowed out into a trough at the top, and the shaft, roughly hewn at the lowest part, is set just deep enough into the hollow for the join to be hidden by the garland. Behind the garland there is a moulding on the inside of the rim which is meaningless in its present context with the shaft. The basin below with the lion head and the harpies outside and the foot of the vase inside flanked by dolphins is also not carved from the same block as the vase above it; but here the parts are so carefully fitted and so cleanly joined that only the thinnest, smoothest join is visible (at the height of the top rim of the basin). The basin, ear-shaped in plan, and the vase pedestal placed over it (in its original circular shape) form a unit, both in design and in the style and quality of their execution. In my opinion they were made for quite another purpose, perhaps as parts of a figure-crowned fountain. This fountain was possibly backed by a wall in its lower zone but must have stood free at the top, where the figure rose from the vase-shaped pedestal. It can best be imagined set up against a low terrace wall.

It also seems probable that the marble fountain basin with its pedestal for a figure was either never set up in the place for which it was originally intended or was subsequently removed from it. It was transferred to S. Lorenzo and, with the addition of a marble wall-facing was set up as a lavabo in the side room of the Sacristy. The falcon emblem and the twice repeated device SEMPER show that this occurred under Piero de' Medici. Instead of a figure the fountain now received a marble crest linked to the vase decoration by the motif of dragon bodies, although when seen close to, the organic connection with the wolf or dragon heads hanging in the oak garland is not entirely successful. The falcon, which appears in the lunette of the wall

decoration, holds the Medici ring in his right claw, round which is wound a banderole with the device SEMPER. The ring and banderole appear again on the front wall of the vase; but the pyramidal diamond is different in placing and shape on this ring from that reproduced in the lunette. The two parts can hardly derive from the same general design. The lettering of the two ribbons is very different in the relation of the height of the letters to the breadth of the ribbon and in the closeness of the arrangement of the letters. Possibly the banderole on the vase was not intended originally to carry a device, i.e. the word SEMPER has been added to it subsequently. All these observations justify the suggestion that the lavabo was indeed set up in its present form in the later sixties for Piero de' Medici, but older parts of a secular fountain structure were used, which had been intended for a (bronze?) mythological figure. Perhaps more intensive research may make it possible to ascertain the connection between the curious condition of the lavabo and the very thought-provoking statement in Vasari's Life of Desiderio da Settignano that in his youth Desiderio made a marble pedestal for Donatello's bronze David with very fine harpies.

In Albertini's guide to the city written in 1510 the lavabo is recorded as the work of Rossellino; in the sections devoted to Donatello in Billi's *Libro* and in the Codice Magliabechiano, as well as in Vasari's Life of Donatello it is mentioned as a joint work of Donatello and Verrocchio. In Vasari's Life of Verrocchio, however, there is no mention of it. Billi and the Anonimo Gaddiano describe Verrocchio's part more closely: 'il falcone et altrij ornamentij intorno'. It is difficult to verify these statements especially because the wall-facing shows traces of later restoration; large slabs of marble with parts of the oak leaf garland seem to have been replaced. The falcon relief does not show any close relation to corresponding work from the Verrocchio studio in the manner of adapting the ornament or in its execution, for instance in the decorative marble facings of the embrasures of the arch round the Medici monument in the Old Sacristy.

The divergence of information in the sources led to a situation in earlier literature where hardly two authors were of the same opinion in the questions of attribution and dating. In more recent times the work as a whole has been more or less generally accepted as Verrocchio's. Early experts on Donatello saw Donatello's hand in the execution of the fountain and only ascribed the wall decoration to Verrocchio. Müntz relies more on Albertini and cites the lavabo as one of Rossellino's

masterpieces. Mackowsky attributes the basin to Verrocchio, and the wall-facing to Rossellino. For Cruttwell, Planiscig, Bertini and Middeldorf the whole complex is an early work of Verrocchio's; Cruttwell sees studio assistants participating in the execution and Middeldorf points out the traceable influence of the art of Desiderio – thereby corroborating the teacher-pupil relationship between Desiderio and Verrocchio.

BIBLIOGRAPHY: Albertini, *Memoriale* 1510 (ed. 1863), p. 11; Billi (ed. Frey), p. 40; Cod. Magl. (ed. Frey), p. 76 and p. 90; Vasari-Milanesi, II, p. 370 and p. 414; Baldinucci, I, p. 536; Richa, V, 1757, p. 39; Semper 1875, p. 288; Bode 1882, p. 252; Müntz, I, 1889, p. 420 ff.; Mackowsky 1896, p. 239 ff.; Reymond, III, 1899, p. 22 f.; Bode 1892–1905, p. 142; Mackowsky 1901, p. 29 ff.; Cruttwell 1904, p. 72 ff.; Reymond 1906, p. 34 ff.; Venturi, VI, 1908, p. 707; Schubring 1915, p. 133; Venturi, VIII, I, 1923, p. 654; Planiscig 1933, p. 89 f.; Bertini 1935, p. 437; Middeldorf 1935, p. 209; Dussler 1940, p. 294; Planiscig 1941, p. 15 ff. and p. 50; Paatz, II, 1941, p. 499; Pope-Hennessy 1958, p. 310; Passavant 1959, p. 21; Pope-Hennessy 1964, p. 164.

A5. IDEAL PORTRAIT OF A CLASSICAL WARRIOR Figs. 48, 50

Washington, National Gallery of Art (previously Collection of Mrs Herbert N. Straus).

Marble relief.

Height: 0·58 m.; width: 0·38 m.

The relief was in the possession of Jacques Seligmann in Paris in 1927. Soulier, who saw it there, gave a written opinion that it was identical with the relief of Alexander by Verrocchio mentioned by Vasari. Planiscig, who was instrumental in acquiring it for the collection of Herbert N. Straus in New York, then published it in 1933 as a work by Verrocchio; he also stated that it had come on to the market in the early twenties and it was said that it had been in the possession of a Hungarian noble family. A pencil note on the back of a photograph in the archives of the Berlin Museum informs us that the work appeared on the market in Vienna in 1922 and became known to Bode through a photograph sent to him by Suida; five years later it came to Seligmann in Paris.

Vasari speaks of the warrior reliefs in the Life of Verrocchio in the following words: 'Fece anco due teste di metallo; una d'Alessandro Magno, in profilo; l'altra d'un Dario, a suo capriccio, pur di mezzo rilievo, e ciascuna da per sè, variando l'un dall'altro ne' cimieri,

nell'armadure ed in ogni cosa: le quali amendue furono mandate dal magnifico Lorenzo vecchio de' Medici al re Mattia Corvino in Ungheria, con molte altre cose, come si dirà al luogo suo'. Vasari's indication of the material as 'di metallo' was dismissed as mistaken without more ado, once people began to identify the newly appeared marble relief with the recorded representation of Alexander by Verrocchio (Soulier, Planiscig). Naturally the news of the Hungarian provenance of the piece was a weighty factor in the argument, though there was no means of verifying its reliability or making it more circumstantial. Valentiner finally went a step further in linking the passage in Vasari with the relief in the Straus Collection: he attempted to reach a closer dating of the work by examining the political conditions which would have enabled the friendship between the Medici and Matthias Corvinus to develop. Since the state of war between Naples and Florence did not come to an end until the visit to Naples of Lorenzo de' Medici in 1480 it seemed unlikely that Lorenzo should be sending presents to Matthias Corvinus, the son-in-law of the King of Naples, before then, and Valentiner fixed on 1480 as the *terminus post quem* for the production of the Alexander relief. And in that case he points out that the drawing by Leonardo in the British Museum of a warrior (fig. 53), which is to be dated to 1475, would have provided the point of departure for the warrior reliefs of Verrocchio. But it does not follow from the passage in Vasari that the reliefs were commissioned by Lorenzo de' Medici directly as gifts for the King of Hungary. Even if one casts doubts on Vasari's remark that Verrocchio prepared the companion works 'a suo capriccio' one must allow that the two reliefs may have been some time in the possession of the Medici before Lorenzo sent them 'con molte altre cose' as a gift to Matthias Corvinus.

Before the marble relief in the Straus collection was known, the Scipio relief of the Rattier collection (now in the Louvre; fig. 55) was for decades the centre of the discussion on the bronze reliefs mentioned by Vasari. Bode in 1882 claimed the Scipio as a marble replica (possibly carved by Verrocchio himself) of one of the pair of bronze warrior reliefs; later (1892–1905) he considered an attribution of the Paris piece to Leonardo. In 1904 Bode expressed the opinion that Verrocchio had perhaps done the Scipio after a model by Leonardo, but in 1921 he came nearer to his earlier interpretation and called the work a free replica of the vanished bronze relief of Alexander by Verrocchio, from the hand of Francesco di Simone. Reymond suggested meanwhile

that it was Leonardo who had made the replica. While Müntz in 1891 thought the work to be at least 'worthy of Leonardo' and in 1897 that Verrocchio should be rejected as the author, Suida and Bertraux called the work a modern imitation. Schubring, however, upheld an attribution to Verrocchio. Maclagan has advanced the most convincing theory: in 1921 he expressed the view that a very poorly preserved stucco relief in the Victoria and Albert Museum (fig. 54), with a strong resemblance to the Paris Scipio relief, derives from a lost Alexander by Verrocchio and that the Scipio relief has its origin in some such replica.

The conflict of opinion grew sharper when the Alexander relief of the Straus collection appeared. Planiscig, who first published the piece in 1933, ten years after its appearance, now dismissed the Scipio relief of the Rattier collection as a studio work of little value: 'It is clear that the Scipio relief must be derived from our Alexander relief; but in the quality of its conception and execution it is far removed from it; the relation rather corresponds to that of the drawing from the Malcolm collection with the original design of Verrocchio's. But while in the latter the hand of Leonardo can be recognized, though still young and tentative, it would be a sin against the Holy Ghost to seek it in the Louvre relief. This empty piece lacks any seed of the future: it is a workshop piece, which feeds on Verrocchio's art, and that is all' (p. 95). Möller took a completely contrary position in his extensive discussion of the problem of the warrior reliefs; it appeared in 1934, but was based essentially on the author's lecture in Florence in 1932. Möller persevered in the attribution of the Scipio relief to Leonardo and took pains to give foundation to his opinion by demonstrating the differences in quality between the Scipio and the Alexander relief of the Straus collection, which he also attributed to Verrocchio, but with very different criteria from those of Planiscig. His critique, quite apart from his argument, exposes the weaknesses of the Alexander relief clearly and unambiguously. Of the execution of the decoration of the helmet he writes i.a.: 'Il drago che pesa sopra una metà dell'elmo con la sua grande testa di cane, le sue gambe mancanti d'articolazioni e ricordanti quelle d'un can barbone, coll'ala destra atrofizzata e la coda somigliante a un tubo di gomma, riempito apparentemente d'una massa soffice, se non gonfiato semplicemente d'aria' (p. 28). On the modelling of the face he criticizes: 'Malgrado l'attitudine marziale e l'ornamento guerriero il viso appare troppo puerile e scialbo, e questa impressione viene ancora aumentata dal labbro superiore sporgente come nei bambini, dal mento fanciullesco, come pure da tutto il trattamento superficiale delle parti carnose. Come sono schematiche le pieghe del collo, accennate da tre scanalature parallele, come mancanti di forma anche le narici, come ciondola giù lassamente quelle ciocca sopra la fronte!' (p. 29). These observations are hardly calculated in fact to convince us, as Möller would have it, that the Alexander relief is a work by Verrocchio; rather do they force us to reject it from his œuvre. The Alexander relief cannot derive from the same hand as the silver relief of the Decollation of St John or the bust of Giuliano de' Medici. Unfortunately the Alexander relief and the bust of Giuliano are now exhibited in different rooms in the National Gallery in Washington. A closer comparison of the two works would show clearly how much the Alexander makes its effect through an artificial theatricality, a false emotional appeal. At first sight it seems that the extravagantly lavish and splendid arrangement springs from an almost inexhaustible artistic imagination; but the forms as visualized fail in the decisive details.

Lastly the uneven state of preservation of the work is disturbing and the variation of the 'handwriting' of the sculptor in the different parts. Against the technically skilful execution of the Triton and Amymone group it is surprising to find the clumsy rendering of the palmette ornament round the neck; compare the drawing of the hair on the Amymone with the unclear rough modelling of the palmettes. And how inexplicable is the bungled shape of the open visor in this context, with its stunted rosette at the joint, with the strange mutilated-looking lower edge all swollen and the floral ornament spreading over it in places. Such negligence of detail is seldom found even in third-rate Florentine marble carving of the quattrocento. The damage and signs of wear on the relief are also questionable. It is curious how the scored ornament on the top border of the neck, a relatively protected and recessed area, should be so rubbed and worn. It must furthermore be considered a strange coincidence that there is only one damaged part in the whole of the lower half of the relief, and that not in a particularly exposed place like the projecting wave border of the round shoulder plate, but just on the end of the nose of the winged mask, which thus is made even more similar in expression to the soldiers' heads of the Careggi Resurrection. None of these observations will find any reassuring explanation until we know more about earlier damage and possible overworking of the relief, and before we can trace its provenance beyond the year 1922.

The following bibliography lists the most important contributions to the problem of Verrocchio's warrior relief, and therefore also includes the early views on the Scipio relief of the Rattier collection.

BIBLIOGRAPHY: Vasari-Milanesi, III, p. 361; Bode 1882, p. 102 f.; Müntz II, 1891, p. 512, n. 1; Bode 1892/1905, p. 147 and plate 463; Eugène Müntz, 'Le type de Méduse dans l'art florentin du XVᵉ siècle et le Scipion de la Collection Rattier', in *Gazette des Beaux-Arts*, XVII, 1897, p. 115 ff.; Eugène Müntz, *Léonard de Vinci*, Paris 1899, p. 160; Mackowsky 1901, p. 46 ff.; André Michel, 'Two Italian Bas-reliefs in the Louvre', in *The Burlington Magazine*, II, 1903, p. 84 ff.; Bode 1904, p. 128; Cruttwell 1904, p. 90 ff.; Reymond 1906, p. 64; Emil Jacobsen, 'Neues über Leonardo', in *Kunstchronik*, 1906/07, p. 192; Seidlitz 1909, p. 384; Émil Bertaux, 'Le secret de Scipion', in *Mélanges offerts à Henry Lemonnier*, Paris 1913, p. 71 ff.; Schubring 1915, p. 135; Leo Planiscig, *Die Estensische Kunstsammlung*, I, Vienna 1919, p. 74, no. 120; Bode 1921, p. 28 ff.; Eric Maclagan, 'A Stucco after Verrocchio', in *The Burlington Magazine*, XXXIX, 1921, p. 131 ff.; Malaguzzi-Valeri 1922, p. 25 f.; Suida 1929, p. 27 f. and p. 35; Heinrich Bodmer, *Leonardo, Des Meisters Gemälde und Zeichnungen*, Stuttgart 1931, no. 112; Emil Möller, 'Beiträge zu Leonardo da Vinci als Plastiker und sein Verhältnis zu Verrocchio', Lecture, 39th Meeting of the Kunsthistorisches Institut, Florence; Résumé in *Mitteilungen des Kunsthistorischen Institutes Florenz*, IV, 1932/34, p. 138 f.; Schottmüller 1933, p. 144, no. 2014; Leo Planiscig, 'Andrea del Verrocchios Alexander-Relief', in *Jahrbuch der Kunsthistorischen Sammlungen in Wien*, (new series), VII, 1933, p. 89 ff.; reviewed by Seymour de Ricci, 'Une sculpture inconnue de Verrocchio', in *Gazette des Beaux-Arts*, XI, 1934, p. 244 f. (also review by Gustave Soulier with the same title in the same number, p. 384); Ulrich Middeldorf, Review of: Catalogue of Italian Sculpture in the Victoria and Albert Museum, in *The Burlington Magazine*, LXV, 1934, p. 41; Emil Möller, 'Leonardo e il Verrocchio, Quattro rilievi di capitani antichi lavorati per il re Mattia Corvino', in *Raccolta Vinciana*, XIV, Milan 1930/34, p. 3 ff.; reviewed by Eric Maclagan in *The Burlington Magazine*, LXVII, 1935, p. 186; Venturi, X, 1, 1935, p. 30 ff., n.; Bertini 1935, p. 462, n. 1; Wackernagel 1938, p. 104 and p. 287; W. R. Valentiner, *Catalogue of an Exhibition of Italian Gothic and Early Renaissance Sculptures*, The Detroit Institute of Arts, 1938, no. 54; reviewed by Ulrich Middeldorf in *Pantheon*, 1938, p. 315 f., and by Carlo L. Ragghianti in *Critica d'Arte*, III, 1938, p. 180; Dussler 1940, p. 296; Planiscig 1941, p. 26 ff. and p. 52; Valentiner 1941, p. 4 and p. 21 ff.; Paolo Romano, 'Le relazioni politiche e culturali tra l'Italia e l'Ungheria durante il regno di Mattia Corvino', in *Emporium*, XCVII, 1943, p. 212; Popham and Pouncey 1950, p. 57 f., no. 96; Valentiner 1950, p. 113 ff. and p. 126 ff.; Pope-Hennessy 1958, p. 38 and p. 311; S. V. Lenkey, *An Unknown Leonardo Self-portrait*, Stanford 1963; Stites 1963, p. 5 ff.; Pope-Hennessy 1964, I, p. 174 ff., no. 148; Balogh 1966, I, p. 514 ff. (with many further bibliographical references to the Warrior Reliefs).

APPENDIX

The direct influence of Verrocchio's masterpieces on the younger artists who brought about the change in the character of Florentine art at the turn of the fifteenth century was certainly great. It is harder to establish in detail than to demonstrate the strong general effect of his teaching on both sculpture and painting. Vasari names only Pietro Perugino and Lorenzo di Credi together with Leonardo da Vinci as painter pupils. In addition we know for certain those phases in the work of Domenico Ghirlandaio, Francesco Botticini and Biagio d'Antonio that were moulded by close contact with Verrocchio. Sandro Botticelli and Cosimo Rosselli were also dominated by Verrocchio's art for a time. By what means the Verrocchiesque elements were assimilated into the style of the Umbrian Fiorenzo di Lorenzo and the Sienese Francesco di Giorgio Martini has not yet been explained.

Very little is known of the sculptors who were active in Verrocchio's studio as pupils or as temporary assistants. In his Life of Verrocchio Vasari names only three: Nanni Grosso, Francesco di Simone and Agnolo di Polo. That Giovanni Francesco Rustici also trained under Verrocchio is mentioned only in the Life of Rustici. Whereas we possess a fairly clear idea of the artistic development of Rustici and Francesco di Simone and of the extent of their *œuvre*, the only certain work of Agnolo di Polo is the bust of Christ from the Liceo Forteguerri in Pistoia. The circle of Verrocchio's sculptor pupils must have been very much larger, as is clear from the numerous Verrocchiesque Madonna reliefs, portrait busts, busts of saints and terracotta statuettes to be found in museums and private collections all over the world. Once we have filled in the gaps in our knowledge of the early development of many of the artists still working in Florence at the turn of the century such as Benedetto da Maiano or Andrea Sansovino it will be possible to recognize the direct influence of Verrocchio's teaching on a number of them.

It need not surprise us that the panegyric of Ugolino Verini or the well-known rhyming chronicle of Giovanni Santi give equal praise to Verrocchio as a teacher and to his achievements as an artist. Santi calls him a 'ponte ala Pittura ala scultura', suggesting the importance in Verrocchio's creativity of the interpenetration and mutual stimulation of painting and sculpture.

Verrocchio's talents and interests were many-sided, his technical facility was outstanding, he had a constant urge to experiment and try out new possibilities, and was deeply serious and intense in his artistic endeavour; for these reasons his studio inevitably attracted young artists from far beyond the boundaries of Tuscany. Here Leonardo could find the training that entitled him to represent himself to the Duke of Milan as an artist experienced in every skill and technique. The wide-ranging effect of the workshop within the sphere of painting alone at the end of the quattrocento is perhaps nowhere better shown than in the fact that in the early eighties practically every artist commissioned with mural frescoes for the Sistine chapel: Perugino, Ghirlandaio,

Cosimo Rosselli, Biagio d'Antonio, as well as Botticelli and Signorelli either shows the direct influence of Verrocchio or can even be proved to have worked in his studio for a time.

In the following pages we list the most important works from Verrocchio's studio, and a few works by followers or imitators that are associated with his name in museums or private collections. Reference will also be made to the interpenetration of the various spheres of influence in the paintings and sculptures of the pupils and assistants, who were often in close contact with Verrocchio for a short time only.

App. 1. Studio of Verrocchio: Piero di Lorenzo de' Medici. Bust, terracotta. Florence, Museo Nazionale del Bargello.

The quality of the bust entitles it to a special place in the work of Verrocchio's studio and followers; nevertheless it has been the subject of surprisingly little scholarly research. Apart from certain distinctive facial peculiarities (the strange shape of the nose, the upper part of the chin and the loose, relatively small mouth, with the upper lip set rather far out beneath the nose), the bust has features in the modelling which may be characteristic of the artist. However, it does not seem possible to connect it with the name of any of the artists who might come in question, such as Francesco di Simone, Benedetto da Maiano, Agnolo di Polo or Andrea della Robbia. There is an obvious discrepancy between the detailed and careful, though not very firm, modelling of the face and the somewhat wooden and unarticulated chest and arms, suggesting that it may be the work of a relatively young artist. Moreover, as type of bust and in the proportions and modelling of the area around the eyes, it clearly derives in style from the marble bust of the Lady with a Bunch of Flowers (Plates 44 and 47). The sitter cannot be definitely established in the absence of an authenticated portrait of Piero di Lorenzo, but he is named in the earliest printed catalogues, deriving in all probability from an old tradition. If this is correct, Piero's dates (1472–1503) would lead to the placing of the work towards the end of the eighties.

App. 2. Imitator of Verrocchio: Portrait of a Lady. Bust, terracotta. New York, Pierpont Morgan Library.

Bode, who ascribed the bust to Verrocchio, first saw it in the years around 1900 in the collection of Edmond Foulc in Paris. The provenance of the piece cannot, evidently, be traced very much further back. Forty years later it was rightly rejected from the autograph œuvre of the artist by Planiscig. Valentiner tried to prove that the sitter is also represented in Leonardo's drawing at Windsor No. 12505; but a comparison only underlines the dubiety of the bust. The rendering of the hair is especially strange. In the Leonardo drawing, as in most Florentine quattrocento portraits of women (such as Ghirlandaio's in the Santa Maria Novella frescoes), the front and sides of the hair are short, while the rest is drawn back and dressed in a coil or bun at the back of the head. Only in the extreme front does the loose hair spring direct from the parting and falling relatively long and free together with the sides form a soft and delicate frame for the face. In the bust all the visible hair is cut quite short to cover the temples and ears in a compact mass with a thick, club-cut edge. The arrangement only serves to stress the dry and rather energetic appearance of the subject, created by the long and thin-lipped mouth, the emphatic cheek bones and the somewhat too thick and massive neck. This is a portrait bust based on quite other canons of feminine beauty to the quattrocento ideal and employing different and later means of bringing out the strength of character and spiritual qualities of a sitter. It is by no means impossible that the New York work is in fact the portrait of a nineteenth-century sitter, represented in the costume and style of a quattrocento bust.

App. 3. Imitator of Verrocchio: Lorenzo il Magnifico. Bust, terracotta. Boston, Museum of Fine Arts.

The bust is documented since the eighteen-eighties when it was in the Quincy Shaw Collection in Boston. It was attributed to Verrocchio by Bode, who dated it to 1466 and claimed it as a portrait of Lorenzo at about seventeen years of age. Mackowsky accepted the attribution but it was rejected by Cruttwell as well as Venturi, who refused even to accept Bode's identification of the sitter. The piece does not stand comparison with Verrocchio's bust of Giuliano (Plates 45, 46, 48; cf. text, p. 35 f.). Apart from the lifeless, straw-like effect of the hair, the uncertainty in the fixing of the eyes between the nose and temples and the peculiar flattened shape of the chin, the

execution of the decorative details of the armour, for example the winged masks on the shoulder plates, is very coarse and unskilled. Moreover it is incomprehensible that the motif of the zigzag border, which appears twice on the bust of Giuliano, should appear here precisely as the lower bordering of the shoulder guard, where it restricts the freedom of movement of the upper arm.

App. 4. Imitator of Verrocchio: Lorenzo il Magnifico. Bust, terracotta. Washington, National Gallery of Art (Samuel H. Kress Collection).

The portrait bust was in the Santarelli Collection in Florence in the early nineteenth century, in 1850 it was lent by Lord Taunton for an exhibition in London, where it appeared, significantly, as a work by Michelangelo. It must have been done in imitation of the death mask of Lorenzo because of the curious position of the wrinkle on the brow and especially the rendering of the chin, which in all the painted representations of Lorenzo from the Quattrocento is very much heavier and fleshier. A comparison with the contemporary portraits also shows that in the bust the head-covering has been pressed much too deeply into the brow – and indeed almost to the point where in the death mask a wire ring now appears which was probably originally covered with cloth drapery. Furthermore the artist has clearly referred to Bronzino's well-known portrait miniature, which in its turn depends upon the death mask. In Bronzino's portrait the strands of hair framing the face are cut rather short, and in the bust they are extended round into a kind of page-boy cut, such as is known in portraits of the Emperor Maximilian I, where it clearly corresponds to the way the sitter wore his hair. It is known, however, from the numerous portraits of Lorenzo painted during his lifetime that he wore his hair very long at the back, well below the nape of his neck, while towards the front it sloped up so that it was short over his cheeks. The bust of Lorenzo, which has at various times been compared with Verrocchio's Colleoni because of the grim expression, has no close stylistic connections with any of Verrocchio's works.

App. 5. Antonio Rossellino: Madonna. Marble relief. Vienna, Kunsthistorisches Museum.

Verrocchio's study of the composition of this relief was an important part of his preparation for the Berlin painting of a Madonna with Seated Child (Plates 69–71); the terracotta relief from S. Maria Nuova (Plates 14–15) and the marble relief in the Bargello (probably by Francesco

di Simone (App. 11)) are related, particularly in the type of head, to the work of Rossellino.

App. 6. Studio of Rossellino: Madonna. Terracotta relief. London, Victoria and Albert Museum.

The work of a pupil of A. Rossellino; it draws inspiration from the reliefs of the Madonna with Standing Child from the studio of Verrocchio (Plates 14–15 and App. 11); in the style of the folds, particularly in the drapery of the cloak over the left arm of the Madonna, the London relief also shows the influence of the early work of Leonardo. Cf. App. 40.

App. 7. Antonio Rossellino: Tondo of the Madonna from the Bruni Monument. Florence, S. Croce.

Vasari names Verrocchio as the executant of this part of the monument, which was designed by Bernardo Rossellino and erected under his direction. However, it is probably an early work by Antonio Rossellino, the eighteen years younger brother of Bernardo. Cf. App. 5 and 8.

App. 8. Antonio Rossellino: Madonna with Laughing Child. Group in terracotta. London, Victoria and Albert Museum.

Pope-Hennessy has recently ascribed the piece to Antonio Rossellino. It had previously been attributed by many scholars to Leonardo, and by others to Verrocchio. The new attribution is convincing when one considers the very informal, intimate character of the work and its small dimensions. It was clearly of the kind intended for private devotions, like a number of other terracotta groups modelled in the round, mostly from the circle of Ghiberti.

App. 9. Studio of Verrocchio (Francesco di Simone?): Madonna and Child with an Angel. Marble relief. Boston, Museum of Fine Arts.

The relief comes from the Quincy Shaw Collection. It certainly dates from the seventies of the Quattrocento and must have originated in Verrocchio's most immediate circle, from the hand of an assistant working independently whose relief style and technique in marble-carving point to a training in the studio of A. Rossellino. The artist was probably Francesco di Simone, with whose name it has frequently been associated over the past half-century. The head of the angel has clear traces of the influence of Verrocchio's bronze David (Plate 22). Single motifs of the composition appear in three paintings attributed to Biagio d'Antonio: the Budapest altarpiece from S. Domenico del Maglio (App.

52), the Madonna in the Poldi Pezzoli Collection in Milan and the Battersea Madonna (cf. Passavant 1959, figs. 85 and 86).

App. 10. Studio of Rossellino: St John as a Child. Bust, terracotta. London, Victoria and Albert Museum.

The bust, which formerly was even attributed by certain scholars to Leonardo, is reminiscent of Verrocchio's David (Plate 22), particularly in the treatment of the hair. The modelling of the area round the eyes and nose and the unusual shape of the mouth with the strongly emphasized upper lip show, however, how closely the artist is still indebted to the style of the studio of Rossellino; useful pieces for comparison are, for instance, Antonio Rossellino's bust of a youthful St John in the Museo Nazionale del Bargello and the putti on the monument of the Cardinal of Portugal in S. Miniato in Florence.

App. 11. Studio of Verrocchio (Francesco di Simone?): Madonna. Marble relief. Florence, Museo Nazionale del Bargello.

The relief can be directly compared in the Bargello with Verrocchio's marble bust of the Lady with a Bunch of Flowers (Plates 44, 47, 49) and the terracotta Madonna from S. Maria Nuova (Plates 14–15). It shows a striking hardness in the modelling of the limbs, particularly of the Virgin's left hand and the body of the Child. The facial expression is strangely cold and lifeless. The style of drapery is monotonous in effect and tends to schematization; this is not disguised by the subtle surface effects of the carefully polished marble. The relief has been attributed to Francesco di Simone by several scholars at various times, while others have considered it to be an autograph of Verrocchio. The curiously puffy shape of the eyes of the Christ child, with strongly protruding eyeballs and the double fold beneath the eyes, occurs again in the head of Hope in the Forteguerri cenotaph (App. 12) and – less markedly – in the head of the angel of the Boston marble relief (App. 9).

App. 12. Studio of Verrocchio (Francesco di Simone): Head of Hope from the Forteguerri Cenotaph. Marble. Pistoia, Duomo.

Cf. note on App. 11. The head differs from the more sharply modelled features of the Faith and the mandorla angels especially in the shape of the eyes. The only resemblance is with the features of Christ with the double fold below the eyes and the protruding edge to the upper lid (Plate 43).

App. 13. Imitator of Verrocchio: Bust of a Boy. Terracotta. London, Victoria and Albert Museum.

There is a close connection with Verrocchio's bust of the Lady with a Bunch of Flowers (Plates 44, 47, 49) in the proportions of the boy's head with the beautiful domed brow stressed by the central parting, the widely set large eyes, the relatively small mouth and the large cheeks framed at the sides by the hair. Even so we miss any individual characterization of the features, and this is very unattractive in a work that is evidently intended as a portrait bust and not as an idealized portrait or a representation of a saint.

App. 14. Imitator of Verrocchio: Bust of a Girl. Terracotta. Zurich, Meissner Collection.

Coming from the Luigi Grassi Collection in Florence, the work was earlier among the most celebrated pieces in the Victor Hahn Collection in Berlin; after the war it was with Heilbronner in Lucerne and about ten years ago it was sold and went to Zurich. Like the London Bust of a Boy (App. 13), the Meissner bust is derived for the proportions of the face from Verrocchio's marble portrait of a Lady. Otto von Falke ascribed it in the Hahn catalogue to an anonymous Bolognese artist influenced by Verrocchio and Francesco Francia.

App. 15. Imitator of Verrocchio: Bust of a Boy. Terracotta. Berlin, Staatliche Museen.

The piece was acquired in Florence in 1842. Although it is over 12 cm. higher it was claimed in the Berlin catalogue as a companion piece to the London bust, and assessed as 'probably an autograph work' of Verrocchio. Pope-Hennessy (1964, p. 206 f.) has demonstrated that neither bust is of a quality to justify its attribution to the artist.

App. 16. Imitator of Verrocchio: Bust of Christ. Terracotta. Berlin, Klewer Collection.

Of the numerous 'Verrocchiesque' busts of Christ (others e.g. in the Victoria and Albert Museum in London or in the Museo del Bigallo in Florence) the Berlin example is probably the least well known. These busts are by very different artists and executed at quite different periods, but they all derive, particularly in the treatment of hair and beard, from the Christ of the Or San Michele group or the Christ figure of the Forteguerri cenotaph. They are all evidence of the contemporary or subsequent influence of Verrocchio's art, but they can hardly have been produced by artists working in the master's studio.

App. 17. Circle of Pollaiuolo: Madonna. Pigmented stucco relief. Florence, Museo Bardini.

The work copies in every detail a marble relief of the Madonna in the Bargello which seems to be by the same hand as the naked angel figures bearing the municipal arms in the great chamber of the City Hall in Pistoia (cf. Mackowsky 1901, figs 28 and 79). In the cast of features, the treatment of the hair, the modelling of the hands and in general the somewhat outré shaping of the limbs these pieces are closer to the work of Antonio Pollaiuolo than to Verrocchio. Even though so far no terracotta work by Pollaiuolo is known, and of marble only the so-called bust of Machiavelli, in the work of the sculptors of the younger generation we have to reckon with a mixture of influences from Verrocchio and Pollaiuolo. The relief of Neptune in the Louvre attributed to Verrocchio by Valentiner (1950, p. 107 ff.) is also probably the work of one of Pollaiuolo's closest associates, if not by Antonio himself.

App. 18. Della Robbia Studio: Madonna. Glazed terracotta relief. Florence, S. Croce, Sacristy.

Cf. notes to App. 19.

App. 19. Studio of Verrocchio (Benedetto da Maiano?): Madonna. Unpainted stucco relief. Christie's sale, 2nd June 1964.

The work, known as the 'Signa Madonna', was acquired from the Orsi family by G. B. Dibblee and is said to have been formerly in the collections of the Florentine families of Federighi and Albizzi. In the summer of 1964 it was acquired at Christie's for £10,000 by an unnamed dealer after having been withdrawn from a sale. A second example of the composition, identical in dimensions and also in stucco, is preserved in the Allen Memorial Museum in Oberlin, Ohio (App. 20). There are also several, mostly weaker repetitions in marble, pigmented and non-pigmented terracotta. Both the stucco examples, which are clearly cast from the same original – as can be seen from the correspondence of the damaged parts – have been grossly overrated in their artistic importance and the quality of their execution ever since they came on the art market. Some scholars (Cook, Venturi and Mackowsky) have tried to attribute the Signa Madonna to Leonardo, while McLagan assigned it to a member of Verrocchio's studio close in style to the della Robbia family (*The Burlington Magazine*, XLIII, 1923, p. 67 ff.). The stucco examples differ in no essential points from the glazed terracotta relief in the Sacristy of S. Croce (App. 18). The composition shows a close relationship in the representation of the Madonna to the marble relief in the Bargello here ascribed to Francesco di Simone (App. 11), and also to the painting of the Madonna in the Metropolitan Museum (App. 32), particularly in the proportions of the child's body, which are clearly based on Verrocchio's Boy with a Dolphin. We meet a strikingly similar build in the putti of Benedetto da Maiano over the portal of the Sala dei Gigli of the Palazzo Vecchio in Florence; in Benedetto we also repeatedly find the not very expressive, rather swollen and unarticulated form of hand which characterizes the left hand of the Virgin in the stucco relief. Likewise the modelling of the few visible parts of the Virgin's hair and the rather indecisive, leather-like style of the draperies have parallels in Benedetto's works. This also applies to the very Leonardesque pensiveness in the expression of the figures and the very restrained and rather dreamy mood of the scene.

App. 20. Studio of Verrocchio (Benedetto da Maiano?): Madonna. Stucco relief, probably originally pigmented. Oberlin (Ohio), Allen Memorial Art Museum.

The piece came from the Tozzi Collection, Florence, to the Drey Galleries in New York in 1935 and in the same year went to the Parish-Watson Galleries. It was acquired for Oberlin in 1944. Cf. note to App. 19.

App. 21. Antonio Pollaiuolo: Charity (detail). Painting. Florence, Uffizi.

The painting of Charity belongs to a series of Virtues destined for the Sala del Consiglio of the Università della Mercatanzia. Verrocchio also competed for the commission along with the brothers Pollaiuolo in 1469 (cf. note to App. 50). The picture exemplifies clearly the hard and stilted figure style typical of Florentine painting at the beginning of the seventies, characterized among other things by the predominance of strongly emphasized hand gestures, repeated like a formula (often several times in the same picture). In a slightly milder form this style can also be seen in Verrocchio's early paintings, in the London Tobias and the Angel, in the Berlin Madonna with Seated Child and in the altarpiece in Argiano; similarly it is one of the important characteristics of the early work of Domenico Ghirlandaio. Cf. App. 22.

App. 22. Domenico Ghirlandaio: St Barbara between St Jerome and St Anthony. Fresco. Cercina, Canonica della Pieve di S. Andrea.

This earliest known fresco of Ghirlandaio's is closely

based on the representation of the male saints in Verrochio's altarpiece in Argiano (Plates 75–77). The figure of St Barbara, however, particularly in the face with the cheeks and chin narrowing towards the bottom and the small mouth, shows clear reminiscences of the art of Antonio Pollaiuolo. Cf. App. 21.

App. 23. Studio of Verrocchio (Domenico Ghirlandaio?): Madonna. Painting. Berlin, Staatliche Museen.

The Verrocchiesque character of the painting was first stressed by Crowe and Cavalcaselle in 1864, since when it has been repeatedly claimed as an autograph work of the artist or as the work of a pupil of Verrocchio. Striking reminiscences of the style of Pollaiuolo, which are seen in the representation and were noticed by Bode, caused Venturi in 1927 to ascribe the work to Antonio Pollaiuolo. Recently there have been attempts to prove that it was the young Perugino who painted the picture in Verrocchio's studio. The basic mood of the representation is close to Verrocchio, the relations with the Berlin Virgin with Seated Child (Plates 69–71) and especially its closeness to the Madonna reliefs executed in the studio of Verrocchio (Plates 14–15 and App. 11) are obvious; but the picture also shows clear reminiscences of paintings by Pollaiuolo, in the same way as Ghirlandaio's fresco at Cercina (App. 22). The type of the Madonna's head is strikingly close both to Pollaiuolo's Charity (App. 21) and to the head of Ghirlandaio's St Barbara in the Cercina fresco, to his St Fina in the fresco of the Burial of the Saint in San Gimignano (App. 27) as well as to the head of the Virgin in the Annunciation from Monte Oliveto in the Uffizi (App. 28). If the proposed attribution of the Berlin painting to Domenico Ghirlandaio suggested here is accepted, it indicates a new possibility which could throw light on the artist's early development. As the style of the Cercina fresco also suggests, Ghirlandaio must have worked in Pollaiuolo's studio for a time, after (or even instead of) the initial period of training with Baldovinetti mentioned by Vasari and before he came into closer contact with Verrocchio. Cf. note to App. 29.

App. 24. Antonio Pollaiuolo: Tobias and the Angel (detail: head of the archangel). Painting. Turin, Pinacoteca Sabauda.

Cf. note to App. 29.

App. 25 Antonio Pollaiuolo (?): Head of a Boy. Drawing. New York, Pierpont Morgan Library.

Cf. note to App. 29.

App. 26. Domenico Ghirlandaio: Meeting of the boy Christ with the young St John the Baptist. Painting. Berlin, Staatliche Museen.

This small panel picture, executed with exceptional care and love of detail, is among the most delightful early works of Ghirlandaio. The arch-like, swinging brushwork used to paint the leaves of the tall trees behind Joseph is very unusual. A very similar sketch of foliage exists, significantly, in Leonardo's early landscape drawing of 1473 and in the Verrocchiesque Madonna with Angels in London (App. 38). The Berlin painting was first attributed to the studio of Verrocchio by Bode; later he ascribed it to the young Ghirlandaio, and Berenson followed him. Valentiner in 1935 recognized the close stylistic relationship between the painting of the Annunciation from Monte Oliveto (App. 29) and the Berlin panel, which he therefore felt impelled also to attribute to Leonardo.

App. 27. Domenico Ghirlandaio: Head of St Fina (detail from the Burial of St Fina). Fresco. San Gimignano, Collegiata.

Cf. note to App. 29.

App. 28. Domenico Ghirlandaio and Leonardo: Head of the Virgin (detail of App. 29).

Cf. note to App. 29.

App. 29. Domenico Ghirlandaio and Leonardo: Annunciation, from Monte Oliveto. Painting. Florence, Uffizi.

The attribution of this painting is still disputed. It has been exhibited in the Uffizi as a Leonardo for about a hundred years. At the earliest period it was considered the work of Ridolfo Ghirlandaio, later Verrocchio and the so-called 'Alunno di Andrea' were named as well as Leonardo as possible authors. Some scholars considered the painting to be a work of collaboration between Verrocchio and Lorenzo di Credi, others thought it Leonardo's with the assistance of Credi. The various opinions were summarized by Passavant (1960, p. 71 ff.), who recently attempted to prove that the picture was designed by Domenico Ghirlandaio, who also did considerable parts of the execution, while Leonardo subsequently altered its aspect by overpainting and correcting. The drawing in the Pierpont Morgan Library (App. 25) which Valentiner published as a sketch of Leonardo's for the head of the Virgin is probably by Antonio Pollaiuolo, as is made clear by comparing it with the head of the archangel in Pollaiuolo's Tobias and the

Angel in Turin (App. 24). Ghirlandaio evidently worked over the drawing and used it for the Annunciation; the sepia wash which disfigures the study for the head, especially the effect of the hair, is not of the Quattrocento. The head of the Virgin in the painting shows the closest relationship with the head of St Fina in San Gimignano (App. 27), the head of St Barbara in the Cercina fresco (App. 22), the head of the Virgin in the Berlin painting of the Madonna No. 108 (App. 23) and with the head of the boy St John in the Berlin panel (App. 26).

App. 30. Cosimo Rosselli: Virgin and Child with St Anne and Saints. Painting. Berlin, Staatliche Museen.

The figures of this altarpiece, which is dated by an inscription to 1471, convey the strong influence of the monumental paintings of Castagno on Rosselli's style, which is primarily orientated towards Benozzo Gozzoli. Cf. note to App. 31.

App. 31. Studio of Verrocchio (Cosimo Rosselli?): Madonna. Painting. Frankfurt, Städel'sches Kunstinstitut.

The half-figure Madonna painting, which repeats the figure composition of the marble Madonna relief in the Bargello (App. 11) shows striking affinities to the Berlin altarpiece of Rosselli (App. 30) in every particular in which it differs from works of Verrocchio and his closest circle of pupils. This is particularly apparent in the type of the head of the Virgin which is directly comparable with the heads of the young women of the Berlin painting, in the occurrence of the coffered ceiling in the Frankfurt picture and in the very tentative inclusion of elements of landscape. The narrow detail of landscape appearing in the arched aperture at the right of the Madonna painting is clearly derived from the harbour of the Uffizi Annunciation (App. 29). The stiff and motionless proximity of Mother and Child is unusual; the movements of the figures are as though frozen for the representation. This also spells a similarity with Rosselli's Berlin altarpiece.

App. 32. Studio of Verrocchio (Francesco Botticini?): Madonna. Painting. New York, Metropolitan Museum of Art.

The painting, ascribed to Verrocchio by a number of scholars, is not of the quality of an autograph of the artist in design or in execution. The mood of the scene, the modelling of the hands and particularly the moulding and modelling of the faces show a strong relationship

with paintings of Botticini (cf. App. 33 and 34). There are many details of the facial form which occur in no other Verrocchiesque Madonnas: the slightly protruding, not fleshy but sharply curved upper lip, the clear dimples at the corners of the mouth, the clearly fixed box shape of the inner corners of the eyes. Added to this is the unusually rich gradation of tones in the modelling of the faces, which seem more played over by candlelight than illuminated by the light of day. The contours of the chin and cheeks, the edges of the nostrils and sides of the nose are lit up by reflected lights; the skin has a matt gleam, unlike the waxy gloss that characterizes the flesh effects in the figures of Lorenzo di Credi. The unobtrusive treatment of the decorative garments is characteristic; the painter has omitted the usual jewelled brooch of Verrocchiesque Madonna paintings.

App. 33. Francesco Botticini: Tobias and the Angel. Painting. Bergamo, Accademia Carrara.

The picture shows, in the smallest format, a version of the London composition by Verrocchio (Plates 72–74). The similar position of the left arm of each of the figures is adopted, and in addition the stepping motif of archangel and boy are now also made similar. The stylization of certain drapery motifs noticeable on the upper arm of Tobias and on the turn-overs of the boots is striking, and is also to be observed in Botticini's Rossi altarpiece (App. 37).

App. 34. Francesco Botticini: The Three Archangels. Painting. Florence, Uffizi.

The composition uses ideas from Verrocchio's London picture (Plates 72–74). Motifs of the movement and garments of the archangel Gabriel are already formulated in Verrocchio's figure of Raphael, while we are directly reminded in Botticini's Raphael, with his softly flowing robe, of clothed figures by Botticelli such as the Athena in the painting of Pallas and the Centaur in the Uffizi or the drawing of Abundance in the British Museum.

App. 35. Studio of Verrocchio (Francesco Botticini?): Head of a Boy or a Girl. Drawing. Florence, Uffizi No. 212 F recto (Berenson 2798). Cf. Catalogue of autograph drawings No. D3.

The individuality of the drawing is made clear by comparing it with Verrocchio's study for the angel seen full face in the Baptism (Plate 89), which is similar in motif but much more realistic. The silver-point drawing, in spite of all the finesse of technical execution, shows uncertainties in the rendering of detail, such as the sides of

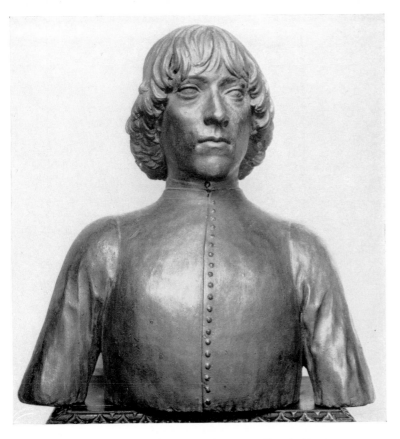

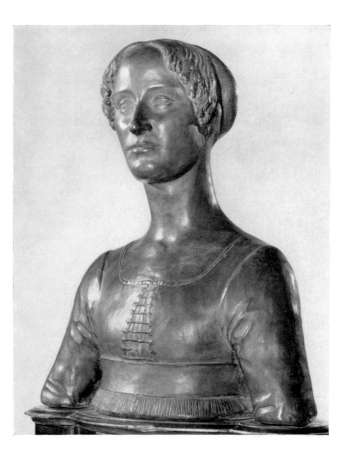

App. 1. Verrocchio Workshop: *Piero di Lorenzo de' Medici*(?). Terracotta bust. Florence, Museo Nazionale del Bargello

App. 2. Imitator of Verrocchio: *A young Woman*. Terracotta bust. New York, Pierpont Morgan Library

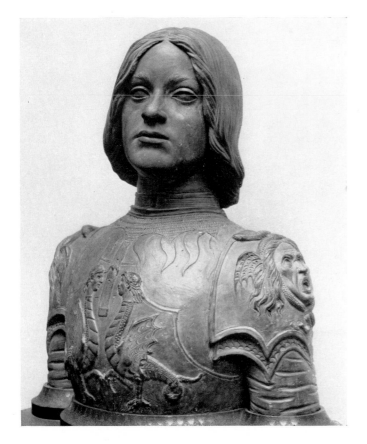

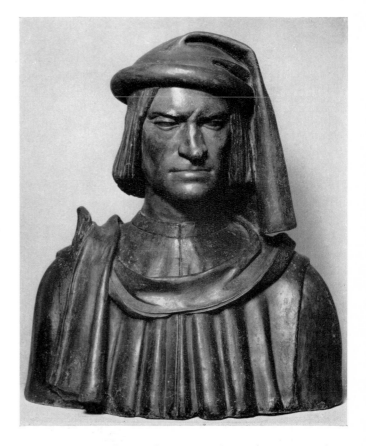

App. 3. Imitator of Verrocchio: *Lorenzo il Magnifico*. Terracotta bust. Boston, Museum of Fine Arts

App. 4. Imitator of Verrocchio: *Lorenzo il Magnifico*. Terracotta bust. Washington, National Gallery of Art, Kress Collection

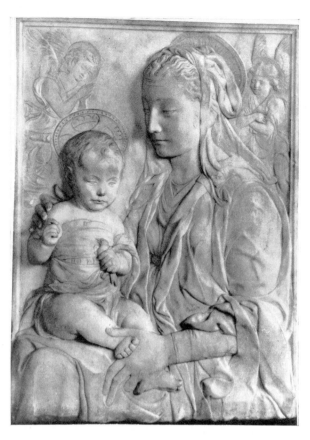

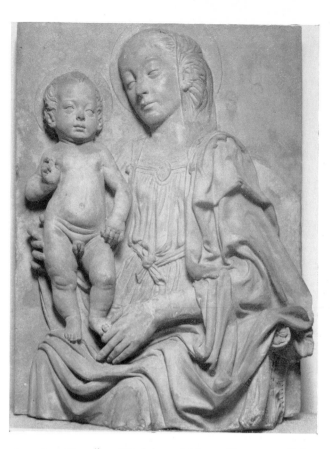

App. 5. Antonio Rossellino: *Madonna*. Marble relief.
Vienna, Kunsthistorisches Museum

App. 6. Rossellino Workshop: *Madonna*. Terracotta relief.
London, Victoria and Albert Museum

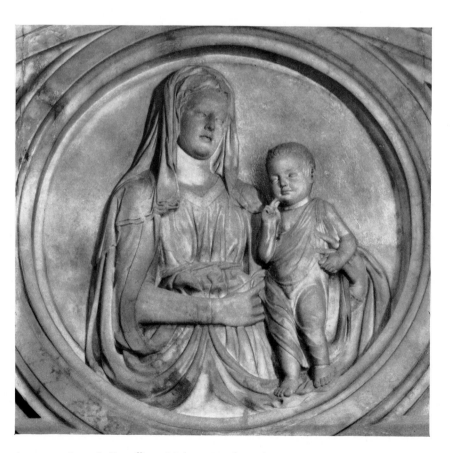

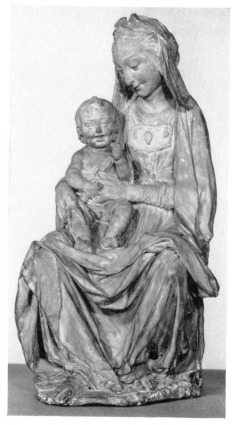

App. 7. Antonio Rossellino: *Madonna*. Tondo on the Bruni monument.
Florence, S.Croce

App. 8. Antonio Rossellino: *Madonna with the Laughing Child*. Terracotta.
London, Victoria and Albert Museum

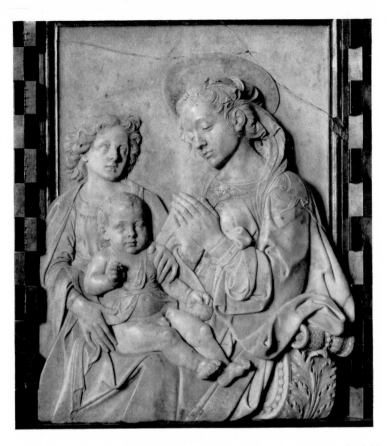

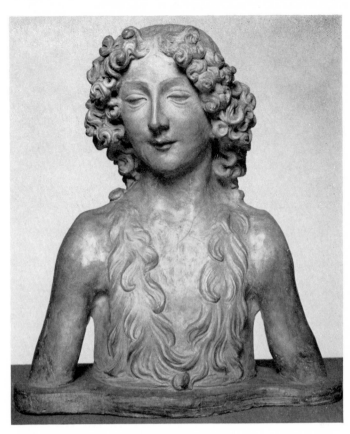

App. 9. Verrocchio Workshop (Francesco di Simone?): *Madonna and Child with an Angel*. Marble relief. Boston, Museum of Fine Arts

App. 10. Rossellino Workshop: *The young St. John the Baptist.* Terracotta bust. London, Victoria and Albert Museum

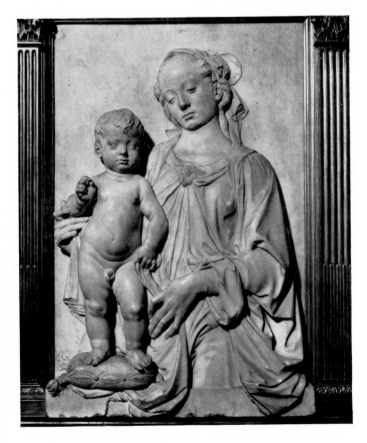

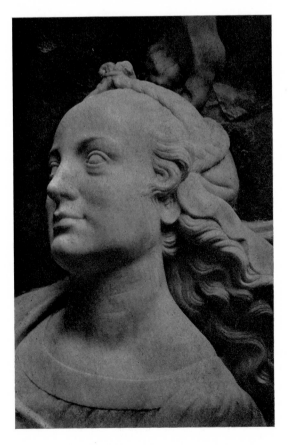

App. 11. Verrocchio Workshop (Francesco di Simone?): *Madonna.* Marble relief. Florence, Museo Nazionale del Bargello

App. 12. Verrocchio Workshop (Francesco di Simone?): *Head of Hope,* from the Forteguerri monument (Plate 41). Pistoia, Duomo

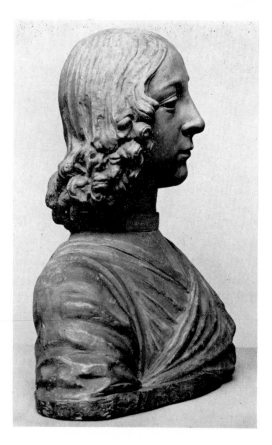

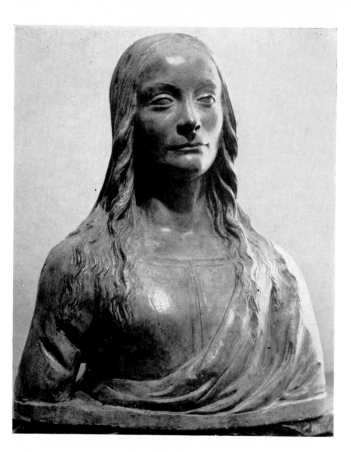

App. 13. Imitator of Verrocchio: *A Boy*. Terracotta bust. London, Victoria and Albert Museum

App. 14. Imitator of Verrocchio: *A Girl*. Terracotta bust. Zürich, Meissner collection

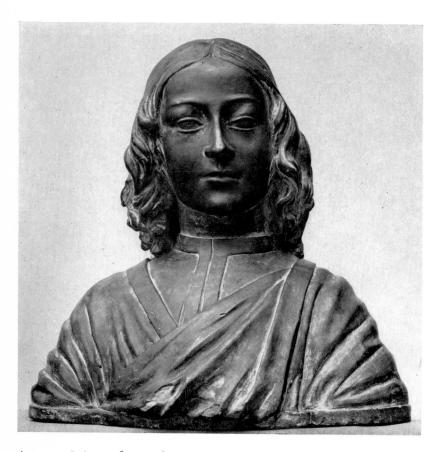

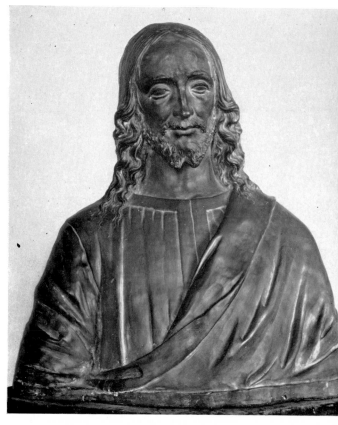

App. 15. Imitator of Verrocchio: *A Boy*. Terracotta bust. Berlin, Staatliche Museen

App. 16. Imitator of Verrocchio: *Christ*. Terracotta bust. Berlin, Klewer collection

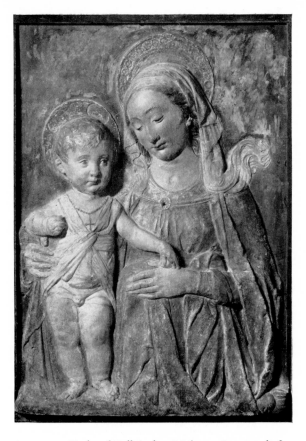

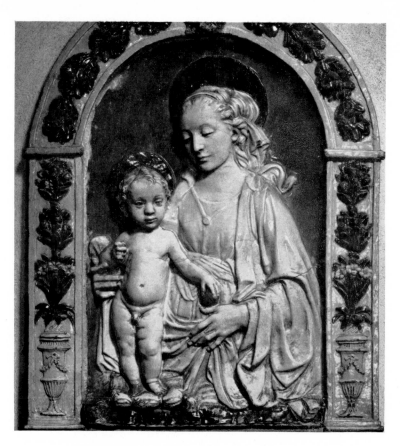

App. 17. Circle of Pollaiuolo: *Madonna*. Stucco relief.
Florence, Museo Bardini

App. 18. Della Robbia Workshop: *Madonna*. Glazed terracotta relief.
Florence, S.Croce, Sacristy

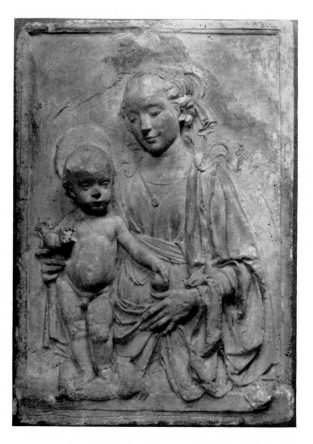

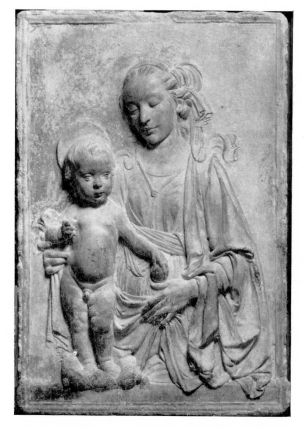

App. 19. Verrocchio Workshop (Benedetto da Maiano?):
Signa Madonna. Stucco relief. Christie's sale,
June 2, 1964

App. 20. Verrocchio Workshop (Benedetto da Maiano?):
Tozzi Madonna. Stucco relief. Oberlin, Ohio,
Allen Memorial Art Museum

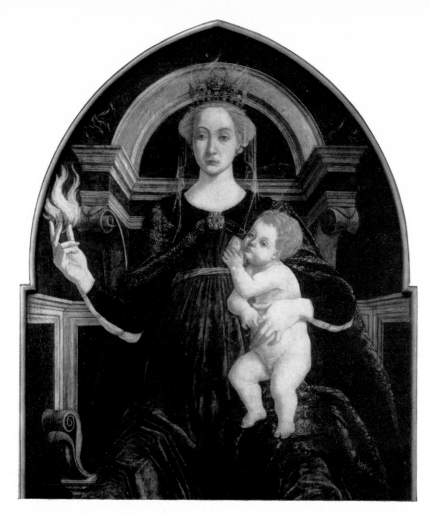

App. 21. Antonio Pollaiuolo: *Charity*. Detail. Florence, Uffizi

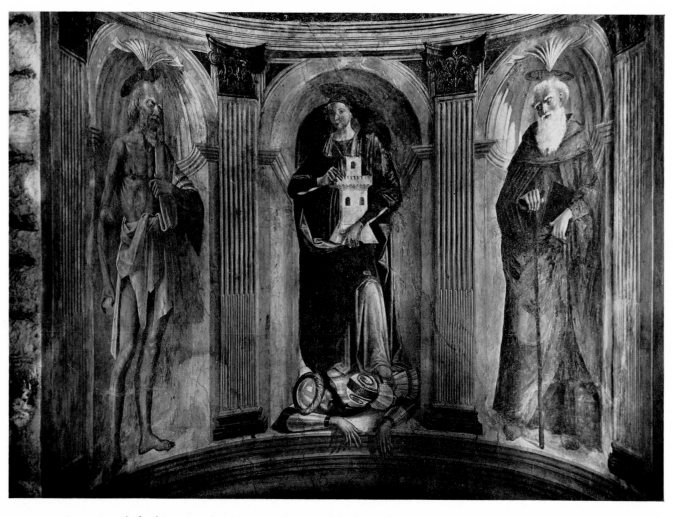

App. 22. Domenico Ghirlandaio: *St. Barbara between St. Jerome and St. Anthony Abbot*. Fresco. Cercina, Canonica della Pieve di S. Andrea

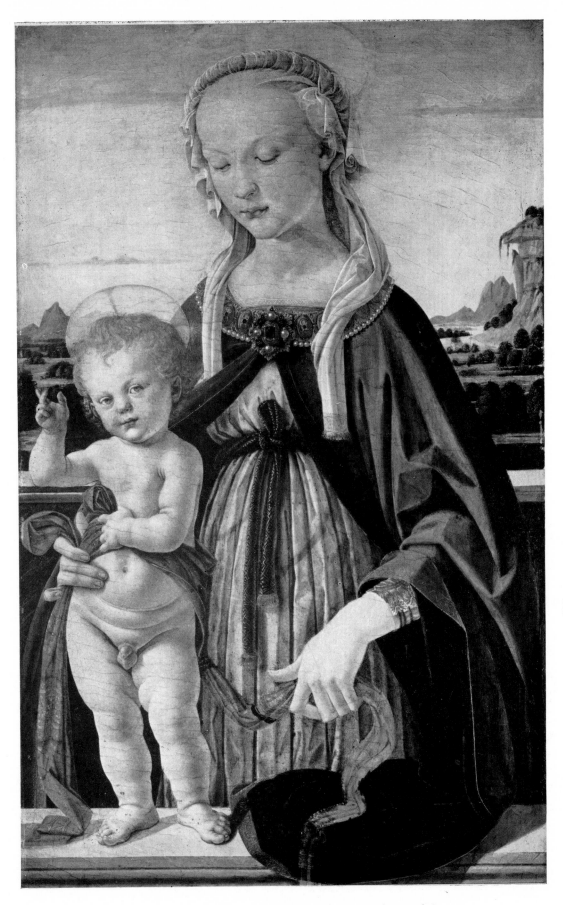

App. 23. Verrocchio Workshop (Domenico Ghirlandaio?): *Madonna*. Berlin, Staatliche Museen

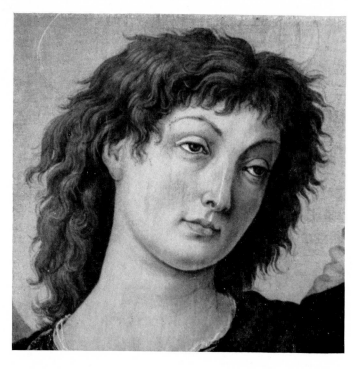

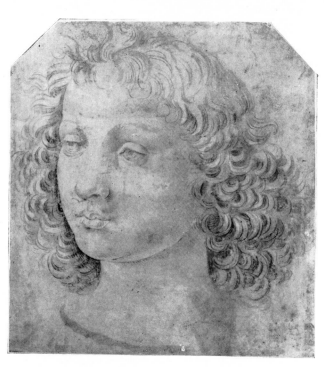

App. 24. Antonio Pollaiuolo: *Tobias and the Angel*. Detail.
Turin, Pinacoteca Sabauda

App. 25. Antonio Pollaiuolo(?): *Head of a Boy*. Drawing.
New York, Pierpont Morgan Library

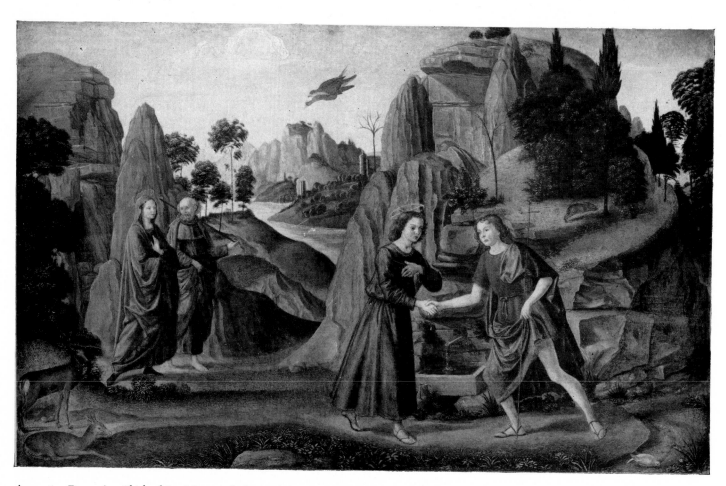

App. 26. Domenico Ghirlandaio: *Meeting of Christ and the young St. John Baptist*. Berlin, Staatliche Museen

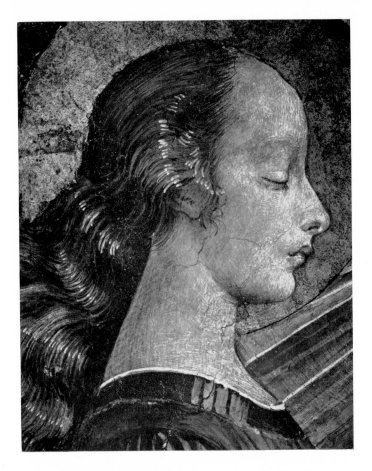

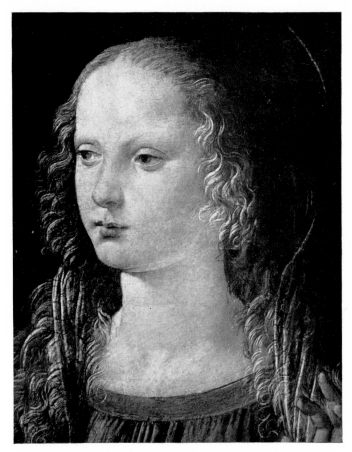

App. 27. Domenico Ghirlandaio: *Funeral of St. Fina*. Detail.
Fresco. San Gimignano, Collegiata

App. 28. Domenico Ghirlandaio and Leonardo da Vinci:
Annunciation. Detail. Florence, Uffizi

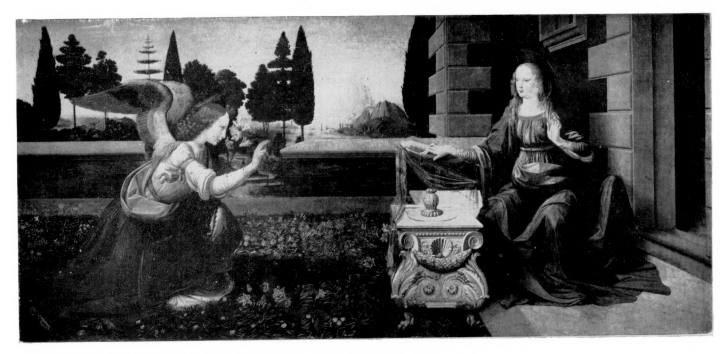

App. 29. Domenico Ghirlandaio and Leonardo da Vinci: *Annunciation*. Florence, Uffizi

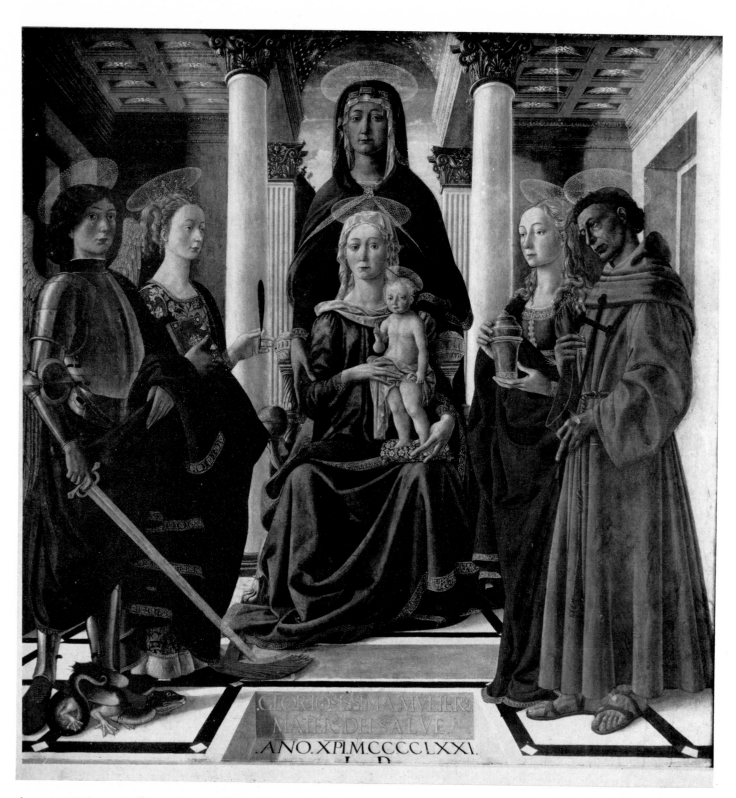

App. 30. Cosimo Rosselli: *Virgin and Child with St. Anne and Saints*. 1471. Berlin, Staatliche Museen

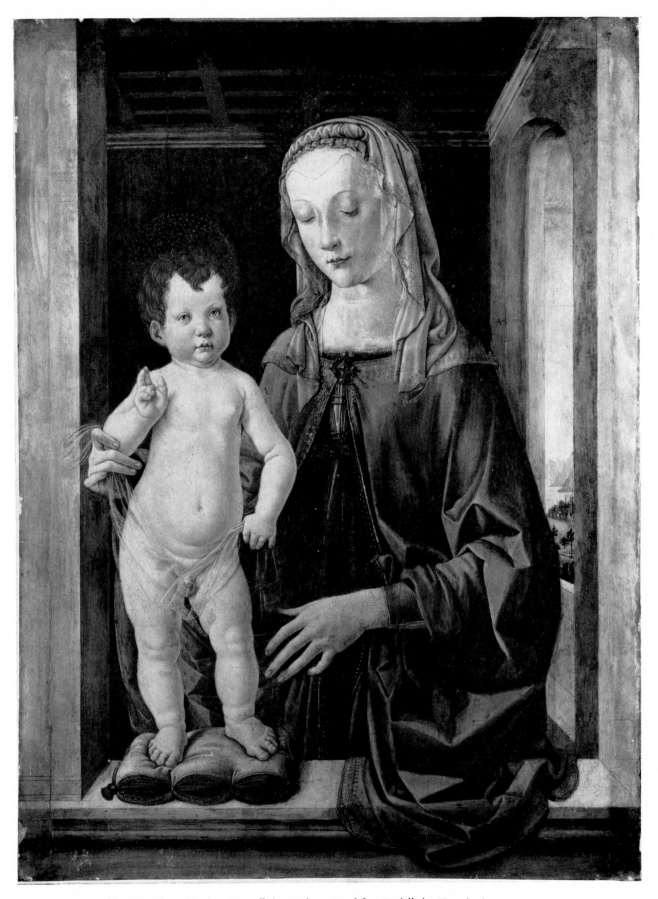

App. 31. Verrocchio Workshop (Cosimo Rosselli?): *Madonna*. Frankfurt, Städel'sches Kunstinstitut

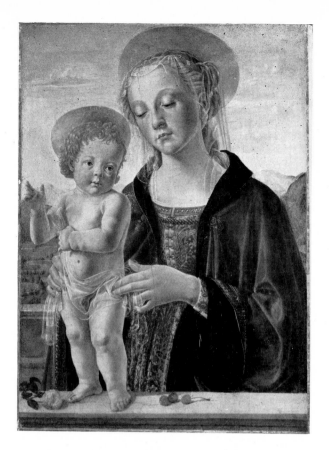

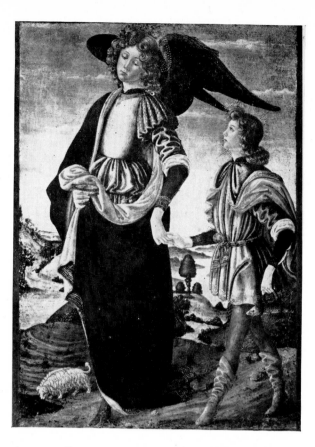

App. 32. Verrocchio Workshop (Francesco Botticini?):
Madonna. New York, Metropolitan Museum

App. 33. Francesco Botticini: *Raphael and Tobias*. Bergamo,
Accademia Carrara

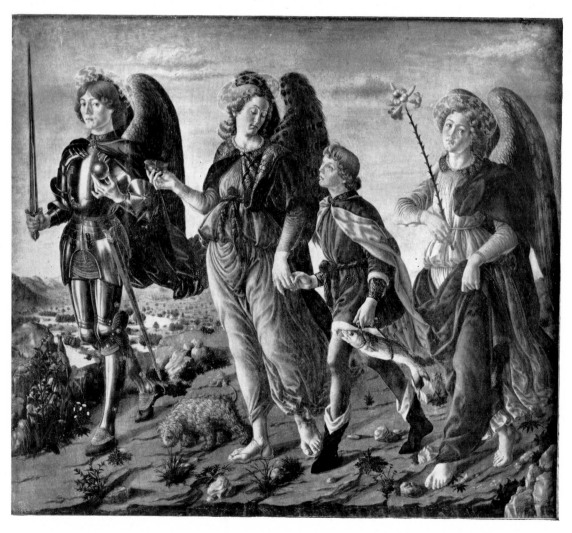

App. 34. Francesco Botticini: *The three Archangels*. Florence, Uffizi

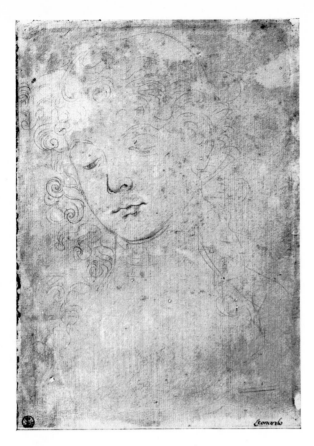

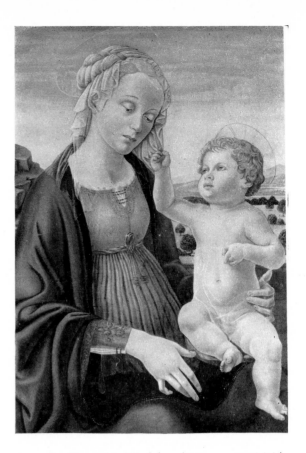

App. 35. Verrocchio Workshop (Francesco Botticini?):
Head of a Girl. Drawing. Florence, Uffizi
(Cat. No. D3 *recto*)

App. 36. Verrocchio Workshop (Francesco Botticini?):
Madonna. Detroit, Mrs. A. G. Wilson collection

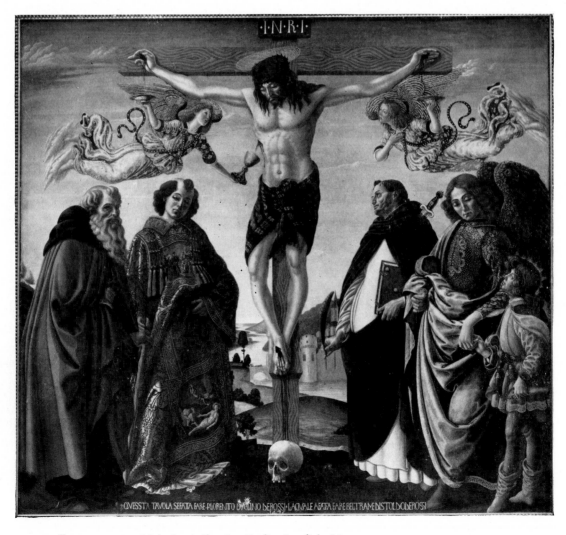

App. 37. Francesco Botticini: *Rossi Altarpiece.* Berlin, Staatliche Museen

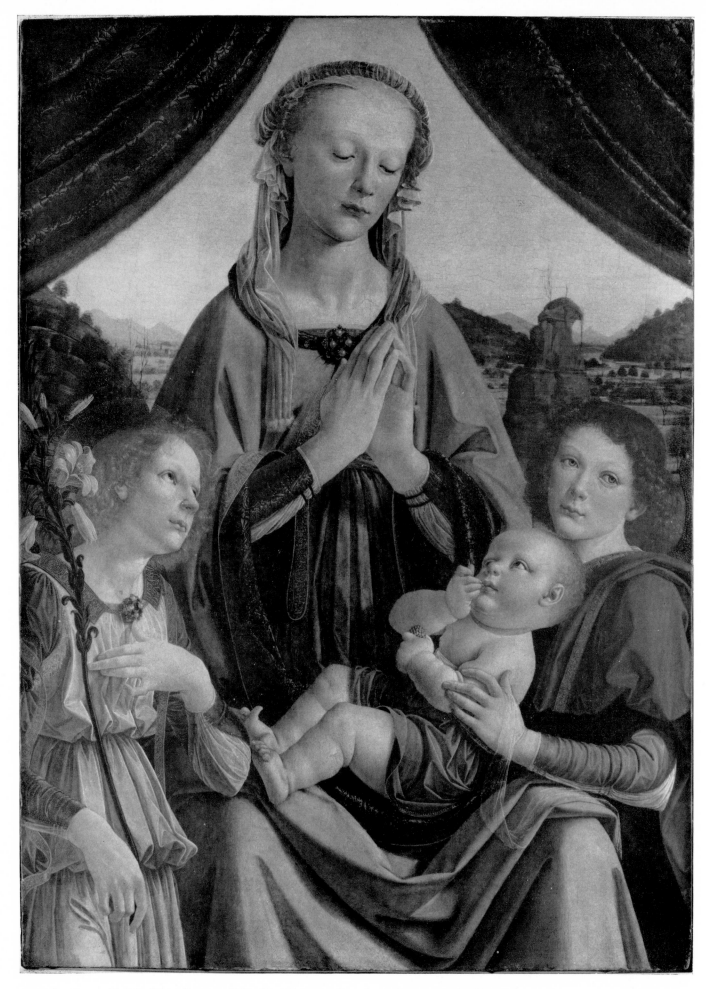

App. 38. Verrocchio Workshop (Lorenzo di Credi?): *Madonna and Angels*. London, National Gallery

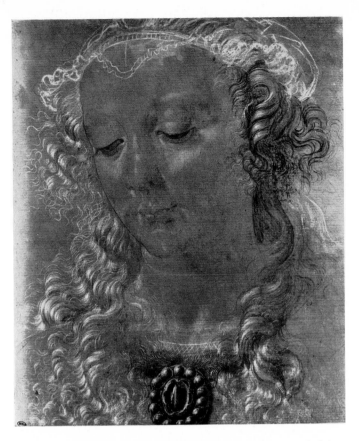

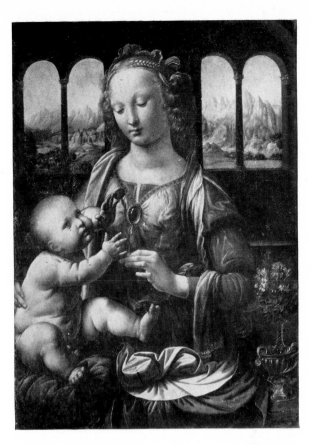

App. 39. Verrocchio Workshop (Lorenzo di Credi?): *Head of the Madonna*. Drawing. Paris, Louvre

App. 40. Leonardo da Vinci: *Madonna with a Pink*. Munich, Alte Pinakothek

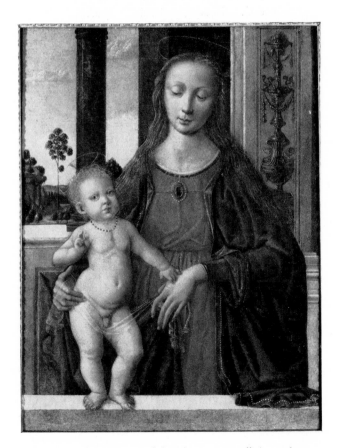

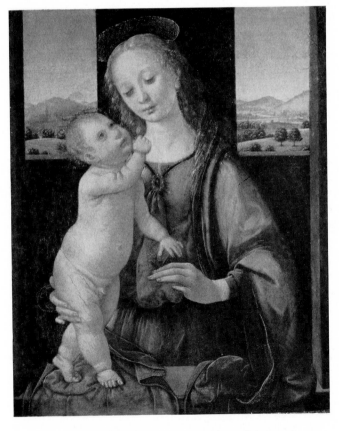

App. 41. Verrocchio Workshop (Luca Signorelli?): *Madonna*. London, Courtauld Institute Galleries, Gambier Parry Bequest

App. 42. Verrocchio Workshop (Lorenzo di Credi?): *Dreyfus Madonna*. Washington, National Gallery of Art, Kress Collection

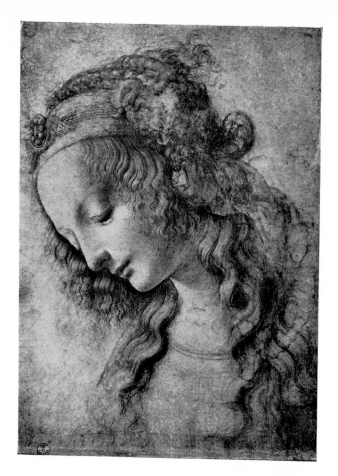

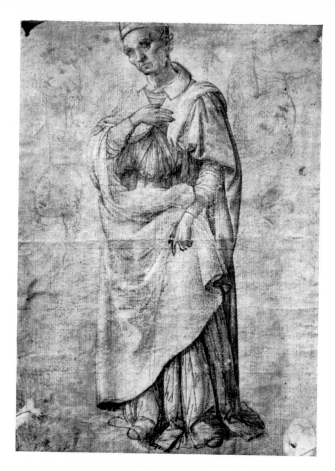

App. 43. Leonardo da Vinci: *Head of the Madonna*. Drawing. Florence, Uffizi

App. 44. Verrocchio Workshop (Lorenzo di Credi?): Sketches (Bishop from the Pistoia altarpiece etc.). Edinburgh, National Gallery of Scotland

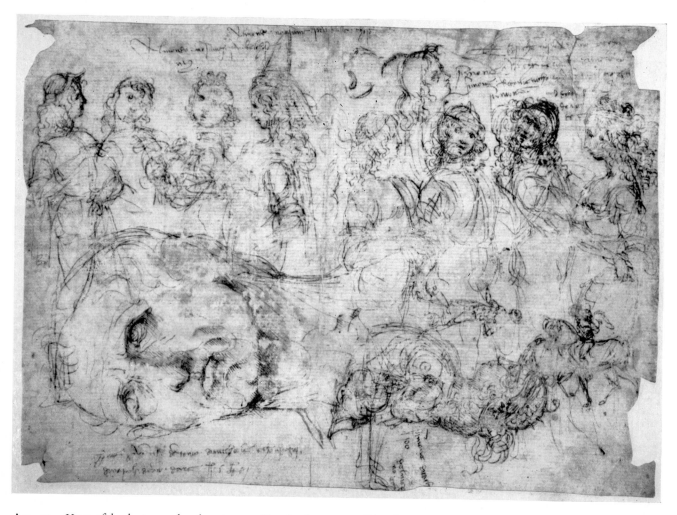

App. 45. Verso of the sheet reproduced on App. 44: Sketches for a group of four figures etc.

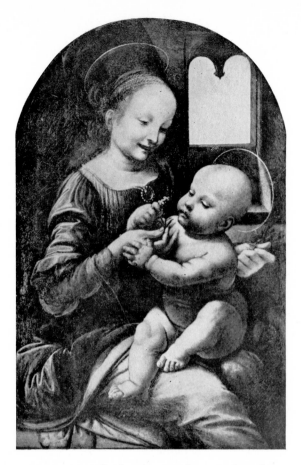 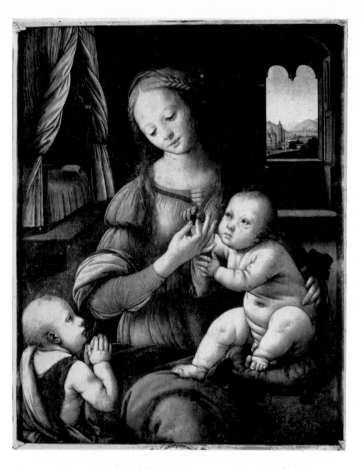

App. 46. Leonardo da Vinci: *Madonna*. Leningrad,
 Hermitage

App. 47. Lorenzo di Credi: *Madonna*. Dresden, Staatliche
 Kunstsammlungen

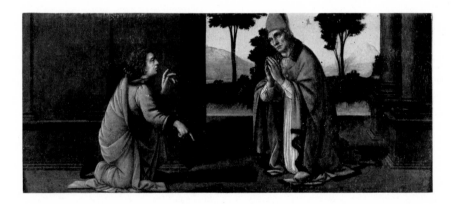

App. 48. Lorenzo di Credi: *St.Donatus and the Tax Collector*. Worcester, Mass.,
 Worcester Art Museum

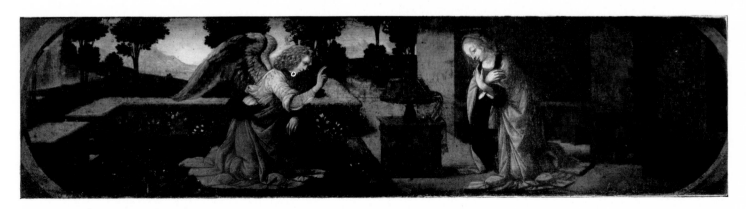

App. 49. Lorenzo di Credi: *Annunciation*. Paris, Louvre

App. 50. Verrocchio Workshop (Biagio d'Antonio called "Utili"?): *Faith*. Drawing. Florence, Uffizi

App. 51. Biagio d'Antonio called "Utili": *Madonna*. Formerly on the London art market

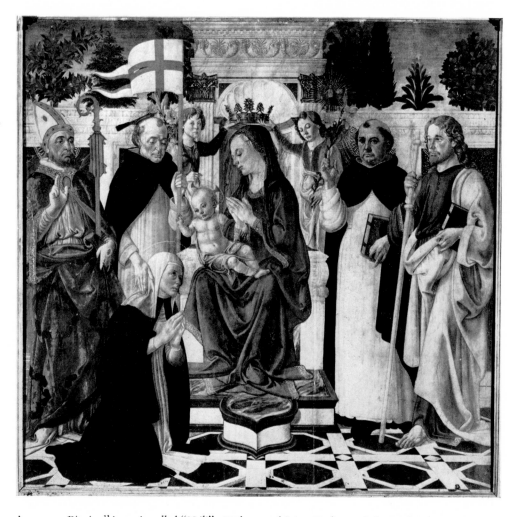

App. 52. Biagio d'Antonio called "Utili": *Madonna and Saints*. Budapest, Szépmüvészeti Múzeum

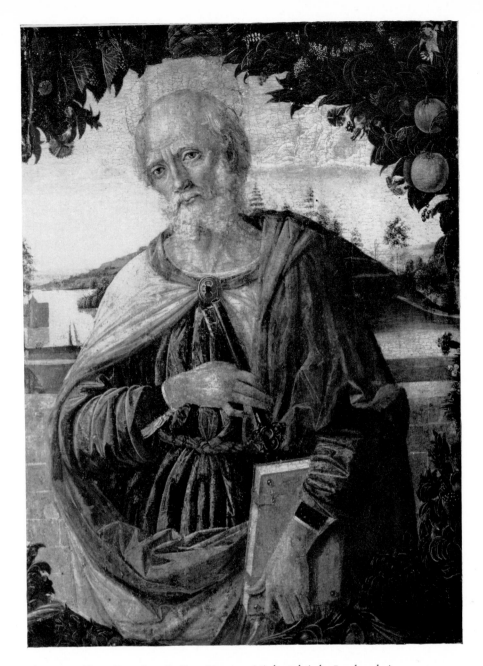

App. 53. Pietro Perugino: *St. Peter*. Hanover, Niedersächsische Landesgalerie

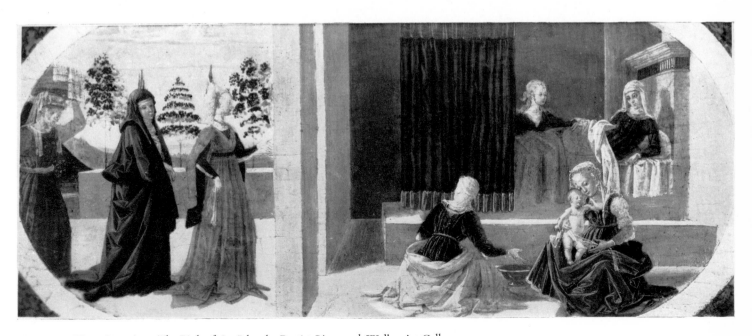

App. 54. Pietro Perugino: *The Birth of St. John the Baptist*. Liverpool, Walker Art Gallery

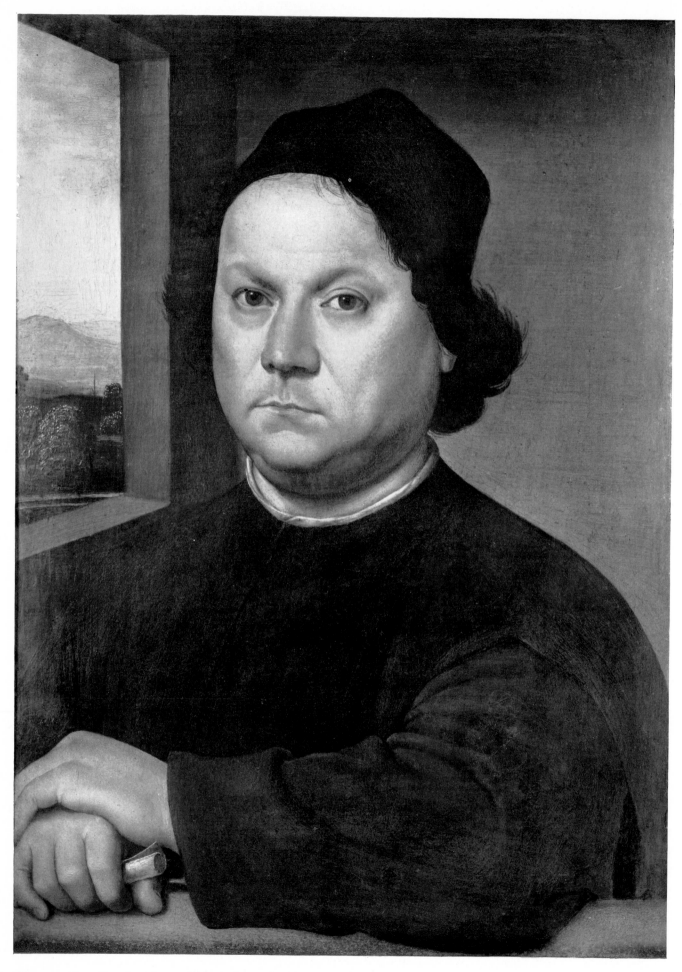

App. 55. Pietro Perugino: *Supposed Portrait of Verrocchio*. Florence, Uffizi

the nose and the upper part of the mouth. The incorrect fixing of the boy's left eye makes sensible the lack of a clear plastic understanding of the head as a whole. In the modelling of the mouth, eyebrows and dropped eyelids the drawing is closely related to paintings of Botticini's, particularly the small Tobias and the Angel in Bergamo (App. 33).

App. 36. Studio of Verrocchio (Francesco Botticini?): Madonna. Painting. Detroit, collection of Mrs A. G. Wilson.

The picture was once one of the best pieces in the Mumm Collection in Frankfort. After some time with Howard Young in New York it was sold and went to Detroit. After its latest, all too thorough cleaning and restoration it is hardly recognizable. As far as its original condition can be judged today with the help of older photographs, it is extremely probably a work of Botticini's, strongly influenced by Verrocchio, and produced at about the same time as the Tobias and the Angel painting in Bergamo (App. 33). The landscape scheme with the rock in the middle distance rising to the left edge of the picture resembles that of Verrocchio's Berlin Madonna (Plates 69–71). The unusual movement of the Child, which also appears in paintings from Ghirlandaio's circle, is possibly derived from a lost drawing by Leonardo. Cf. in this connection Windsor 12276 recto and the Louvre drawing of the Madonna with the Bowl of Fruit. The head of the Virgin in the Detroit picture is very close to the Uffizi drawing No. 212 F recto (App. 35).

App. 37. Francesco Botticini: Altarpiece of the Rossi Family. Berlin, Staatliche Museen.

In this picture, dated by the inscription to 1475, Botticini shows a mingling of the influences of Verrocchio and Botticelli. In the representation of the Christ on the Cross the artist refers to the Argiano painting (Plates 75–77; the group of Tobias and the Angel is very similar in Botticini's small picture in Bergamo (App. 33). In the types of the male saints, the rather exaggerated differentiations of head turns and positions and the direction of the gaze of all the figures one feels clearly the effect of Botticelli's art.

App. 38. Studio of Verrocchio (Lorenzo di Credi?): Madonna with Angels. Painting. London, National Gallery.

The panel was hung under the name of Piero della Francesca in the Contugi Collection in Volterra until the middle of the nineteenth century when it was acquired in 1857 through L. Hombert in Florence for the

National Gallery and there catalogued as the work of Ghirlandaio. Since then the following attributions have been proposed for the picture: Lorenzo di Credi, Pollaiuolo, School of Verrocchio, 'Alunno di Andrea', Verrocchio with the assistance of Leonardo, Verrocchio (autograph), Perugino. The landscape, particularly the rendering of the foliage in the trees visible on the hill at the left edge of the picture, seems influenced by Leonardo's landscape drawing of 1473 (or similar, lost drawings) (cf. note to App. 26). The figure composition with the steeply rising figure of the Virgin praying, and behind her approximately at shoulder height the horizon of the distant landscape, with the fair-haired angel in profile and the pensive brown-haired angel seen full face, is obviously strongly and directly influenced by the Baptism of Christ by Verrocchio (Plates 78–82) in design and execution, and at a time when the Baptism had not yet been gone over and altered by Leonardo. The London Madonna can be dated about the middle of the seventies or a little earlier; apart from the connection of the picture with the landscape drawing of 1473 already mentioned there are no relationships to early works of Leonardo to be seen (for instance the Leningrad or Munich Madonnas; App. 40, 46) or to the Pistoia Madonna group (Plate 87) which was designed in the late seventies. The London picture has not the quality of an autograph of Verrocchio's. The execution is rather matt and weak in effect; the treatment of detail, for instance the drawing of the angels' hair is overcareful and monotonous. The style of the young Ghirlandaio is, in comparison, more varied in the handling of colour and in rendering the effects of light and shade. This is also true of the young Perugino, to whom the picture has been recently attributed – probably because of the Peruginesque expression on the faces of the angels. Perugino, particularly in his early work (cf. App. 53 and 54) shows a marked sense of painterly effects, especially breaks in colour and the effect of sheen in the rendering of the draperies. The suggested attribution of the London panel to Lorenzo di Credi made here, which refers back to the opinion of Crowe and Cavalcaselle, is supported by everything that Credi's work conveys of the qualities of his artistic temperament and his talent, his quiet and harmonious unproblematical nature, his lack of response to stronger painterly effects, to tension and subtlety of expressive gesure, and also his preference for painstaking detail and his unvaried and solid colour technique. Of the early work of Credi the Madonnas in Washington and Dresden, both of which are already strongly influenced by Leonardo's Munich

Madonna with the Carnation and his Leningrad Madonna, are only comparable in a limited way with the London panel; the later works of the artist are more fruitful comparisons, or the study for the Baptist figure of the Pistoia altarpiece (Plate 91) which was worked over by Credi. Perhaps the London Madonna can be associated with a passage in the Florentine notary's minute of 5th November 1490 published by Covi, in which it is stated that Credi '. . . dal mese di novembre 1473 insino adi primo del mese di setembre dell'ano 1474 (?) . . . dipinse una tavola di nostra Dona . . .'. (Cf. Covi 1966, p. 97 ff.)

App. 39. Studio of Verrocchio (Lorenzo di Credi?): Head of the Virgin. Drawing. Paris, Louvre.

The drawing was first attributed to Leonardo by Suida and has subsequently been claimed as a study for the Munich Madonna with the Carnation (App. 40) by several scholars. The sheet was certainly produced in connection with the preparatory work for the Munich painting, though it is not by Leonardo himself but by a fellow pupil imitating the technique and style of early Leonardo drawings – as is shown by the excessively uniform and studied brush-work particularly in the light parts of the hair. The rendering of the hair below the right cheek is not convincing, nor lower down where the hair is divided by the shoulder; the waves of the hair run almost parallel into the depth of the picture, causing a lack of clarity in the modelling of the head. The small degree of idealization achieved, or even attempted, in this study (especially the rather adenoidal expression of the face engendered by the curious formation of the mouth and nose) brings the Louvre drawing close to the London Madonna with Angels (App. 38).

App. 40. Leonardo: Madonna with the Carnation. Painting. Munich, Alte Pinakothek.

In this early work of Leonardo's, the attribution of which has, wrongly, been questioned, the artist attempted to translate a composition derived from the reliefs of the Virgin and Child into a painting. The relief-like character of the group of figures becomes clear as soon as it is compared with Verrocchio's Berlin Madonna with the Seated Child (Plates 69–71) or with Leonardo's Leningrad Madonna (App. 46). For the rendering of the bust of the Virgin, for the drapery motifs and the brooch bordered with pearls, and especially for the arrangement of the Virgin's left hand, Leonardo had patently worked on ideas inspired by Verrocchio's designs for the Pistoia altarpiece.

App. 41. Studio of Verrocchio (Luca Signorelli?): 'Gambier-Parry' Madonna. London, Courtauld Institute Galleries.

This picture, inspired by study of a work of Flemish painting, probably the Portinari altarpiece by Hugo van der Goes, is modelled on Leonardo's Munich Madonna (App. 40), as the motif of the Virgin's left hand shows, and is also closely related to the Dreyfus Madonna in Washington (App. 42). The type of the Christ-child is known from Umbrian works, particularly paintings by Fiorenzo di Lorenzo; the motif of the child's movement recurs in miniature in Perugino's scene for the predella of the Pistoia altar (App. 54). (For the only very recently debated question of the attribution, cf. John Shearman, 'A Suggestion for the Early Style of Verrocchio', in *The Burlington Magazine*, 1967, p. 121 ff.; also Günter Passavant, 'Die Courtauld Institute Galleries', in *Kunstchronik*, 1967, p. 311 ff.; esp. 317 ff.)

App. 42. Studio of Verrocchio (Lorenzo di Credi?): 'Dreyfus' Madonna. Painting. Washington, National Gallery of Art (Samuel H. Kress Collection).

The pose of right hand of the Virgin is taken over from Leonardo's Munich Madonna (App. 40), yet the type of head is modelled more closely on the Madonna of the Pistoia altarpiece (Plate 87). The spatial relationship of the figures remains unclear. The child looks upwards and reaches out with his arm as though to stroke his mother's cheek, but the head of the Virgin does not appear obliquely in front of the child but in a plane behind. The spectator thus has the impression that the child is looking up at the ceiling (or perhaps at an insect which he is trying to catch with his right hand). In the Munich Madonna by Leonardo the very similar poise of the head and direction of the look of the child is motivated by his reaching for the carnation, which his mother is holding out to him. Because of the very careful and delicate execution of detail the Washington picture has repeatedly been claimed as an autograph of Leonardo, some scholars saw in it a work of collaboration between Leonardo and Lorenzo di Credi: a suggestion made even less convincing by the miniature format of the panel.

App. 43. Leonardo: Head of the Madonna. Drawing. Florence, Uffizi No. 428 E.

The dark wash added by another hand on the hair outlining the profile of the face falsifies the modelling of nose, mouth and chin. At the same time the expression of the face is rather disfigured by the swollen appearance

of the upper lid, which has been subsequently drawn in very clumsily. The treatment of the hair in the intact parts of the sheet shows the pains taken by the draughtsman to catch the play of the locks in its true order, over and above their momentary, fortuitous appearance, and to make visible the formal values dictated by its inner structure. This is what brings this drawing so close to the later studies of plants, waves and clouds by Leonardo; and this is what distinguishes it so clearly from the study for the head of the Virgin in the Louvre (App. 39).

App. 44. Studio of Verrocchio (Lorenzo di Credi?): Charcoal and wash drawing after the figure of the bishop in the Pistoia altarpiece, and silverpoint studies of a boy's head and the head of a bearded old man (recto of App. 45). Edinburgh, National Gallery of Scotland.

Verrocchio's bishop (Plate 84) has been strikingly refined towards elegance in the drawing: the head and hands turn out much too small in relation to the fulsome drapery motifs, which in the altarpiece correspond to the monumentality of the figure. The shaping of the hands with the very short thumb and little finger is similar in the figures of the Louvre Annunciation (App. 49) and the Dreyfus Madonna (App. 42). The three sketches of a boy's head might almost be taken as studies for the head of the angel seen full face in the London Virgin and Child (App. 38), but they are much later, since they were drawn after the bishop on the same sheet. These very cleanly executed sketches in silverpoint with economical and very uniform hatched shading demonstrate what delicacy and surety Credi's style of drawing could attain under the influence of the early work of Leonardo.

App. 45. Verso of the Edinburgh sheet of sketches (App. 44): Sketches for a four-figure group, etc.

Two sketches for the composition of a four-figure group, each with a pair of young people on the right. In the left-hand sketch a youth leads the girl from right to left to two other young men, one of whom is wearing a parade helmet. In the right-hand sketch the youth is turned to the right; he has just approached the girl whose arm he is holding so as to conduct her. The artist has tried a second variant for the poise of his head, which is adopted for the obviously later left-hand sketch. Above the right-hand group is a sketch after Leonardo's angel in the Uffizi painting of the Baptism (cf. Plate 82), as is shown by the correspondence of the motifs; the upper arm of the angel in the sketch is, however, hanging less straight than in the figure of the Baptism. In the lower part of the sheet appears the head of a beardless old man, similar in type to the St Jerome of the Argiano altarpiece (Plate 76) or the painting in the Pitti Palace (Passavant 1959, Pl. 129); there is also a sketch of the bust of a youth seen in profile. His armour is reminiscent of that of the right-hand centurion in the Decollation relief of the silver altar (Plate 53) because of the motif of the lion's head.

App. 46. Leonardo: 'Benois' Madonna. Painting. Leningrad, Hermitage.

The starting-point for Leonardo's conception is not, significantly, Verrocchio's Berlin Madonna (Plates 69–71) but a relief composition by Desiderio da Settignano: the Panciatichi Madonna (now in the Museo Nazionale del Bargello in Florence), which was also the model for the relief by Antonio Rossellino in S. Clemente in Sociana. Apart from the direct attraction which Leonardo must have felt for the sensibility of Desiderio and the grace of his figures, it is clear that Desiderio's pictorial vision must have suited him much better than Verrocchio's three-dimensional, sculptural approach, which also affected the artist's reliefs and paintings. Like Leonardo, Desiderio possessed a remarkably fine sense of the beauties and subtleties of expression which the motifs of movement and forms of the figures could achieve according to their arrangement and projection within the plane of the painting or relief. In Desiderio we also find, particularly in the reliefs in Turin and Philadelphia, the girl-like, almost child-like type of the Virgin which creates a model for the Leningrad painting.

App. 47. Lorenzo di Credi: Madonna. Painting. Dresden, Staatliche Kunstsammlungen.

Credi takes over the motif of the child's movement and his position in relation to his mother from Leonardo's Leningrad Madonna (App. 46), but he turns the head and bust of the Virgin more towards full face and adds the half-figure of St John. This latter figure in three-quarter back view with the head turned in profile is very similar to that in Leonardo's early sketch of the Madonna on the Windsor sheet 12276r. In the rendering of the head of the Virgin, her unusual hair arrangement with the strands falling vertically from the temples (and also in the motif of the gathered bodice visible at the cut out neck) Credi seems to model himself more closely on Verrocchio's designs for the Madonna of the Pistoia altarpiece, or on the painting itself which was already laid in (Plate 87). The landscape seen through the window with the walls and towers of a town repeats with

little alteration the landscape which appears in the Pistoia altarpiece between the left edge of the painting and the figure of the Baptist (Plate 85).

App. 48. Lorenzo di Credi: St. Donatus with the Tax-collector. Painting. Worcester, Worcester Art Museum.

This rather uninspired predella scene constructed from the scheme of an Annunciation with kneeling figures was executed by Lorenzo di Credi in or after 1485 in connection with the completion of the Pistoia altarpiece and obviously to his own design. For the kneeling St. Donatus Credi clearly uses the corresponding figure of the altarpiece (Plate 84), arranging the saint so that he can copy closely the particular aspect and, thanks to identical lighting, the modelling of the head as well. Characteristic of Credi here are again the curious proportions of the hands, with the thumb and little finger very short.

App. 49. Lorenzo di Credi: Annunciation. Painting. Paris, Louvre.

The picture, which originally formed the centre panel of the predella of the Pistoia altar (Plate 84), is modelled in its scenery and especially in the figure of the angel on the Annunciation which Leonardo had now completed for Monte Oliveto (App. 29). The transposition to the very small format of a predella gives rise to a number of distortions in the details of the figures: the hands are rather too large and heavy in effect, and the feathers of the angel's wing seem much too strong in relation to the head and bust of Gabriel. Despite its many defects, as for example the ugly structure of the angel's face with its vestigial chin and the stupid expression of the eyes, the picture pleases with the harmony of the colour scheme and the intimate devotional mood of the scene. It is not impossible that Credi modelled his rendering of the head of the Virgin on corresponding drawings by Leonardo; there is a similarity of type with the head of the Madonna in Leonardo's early Louvre drawing for the Adoration of the Kings. Less convincing is the idea of some scholars that Leonardo worked out large-format studies of heads, such as the Uffizi sheet (App. 43), for the preparation of the small predella scene. Doubtless Credi used such drawings of Leonardo's, which he knew or may have even possessed, in his own preparatory work. The opinion, repeatedly advanced at various times, that Leonardo himself painted the Louvre Annunciation or had a determining share in its production must be rejected because of the weaknesses in the design and execution of the picture.

App. 50. Studio of Verrocchio (Biagio d'Antonio, called 'Utili'?): Faith. Drawing. Florence, Uffizi No. 208 E.

Berenson first thought the sheet was the work of a pupil of Botticelli, under the influence of the artist's early Verrocchiesque stylistic phase. Later Cruttwell was able to demonstrate (*Rassegna d'Arte*, 1906, p. 8 ff.) the connection of the drawing with the competition held in the autumn of 1469 for the commission for the paintings of the Virtues for the Council Chamber of the Merca-tanzia; Cruttwell's identification of the documented drawing for Faith by Verrocchio with the Uffizi sheet was rightly rejected by Berenson i.a.; it is probably a smaller and simplified drawing after Verrocchio's design for the competition. The 'Castagnesque' style of draperies connects the drawing closely with the Budapest altar-piece (App. 52), as can be shown by a comparison with the drapery of the cloak of St James the Less, recognizable by his fullers' staff. The head of Faith is closely related to the head of the child in the Madonna (App. 51) in its facial structure and in the expression of the eyes.

App. 51. Biagio d'Antonio, called 'Utili': Madonna. Painting. Formerly London, art market.

The work has clear reminiscences of the art of Pol-laiuolo, especially in the landscape and also in the proportions of the seated figure of the Virgin, which echo the cycle of the Virtues (cf. App. 21), in the form and gesture of her hands and in the style of the draperies. The motif of the Child's movement and his placing in relation to the Virgin are strikingly similar to a relief composition from the studio of Rossellino known in several slightly diverging variants (e.g. Berlin, Staatliche Museen, Inv. No. 90). Utili was obviously, like Francesco Botticini, one of those competent but not very independent artists whose development was determined by his changing association with the chief representatives of Florentine painting. In his early period he seems to have been influenced by the work of the circle of Fra Filippo Lippi, especially the Madonnas of Pesellino, as the Madonna of the Poldi Pezzoli collection in Milan shows. Like Domenico Ghirlandaio he joined the brothers Pollaiuolo for a time. He must have come into closer contact with Verrocchio at the beginning of the seventies, when Verrocchio's studio began to play a leading role in the field of painting.

App. 52. Biagio d'Antonio, called 'Utili': Madonna with Saints. Painting. Budapest, Szépmüvészeti Muzeum.

The work is probably to be identified with the altar panel which Vasari mentions in the church of the con-

vent of S. Domenico del Maglio in Florence and which he or the authority on which he was depending held to be a work of Verrocchio's (cf. Passavant 1959, p. 88 ff.). The picture was certainly painted under the direct influence of the works produced by Verrocchio in the early seventies. The general mood of the scene is reminiscent of the Baptism (Plate 78) and also many details such as the heads of the angels holding the crown and the types of the heads of the male saints. The draperies of the cloaks of the Virgin and the figure of St James at the far right are rendered in supple folds characterized by the occurrence of 'ox muzzle' and loop shapes; the style corresponds somewhat to that of the draperies of St John in the Baptism, though it does not achieve the same significance and clarity of motif. It is interesting that in the Budapest altarpiece Verrocchio's study of the art of Castagno is almost more clearly reflected than in the works of the artist himself. Cf. also App. 50.

App. 53. Pietro Perugino: St Peter. Painting. Hanover, Niedersächsische Landesgalerie.

The half-figure painting, which probably had a companion with the representation of the Apostle Paul, arose under the influence of Verrocchio's paintings of the early seventies. While the poise of the right hand of St Peter with the book is taken over from the corresponding part of the figure of St Anthony in the Argiano altarpiece (Plate 76) the gesture of the other hand holding the key and the motif of the cape forming a C shape as it is drawn round the elbow seem to come directly from the figure of the angel in the London Tobias and the Angel (Plate 72); but the play of folds in Perugino's picture is very much richer and more broken up, and also less clear in arrangement. The accentuation of the sheen of the cloths and the rendering of the nuances of breaks in the colour which arise in the modelling of the folds and from the reflected lights at the juxtaposition of cloths of different colours, betray the Umbrian origin of the painter and his schooling in colour by Piero della Francesca. No such observations can be made of any of the other paintings from the studio of Verrocchio discussed here (except Perugino's predella painting in Liverpool (App. 54)) nor in the autograph paintings of the artist in Argiano and London (Plates 72–77) in which some scholars have thought to recognize early works by Perugino.

App. 54. Pietro Perugino: The Birth of St John the Baptist. Painting. Liverpool, Walker Art Gallery.

That the picture originally belonged to the predella of the Pistoia altar (Plate 84) has been established by the research of Valentiner (1950, p. 140 ff.); his reconstruction has recently been questioned erroneously. Perugino's picture and Credi's two-figure scenes (App. 48 and 49) can in any case hardly be referred to a uniform general design for the predella. Perugino must have painted his picture during the first phase of the production of the Pistoia Altar, about 1478/79, while Credi executed the two scenes still needed for the predella when completing the altar after 1485, though now with two larger figures which in comparison with the surroundings (such as the prayer stool and the benches in the Louvre Annunciation) are almost too large in effect.

App. 55. Pietro Perugino: Portrait, possibly of Verrocchio. Painting. Florence, Uffizi.

The sitter is certainly not Perugino, though there have repeatedly been attempts to prove this by comparing it with his self-portrait in the Cambio in Perugia (Ill. in Camesasca, *Perugino*, Milan 1959; plate 123); both portraits agree so much in the specific poise of the head, in the lighting and especially in the costume, that at first sight it would in fact seem to be the same person. Perugino's nose in its general shape is not as broad as that in the Uffizi portrait; the ridge of the nose is at its broadest up between the eyes, then it becomes narrower at first until it broadens out again a little at the tip. The side contours of the temples and cheeks do not agree either: Perugino's head is a uniform rounded oval shape, reaching its maximum breadth rather below the height of the eyes. In the other portrait the head is at its broadest at the height of the tip of the nose. Perugino's head has a rather broader chin, clearly indented beneath. Vasari, who used the Uffizi portrait as the model for the woodcut portrait for his Life of Verrocchio, says in the Life of Lorenzo di Credi that he knows portraits of Perugino and of Verrocchio which came from Credi's estate. In a legal document interpreted by Covi (1966, p. 103, IV) it is said that Credi inherited or took over a portrait of his master together with numerous other pieces in the inventory of Verrocchio's studio. People in Florence certainly had a good idea of what the artist looked like some decades after the death of Verrocchio, and Vasari's designation of the Uffizi painting as a portrait of Verrocchio should not be questioned without important reasons. The Uffizi portrait is not by Credi, but evidently by Perugino. This is proved particularly by the colouring of the flesh, the manner of rendering the hair and above all by the representation of the landscape through the window.

INDEX OF LOCATIONS OF ILLUSTRATED WORKS

Sc. = Sculpture; P. = Painting; D. = Drawing; Fr. = Fresco.

INDEX OF NAMES AND WORKS OF ART

Authors are included only where they are cited in the Essay or in the Catalogue apart from the Bibliographies.